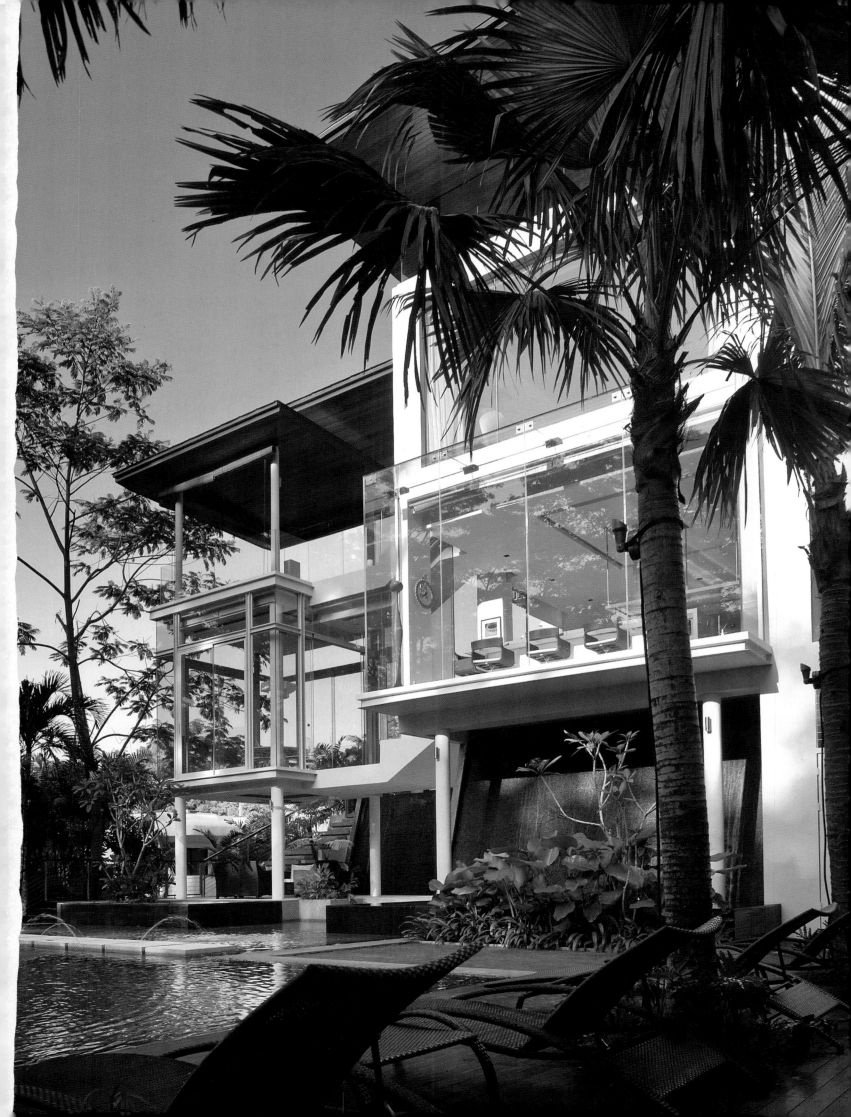

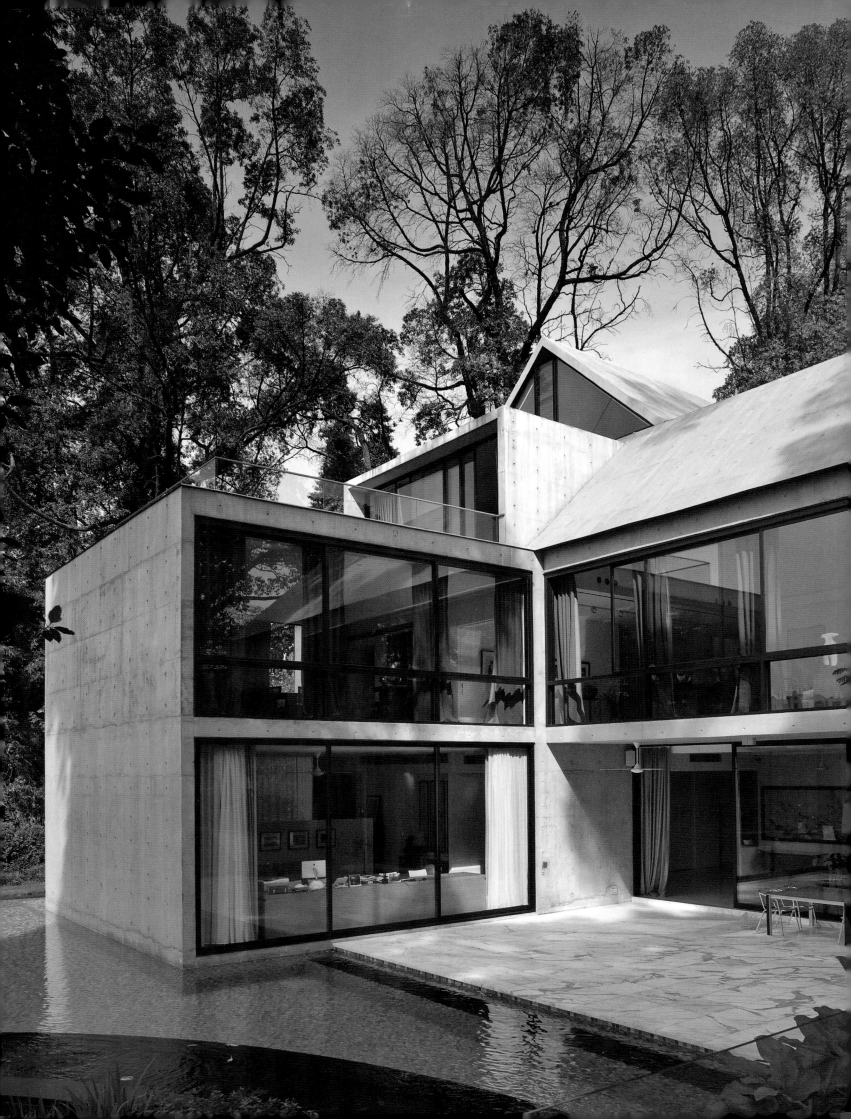

SINGAPORE HOUSES

ROBERT POWELL

photographs by ALBERT LIM KS

TUTTLE PUBLISHING
Tokyo • Rutland, Vermont • Singapore

Published by Tuttle Publishing, an imprint of Periplus
Editions (HK) Ltd., with editorial offices at 364 Innovation
Drive, North Clarendon, Vermont 05759, USA, and
61 Tai Seng Avenue, #02-12, Singapore 534167.

Text © 2009 Robert Powell
Photographs © 2009 Albert Lim Koon Seng

ISBN 978-0-8048-4051-4

Distributed by:
North America, Latin America & Europe
Tuttle Publishing
364 Innovation Drive, North Clarendon, VT 05759-9436, USA
Tel: 1 (802) 773-8930; Fax: 1 (802) 773-6993
info@tuttlepublishing.com
www.tuttlepublishing.com

Asia Pacific
Berkeley Books Pte Ltd
61 Tai Seng Avenue, #02-12, Singapore 534167
Tel: (65) 6280-1330; Fax: (65) 6280-6290
inquiries@periplus.com.sg
www.periplus.com

Japan
Tuttle Publishing
Yaekari Building, 3rd Floor, 5-4-12 Osaki
Shinagawa-ku, Tokyo 141 0032
Tel: (81) 03 5437-0171; Fax: (81) 03 5437-0755
tuttle-sales@gol.com

Printed in Singapore

11 10 09
6 5 4 3 2 1

Front endpaper The Alleyway House (page 176) is arranged
around a large aviary for the owner's parrots.

Back endpaper A vertical landscape ascends the walls of
the airwell in the Jalan Elok House (page 82).

Page 1 In the VUe House (page 110), the kitchen/dining room
overlooks a splendid Balinese-style water court.

Page 2 Off-form concrete walls are the principal external
material of 2Q Bishopsgate (page 120) and give the house
its distinctive character.

Pages 4–5 House 229 (page 102) is a compact, well-detailed
residence that responds creatively to the design codes
imposed on the Sentosa Cove development.

Pages 6–7 left to right Sundridge House (page 74), Nassim
Road House (page 66) and Ocean Drive House (page 128).

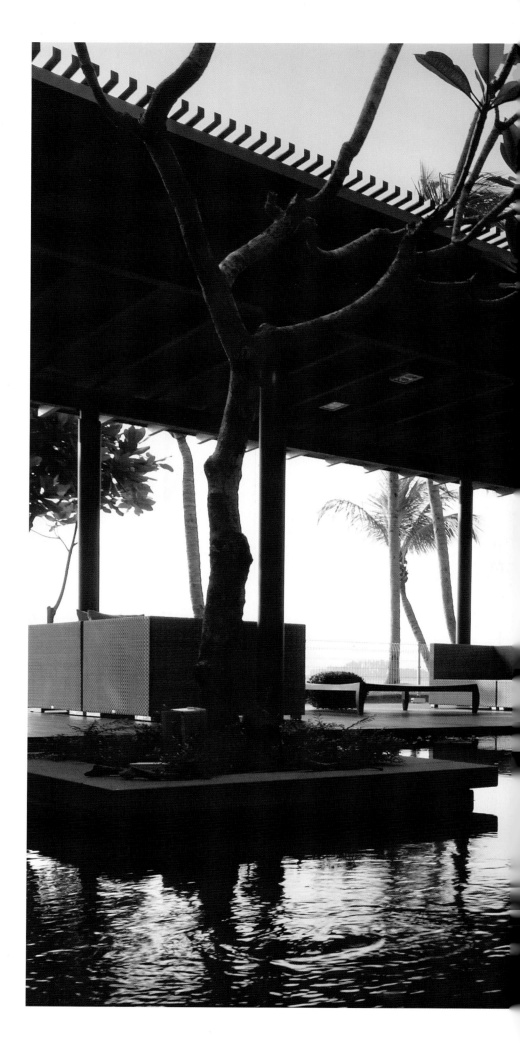

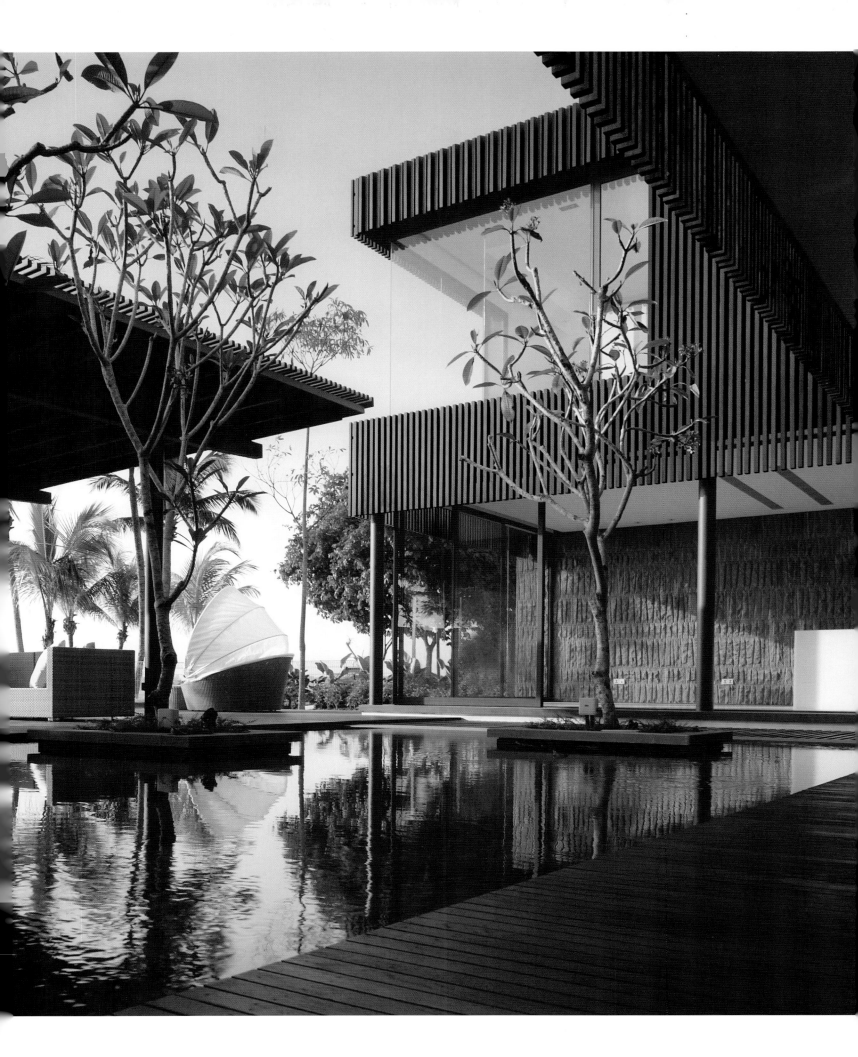

Contents

From the pool terrace of the Lakeshore House (page 160), there are dramatic views over the Straits of Singapore.

cutting-edge tropical architecture in a global city

THE HOUSES IN THIS BOOK EPITOMISE CUTTING-EDGE RESIDENTIAL ARCHITECTURE IN SINGAPORE AT THE BEGINNING OF THE TWENTY-FIRST CENTURY AND DEMONSTRATE A REMARKABLE SURGE OF DESIGN EXPLORATION IN THE CITY-STATE.[1]

Architects in Singapore are producing work with a level of refinement and sophistication that is comparable with the best in the world, and one would be hard pressed to find a nation of similar size with such an abundance of accomplished young designers who have built independently.

In the last two decades of the twentieth century, architectural debate in Singapore, as in many Asian countries that had formerly been colonized by European powers, revolved around the notions of Identity[2] and Critical Regionalism.[3] Prominent Singapore participants in seminars that were convened in the 1980s and 1990s included Tay Kheng Soon and William Lim Siew Wai. Both wrote at length about the social, cultural and climatic imperatives of architecture.

Lim's *Contemporary Vernacular* (1998),[4] written in collaboration with Tan Hock Beng, extolled the merits of reinvigorating and reinterpreting the traditional vernacular architecture of the region. His design for the Reuter House (1990) was just such a contemporary interpretation. In contrast, the King Albert Park House (1994) by Tay Kheng Soon was designed in a modern tropical idiom that demonstrated what Tay identified in *Modern Tropical Architecture* (1997)[5] as 'a language of line, edge, mesh and shade'.

The discourse on the 'global' and the 'local' fuelled several publications, such as *The Asian House* (1993),[6] *The Tropical Asian House* (1996)[7] and *The Urban Asian House* (1998),[8] which placed the production of architect-designed dwellings within a broad theoretical framework linked to issues throughout the so-called developing world.

Other publications followed in the next decade, including *Houses for the 21st Century* (2004),[9] *New Directions in Tropical Architecture* (2005)[10] and *25 Houses in Singapore and Malaysia* (2006),[11] as publishers in the Antipodes belatedly turned their gaze on developments in Asia.[12] In 2008, David Robson's magnificent volume, *Beyond Bawa*,[13] also drew attention to the work of a group of Singapore architects bewitched by the magical houses designed by the Sri Lankan master architect Geoffrey Bawa.

Another Singapore architect, Tang Guan Bee, wrote little, but through his built work, such as The Mountbatten House (1988) and later the Windsor Park House (1997), demonstrated a spirit of invention and audacity that captivated the imagination of many young architects entering the profession. The diverse approaches to domestic architecture of Tay, Lim and Tang laid the foundations for the explosion of design ideas in Singapore in the first years of the new millennium. Significantly, four of the architects featured in this book worked at some time or other with TANGGUANBEE Architects, while five began their careers with William Lim Associates and three with Tay's practice, Akitek Tenggara.

A HOUSE IN THE HUMID TROPICS

'SPACE … IS NOT REALLY ABSTRACT. SPACE IS SOMETHING WE CAN MODERATE AS ARCHITECTS TO SATISFY A WHOLE RANGE OF FUNCTIONS, INCLUDING VISUAL, SOCIAL AND PSYCHOLOGICAL REQUIREMENTS. NOBODY EXCEPT THE ARCHITECT CAN DO THIS … IT IS THE MOST SIGNIFICANT ROLE OF THE ARCHITECT.' *Tang Guan Bee*[14]

For an architect, the design of a bespoke family dwelling is a demanding yet fascinating commission. A designer rarely

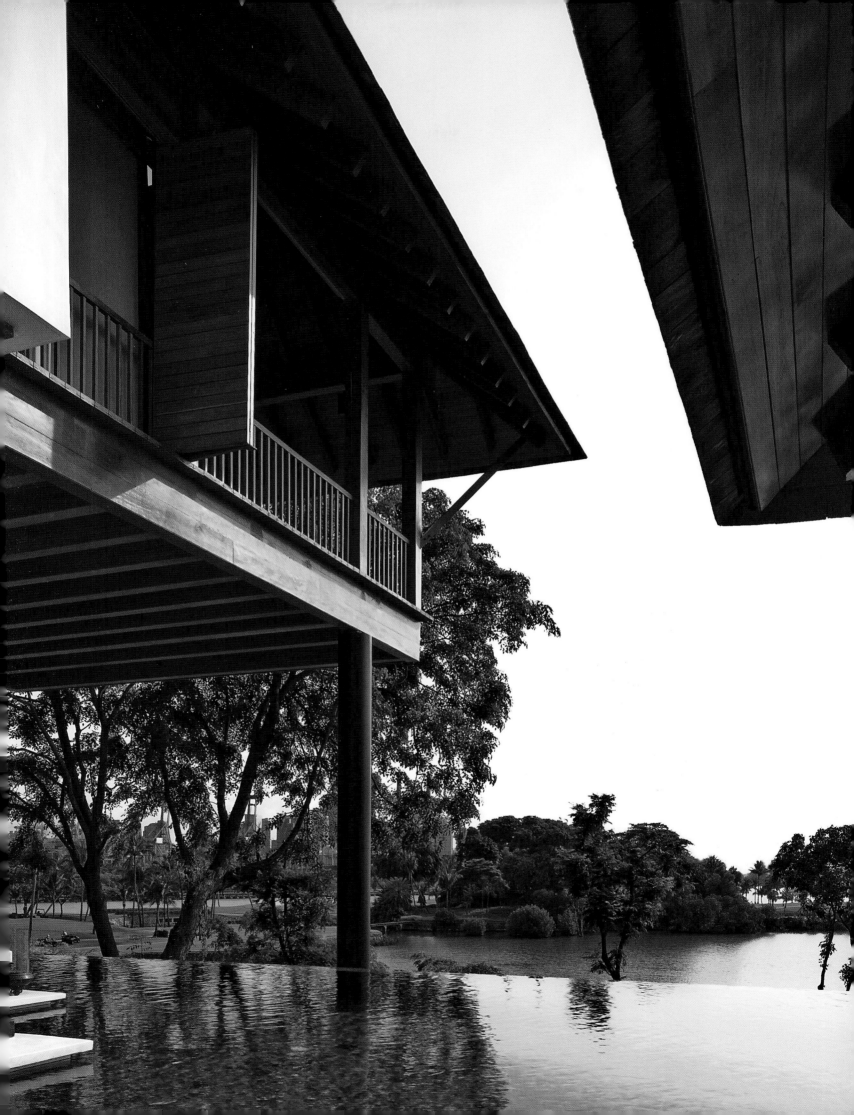

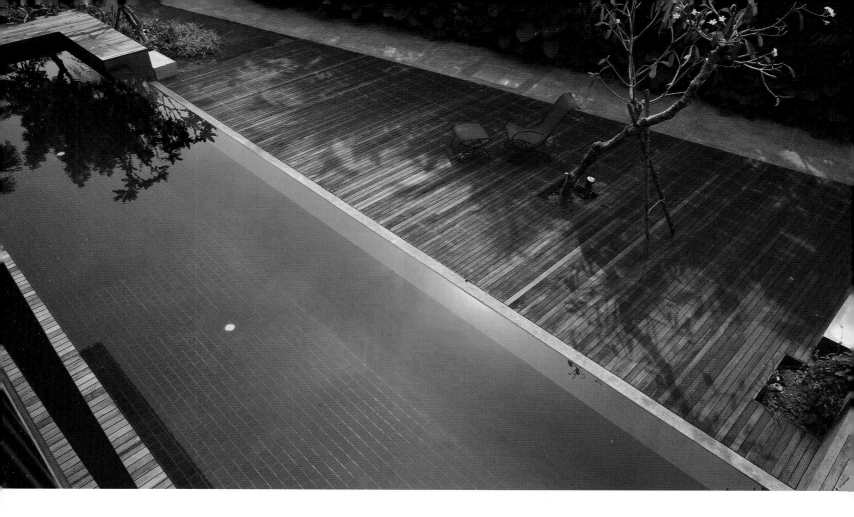

has such a close relationship with the end user. The most successful houses arise out of a strong empathy between the client and designer. This consonance is of critical importance because a house is ultimately 'a social portrait of its owner'.

Single-family houses frequently acquire a hold on the imagination of generations of architects and are transmitted around the world. Think, for example, of the Villa Savoye by Le Corbusier (1928–9) or Gerrit Rietveld's Schroeder House in Utrecht (1923–4). In a similar manner, Jimmy Lim's Aga Khan Award-winning Salinger House at Bangi, Malaysia (1993), Ernesto Bedmar's Eu House in Singapore (1993) and Geoffrey Bawa's Cinnamon Hill House at Lunuganga, Sri Lanka (1993) fired the imagination of many young architects in Southeast Asia in the 1990s.

In 1996, in *The Tropical Asian House*, I summarized the attributes of a dwelling in the humid tropics. The first three criteria were articulated in a discussion with Bawa[15] while dining on the terrace of his home at Lunuganga. He maintained that a house in the tropics is about living in close proximity to the natural world, and therefore no substantial trees should be destroyed on the site. He also asserted that a house in the tropics should be designed with the minimal use of glass, while other attributes include the use of gardens and non-reflective surfaces to reduce radiated heat, wide overhanging eaves to provide shade, in-between spaces in the form of verandahs, terraces and shaded balconies, tall rooms to create thermal air mass and provide thermal insulation, permeable walls facing prevailing winds to give natural

ventilation, plans that are one room deep with openings on opposite sides capable of being adjusted to promote natural ventilation by the 'venturi' effect, and the omission of gutters. Bawa's houses and resorts, published in a monograph of his work, *Geoffrey Bawa*, edited by Brian Brace-Taylor (1986),[16] influenced a generation of Singapore architects educated in the late 1980s and 1990s.[17]

These criteria are still relevant in the densely populated island although the urban house cannot be so pure. To this list must be added another imperative, namely, duality between the public side of a house and the private side. This is linked to the perception of security with the public side being 'closed' and the private side 'open'.

The challenge facing architects even in the relatively crime-free city of Singapore is to design houses that permit their clients to live a relaxed, open lifestyle, with verandahs, terraces and courtyard spaces, while simultaneously solving issues of security. Living in a conurbation necessitates a variety of responses to the perceived threat of intruders, including perimeter walls, fences and electronic surveillance devices. A house in the city invariably includes some means of isolating and securing the family sleeping quarters at night.

The houses shown here embody a hierarchy of privacy with a public façade that seeks not to attract undue attention or to make an extravagant display of wealth, and interior spaces that embrace and shelter their occupants while opening out to courtyards and terraces. They provide a haven of calm and a 'refuge' from the frantic pace of life in the city-state

and seek to modify the effects of air pollution, noise and increasingly high temperatures that inevitably necessitate air conditioning in some parts of the house.

THE HOUSES IN THIS BOOK

'IT IS VERY DIFFICULT TO DESIGN A HOUSE — TO TRY TO PSYCHOANALYSE YOUR CLIENT, TO DETERMINE BEHIND THE FAÇADE WE ALL ERECT TO THE WORLD WHO THE CLIENT REALLY IS ... BUT IT IS ESSENTIAL IF THE HOUSE IS TO FIT THE PERSONALITY.' *Geoffrey Bawa*[18]

The houses in this book were all constructed in the first decade of the twenty-first century and vividly illustrate emerging ideas on living in the city-state. They are the work of three generations of architects.

Two of the houses are designed by respected doyens of the profession in Singapore, namely, Sonny Chan Sau Yan and Kerry Hill. Both began their architectural careers in the 1960s and have impressive portfolios of work carried out internationally over a forty-year period. In the process, they have garnered numerous awards.

But the majority of the dwellings, eighteen in all, are designed by what I defined, in October 1999, as the 'Next Generation'.[19] The architects who fall in this category include Ernesto Bedmar, Chan Soo Khian, Ko Shiou Hee, Lim Cheng Kooi, Mok Wei Wei, Siew Man Kok, Kevin Tan, Tan Kok Hiang, René Tan, Teh Joo Heng, Toh Yiu Kwong, WOHA (Wong Mun Summ and Richard Hassell) and Yip Yuen Hong. I had the privilege of teaching some of this cohort, and subsequently I have tracked their progress over two decades.

This generation, to quote Philip Goad, 'has moved beyond the attractive formal signs of so-called regional architecture, to a re-thinking of the fundamental issues of space, material practice, tropicality, sustainability, urbanity and place – in essence, a return to Ignasi de Sola Morale's "ground zero" for architecture, a sort of phenomenological and existential base for the production of architecture....'[20]

Finally, there are six houses that have been designed by a younger generation of architects who represent a 'new force' in the profession. This group includes Brenda Ang of LAB Architects, Randy Chan of zarch col**lab**oratives, Chang Yong Ter of CHANG Architects, Ling Hao of Linghao Architects, and the four partners (Alan Tay, Gwen Tan, Berlin Lee and Seetoh Kum Loon) in the collaborative practice of formwerkz architects.

Some of the youngest practitioners question the conspicuous consumption displayed in Singapore houses in the recent past, while others in the book explore the need to design in a more sustainable manner as the world's resources become rapidly depleted. There is also evidence of greater contextual sensitivity and the pursuit of phenomenology, while the ability to work with the existing topography has noticeably improved.

Some of the younger architects consciously employ a narrative technique, where the house can be 'read' as a 'story' about its inhabitants, how they apportion their lives, the relationships they forge and how they relate to other family members and to visitors.

CHANGING CULTURAL PATTERNS

'THE REGIONALLY UNIQUE FAMILY COMPOUND ... MERITS FAR GREATER ANALYSIS THAN HAS BEEN GIVEN TO IT AS YET.... ARE THE SPACES AS LAYERED AND VEILED AS THEY APPEAR TO BE? HOW DO THEY ALLOW FOR THE SUBTLE RANGES OF "KNOWING" AND "CHOOSING-NOT-TO-KNOW" THAT MUST CHARACTERISE THE RELATIONSHIPS BETWEEN THE THREE GENERATIONS OF THE FAMILY THAT INHABIT A COMMUNE?"' *Leon Van Schaik*[21]

Society in Southeast Asia places great value on filial piety, and it is common to encounter three generations of a family living together. The multigenerational home presents a number of challenges for the designer. It is necessary to understand the relationships between members of the family and to consider the hierarchies of privacy. Balance also has to be maintained between intimate private space and shared space that reflects the family structure.

The custom of grandparents residing with their children and grandchildren is an enduring phenomenon in Singapore, and eight of the houses demonstrate solutions to this mutually supportive form of living. High land prices in Singapore have motivated some house owners to find innovative ways of building that assure their offspring of a house that they could not aspire to on their own. They demonstrate a strong Asian cultural tradition of filial piety that is manifested in three-generation family homes or compounds.

Paradoxically, there are also houses designed for somewhat less conventional family groupings that reflect subtle social and cultural changes in Singapore, for 'unlike large projects, which normally require broader societal, corporate or political consensus, the private house … often expresses, in the most uncompromising way possible, the vision of a client or architect, or both.'[22]

The design of bespoke dwellings is a discernable trend. Whereas previously a house would be, to some extent, generic in that the owner(s) would often have an eye to the house's future resale value, nowadays a house is more likely to be purpose-built. In the past, floor area would generally be maximized whereas now some house owners are prepared to sacrifice Gross Floor Area (GFA) in order to enjoy greater outdoor space in the form of gardens, terraces, verandahs and courtyards. In many instances, this has improved the environmental performance of the house.

The kitchen is the focus of several houses in this volume. It is still the usual practice in Singapore to put the 'wet kitchen' out of sight at the rear of the house; indeed, even the Western-style 'dry' kitchen in many houses is often the domain of a Filipino, Indonesian or Sri Lankan maid. But this is no longer always the case. Some house owners prefer to entertain in the kitchen, displaying their culinary skills to guests. Daytime television programmes, dominated by local and international cooking shows, have influenced social attitudes. Well-stocked wine cellars are increasingly a feature of the houses of upper-income Singaporeans.

Five of the houses are located on the reclaimed land of Sentosa Cove. Heralded as a bold experiment on a virgin site, the quality of design at Sentosa is generally disappointing. This can be attributed, in part, to a design code that has seemingly stifled and suffocated innovation with its insistence upon pitched roofs. The code was presumably intended to bring about conformity with a prescribed notion of the traditional vernacular. But the pitched roofs of many houses sit uneasily above modernist glazed boxes, whereas the houses published here show that it is possible to produce excellent solutions within tight constraints.

The houses in the book are first and foremost beautiful objects fashioned by architects and designers who display confidence in the handling of space and form. Some of the established architects are at the height of their creative powers, building upon a lifetime of experience. Some of

the youngest explore radical ideas of living in a global city, often designing for a young, affluent group of clients with a singularly different attitude to life than their parents. Some are raw in execution but they are clearly the result of an energetic and intelligent process.

NURTURING LOCAL TALENT

MORE THAN HALF OF THE HOUSES IN THE BOOK ARE DESIGNED BY GRADUATES OF THE SCHOOL OF ARCHITECTURE AT THE NATIONAL UNIVERSITY OF SINGAPORE IN THE 1980S AND 1990S. IN 1984, FOLLOWING A REPORT BY PROFESSOR ERIC LYE KUM-CHEW, A MAJOR REORGANIZATION OF THE SCHOOL SAW THE ARRIVAL OF A DYNAMIC NEW CO-HEAD, MENG TA-CHENG,[23] AND THIS COINCIDED WITH AN INFLUX OF EXPATRIATE TEACHERS – INCLUDING MYSELF – TO SUPPLEMENT THE LOCAL STAFF. DR NORMAN EDWARDS,[24] WHO HAD WORKED WITH WALTER GROPIUS, RICHARD NEUTRA AND SIR DENNIS LASDUN, HEADED THE B. ARCH. PROGRAMME, AND OTHER IMPORTANT APPOINTMENTS INCLUDED THE ACCOMPLISHED BRITISH DESIGNER DEREK GOAD, THE CALIFORNIAN ARCHITECT PETER WOLFGANG BEHN, DR RICHARD HYDE (CURRENTLY PROFESSOR OF ARCHITECTURAL SCIENCE AT THE UNIVERSITY OF SYDNEY) AND PETER WOOD (CURRENTLY PROFESSOR AND CHAIR OF THE KNOWLEDGE MANAGEMENT CENTRE AT THE MULTIMEDIA UNIVERSITY OF MALAYSIA).

The charismatic Thai architect Mathar Bunnag also taught in the School for three years, as did Winston Yeh and Pai Chin (later Professor of Architecture at the National Taiwan University of Science and Technology). They joined Asian scholar Dr Pinna Indorf, James Harrison, Ng Kheng Lau, Stephen Lau (later Associate Professor of Architecture at the Chinese University of Hong Kong), Dr Suthipanth Sujarittanonta (later Dean of the Faculty of Architecture at Sripatum University) and the distinguished art historian T. K. Sabapathy.

The studio culture was enhanced by the probing interrogation of student projects by sociologist Dr Chua Beng Huat and by the research methodology of Dr Kenson Kwok, at that time the head of research at the Housing and Development Board and later to become Director of the Asian Civilisations Museum.

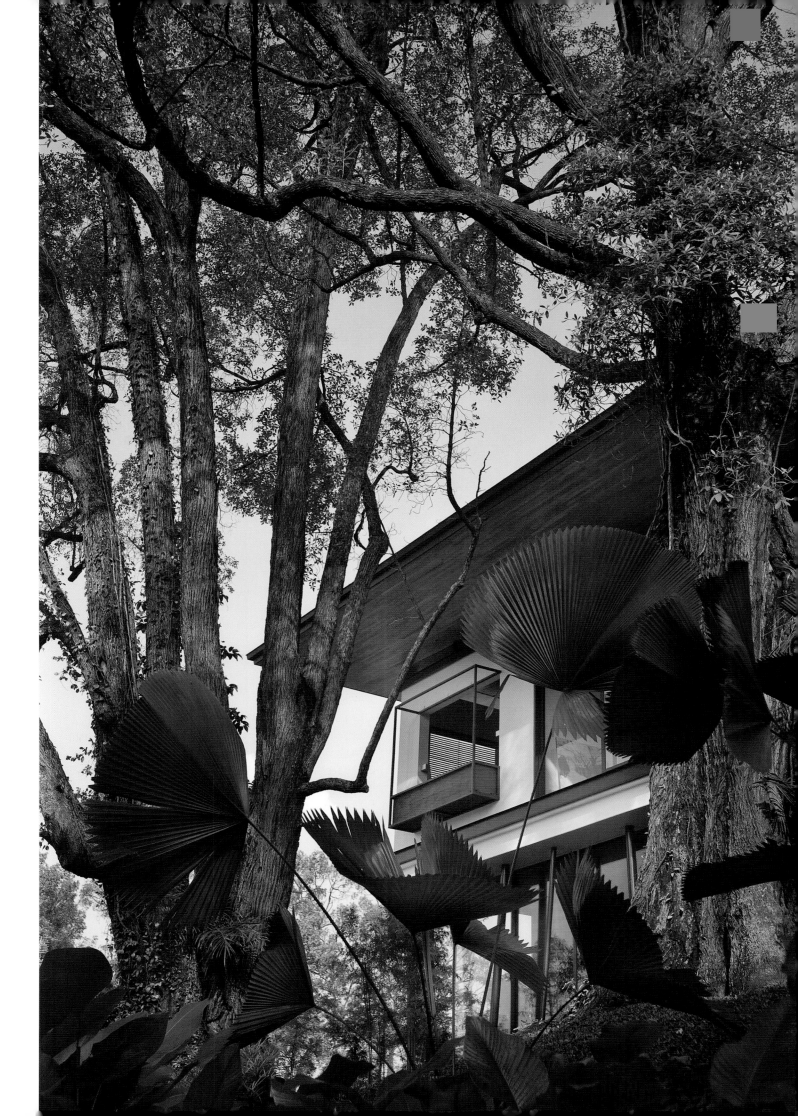

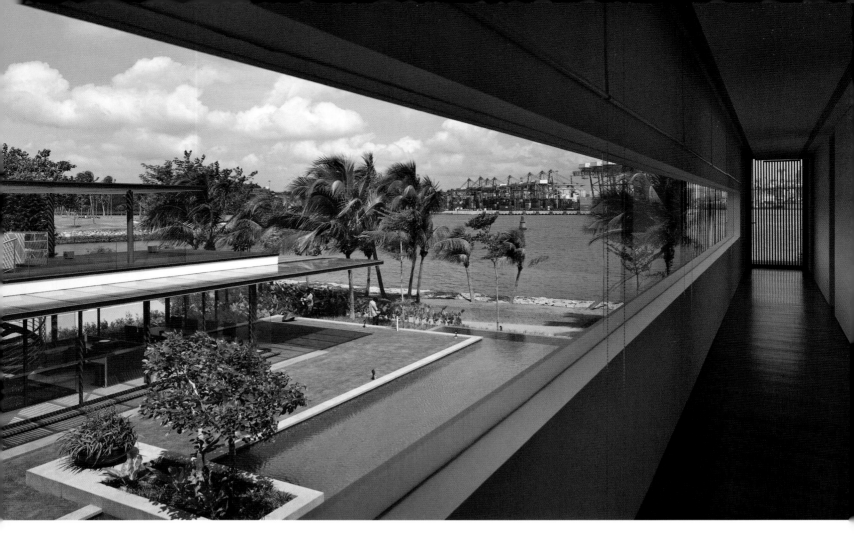

Visiting professors included RIBA Gold Medallist Sir Colin Stansfield Smith, Aga Khan Award winner eco-architect Dr Ken Yeang, Professor Ivor Smith, Filipino architect Bobby Mañosa, Pritzker prizewinner Charles Correa, Professor Andy McMillan, Professor Lionel March and the esteemed Hong Kong practitioner Tao Ho.

A rich amalgam of teachers from all parts of the world was drawn to the School of Architecture in this period, and it resulted in a highly creative studio culture that was frequently supplemented by lectures from 'superstars' such as Aldo van Eyke, Will Alsop, Norman Foster and Shin Takamatsu.[25]

Local staff members were encouraged to pursue graduate studies overseas, returning from the early 1990s to take up key positions. Heng Chye Kiang, now Professor and Dean of the School of Design and Environment, gained his Ph.D. at the University of California at Berkeley, and Wong Yunn Chii, now Associate Professor and Head of the Department of Architecture, returned with a Ph.D. from MIT at Cambridge, USA.[26] Others gaining doctorates included Foo Ah Fong (University College London), Joseph Lim Ee Man (Heriot Watt University), Ong Boon Lay (Cambridge University), Milton Tan (Harvard University) and Lam Khee Poh (Carnegie Mellon University, where he is now Professor of Architecture). Chan Yew Lih and Bobby Wong Chong Thai also pursued postgraduate studies at the Institute of Advanced Architectural Studies at York (UK) and Harvard University.

Several of the architects featured in this book have taught or are currently teaching part time in the Department of Architecture. Chan Sau Yan was for a period Adjunct Associate Professor, and Kerry Hill, Ernesto Bedmar, Chan Soo Khian, Mok Wei Wei, Teh Joo Heng, René Tan, Yip Yuen Hong, Alan Tay, Wong Mun Summ and Richard Hassell have all endeavoured to 'put something back' into the profession by imparting their knowledge and experience in the design studio or as visiting critics.

The practice of engaging respected overseas academics continued in the 1990s with Dr Gulsum Baydar Nalbantoglu (currently Professor and Head of the Department of Architecture at Izmir University of Economics, Turkey), Dr P. G. Raman (later Professor and Head of the School of Architecture at the University of Witwatersrand, South Africa), and Dr Edward Ng (currently Professor in the Department of Architecture in the Chinese University of Hong Kong) teaching for several years in the school.

The engagement of overseas academic staff to fast track the development of architectural education had parallels in broader strategies encouraged by the Singapore government in the 1980s and 1990s. Foreign architects were frequently employed as design consultants to project the image of the island's astounding economic achievements onto a world stage. I. M. Pei designed the iconic OCBC Centre (1975) and later added Raffles City (1985) to his

portfolio. John Portman was responsible for the design of the Marina Square complex (1985). Others followed, including Habitat (1984) by Moshe Safdie, OUB Centre (1991) and UOB Plaza (1993–5) by Kenzo Tange and Republic Plaza (1996) by Kisho Kurokawa. The American architect Philip Johnson placed his marker with the Millenia Walk (1996), while James Stirling's contribution was Temasek Polytechnic (1995).[27]

The heavy investment in foreign design expertise inevitably created a spirited response from local architects and fuelled the debate on identity, regionalism and the 'global' versus the 'local'. It was in the context of this debate that the younger architects in this book were educated.

Several architects whose work is illustrated here received part of their education overseas and have worked for a period outside their homeland. Four of the architects attended architectural schools in Australia, two in the UK and four in the USA. After some years they returned to Southeast Asia to be confronted with what Tay Kheng Soon has described as 'a process of (un)learning', where a new language must be assimilated in which 'the building section takes precedence over the plan as the generator of building form and the basis of design thinking....'[28]

Some of the architects pursued their architectural education in Australia, at Curtin University of Technology, the University of New South Wales, RMIT University and the University of Western Australia. Others took a route that led them to Yale University, the Pratt School of Architecture New York and Washington University in the USA. A third group chose to further their architectural studies in the UK at the Architectural Association, Cambridge University, the University of North London and the University of London.

It is not surprising that the early masters of the modern movement have been a significant influence on all three generations of architects. Most of the designers refer to the seminal projects of Le Corbusier, Oscar Niemeyer, Mies van der Rohe, Alvar Aalto and Louis Kahn, while Frank Lloyd Wright and Carlo Scarpa are also frequently mentioned as formative influences. The Japanese masters Kenzo Tange, Fumihiko Maki and Kisho Kurokawa are evidently influential, and all three have built in Singapore.

Younger architects allude to the work of Peter Zumthor, Rem Koolhaas, Herzog & de Meuron, Stephen Holl, Kazuyo Sejima, Paulo Mendes, Glenn Murcutt, Ken Yeang, Norman Foster and Kerry Hill as sources of inspiration. The latter two have built extensively in Singapore. It is evident that it is global practice that inspires the majority of Singapore architects, yet the work of Geoffrey Bawa, which gained wide exposure in the mid-1980s with the publication of a monograph of his work by Concept Media, the publishing arm of the Aga Khan Award for Architecture, was a major influence on the 'next' generation.

Most of the architects whose work is illustrated within the pages of this book are members of AA Asia, a group established in 1990 by graduates of the AA School of Architecture, including William Lim, Ken Yeang, Suha Özkan, Geoffrey London, Chan Sau Yan and Karen Grover. In 1993, its membership was widened to embrace architects from other institutions. The group continues to be an incredibly valuable forum for discourse on theories of architecture and urbanism and has done much to promote excellence in design. Its members meet several times each year, often in William Lim's home, to hear informal talks and contribute to discussions with internationally renowned practitioners and academics. Speakers have included Charles Correa, Fumihiko Maki, Takeo Muraji, Sumet Jumsai, Leon Van Schaik and Rem Koolhaas. The group also organizes seminars and architectural study tours, and members have visited Japan, China, Spain, Australia, Thailand and India.

The value of AA Asia in promoting a dialogue among design-led practitioners cannot be underestimated, and it is significant that among its members are Ernesto Bedmar, Chan Soo Khian, Richard Hassell, Kerry Hill, Ko Shiou Hee, Mok Wei Wei, Tan Kok Hiang, Teh Joo Heng, Wong Mun Summ and Yip Yuen Hong.

DESIGNING WITH CLIMATE

'(THERE IS) ... A GROWING CONSENSUS THAT THE NEW ARCHITECTURE IF IT IS TO MEET THE CHALLENGE OF THE ENVIRONMENTAL CRISIS, ASIDE FROM MORE PAROCHIAL ISSUES, MUST BE FIRMLY GROUNDED IN ECOLOGICAL PRINCIPLES.' *Chris Abel*[29]

In a world where climate change and carbon emissions will impact upon every region and every country, there is evidence of an increasing awareness of the responsibility of architects to build in a sustainable manner. The houses in this book show a good grasp of the principles of designing with climate. They are concerned with orientation in relation to the sun path and to wind. Overhanging eaves are part of

In response to the sun path, the roof of the Ocean Drive House (page 128) folds down to become a shading device on the northern façade.

the vocabulary that most architects draw upon, as are high ceilings, louvred walls and the use of the 'skin' of the building as a permeable filter. Vertical 'green walls' are increasingly a feature, and one house designed by Chang Yong Ter makes significant progress in the use of green technology.

Sustainability, ecological design, bioclimatic performance and green credentials are now much higher on the agenda of prospective house owners, and these are becoming marketable features as the planet's fossil fuels are depleted. It is not overstating the case to say that within the next decade, energy conservation will become the single defining issue in the form of buildings.

It is evident, too, that architects appreciate that buildings in the tropics should be designed in section rather than in plan. The roof is frequently the most important element in the design of a house, providing shade from the sun and shelter from the monsoon rains. Water is incorporated into every house, and a number of dwellings incorporate a wind shaft to create a 'stack' effect that enhances ventilation. Vestiges of the rain forest in Bukit Timah, Sentosa, Tanglin and Dalvey Estate form the backdrop to almost every house in this book. Several houses are built on hillsides, and they exploit the topography to create imaginative sections.

Yet, some factors never change, and in the geographical context of Singapore, just 1° 33' north of the Equator, the sun path and the direction of the monsoon winds are always givens. What is changing is the flow of ideas about how to live in the twenty-first century – changing cultural responses and greater awareness of environmental issues – and this is resulting in new and often unconventional dwellings in the Singapore context. What we are witnessing is the emergence of design genius that has been germinating since the early-1980s. Now it has blossomed in an abundance of exhilarating architectural expressions.

[1] Inevitably, this book is a 'snapshot' taken at a specific time (early 2008) and as such there are omissions. The intention was to include houses by architects Chan Sau Yan, Norman Foster and Tan Hock Beng, but their owners were desirous of privacy. Time constraints and publishing deadlines meant that houses designed by Look Boon Gee, Aamer Tahir and Ang Gin Wah also missed inclusion in the book.

[2] Robert Powell (ed.), *Architecture and Identity: Exploring Architecture in Islamic Cultures*, Vol. 1, The Aga Khan Award for Architecture and Universiti Teknologi Malaysia, Singapore: Concept Media, 1983.

[3] Robert Powell (ed.), *Regionalism in Architecture: Exploring Architecture in Islamic Cultures*, Vol. 2, The Aga Khan Award for Architecture and Bangladesh University of Engineering and Technology, Singapore: Concept Media, 1985.

[4] William Lim Siew Wai and Tan Hock Beng, *Contemporary Vernacular*, Singapore: Select Books, 1998.

[5] Tay Kheng Soon, 'The Architectural Aesthetics of Tropicality', in Robert Powell (ed.), *Modern Tropical Architecture: Line Edge and Shade*, Singapore: Page

One, 1997, pp. 40–5. Tay is currently Adjunct Professor in the Department of Architecture at the National University of Singapore.

[6] Robert Powell, *The Asian House: Contemporary Houses of Southeast Asia*, Singapore: Select Books, 1993.

[7] Robert Powell, *The Tropical Asian House*, Singapore: Select Books, 1996.

[8] Robert Powell, *The Urban Asian House: Contemporary Houses of Southeast Asia*, Singapore: Select Books, 1998.

[9] Geoffrey London (ed.), *Houses for the 21st Century*, Singapore: Periplus Editions, 2004.

[10] Philip Goad and Anoma Pieris, *New Directions in Tropical Architecture*, Singapore: Periplus Editions, 2005.

[11] Paul McGillick, *25 Houses in Singapore and Malaysia*, Singapore: Periplus Editions, 2006.

[12] In the years 1992–4, under Prime Minister Paul Keating, Australia sought to strengthen its links with its neighbours in the ASEAN (Association of Southeast Asian Nations) group, and worked to achieve closer regional economic cooperation through the APEC (Asia-Pacific Economic Cooperation) organization. The political and economic interest in the ASEAN countries was mirrored in academia.

[13] David Robson, *Beyond Bawa: Architecture of Monsoon Asia*, London: Thames and Hudson, 2008. Robson was Visiting Professor in the Department of Architecture at the National University of Singapore, 2002–5.

[14] Tang Guan Bee, 'Sense and Sensibilities in Architecture', interview with Tan Ju Meng, *Singapore Architect*, No. 214, Singapore Institute of Architects, June 2002, pp. 98–105. Tang was the recipient of the Singapore Institute of Architects Gold Medal in 2006.

[15] Geoffrey Bawa, in conversation with the author, Lunuganga, November 1994, reproduced in Powell, *The Tropical Asian House*, pp. 30–7.

[16] Brian Brace-Taylor, *Geoffrey Bawa*, Singapore: Concept Media, 1986.

[17] Robson, *Beyond Bawa*.

[18] Geoffrey Bawa, in conversation with the author, Lunuganga, November 1994.

[19] Robert Powell, 'Singapore: The Next Generation', *Monument*, No. 32, NSW, Australia, October/November 1999, pp. 72–89. The article identified Mok Wei Wei, Wong Mun Summ, Richard Hassell and Chan Soo Khian as 'a new breed of architects who are changing the face of Singapore architecture'. In a follow up to this article, 'The Next Generation: Part II', in *Monument*, No. 43, NSW, Australia, August/September 2001, pp. 62–9, Tan Kok Hiang, Ko Shiou Hee and Toh Yiu Kwong were also identified as being part of the 'next generation'.

[20] Goad and Pieris, *New Directions in Tropical Architecture*, pp. 17–18.

[21] Leon van Schaik, 'SCDA Architects: A Review', *SIA-GETZ Architecture Prize for Emerging Architecture*, exhibition catalogue, Singapore, 2006.

[22] Terence Riley, *The Un-Private House*, New York: Museum of Modern Art, 1999, p. 28.

[23] Meng Ta-Cheng is the principal of OD Architects.

[24] Dr Norman Edwards was Associate Professor in the School of Architecture at the National University of Singapore throughout the 1980s. He had previously taught at Sydney University, the Massachusetts Institute of Technology and the Architectural Association in London. Edwards was the author, with Peter Keys, of *Singapore: A Guide to Buildings, Streets, Places*, Singapore: Times Books International, 1988. It is still the most informative guide to Singapore architecture. In the book, Dr Edwards pays tribute to the work of other staff in the early 1980s, including Associate Professor David Lim, Jon Lim, Paul Notley, Michael Woodcock and Visiting Professors Dunbar Naismith and Chris Riley.

[25] The School of Architecture in the 1980s and 1990s provided fertile ground for nurturing a new generation of Singapore academics. Current staff of the Department include Dr Chee Li Lian, who received her doctorate from The Bartlett, University College London, Cheah Kok Ming, Dr Hee Limin (Harvard University), Dr Lai Chee Kien (University of California at Berkeley) and Dr Nirmal Tulsidas Kishnani (Curtin University of Technology). All are graduates of the B.Arch. course at the National University of Singapore.

[26] In June 2000, the name of the Faculty of Architecture, Building and Real Estate was changed to the School of Design and Environment. At the same time, the School of Architecture was renamed the Department of Architecture.

[27] For a more complete discussion on the role of foreign architects, see Robert Powell, *Singapore: Architecture of a Global City*, Singapore: Archipelago Press, 2000, pp. 9–19.

[28] Tay, 'The Architectural Aesthetics of Tropicality', pp. 40–5.

[29] Chris Abel, *Architecture and Identity*, Oxford: Architectural Press, 1997, p. 195. Abel taught in the School of Architecture at the National University of Singapore in the mid-1980s.

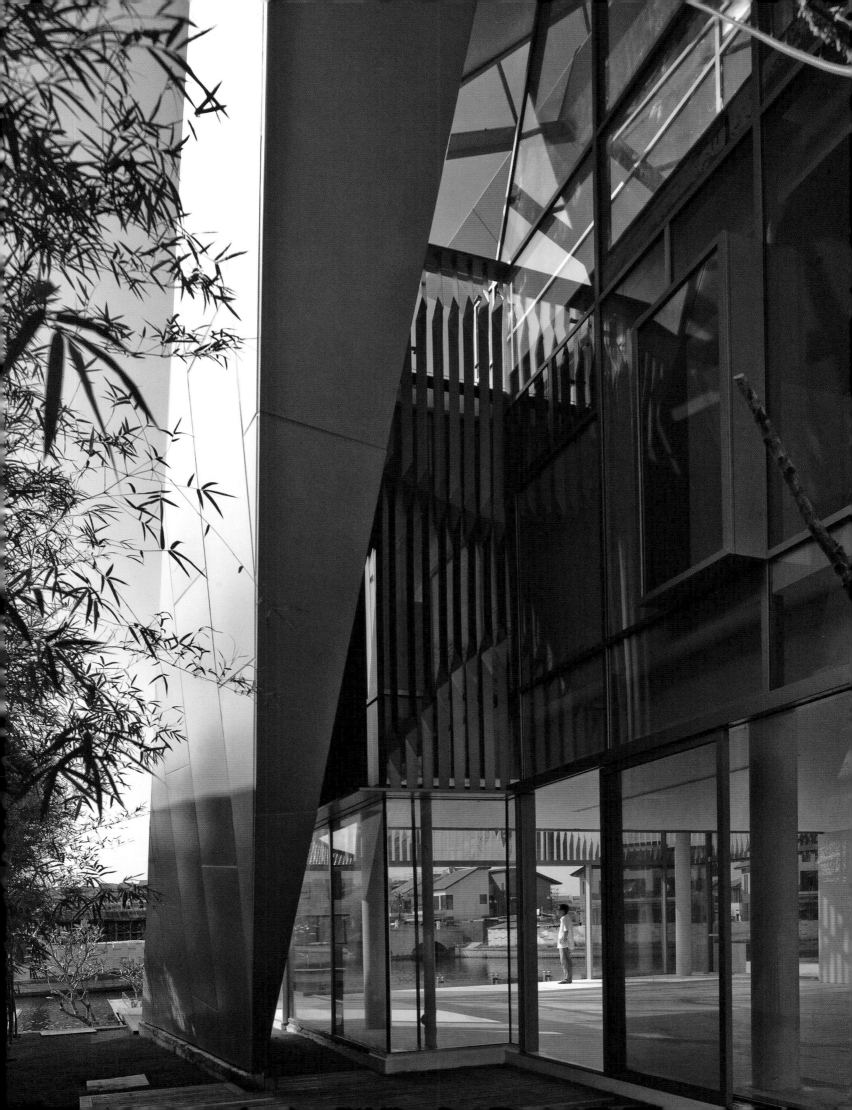

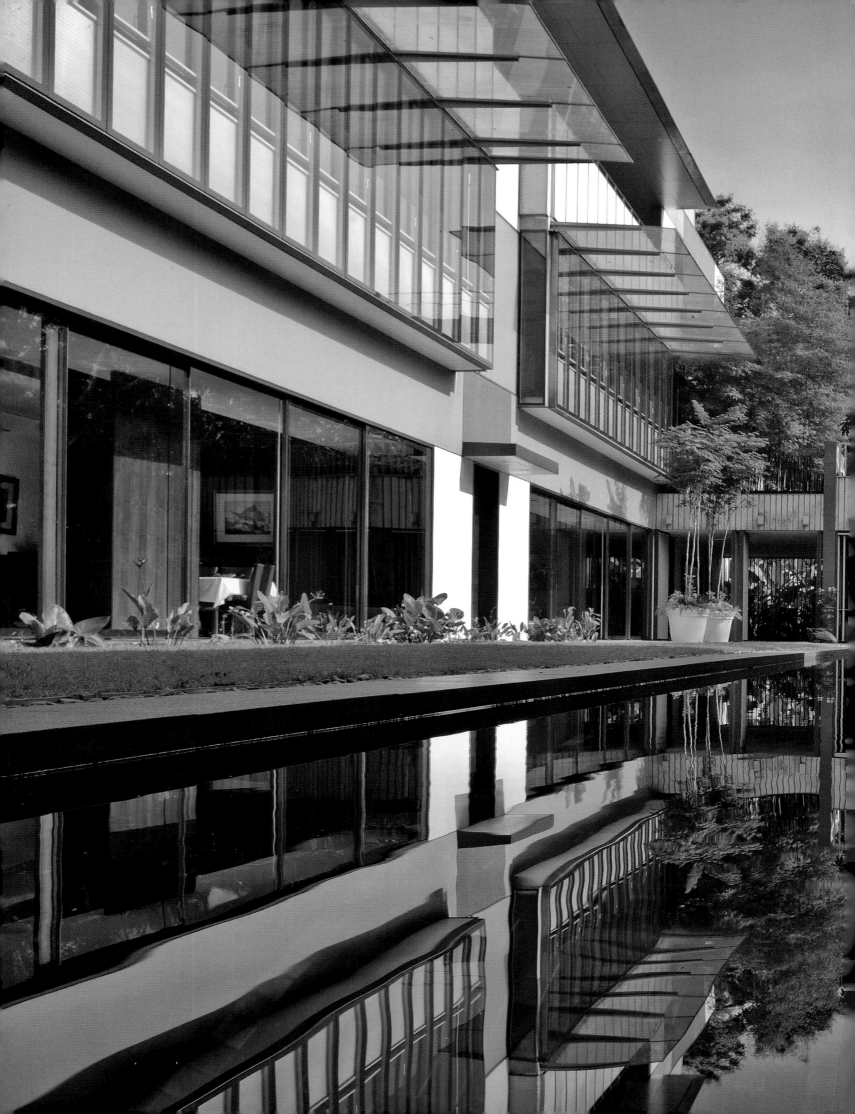

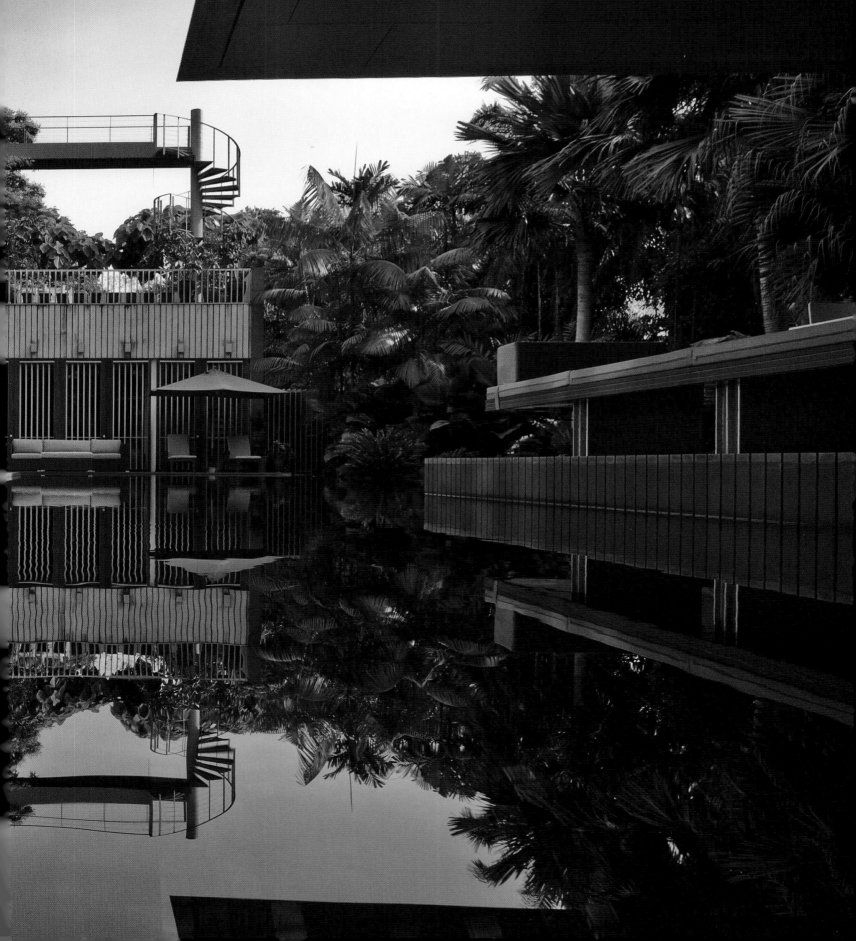

wind house

ARCHITECT: WONG MUN SUMM & RICHARD HASSELL
WOHA ARCHITECTS

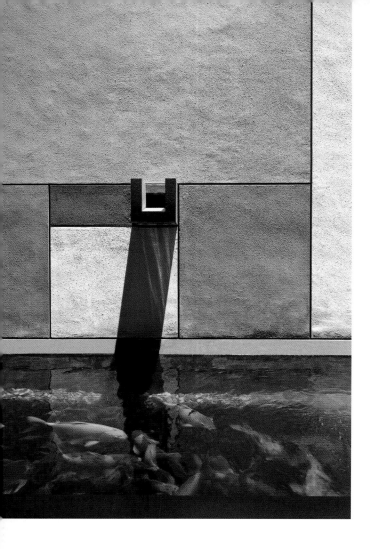

WOHA Architects is, in the opinion of the respected architect and urban theorist Professor William Lim Siew Wai, 'currently the most innovative practice in Singapore, where the partners and staff are constantly testing themselves and reinventing their architecture through experimentation and never repeating themselves.'[1]

Wong Mun Summ is a 1989 graduate of the School of Architecture at the National University of Singapore. He was one of a high-flying cohort of final year students that included Tan Hock Beng, now a principal of MAPS Design Studio, and Siew Man Kok, a principal of MKPL Architects. In his pre-final year, Wong won an award in a national competition for the design of City 2000 that showed a 'preference for clearly expressed formal solutions'. For a period in the mid-1980s he worked with Kerry Hill Architects and later with William Lim Associates. Upon graduation, he returned to Kerry Hill's practice where he was closely associated with the design of several resorts, including The Datai at Pulau Langkawi and The Serai in Bali. While at Kerry Hill Architects, Wong met Richard Hassell, a top graduate of the University of Western

Australia who had studied under Professor Geoffrey London and later completed a Master of Architecture programme at RMIT University in Melbourne with Professor Leon van Schaik.

In 1994, the Singaporean and Australian duo moved on to set up WOHA and have subsequently designed several award-winning buildings, including No. 1 Moulmein Rise (winner of a prestigious Aga Khan Award for Architecture in 2007) and the Stadium MRT (winner of a Singapore Institute of Architects Award in 2008). The practice is in the forefront of 'green' design solutions, and a number of their buildings have been commended for their forward-thinking ideas on the environment. While many architects are familiar with the principles of 'green walls' and 'vertical gardens', WOHA have gone further and implemented these ideas in several projects.

The Wind House, on the edge of the Botanical Gardens, embraces this spirit of exploration of climatically appropriate form and sustainable technology and is designed to exploit its unique location.[2] The architects sought to 'develop a formal language from environmental strategies and to create a poetic expression of technology'. The idea of harnessing the cooling effect of the wind is a key determinant of the built form. The plan is in the form of three parallel 'layers' arranged in a north–south direction that permit the prevailing southwest and northeast monsoons to naturally ventilate the house. Other environmental measures include directing winds over water for evaporative cooling and using louvres and large overhangs with expansive roof gardens for shade.

A series of aligned openings in enfilade creates air paths through fully operable door panels in the façade, and electrically operated louvres located at the highest point of the stair core permit the owner to induce ventilation using the 'stack' effect. Opening windows alongside the elevator shaft at the third storey level create an area of negative pressure in the lee of the house, allowing air to be rapidly drawn through.

The house has a south-facing 'L'-shaped form which embraces a black-tiled swimming pool and a tranquil open-sided pavilion. The boundary fence is obscured by dense planting, which makes the garden appear much larger than it actually is. In addition, a spectacular bridge at the 'summit' of the house gives a dramatic elevated view south towards the Singapore Botanical Gardens so that the public landscaped park appears to be an extension of the house.

Finishes of the house, in aluminium, steel, concrete and glass, have been detailed with such precision that, at first, the house appears somewhat austere. The gentle tactile aesthetic of several of WOHA's earliest houses, derived from Wong and Hassell's experience of resort design, has gradually been replaced by a more ascetic abstract modernism. This possibly reflects the fact that the practice has consciously moved on to larger commissions. However, it also arises out of the clients' preference for stone and metal rather than timber.

The owner's brief was very clear. 'We did not want a humongous house,' he explains. 'The largest room in the house is the living space that is 11 m x 6 m, and the dining room is just

Above A water fountain allows gushing water to discharge into a *koi* pond.

Right Prevailing breezes cool the tranquil pool pavilion.

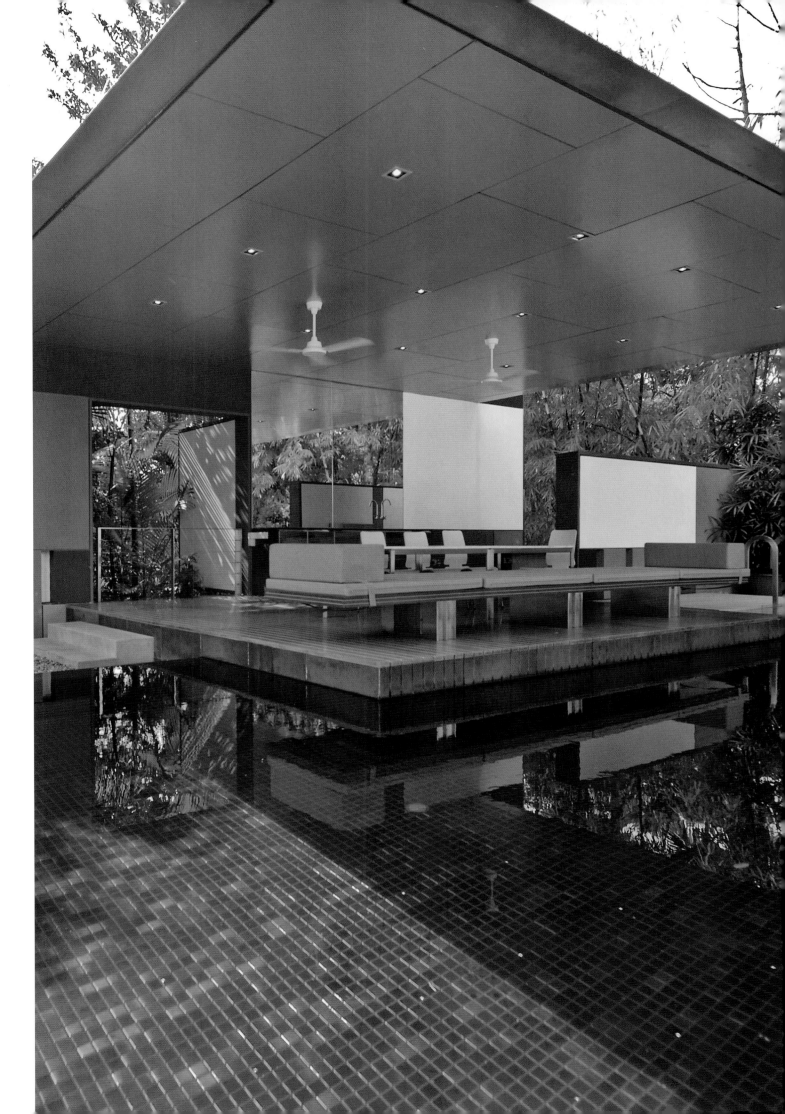

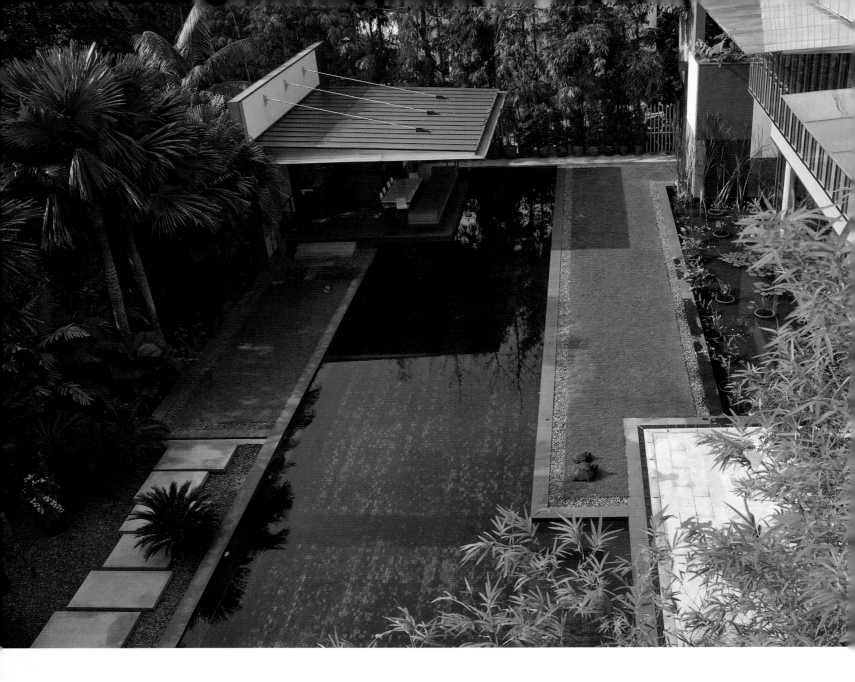

6 m x 6 m. We were also clear that we did not want the house to rely on air conditioning. In addition, we specified that the house be "future-proofed", with the inclusion of an elevator providing access to all levels.'

The modern aesthetic of the house employs vertical striated concrete. Verticality is further evident in the window and cladding details. In contrast, the concrete wall in the entrance lobby is more tactile, with a low relief sculptural design in cement by Brisbane artist Bruce Reynolds. The wall depicts the house owner's favourite flora and fauna. Also in sharp contrast to the modernist form is the owner's furniture, crafted in a dark timber in a traditional Chinese style, much of it transported from their former residence.

The residence has been described as 'a machine that captures the monsoon breezes' in Singapore's tropical climate. The notion of harnessing the wind drove the concept and it undoubtedly works. The form encourages natural ventilation, and the breezes at the top of the house are exceptionally strong. The principles of sustainable design extend to the roof where the house owner grows a variety of herbs in a small 'kitchen garden'. Another sustainable principle is the simultaneous use of part of the house as a management office, with a small amount of the ground floor space used as the hub of the owner's business. The owner also has a sophisticated and well-stocked wine cellar where he entertains colleagues and friends.

WOHA's cutting-edge work is increasingly recognized on the international stage and its projects have been published in *Architectural Review* (UK), *a+u* (Japan), *Interior Design* (USA), *Architecture Australia* and *Monument* (Australia). The firm's work appeared in the second edition of *10X10*,[3] and in 2006 was exhibited at the Aedes East Gallery in Berlin.

[1] Professor William Lim Siew Wai, in conversation with the author, January 2008.
[2] The Wind House was first published in Alexander Cuthbert, *Home: New Directions in World Architecture and Design*, NSW, Australia: Millennium House, 2006.
[3] *10x10*, 2nd edn, London: Phaidon, 2005.

Above The bridge at the summit of the house overlooks the swimming pool and pavilion.

Right The architects employ a harmonious combination of colours and materials.

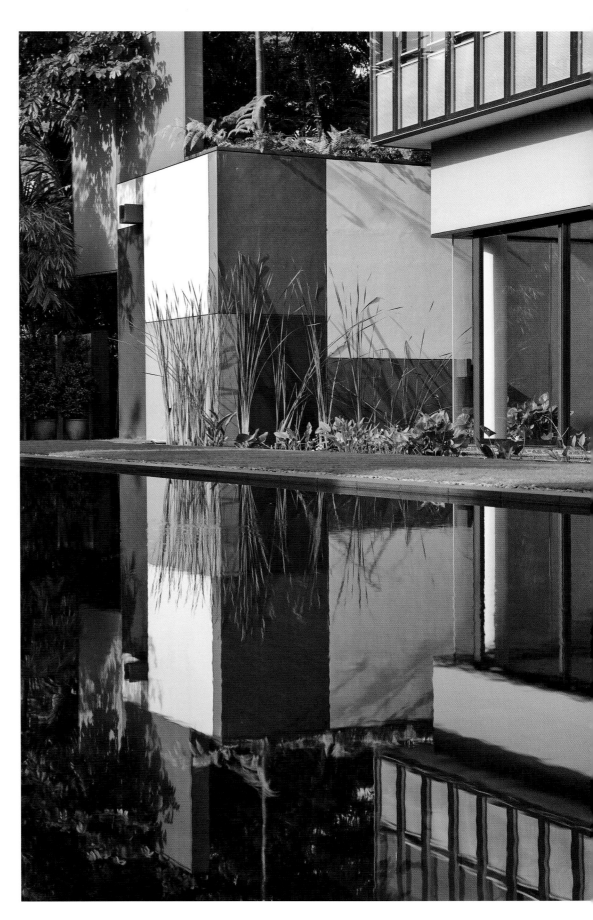

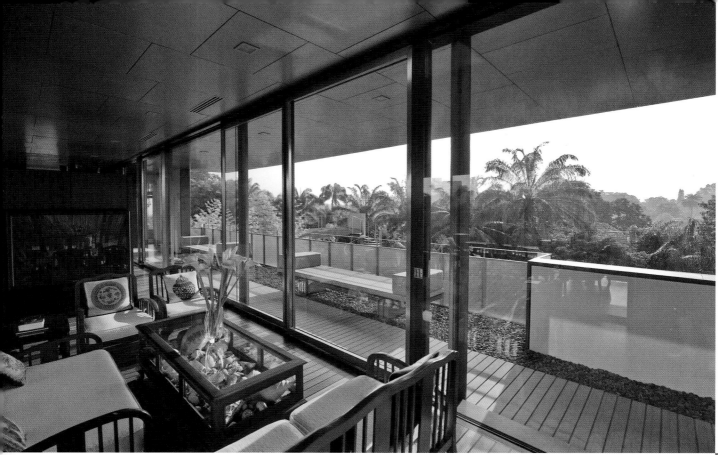

Above The rooftop is a breezy spot, with views over the tree canopy to the city skyline.

Right The vertical circulation, including an elevator, is located in a tall three-storey atrium.

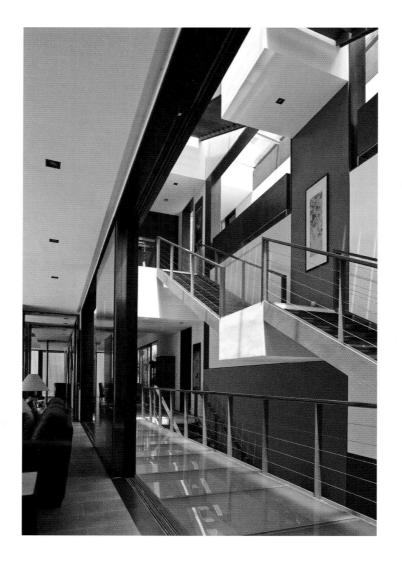

Right Sitting room windows slide aside to permit the prevailing wind, cooled by the pool, to enter the house.

Below The precise details of aluminium, steel, concrete and glass are reflected in the smooth surface of the pool.

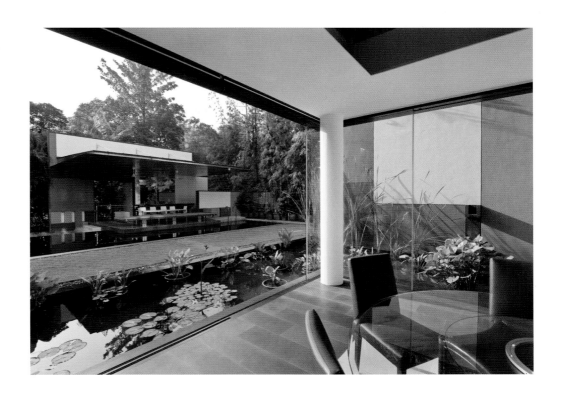

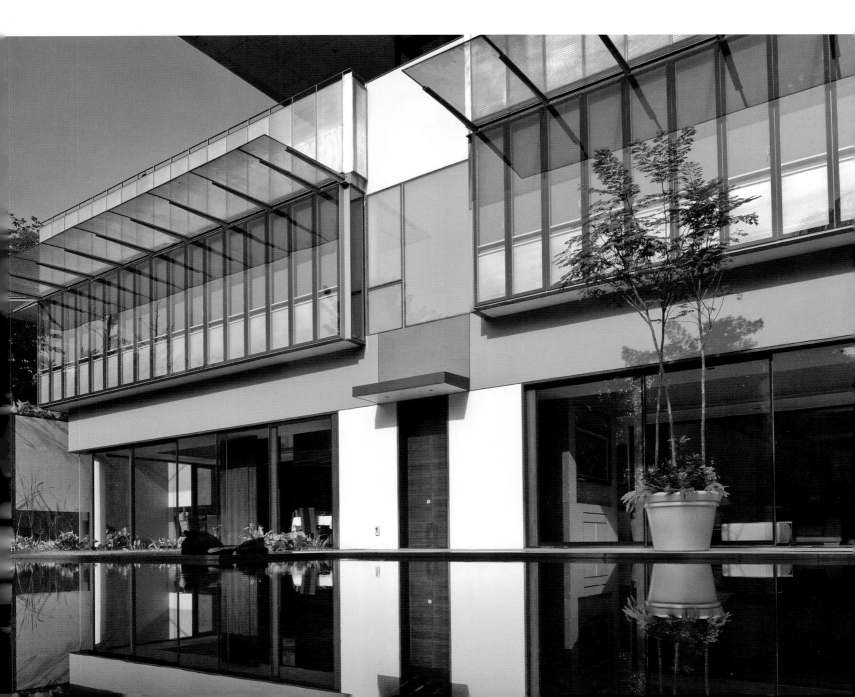

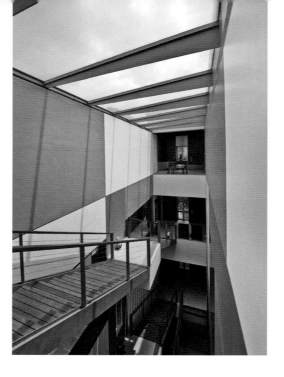

Far left A meticulously detailed metal staircase gives access to a sky bridge.

Left A tall atrium on the western flank encourages natural ventilation.

Below From the roof terrace there are spectacular views over the Singapore Botanic Gardens.

Right The rooftop herb garden overlooks the entrance drive.

Below right The plan and section are a formal expression of environmental strategies.

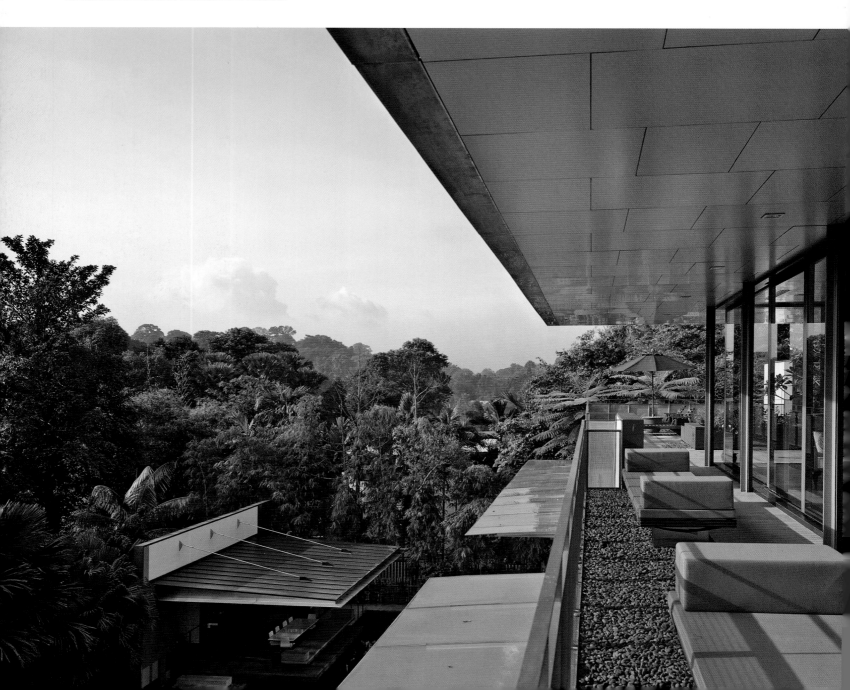

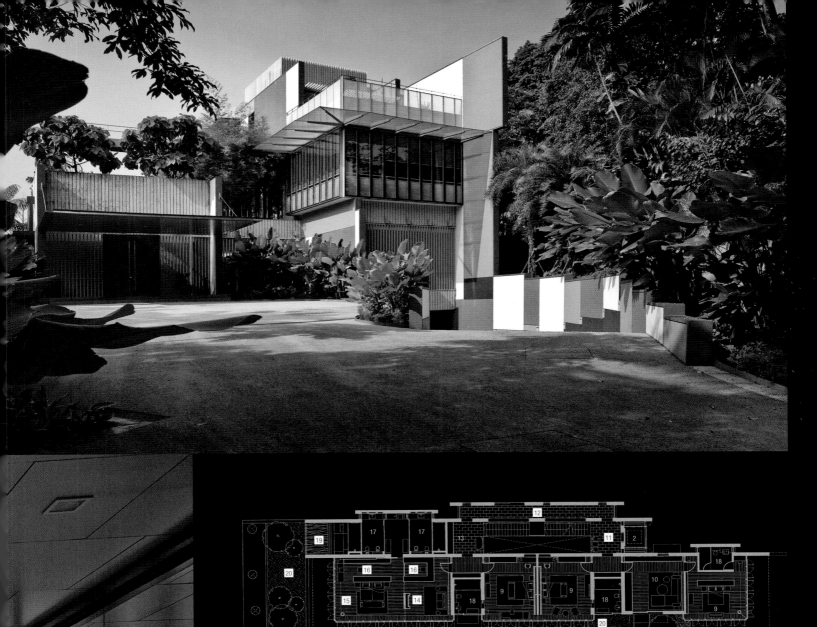

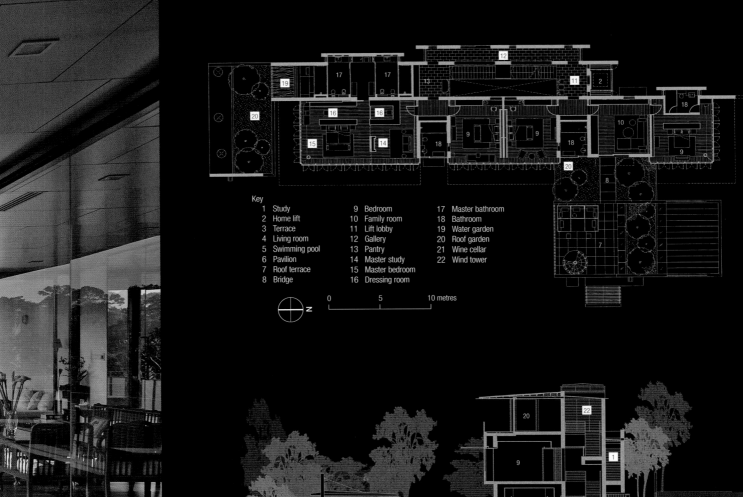

Key
1 Study
2 Home lift
3 Terrace
4 Living room
5 Swimming pool
6 Pavilion
7 Roof terrace
8 Bridge
9 Bedroom
10 Family room
11 Lift lobby
12 Gallery
13 Pantry
14 Master study
15 Master bedroom
16 Dressing room
17 Master bathroom
18 Bathroom
19 Water garden
20 Roof garden
21 Wine cellar
22 Wind tower

0 5 10 metres

N

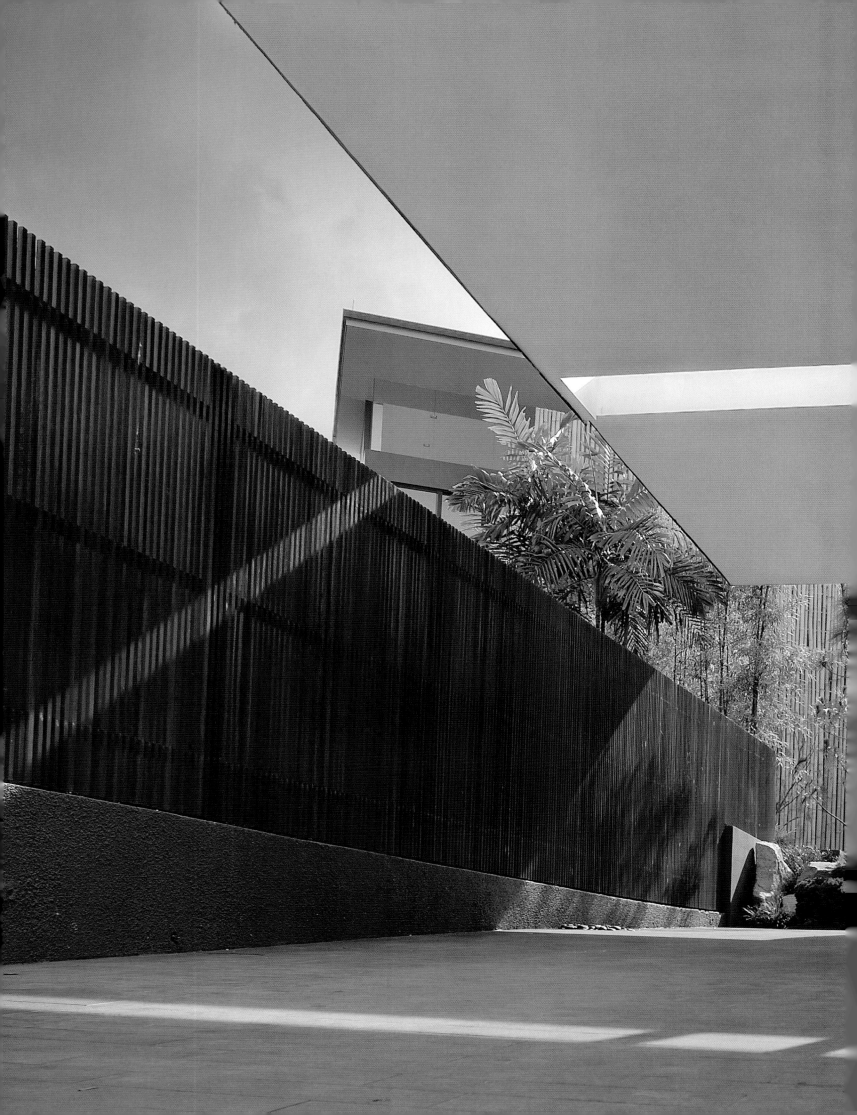

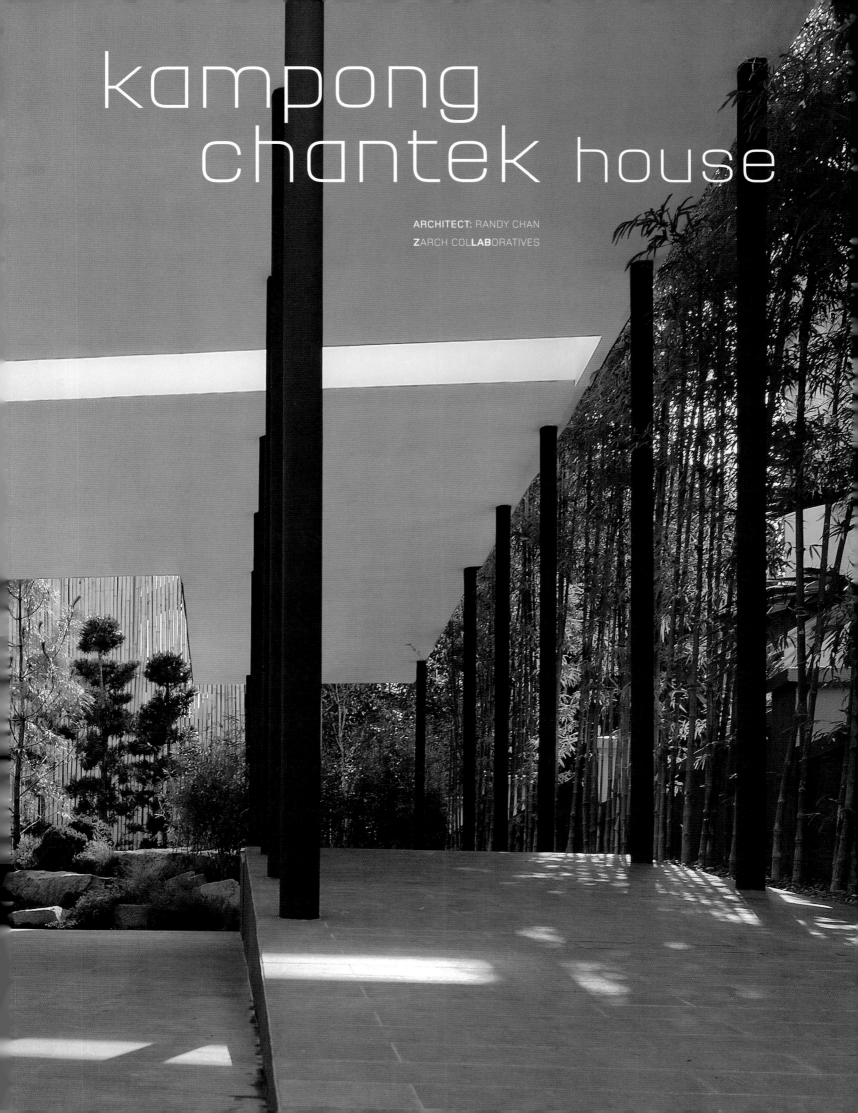

kampong chantek house

ARCHITECT: RANDY CHAN
ZARCH COL**LAB**ORATIVES

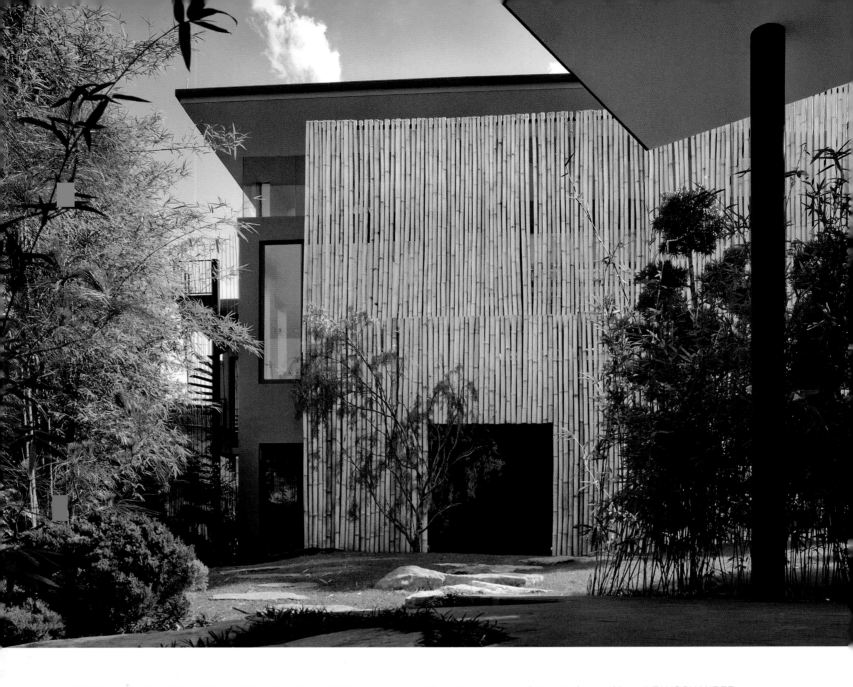

A 1997 graduate of the School of Architecture at the National University of Singapore, Randy Chan's final year mentor was Associate Professor Pinna Indorf. Chan's thesis, 'Architecture as Theatre as Architecture', spoke about the urban phenomenon of persistence of memory that continues to operate in Singapore despite the surrounding urban fabric being torn down. Chan worked for a year as an intern with Tang Guan Bee, in 1994. The following year he won a scholarship to study at Sophia University in Tokyo before returning to the National University of Singapore to complete his studies.

Chan recalls his year out with TANGGUANBEE Architects as being formative. He joined the practice shortly after Ling Hao, whose work is also featured in this book. At the time, Tang Guan Bee was working on the conspicuous Fortradale Condominium at Fort Road, the Bedok Market and the beguiling Gallery Hotel on the Singapore River. 'I enjoyed Tang's sense of humour and discussions, often conducted in the Hokkien dialect, which somehow added to the flavour,' says

Chan. 'It was a good time to be working at TANGGUANBEE Architects and there were many evenings when the staff shared ideas on architecture through slide shows.'

On graduating, Chan worked with the Alfred Wong Partnership, but after three years with the esteemed winner of the inaugural Gold Medal of the Singapore Institute of Architects he moved on to set up **z**arch col**lab**oratives, in 2000.

The Jalan Kampong Chantek House is designed for the family of a neurosurgeon in private practice in Singapore. The house is essentially a two-storey square box with a central courtyard, located on a sloping square site. That simple description belies, however, the immense complexity of the architectural composition. Chan has first rotated the box so that triangular spaces are created at each corner of the site. Then he has sliced off the northwest corner of the cube and attached a similar volume to the southeast corner. Suddenly, all manner of spatial opportunities are apparent. The site does not offer any distant views and, consequently, the plan is focused on the peripheral spaces within the

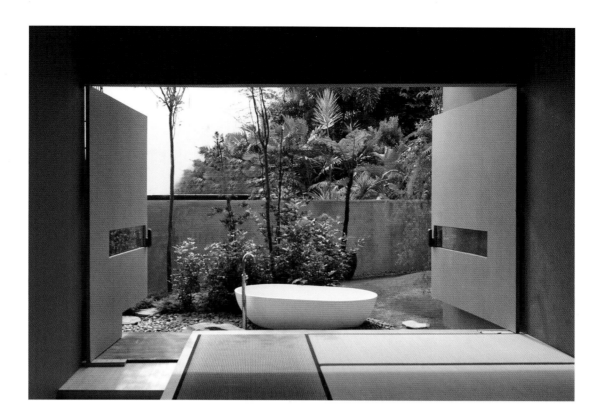

Left Approaching the bamboo screen at the entrance, there is a strong sense of materiality.

Above An outdoor bathroom is located adjacent to the six-mat *tatami* room.

Below The entrance lobby and living space.

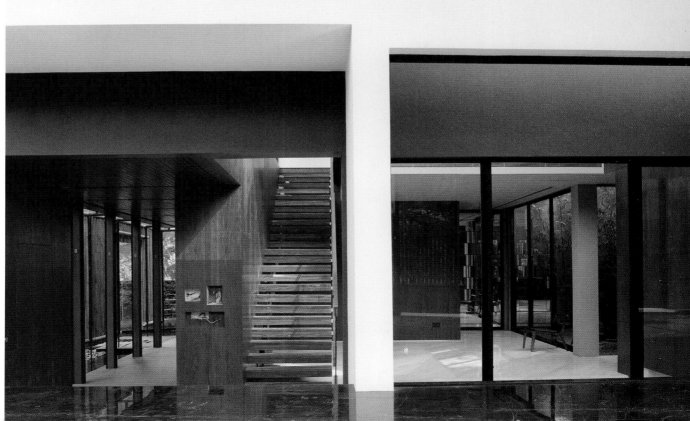

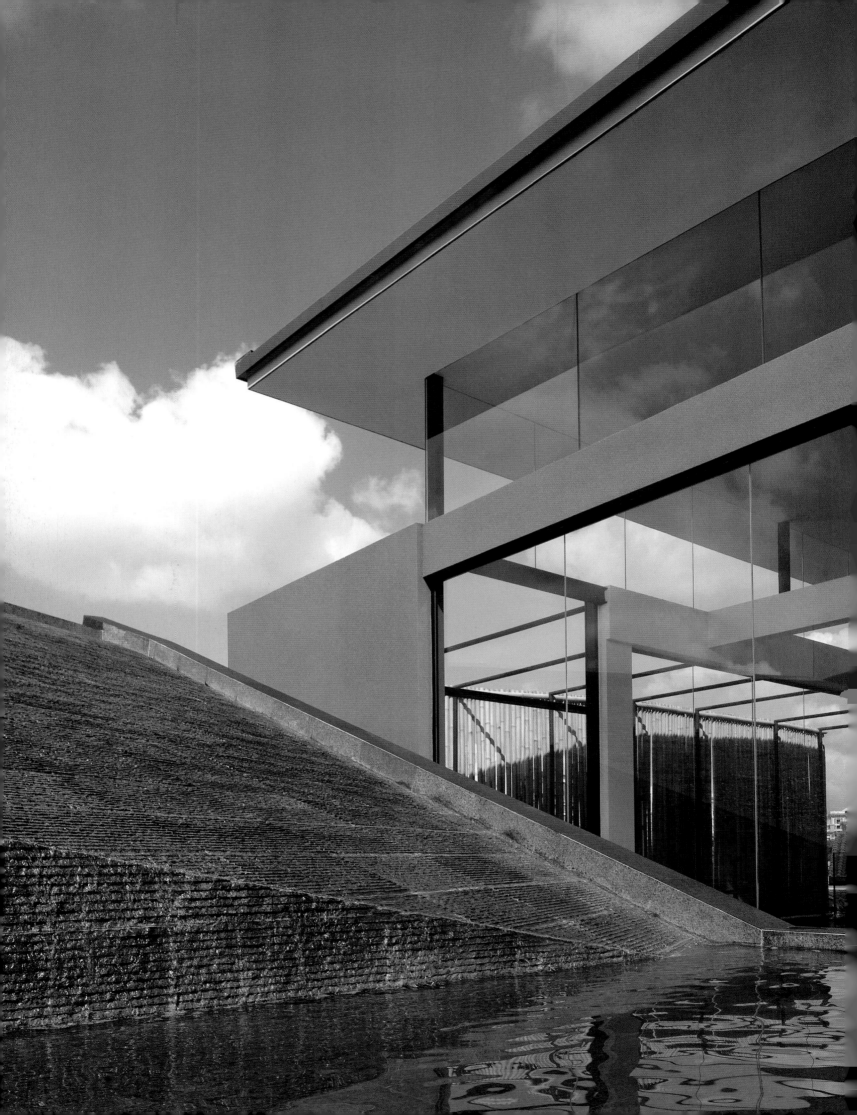

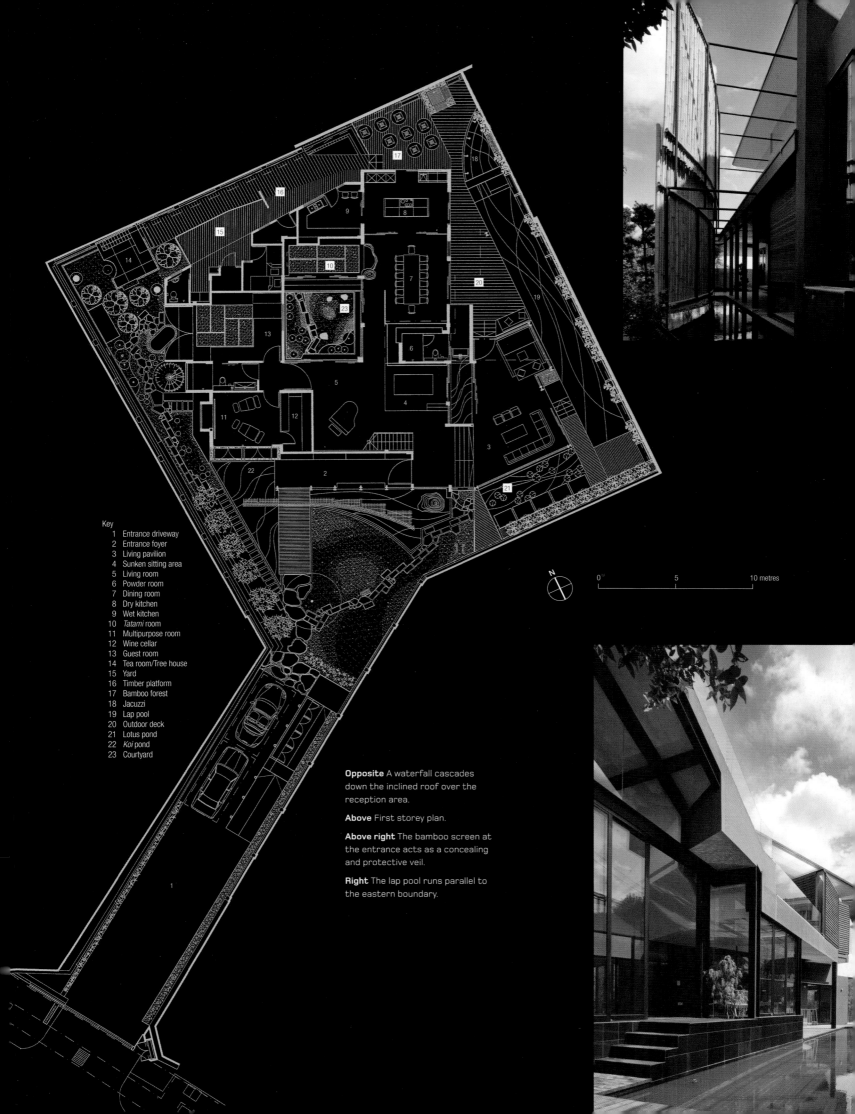

Key

1 Entrance driveway
2 Entrance foyer
3 Living pavilion
4 Sunken sitting area
5 Living room
6 Powder room
7 Dining room
8 Dry kitchen
9 Wet kitchen
10 *Tatami* room
11 Multipurpose room
12 Wine cellar
13 Guest room
14 Tea room/Tree house
15 Yard
16 Timber platform
17 Bamboo forest
18 Jacuzzi
19 Lap pool
20 Outdoor deck
21 Lotus pond
22 *Koi* pond
23 Courtyard

N

0 5 10 metres

Opposite A waterfall cascades down the inclined roof over the reception area.

Above First storey plan.

Above right The bamboo screen at the entrance acts as a concealing and protective veil.

Right The lap pool runs parallel to the eastern boundary.

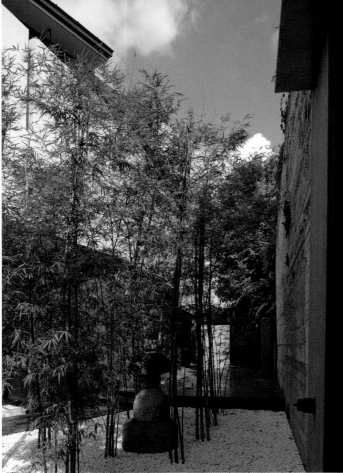

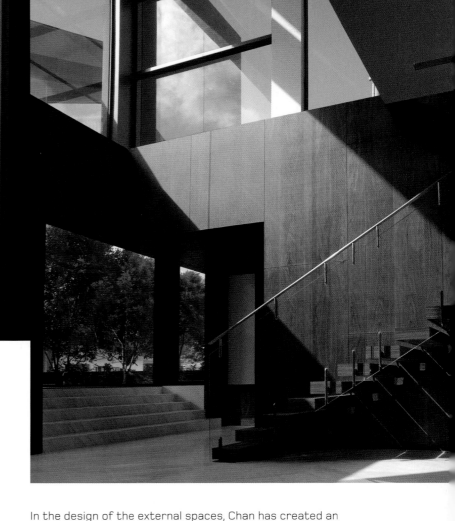

perimeter and inwards to a square central courtyard that serves as both a lightwell and an airwell. 'The clients wanted a house where every space was able to relate to the exterior,' says Chan. 'This explains the central courtyard and the external spaces. He and his wife also wanted the house to have an "earthy" palette of materials.'

Approaching the dwelling along a narrow drive from the southwest, a gentle ramp gives access to a random-paved pathway and hence to a timber bridge across a *koi* pond. A 'veil' composed of vertical timber slats on the left and bamboo poles on the right partially conceals the entrance foyer. Turning sharply right on entering, a short flight of stairs leads to a raised triangular reception pavilion.

Turning again, this time through 180 degrees, is the living room that adjoins the central court. The double-storey space has a sunken sitting area accommodating a grand piano. The other rooms on the ground floor are related to the central courtyard: a formal dining room, a guest suite with access to an open-to-sky bathtub and a five-*tatami* mat meditation room. There is also an entertainment room with an attached wine cellar, wet and dry kitchens and the maid's quarters. The orientation of the cube permits southwest and northeast monsoon breezes to flow through the house. The central court also assists in natural ventilation.

The second storey is similarly organized around the courtyard. The master bedroom suite, a child's bedroom and the family hall and library each have one wall adjoining the central void. A gym, a Jacuzzi and a spa garden attest to a sybaritic lifestyle, an antidote to the frenetic pace of Singapore.

In the design of the external spaces, Chan has created an attractive garden that flows around the perimeter of the site and offers a multitude of spatial experiences. From the entrance of the house, the garden, linear in form, extends along the western boundary in combination with a mixture of random and orthogonal paving. Upon reaching the northwest corner, it assumes a triangular shape, where a tea room sits prettily beneath a tree house. A skeletal circular staircase amidst the western garden ascends to a rooftop terrace.

The northern garden also extends in a linear manner along the boundary, with timber decking skirting the obligatory yard, leading to a grove of bamboo trees in the northeast corner of the site. Turning once again, a 25-metre lap pool runs parallel with the eastern boundary alongside an extension of the timber deck. A lotus pond, at right angles to the southern end of the lap pool, adds further variety.

The most striking feature of the house is the total integration of the interior and external spaces and the intensity instilled into the design. In this way, the house embraces a rich variety of spatial experiences expertly orchestrated by the architect.

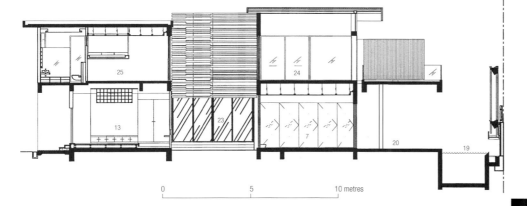

0 5 10 metres

Opposite left Bamboo groves line the western and northern boundaries of the site.

Opposite right The reception area and music room.

Top Section indicating the central open-to-sky courtyard that assists in cross-ventilation.

Above Privacy is provided by the bamboo entrance screen.

Left The entrance viewed from the reception area.

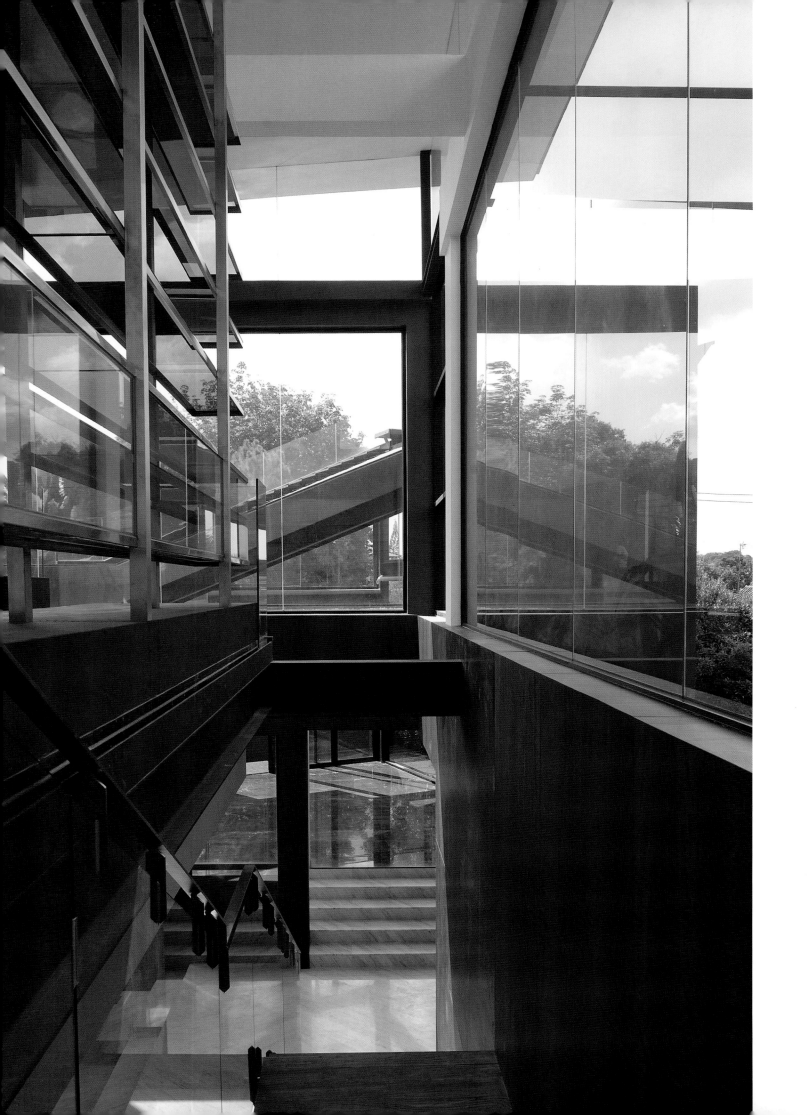

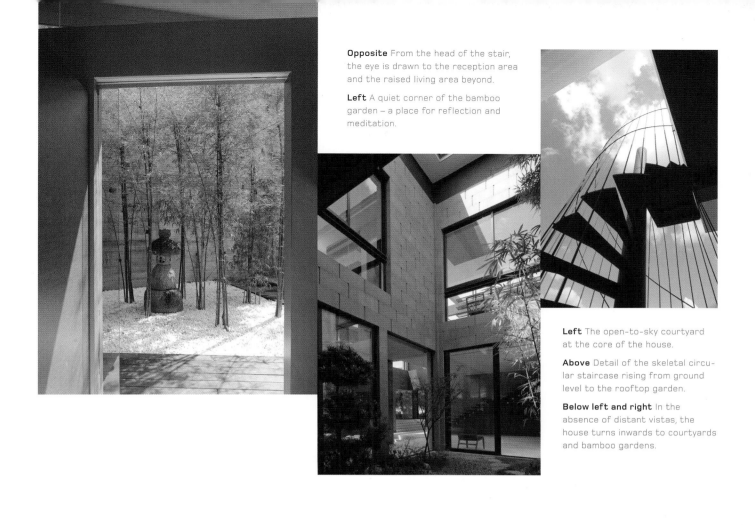

Opposite From the head of the stair, the eye is drawn to the reception area and the raised living area beyond.

Left A quiet corner of the bamboo garden – a place for reflection and meditation.

Left The open-to-sky courtyard at the core of the house.

Above Detail of the skeletal circular staircase rising from ground level to the rooftop garden.

Below left and right In the absence of distant vistas, the house turns inwards to courtyards and bamboo gardens.

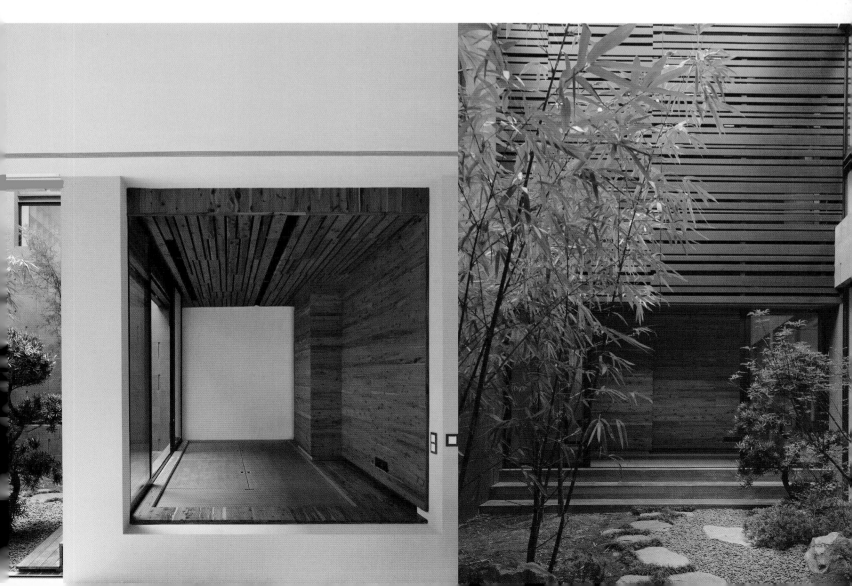

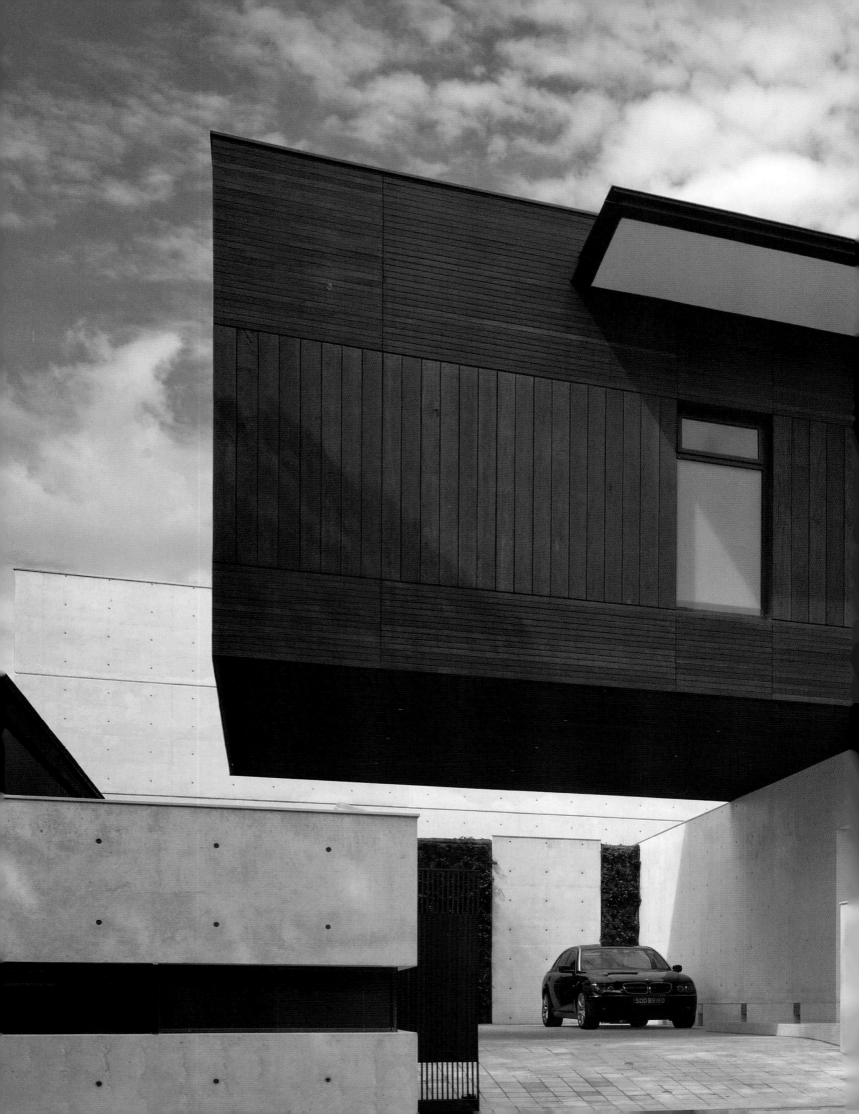

cornwall
gardens house

ARCHITECT: MOK WEI WEI

W ARCHITECTS

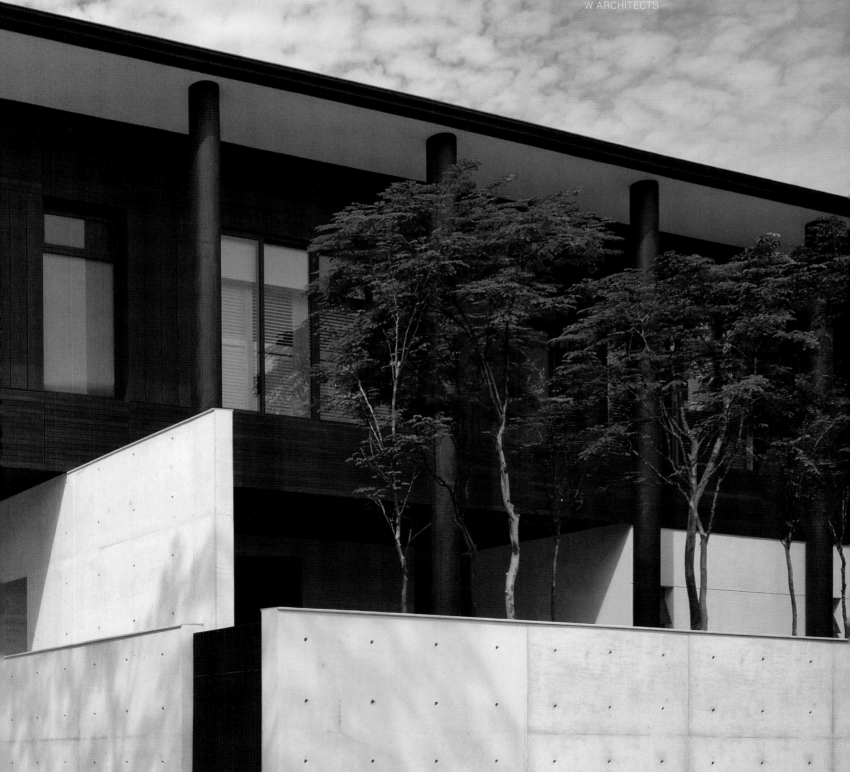

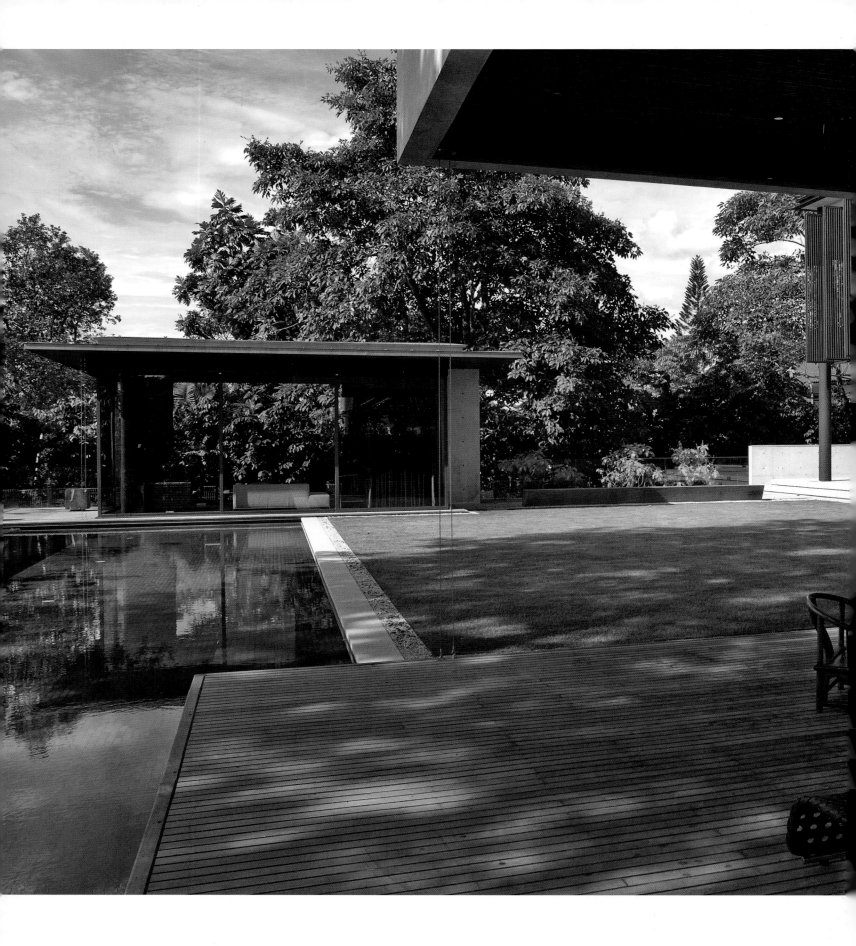

Above Beyond the dining room, a shaded patio overlooks the infinity pool.

Mok Wei Wei is a 1982 graduate of the School of Architecture at the National University of Singapore, one of four architects in this book who pursued their final year studies under the influential Asian scholar, Associate Professor Pinna Indorf. On graduation, Mok joined William Lim Associates and practised in partnership with Professor Lim until 2003 when he became the principal, continuing the firm under the name W Architects.

In a 1997 article for the Australian magazine *Monument*, I described Mok as the *de facto* 'leader' of the 'next generation' of Singapore architects, that is to say, the generation that took over the task of pursuing a design agenda from William Lim Siew Wai, Tay Kheng Soon and Tang Guan Bee. Mok speaks with quiet authority and he has produced a number of brilliant design solutions for buildings such as the National Museum of Singapore, Patterson Edge and the Morley Road House. International recognition has followed, and Mok's work was exhibited at the Venice Biennale in 2005 and at the Aedes East Gallery in Berlin in 2006.

Designed for Simon and Michelle Cheong, the Cornwall Gardens House is located on high ground with expansive views to the west over the rooftops of neighbouring properties that are one and a half storeys lower. In essence, the plan is an asymmetric 'H' shape, with two parallel wings running from east to west across the contours, linked at first-storey level by a spacious living room and at second-storey level by the family room. A west-facing double-height verandah serves as a unifying element tying the orthogonal form into a coherent whole. The circular columns and vertical timber sunscreens of the verandah bear a slight resemblance to the façade of the 1993 Reuter House designed by William Lim Associates.[1] The two wings and the living room embrace an open-to-sky courtyard that is the epicentre of the spatial composition.

The northern wing of the house takes the form of a timber box 'floating' above a white concrete podium. The two-storey structure contains the entrance water court, foyer and powder room at ground level, with four bedrooms at the upper level. The longer southern wing of the dwelling is a planar composition of white pigmented off-form concrete walls containing, at first-storey level, the kitchen and service spaces, a family dining room, a spectacular semi-circular stairway and a formal dining room extending out to a shaded timber pool patio. The upper floor of the south wing houses the master bedroom suite, a study and a generous bathroom with a walk-in wardrobe.

The entrance to the house is from a minor road along the northern boundary and it is deliberately understated.

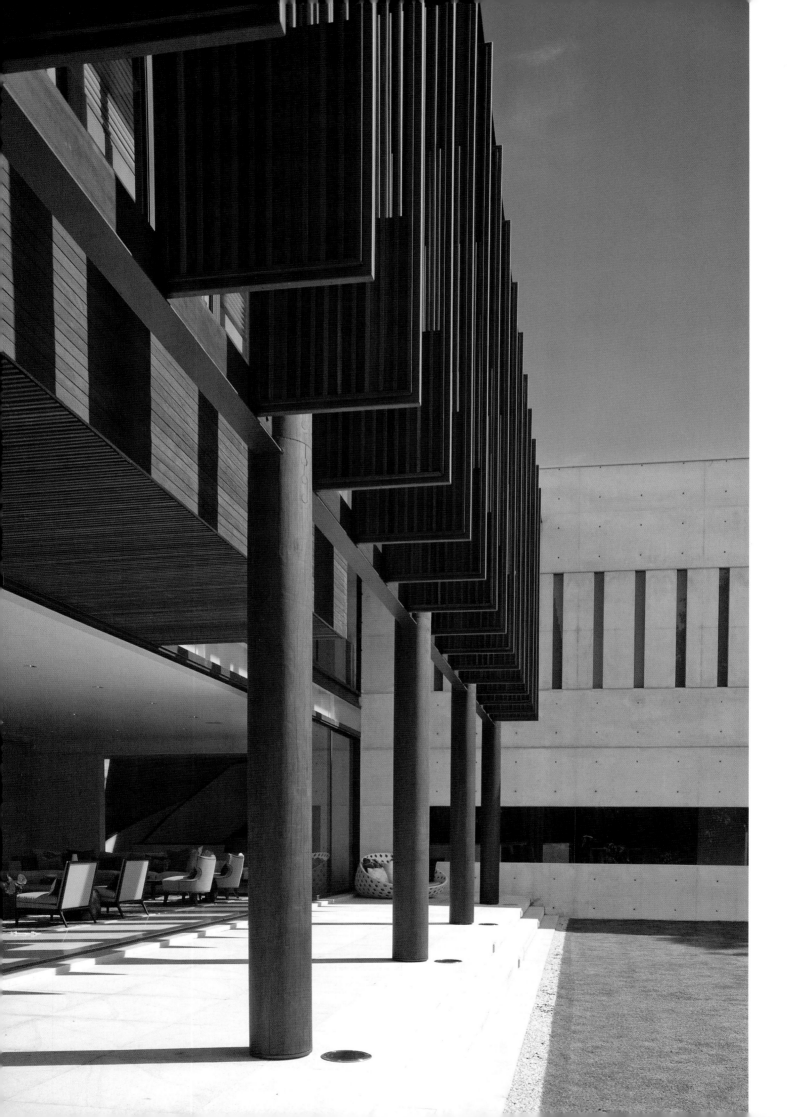

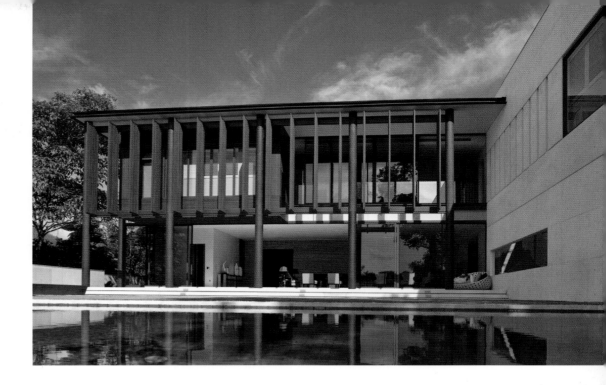

Left The living room verandah is a double-height space with project-ing vertical timber louvres.

Right Elegantly proportioned columns and louvres are reflected in the infinity pool.

Turning into a walled vehicle court, the drop-off point is defined by an entrance door set in a concrete wall beneath the seven-metre-high cantilever of the second storey. The entrance threshold signifies the beginning of two choreo-graphed routes through the dwelling that frame contrasting views and heighten the perception of the elevated site.

The two processional routes embody a sequence of unfold-ing spatial experiences. Typically, a visitor to the house would proceed from the porte-cochere along a north-facing verandah flanked by a linear reflecting pool with lush planting as a backdrop. Turning sharply left, he or she would encoun-ter a semitransparent screen wall that partially reveals (and partially obscures) a sculptured 'tree' within the central courtyard. Turning again, this time to the right, the visitor passes from the relative enclosure and spatial containment of the foyer to emerge in the spacious living room. The dramatic impact of this light-filled space is heightened by an expansive view to the west beyond the double-storey verandah towards a garden pavilion and an infinity pool.

The stone-clad eastern wall of the living room is punctured by a narrow horizontal window opening set at the eye level of a seated person, so that the courtyard with its sculptured tree is again partially revealed like a horizontal scroll painting.

Moving through the living room, the visitor next encounters a grand semicircular staircase seen against a backdrop of silver travertine. To the right of the stairs is an east–west axis that stitches together the formal dining room, the pool patio and the pool in a continuous manner, permitting the visitor to enjoy the principal vista from a different perspec-tive. A freestanding meditation pavilion brings visual closure to this architectural promenade. Navigating from one point to another, the visitor is encouraged to pause and appreci-ate the qualities of each space. This is essentially the 'formal route' that is experienced by a guest arriving for dinner with the family. In the course of the 'journey', the main vista is appreciated from several different viewpoints.

A second, more introspective, private route is embedded in the design. From the entrance foyer the house owner can move, via a door in the glazed Chinese screen, into the central courtyard. Here, the focus is the sculptured tree. The floor pattern, with grey Shanxi granite strips and white pebbles, recalls traditional Chinese courtyards. This imbues a sense of nostalgia into the otherwise modern architec-tural language and promotes quiet contemplation.

The route through the courtyard culminates at the family dining room, and its exclusivity to the house occupants is conveyed through the idea of enclosure, its opaque surfaces and controlled openings on three sides contrasting with the transparency of the south wall that affords views into and out of the dining room.

The most private part of the house is the family room at second-storey level. This 'bridge' between the generations serves as a family bonding space offering dual views, one to the main vista, the other to the private courtyard below.

The concept of duality is incorporated into the spatial orga-nization. In a similar manner to his design of the Morley Road House (1999),[2] Mok Wei Wei has employed the processional route in a composition that creates an interplay between topography and vista. In the Cornwall Gardens House, Mok demonstrates an ability to design a large house that is simultaneously intimate in scale.

[1] Robert Powell, 'The Reuter House,' *The Asian House: Contemporary Houses of Southeast Asia*, Singapore: Select Books, 1993, pp. 96–103.
[2] Robert Powell, 'The Morley Road House', *The New Singapore House*, Singapore: Select Publishing, 2001, pp. 138–49.

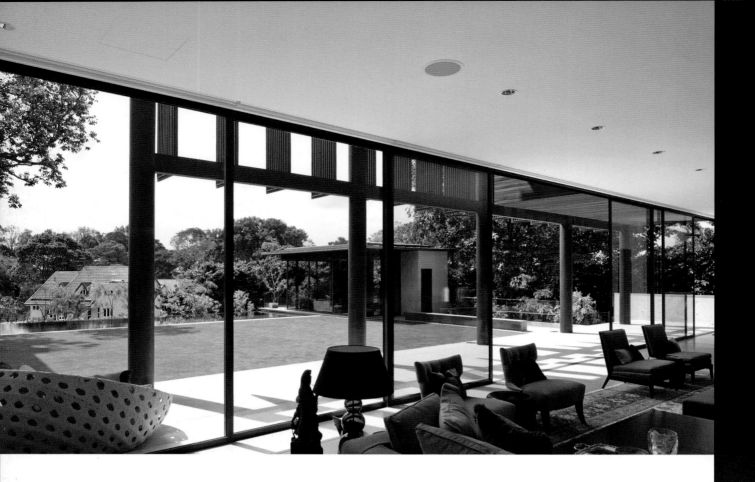

Above Looking northwest from the living room, the Bukit Timah Reserve can be glimpsed on the horizon.

Below A grand semicircular staircase ascends from the living room to the private areas of the house.

Right The elegantly proportioned colonnade alongside the entrance lobby.

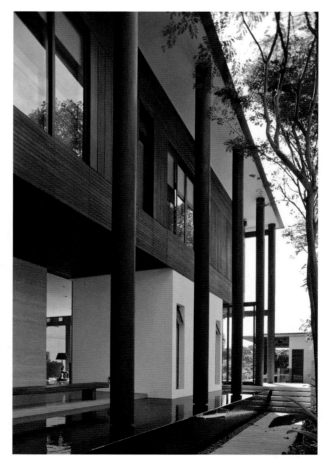

Opposite above First storey plan.

Right The master bedroom cantilevers over the dining room patio, creating an intimate shaded area with views to the west

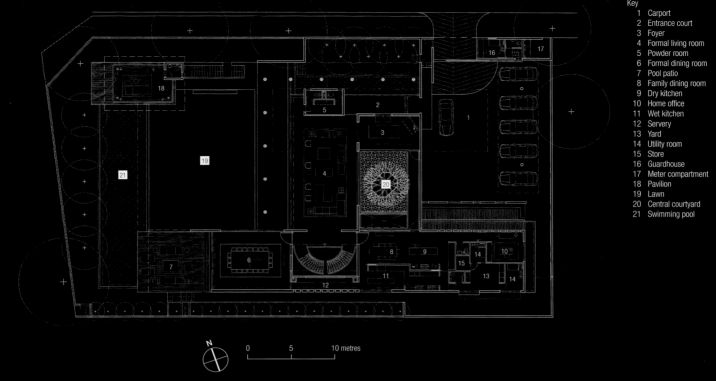

Key

1 Carport
2 Entrance court
3 Foyer
4 Formal living room
5 Powder room
6 Formal dining room
7 Pool patio
8 Family dining room
9 Dry kitchen
10 Home office
11 Wet kitchen
12 Servery
13 Yard
14 Utility room
15 Store
16 Guardhouse
17 Meter compartment
18 Pavilion
19 Lawn
20 Central courtyard
21 Swimming pool

N

0 5 10 metres

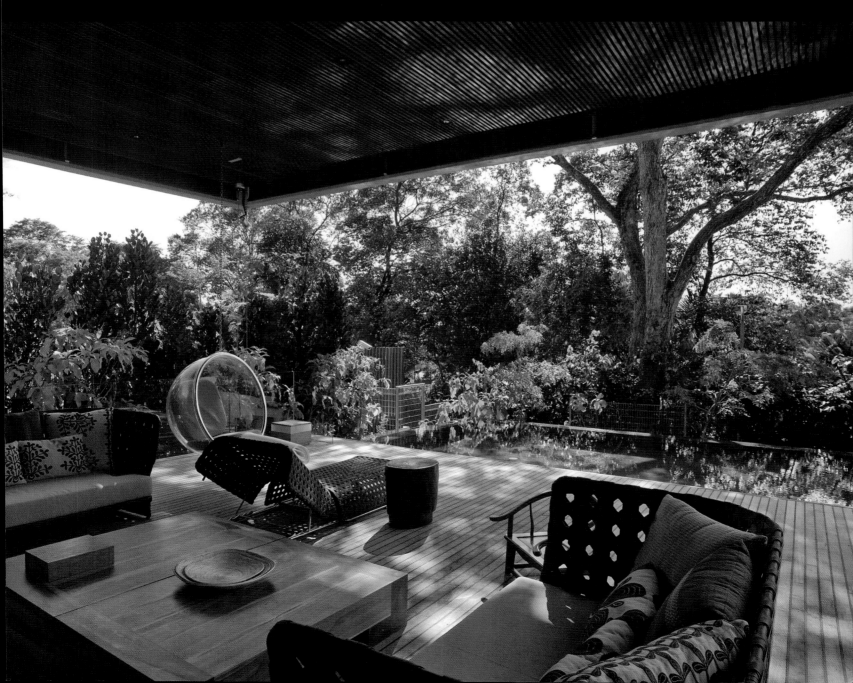

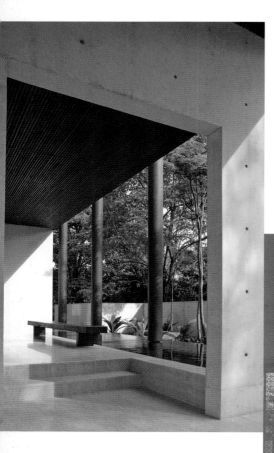

Left and right A bench alongside the linear pond in the entrance courtyard permits visitors to remove their outdoor shoes.

Below Beyond the entrance lobby, the central courtyard is seen behind a semitransparent screen.

Bottom A horizontal window in the living room gives glimpses of the activity in the courtyard.

Right top The central courtyard recalls traditional Chinese courts, with a sculptured tree and Shanxi granite flooring.

Right bottom Section through the courtyard, living room, verandah and pool.

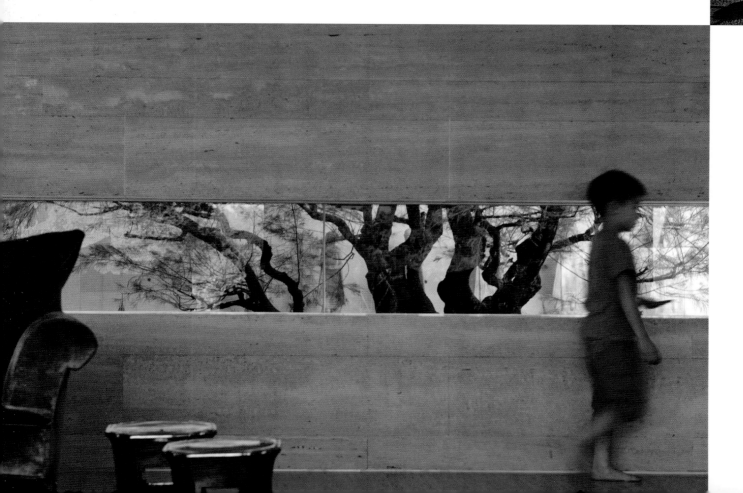

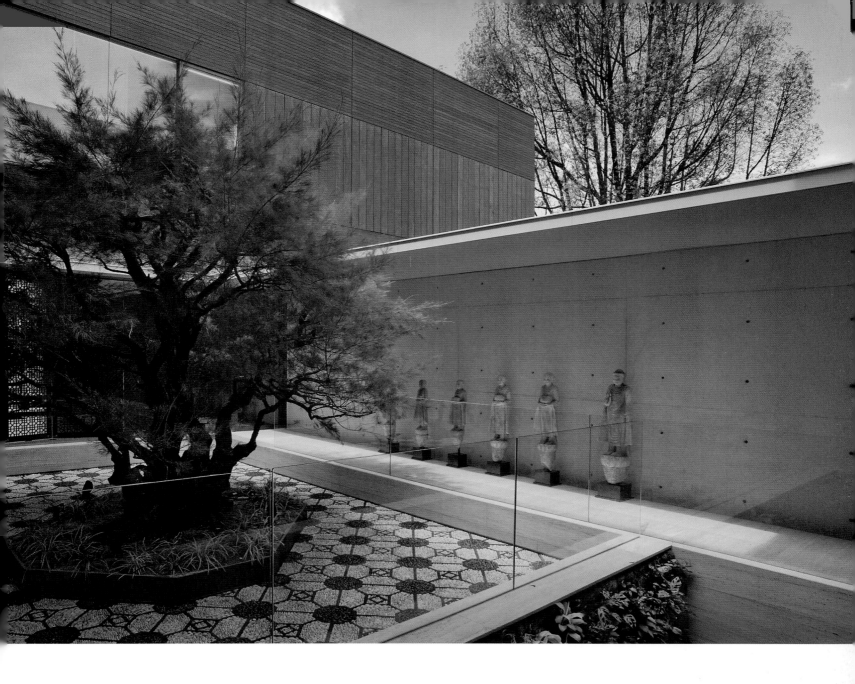

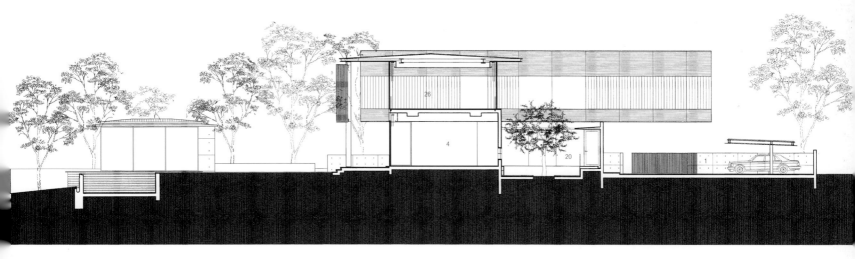

Key
1 Carport
4 Formal living room
20 Central courtyard
26 Family room

0 5 10 metres

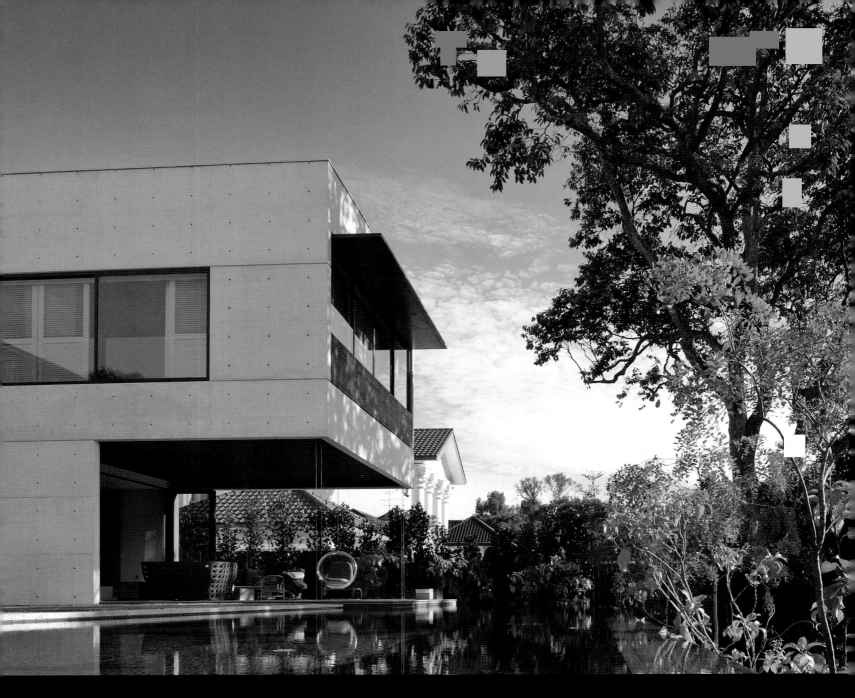

Key
22 Master bedroom
23 Library
24 Master bathroom
25 Study/Wardrobe
26 Family room
27 Bedroom

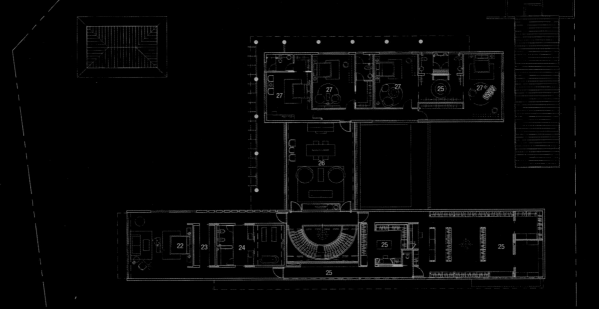

0 5 10 metres

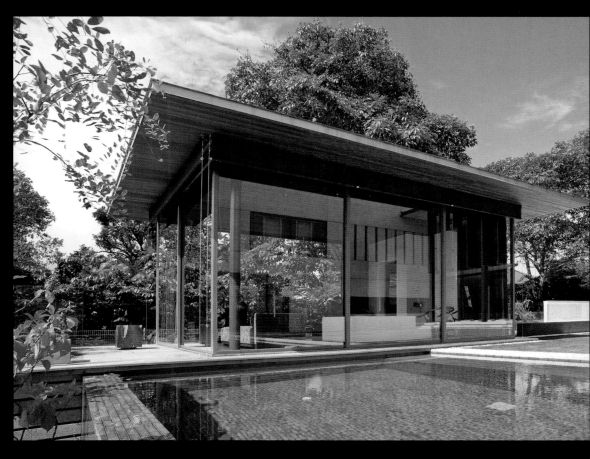

Left The master bedroom cantilevers over the dining room patio.

Left below First storey plan.

Top A tranquil meditation pavilion is set a short distance from the main house.

Bottom left The entrance lobby seen from the porte-cochere.

Bottom right The porte-cochere with the carport beyond.

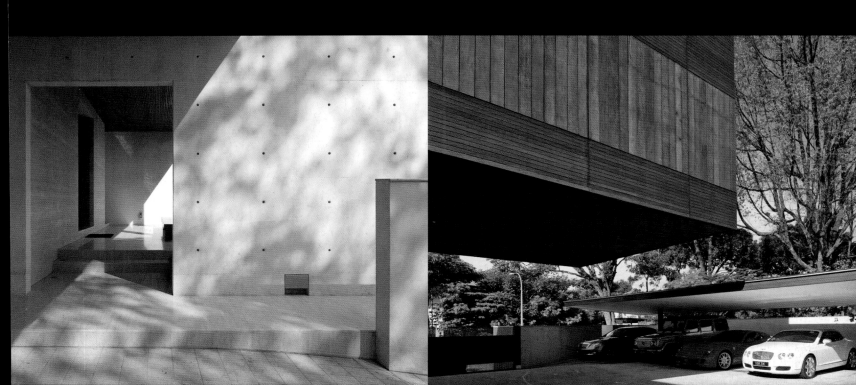

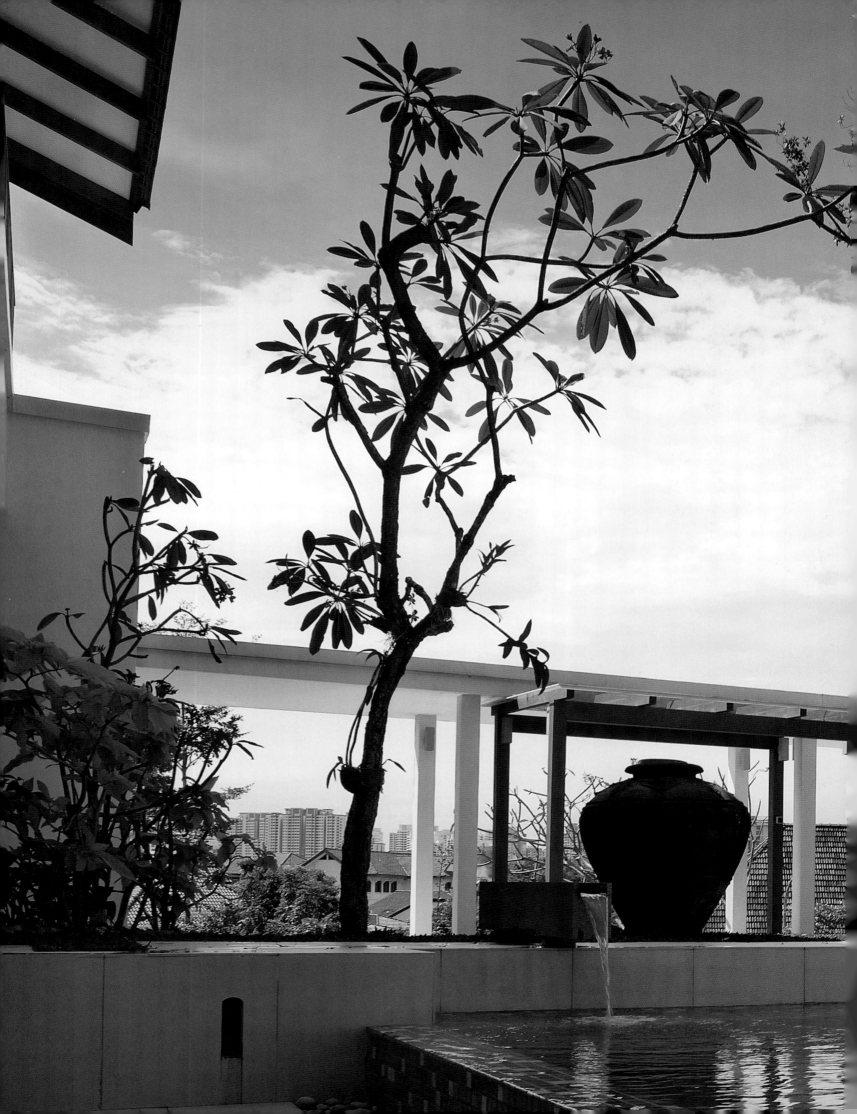

bishopsgate house

ARCHITECT: SIEW MAN KOK
MKPL ARCHITECTS

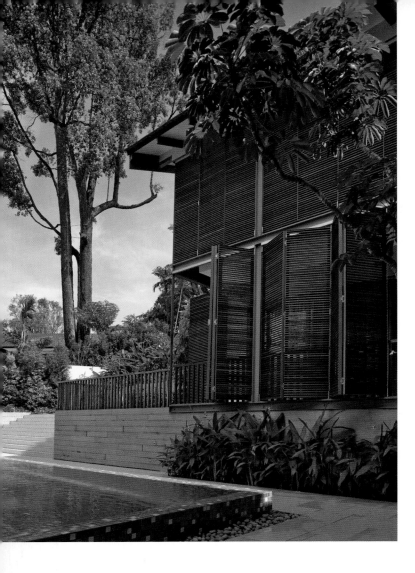

A 1989 graduate of the School of Architecture at the National University, Siew Man Kok revealed his creative potential in his pre-final year of the B.Arch. course when he won first prize, beating several practising architects, in a national competition for the design of Singapore City 2000 that 'attempted to create a timeless city and demonstrated a keen awareness of relating to the urban context'. His final year thesis, the controversial Museum of the Western Han Dynasty in Guangzhou, identified him as an architect of considerable promise. After graduating, he joined the practice of Andrew Tan Associates where he met Cheng Pai Ling, another top graduate of NUS (1985) who, coincidently, was second prizewinner in the City 2000 competition.

In 1995, Siew and Cheng set up MKPL Architects. Their practice has subsequently flourished, founded on a mixture of poetic design and pragmatism.

MKPL has garnered numerous awards for its work, including the Urban Land Institute Award for Excellence: Asia Pacific 2006 for Glentrees Condominium at Mount Sinai Lane. The

Above The family room and the master bedroom overlook the pool court.

Opposite To the left on entering the house is a verandah leading past a small pavilion or *sala*.

project also scooped a Design Award from the Singapore Institute of Architects in the same year. MKPL is now working in Bangkok, Hong Kong, Dubai, India (Mumbai) and Vietnam.

The Bishopsgate House is located on a steeply sloping, southwest-facing site and is essentially a composition of three pavilions around a central courtyard containing a rectangular swimming pool. A two-storey pavilion on the highest part of the site, with a master bedroom suite, two smaller bedrooms, a study and an audiovisual theatre, serves the most private needs of the family. These activities equate to the 'nighttime activities' of the household. A double skin of sliding-folding screens provides sunshading and privacy.

A second two-storey pavilion located in the southeast corner of the site contains the wet and dry kitchens, breakfast room, formal dining room, two guest bedrooms and a family room, together with the maid's accommodation. These activities can be generally grouped under the heading of 'daytime activities'.

The third pavilion is slightly more remote and is situated in the southwest corner of the site. This single-storey high-ceilinged structure contains the principal living and reception area and a spacious entertainment room overlooking the pool court and *koi* pond. Each part of the plan thus has a clearly defined function.

An essential element in the overall composition is the 'processional route' that conceptually links the three pavilions. On entering the house, there is a choice of routes. Turning left, an external ramp leads alongside a *koi* pond and via an open-sided gazebo, reminiscent of a Thai *sala*, to the living and entertainment area. To enter via this route is to have a gentle introduction to the house, culminating in the pool court concealed in a slight depression, that comes as dramatic conclusion. The alternative route from the entrance immerses a visitor immediately in the semiprivate areas: the 'tea room', formal dining room, kitchen and family room. This internal route loops around and also terminates in the central courtyard.

The spatial interplay along this circular route is the most memorable feature of the house, coupled with the hierarchy of privacy. The entertainment pavilion is remote from the private accommodation and the verandah somewhat exposed, but Siew's response is unequivocal: 'The open-sided verandah is intentional as the clients like a feeling of openness. The relative remoteness of the entertainment area is also intentional, as the clients wanted it to be as far away from the main house as possible and to be accessed separately without people going through the house. It is this element that differentiates the house from many other totally interiorized houses.'

Siew Man Kok has an analytical mind that seeks solutions in formal relationships. The delightful interplay of levels and the architectural promenade against a backdrop of tall, mature trees surrounding the site raises the dwelling above the commonplace. The house works exceptionally well with

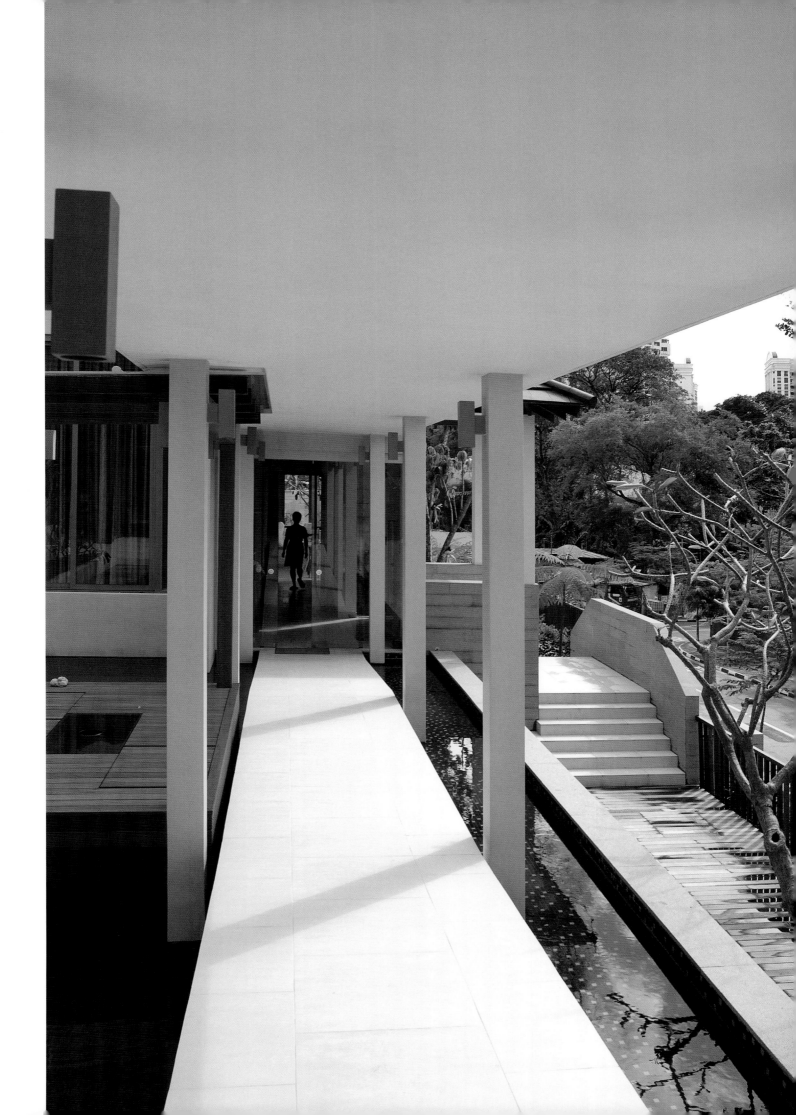

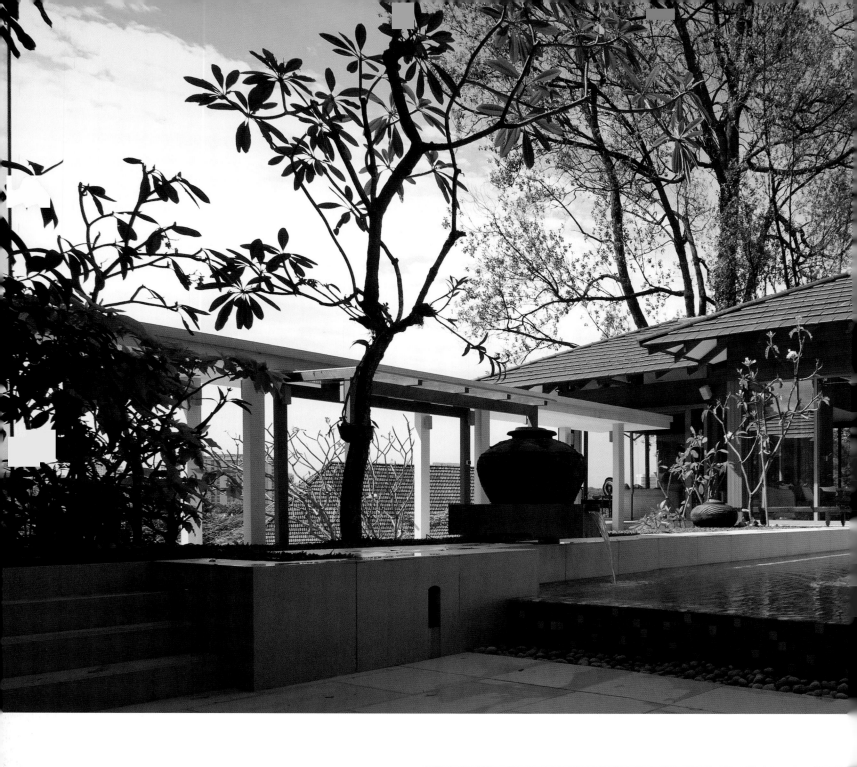

the natural contours. A collection of pots and jars from the owners' previous home was transported to the new house and placed in the landscape – with moss and algae intact.

Speaking of his own ambitions, Siew observes, 'I am currently studying Zumthor, Herzog & de Meuron as well as Paulo Mendes' works and writings but Le Corbusier is the architect I still admire the most. I find references to his works and ideas in many of today's architects. I am also inspired by the work of Carlo Scarpa for his craft and esoteric architectural language and Geoffrey Bawa for his sensitivity in crafting an architectural language for the tropics. Our work is very much about asking questions about the site, the context, history and meaning to evolve a unique architectural solution.'

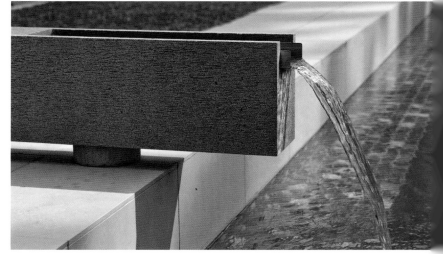

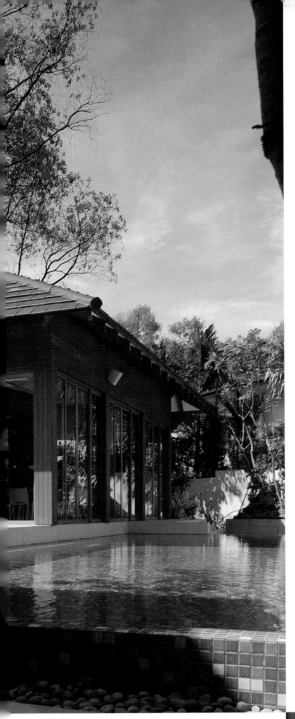

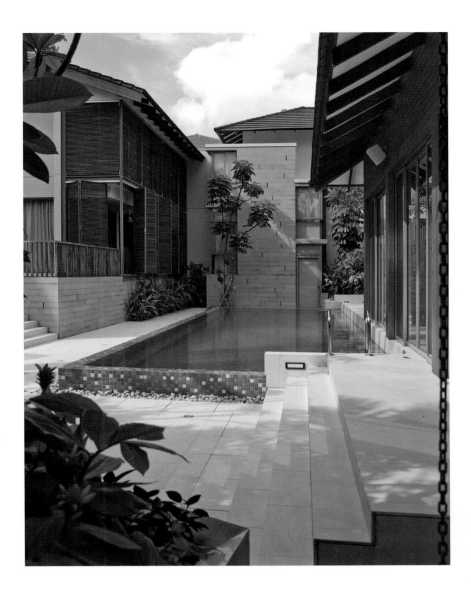

Above An open-sided verandah leads to the living and entertainment pavilion.

Left A beautifully detailed water-spout, perhaps inspired by the work of Carlo Scarpa.

Above right Three pavilions surround a central courtyard containing a rectangular pool.

Right The house folds into the natural contours.

Far right A double skin of sliding-folding screens provides sunshading and privacy to the master bedroom suite.

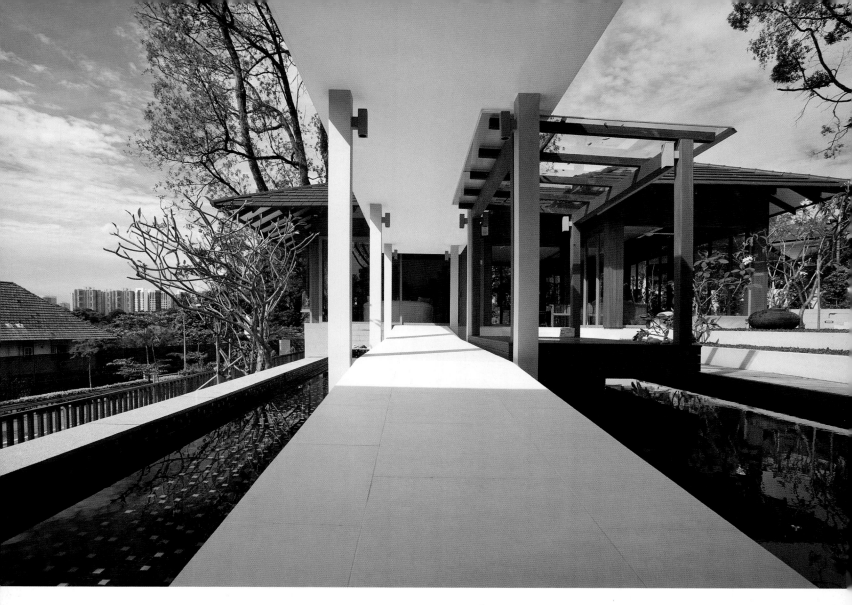

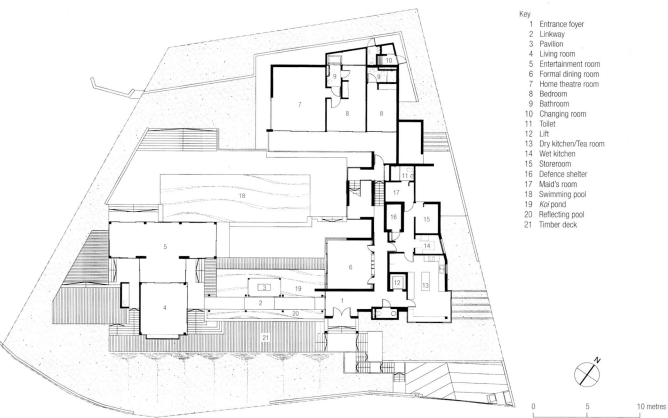

Key
1 Entrance foyer
2 Linkway
3 Pavilion
4 Living room
5 Entertainment room
6 Formal dining room
7 Home theatre room
8 Bedroom
9 Bathroom
10 Changing room
11 Toilet
12 Lift
13 Dry kitchen/Tea room
14 Wet kitchen
15 Storeroom
16 Defence shelter
17 Maid's room
18 Swimming pool
19 *Koi* pond
20 Reflecting pool
21 Timber deck

0 5 10 metres

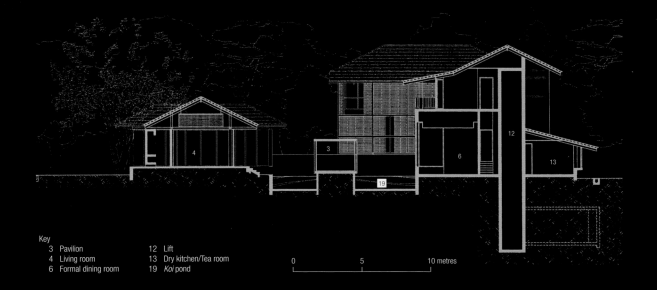

Key
3 Pavilion
4 Living room
6 Formal dining room
12 Lift
13 Dry kitchen/Tea room
19 *Koi* pond

0 5 10 metres

Above Section through the central pool court.

Left The house sits on a steeply sloping site with views to the southwest.

Left below The first-storey plan showing three pavilions arranged around a pool court.

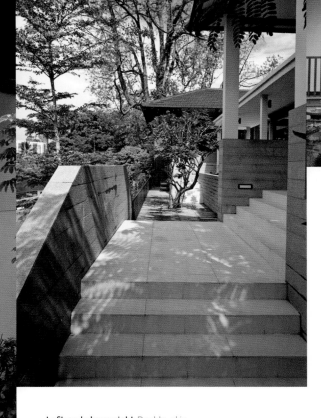

Left and above right Double-skin sliding-folding louvred screens provide privacy and protection from the sun.

Above The delightful interplay of levels at the entrance to the house.

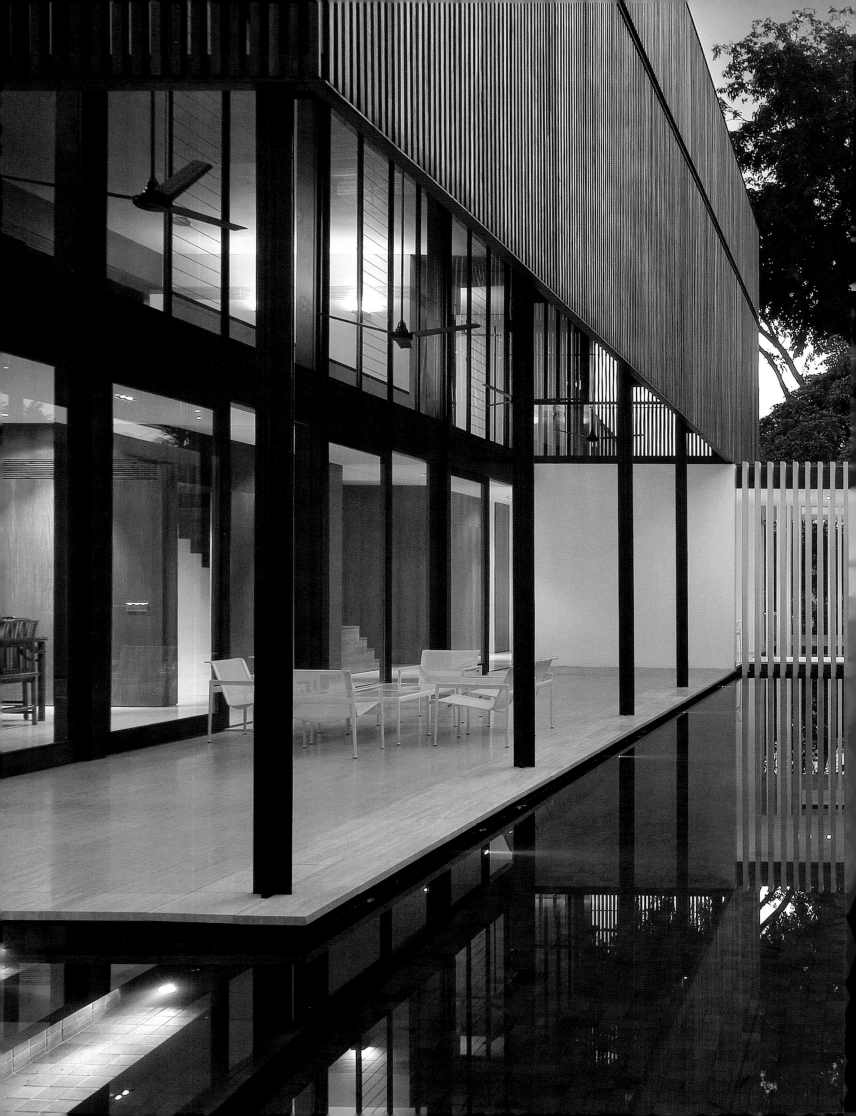

garlick avenue house

ARCHITECT: KERRY HILL
KERRY HILL ARCHITECTS

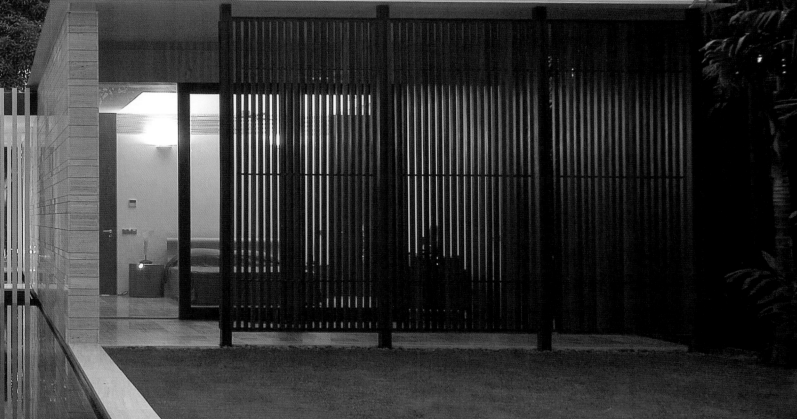

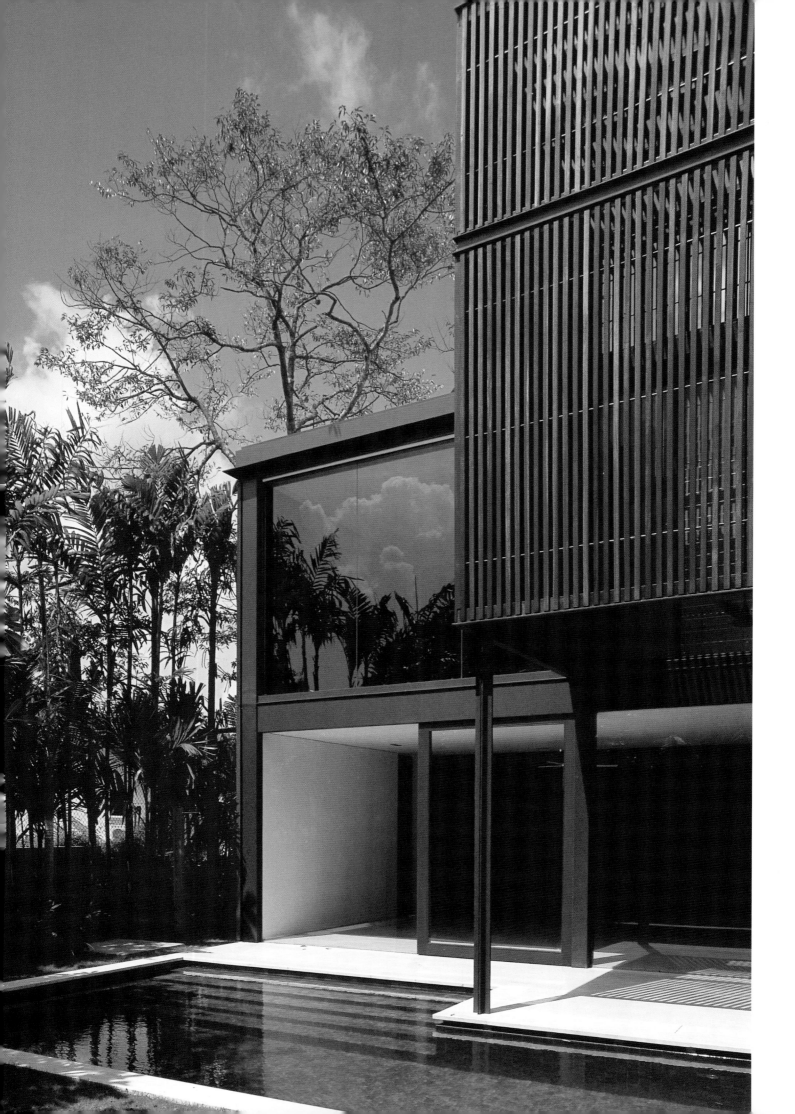

A 1968 graduate of the University of Western Australia, Kerry Hill relocated from Perth in 1971 to work for the Hong Kong-based practice of Palmer and Turner. Soon after, he found himself seconded to Bali as the resident architect working on the Bali Hyatt (1972–4) and he subsequently managed the Palmer and Turner office in Jakarta. By 1979 Hill had established his own practice in Singapore, and in the 1980s gained international recognition with a string of sybaritic dwellings and resort hotels, including the Beaufort Hotel on the Singapore island of Sentosa and the Amanusa in Bali. His work has garnered a number of awards, including the prestigious Aga Khan Award for Architecture (2001) for the design of the Datai Hotel at Pulau Langkawi. His outstanding oeuvre was recognized in 2006 by the award of the Gold Medal of the Royal Australian Institute of Architects.

Like other projects by Kerry Hill Architects, the Garlick Avenue House exhibits a lucid plan. Explaining his desire for clarity, Kerry Hill has said: 'The plan is seen as a mode of distilling elements into a clear diagram, a key to the scheme.'[1] The plan, in this instance, is conceptualized as three parallel linear spaces orientated east to west and defined by 'walls' extending outwards to frame views and to embrace gardens and paved courts.

The first of the three layers of the house contains the master bedroom suite. The bathroom overlooks a small courtyard facing west while, conversely, the bedroom looks east over a terrace into a linear garden fringed with palm trees and culminating in a splendid frangipani. The second layer contains the entrance lobby and a stunning linear atrium. A beguiling water court precedes the entrance and a stone bridge connects the entrance lobby to the master bedroom suite. Beyond, a screen of vertical concrete fins is the swimming pool. The third layer contains the principal living spaces: the living room, dining room and galley kitchen. Above are the guest suite, library, gym and a second bedroom, all aligned west to east and looking into the upper part of the atrium.

Commencing at the pedestrian entrance in the northwest corner of the site, a processional route has been choreographed through the house in a series of clearly defined linear movements interspersed with right-angle turns experienced sequentially and punctuated by framed vistas and glimpses of courtyards, reflecting pools and mature trees. Hill manipulates the architectural promenade with skill and dexterity; he is a skilled sceneographer, and in this regard he has frequently expressed his admiration for the work of the Sri Lankan master architect, Geoffrey Bawa.[2]

But the heart of the dwelling is the magnificent two-storey, linear 'tropical atrium', an expression used to describe an atrium that unlike its inward looking, air-conditioned, weather-excluding counterpart in temperate climates is open-sided, naturally ventilated and located on the edge of a building.[3] The atrium in the Garlick Avenue House is a

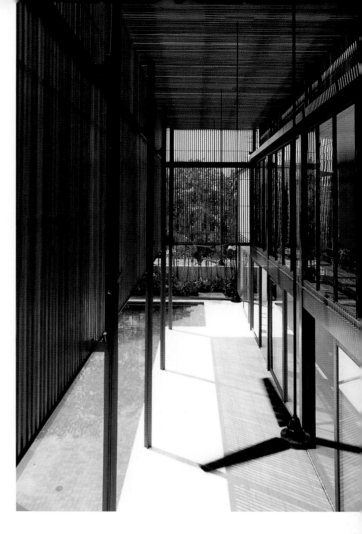

semi-outdoor space shaded by vertical timber louvres and at roof level by a glazed pergola. Alongside the atrium is the luminous grey-green tiled swimming pool that is read as an extension of the pond at the entrance to the house. The most dramatic view of the atrium is from a roof terrace adjoining the guest suite.

The plan form works remarkably well with the tropical climate. The narrow gables are orientated towards the morning and afternoon sun, while the longer façades face north and south. Thus, when the sun is at its zenith, the house does not suffer from insolation. The parallel 'walls' deflect the northeast and southwest monsoon winds into the interior, enabling it to function much of the time without air conditioning.

Writing of Kerry Hill's work, Philip Goad observes that the architect's experience in hotel commissions is carried to intense levels in individual house design and, 'combines the idea of court, timber-slatted screen, the framed panorama, the calming presence of water against mass, and a rigorous spatial order'.[4] The Garlick Avenue House distils all these elements into a composition of immense clarity and serenity.

[1] Kerry Hill, in a lecture delivered at the University of Western Australia, September 1996.
[2] David Robson, *Beyond Bawa: Architecture for Monsoon Asia*, London: Thames and Hudson, London, 2008, pp. 206–21.
[3] The expression 'tropical atrium' was coined by architect and theorist Tay Kheng Soon to describe an atrium that challenges the notion of the internalized, air-conditioned atrium. See Robert Powell, *Tropical Modern Architecture: Tay Kheng Soon and Akitek Tenggara*, Singapore: Page One, 1990, pp. 60–3.
[4] Phillip Goad, 'Kerry Hill', in Phillip Goad and Anoma Pieris, *New Directions in Tropical Asian Architecture*, Singapore: Periplus Editions, 2005, p. 35.

Left The dining room overlooks a luminous green pool.

Above An exhilarating two-storey tropical atrium is at the heart of the plan.

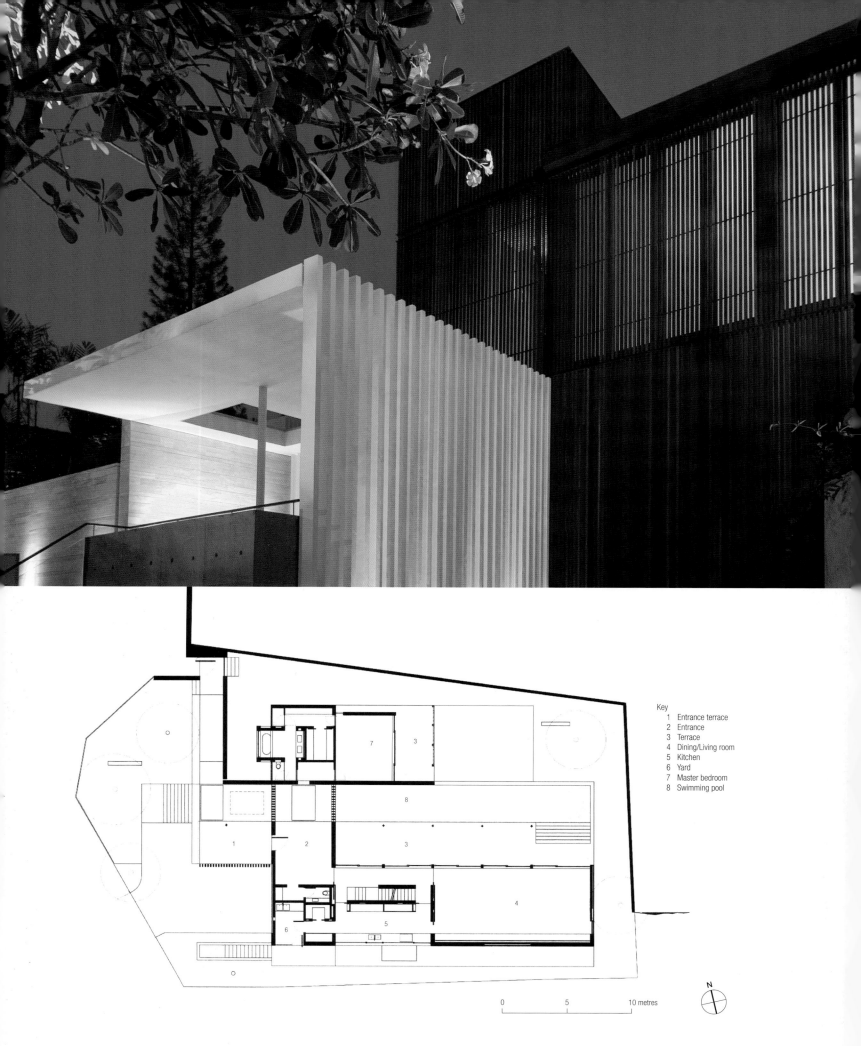

Key
1 Entrance terrace
2 Entrance
3 Terrace
4 Dining/Living room
5 Kitchen
6 Yard
7 Master bedroom
8 Swimming pool

0 5 10 metres

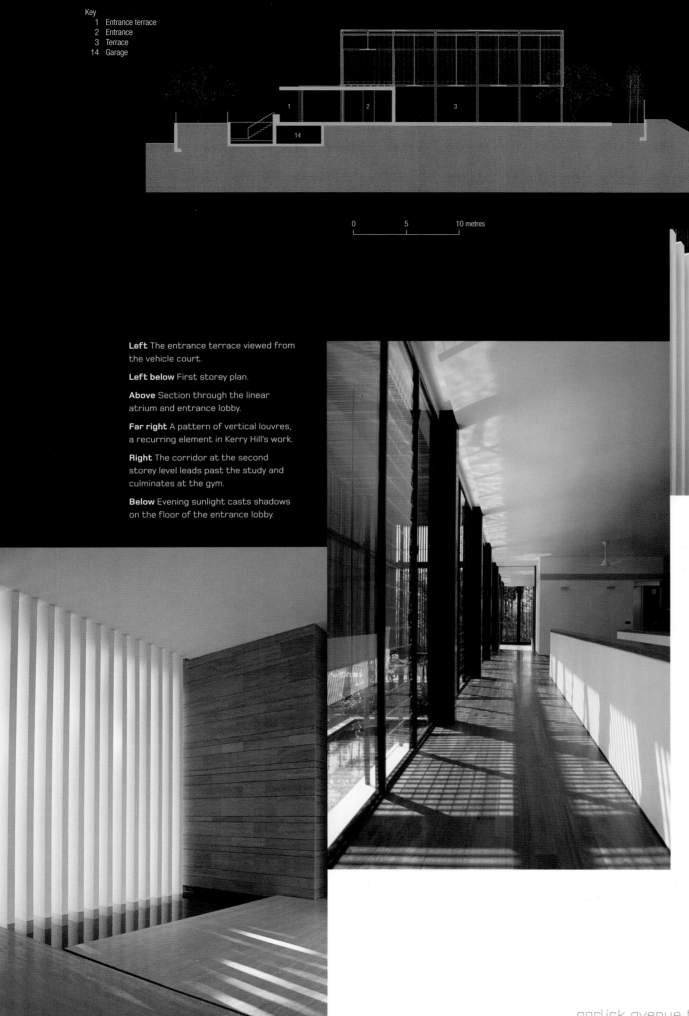

Key
1 Entrance terrace
2 Entrance
3 Terrace
14 Garage

0 5 10 metres

Left The entrance terrace viewed from the vehicle court.

Left below First storey plan.

Above Section through the linear atrium and entrance lobby.

Far right A pattern of vertical louvres, a recurring element in Kerry Hill's work.

Right The corridor at the second storey level leads past the study and culminates at the gym.

Below Evening sunlight casts shadows on the floor of the entrance lobby.

Above The entrance area looking east towards the staircase.

Right Breezes pass over the swimming pool and bring cool air into the double-height atrium.

Opposite above right Second storey plan.

Opposite above far right Looking from the cool, shaded atrium towards the entrance lobby screen.

Opposite below A stone bridge spans the pond in the entrance lobby and leads to the master bedroom suite.

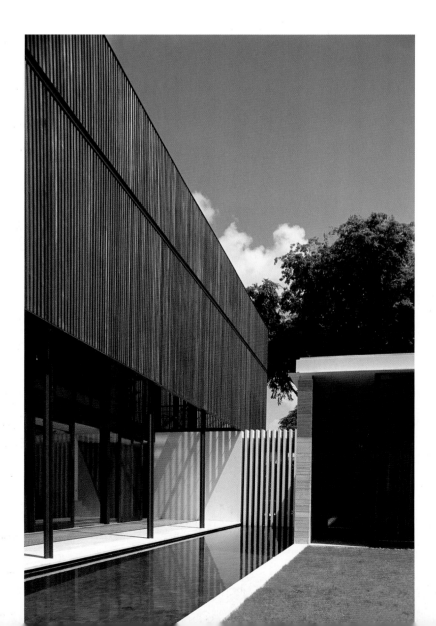

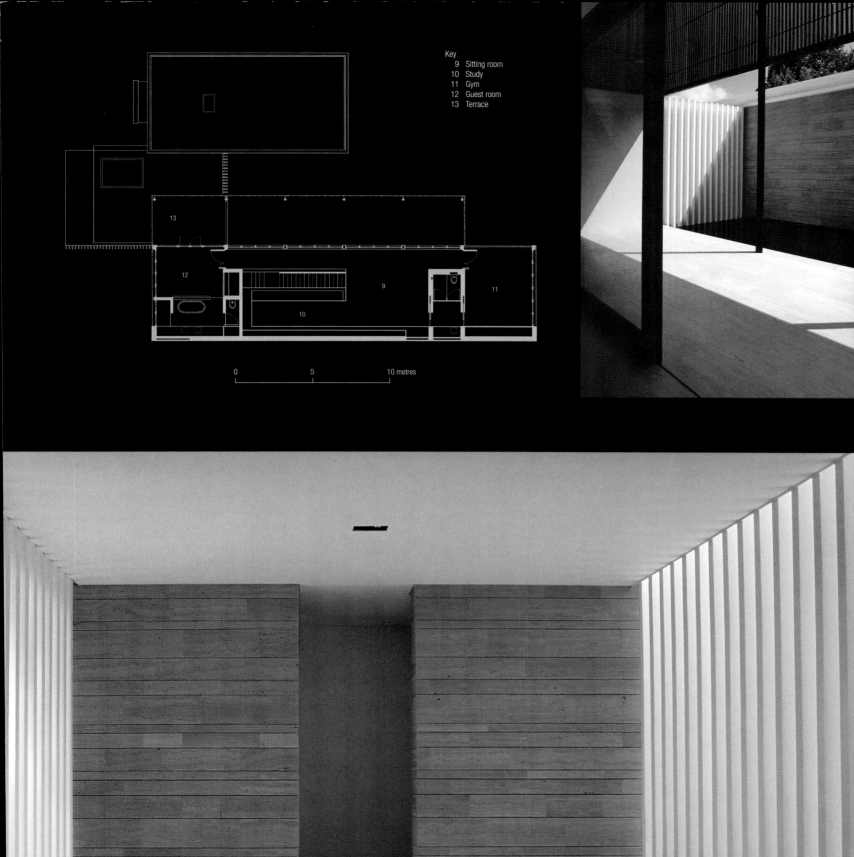

Key
9 Sitting room
10 Study
11 Gym
12 Guest room
13 Terrace

0 5 10 metres

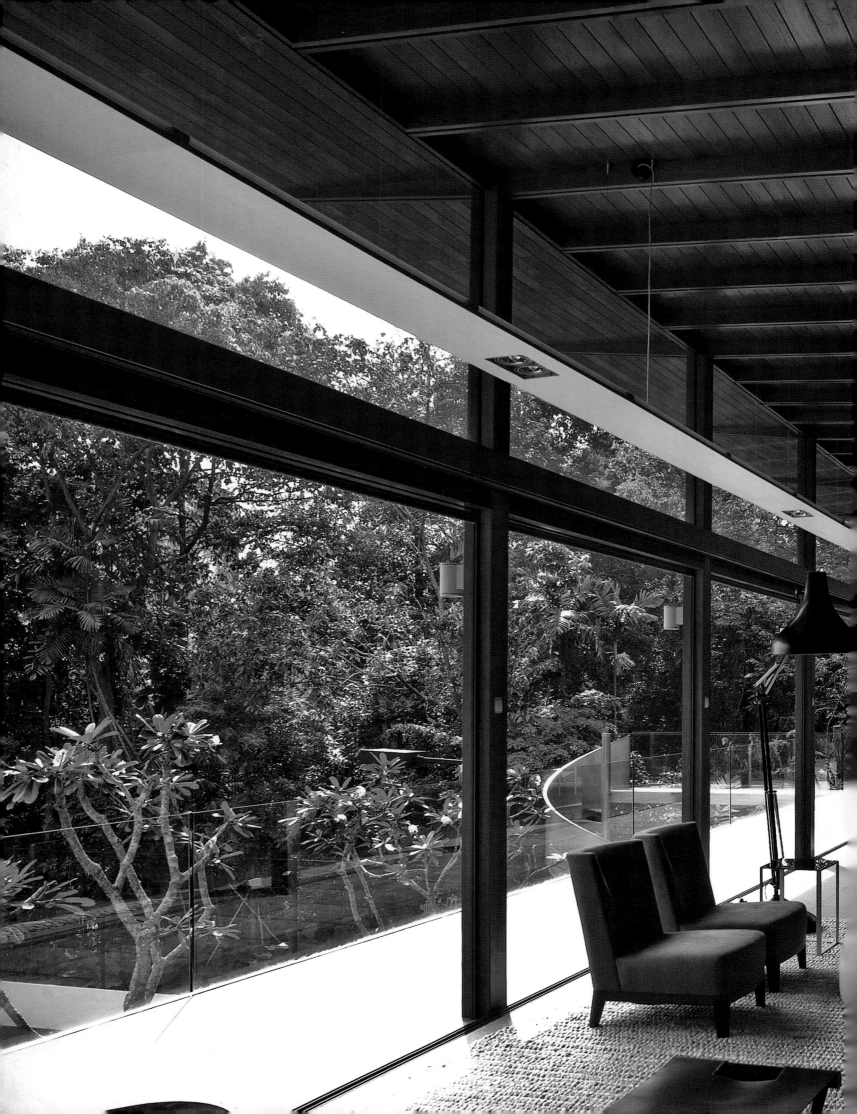

nassim road
house

ARCHITECT: ERNESTO BEDMAR

BEDMAR & SHI

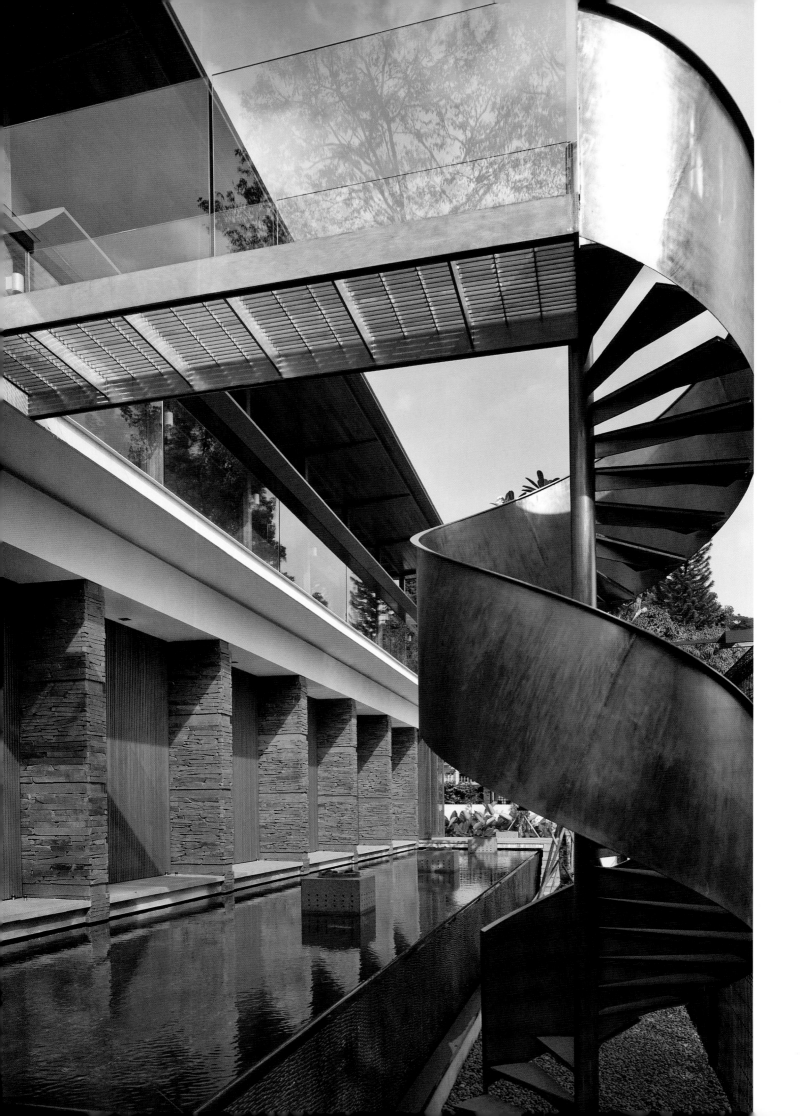

The Nassim Road House is essentially a recreation venue for an extended family. Here, the parents and siblings converge to play tennis, work out in the gym, watch a movie, read or simply entertain friends and business associates. There are facilities for accommodating guests, and in the long term the house could be adapted, with minimal disruption, to become the primary residence of one of the owner's children.

The house consists of a pair of two-storey linear blocks separated by a deep, linear void, assigned entirely to vertical and horizontal circulation, aligned from west to east along the north-facing slopes of Nassim Hill. The plan form captures precisely Louis Kahn's maxim that a house should have clearly defined 'served' and 'servant' spaces, meaning that there are primary spaces in a dwelling and there are support spaces, and in a well-planned dwelling these are defined with utmost clarity.

Entering a vehicular courtyard in the west corner of the rectangular site, family and guests ascend a broad staircase to arrive at the very core of the house – a double-height lightwell. The open-plan living and dining space extends along the north-facing façade, with a shaded verandah that serves as a 'spectators' gallery' overlooking the tennis court at the lower level. Unrestricted views of the on-court activity are ensured by the use of a glass balustrade, while a delicate circular staircase gives direct access from the verandah to the tennis court. An outdoor shaded patio with barbecue facilities extends to the east of the living space, while a six-metre-wide sliding glass door permits the whole of the east elevation to be opened to this outdoor living space.

Two sturdy steel and glass bridges span the central void linking the dining room to the spacious kitchen and the preparation area on the south side. Bedmar concurs with the view that the so-called 'integrated kitchen' is now high on the list of requirements as home owners become more interested in the culinary arts and entertaining at home.

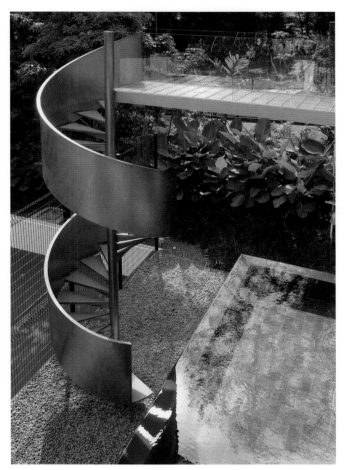

Opposite An elegant steel and glass bridge connects to a spiral staircase that gives access to the tennis court.

Top From the entrance court, a broad flight of stairs ascends to the entrance lobby.

Above Detail of the stainless steel spiral staircase.

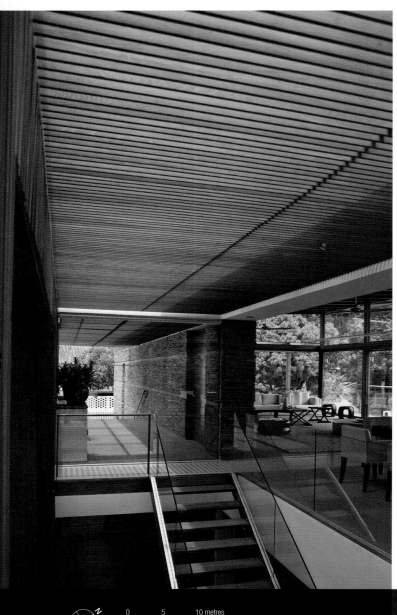

At the lower level, a large audiovisual theatre and a well-equipped gym provide more recreational activity, and a second, more private entrance at first-storey level gives direct access to the changing room for tennis. There is also a guest suite in close proximity to the lower entrance and a study/library that can be used as a second guest room. Both are deeply recessed behind timber louvred shutters, while a lotus pond skirts the north façade of the house and distances them from the tennis court.

The house has a strong underlying functional rationale and a distinctly layered plan form. To afford an overview of the tennis court, the spaces for entertainment are elevated to the highest level. In this sense, the recreational purpose of the house is instantly conveyed. Surrounded by a fringe of mature vegetation, the house enjoys a secluded location. Tall trees in neighbouring gardens add to the resort-like setting.

Throughout, Bedmar employs a palette of tactile materials that, allied with the sensitive introduction of daylight and integrated with the sensory qualities of fountains and cascading waterfalls, create a calm retreat from the stress and strains of city life.

In passing, Bedmar makes an off-the-cuff but significant remark that 'our houses are getting smaller'. It has a resonance with comments by other architects, and perhaps the days of building maximum Gross Floor Area are passing. If so, it points, perhaps, to a curbing of what some describe as 'a culture of excess'.

Left The entrance lobby at second storey level.

Below left First storey plan.

Below A second stair descends from the entrance to the audiovisual room and the gym.

Right The external dining patio with pergola overhead.

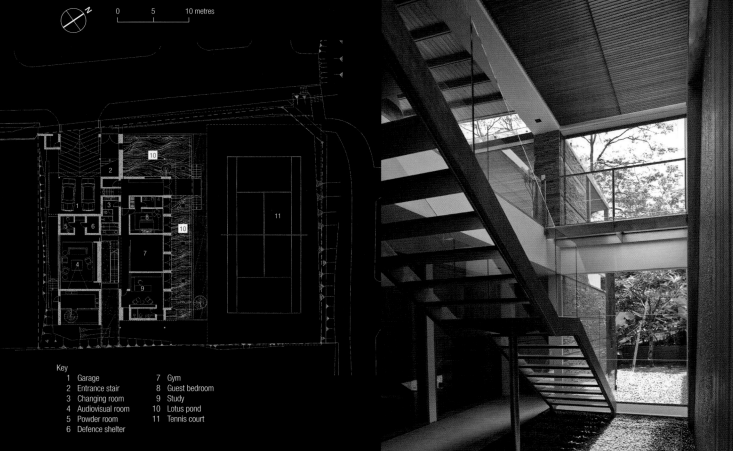

0 5 10 metres

Key
1 Garage
2 Entrance stair
3 Changing room
4 Audiovisual room
5 Powder room
6 Defence shelter
7 Gym
8 Guest bedroom
9 Study
10 Lotus pond
11 Tennis court

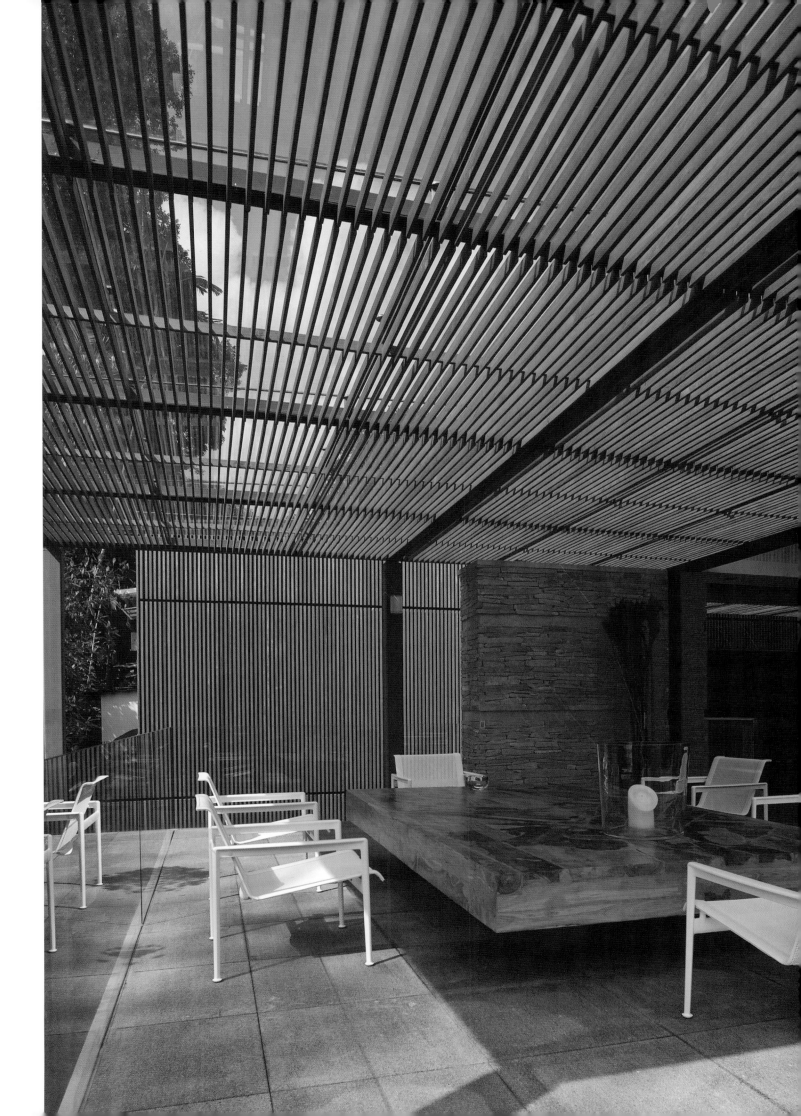

Right The upper terrace overlooks an azure blue pool.

Below A palette of tactile materials is enhanced by the sensitive introduction of daylight.

Above Timber louvred shutters conceal the study/library.

Right A glass and metal bridge spans the lotus pond from the terrace to a circular metal stair.

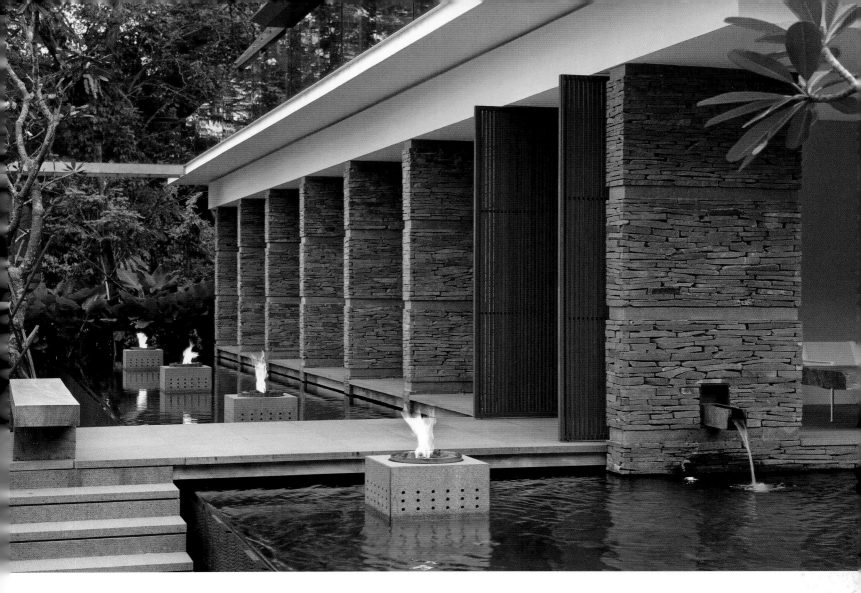

Above Tall trees in the neigh-bouring garden shelter the dining terrace.

Right and below The sections reveal that at the core of the house is a tall, linear void.

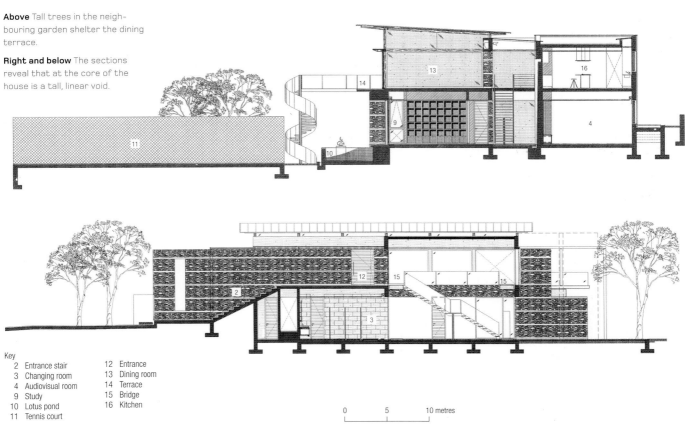

Key

2	Entrance stair	12	Entrance
3	Changing room	13	Dining room
4	Audiovisual room	14	Terrace
9	Study	15	Bridge
10	Lotus pond	16	Kitchen
11	Tennis court		

0 5 10 metres

sundridge house

ARCHITECT: RENÉ TAN
RT+Q ARCHITECTS

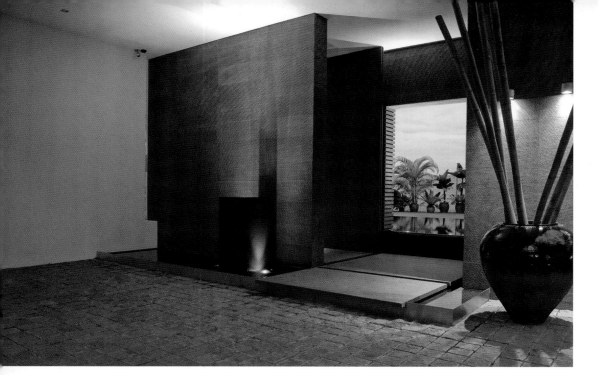

Left A framed view of the garden precedes a sharp left turn to the entrance door.

Right Timber louvres shade the detached pool pavilion.

René Tan was born in Malaysia and attended Penang Free School (1977–83), the alma mater of two other notable Southeast Asian architects, Ken Yeang and Chan Soo Khian. He then studied at Yale University (1983–7), where he began as a music major intending to be a concert pianist but eventually graduating with a Bachelor of Arts in music and architecture. He went on to pursue graduate studies at Princeton (1987–90), where he received his Master of Architecture.

Amongst the notable teachers he encountered at Princeton were Ralph Lerner, the Dean, and Michael Graves. From Ralph Lerner he learnt about 'attitude', 'rigour', 'discipline' and 'commitment', while Michael Graves taught him the value of history, plan-making and the 'necessity of drawing'.

Asked to single out practitioners who have influenced his architecture, he identifies Oscar Niemeyer (who he admires for the boldness of his forms), Louis Kahn (for the rigour of his forms) and Le Corbusier (for the fearlessness of his forms). But the Sundridge House appears to pay homage to yet another master, for it is Miesien in appearance, its elegant, orthogonal, 'L'-shaped dwelling embracing a narrow, rectangular swimming pool.

The owners of the Sundridge House are a young expatriate couple. The house was commissioned in 2005 and the building completed in 2007. It was one of the first dwellings designed by the nascent practice, RT+Q, and Tan admits it was given an extraordinary amount of attention; the detailing is exemplary. He is quick to acknowledge the contribution of his partner, Quek Tse Kwang, and associate, Chua Z-Chian.

The Sundridge House is one of two built on the site of a larger house now demolished. It is not visible from the public road and is approached via a narrow side lane. Entry is from a carport into an entrance porch with a right-angle turn through a tall, pivoted entrance door that leads directly into a linear living room that forms the longer leg of the 'L'-shaped plan and looks north over a swimming pool. A narrow,

vertical window looks back towards the entrance. Along the south side of the living room is a linear courtyard with palm trees that block the view of the adjoining house. At the far end of the living room is an off-form reinforced concrete wall and a dog-leg staircase leading to the second storey. Beyond is the kitchen and maid's room. Terminating the entrance axis is an exquisite open-to-sky powder room.

The shorter leg of the 'L'-shaped plan is a transparent glass dining pavilion beneath a flat roof terrace with a glass balustrade. A timber terrace extends north from the dining pavilion, terminating in a head-height timber-clad wall that contains a cut-out 'picture window'.

Beyond the swimming pool, the lawn extends to the boundary wall, and in the northeast corner of the garden is a delightful pavilion that looks back towards the house.

At second-storey level, the master bedroom and three other bedrooms, including a nursery for the owners' first child, look north and are linked by a wide, north-facing corridor. Details such as the recessed lights in the timber floor attest to the architect's and the lighting consultant's attention to nuances.

This is first and foremost a superbly detailed house. Tan's design methodology involves working with numerous scale models, testing form and spatial relationships and refining junctions. The Sundridge House, he asserts, 'is about details, materials and construction; it is rich in texture and surface composition. It is a rigorous exploration of tectonics and construction where every corner and angle is thought through.'[1]

The house owners have lived in Singapore for eight years and previously worked in Vietnam. Artefacts acquired from their previous postings in Asia are a counterpoint to the clean modernist lines of the house. The lasting impression is of a superbly detailed house crafted with exceptional care.

[1] René Tan, in e-mail correspondence with the author, 15 July 2008.

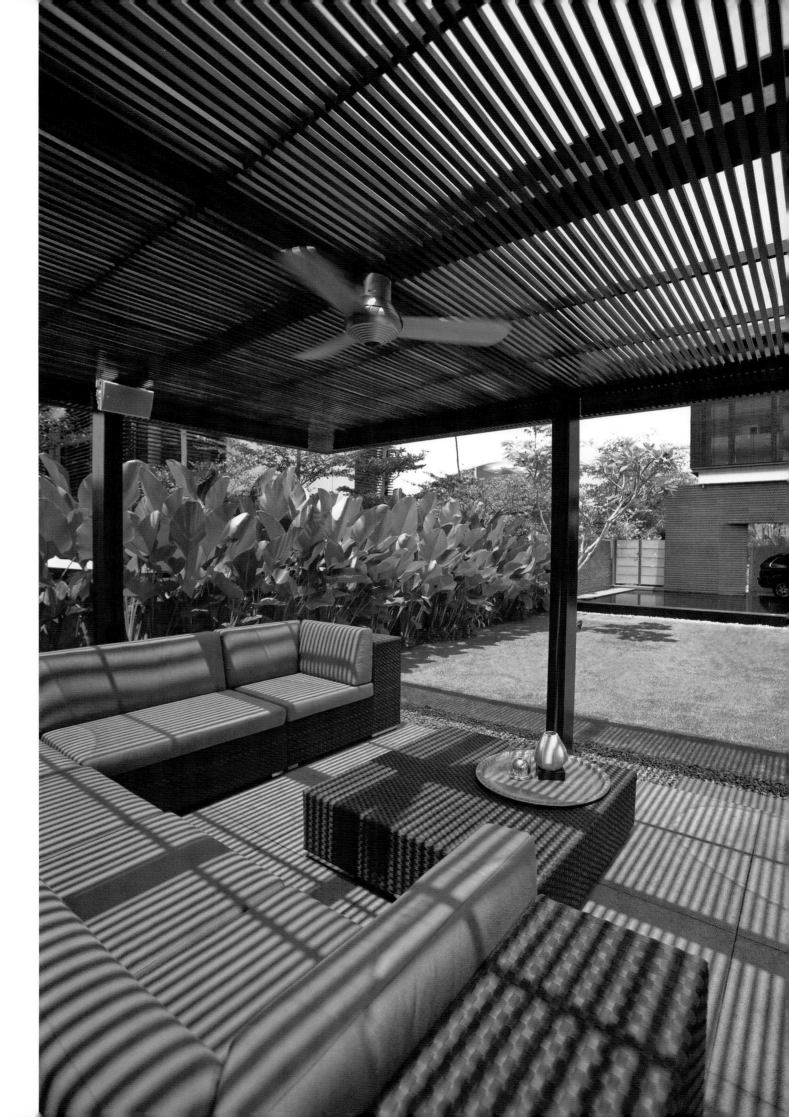

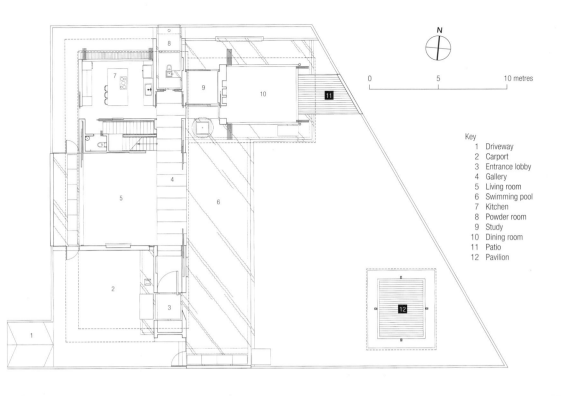

N

0 5 10 metres

Key
1 Driveway
2 Carport
3 Entrance lobby
4 Gallery
5 Living room
6 Swimming pool
7 Kitchen
8 Powder room
9 Study
10 Dining room
11 Patio
12 Pavilion

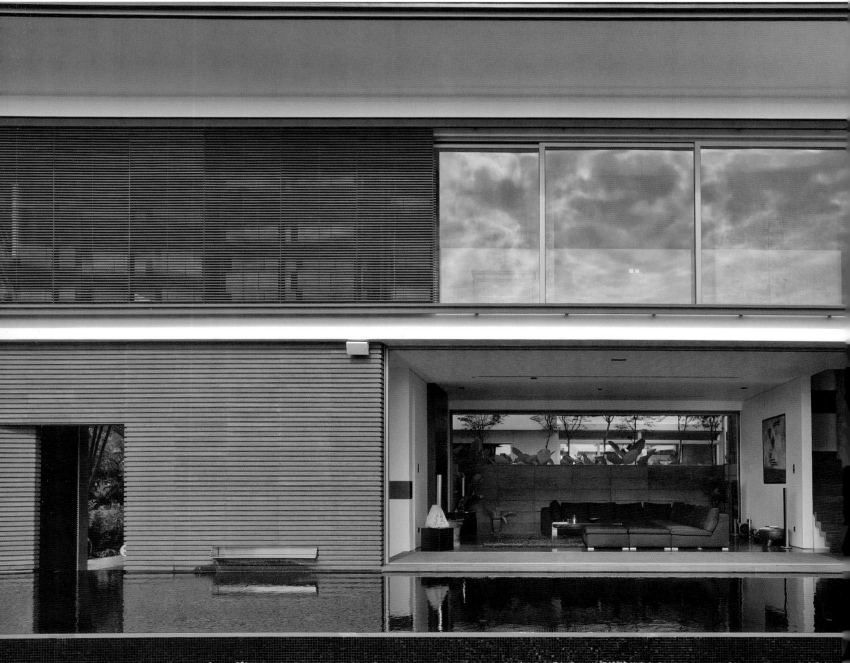

Far left First storey plan.

Left The open-to-sky powder room.

Below The elevations are a finely detailed orthogonal composition.

Right The entrance lobby gives access to a linear spine along the east side of the house.

Below right Section through the living room and the pool.

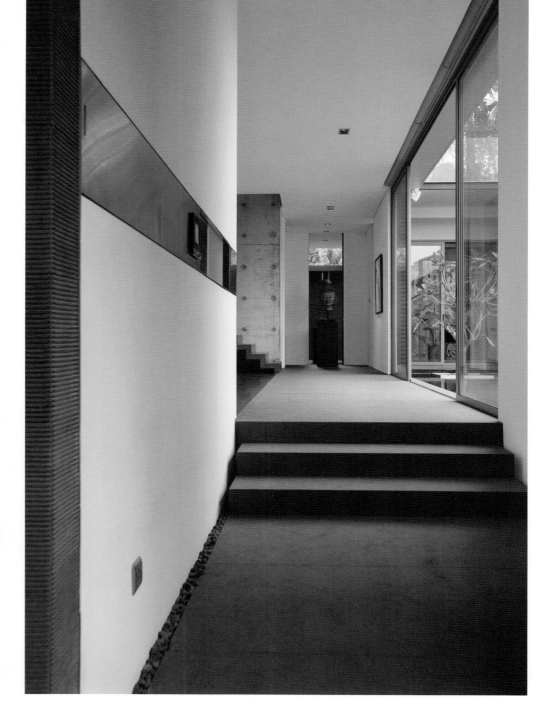

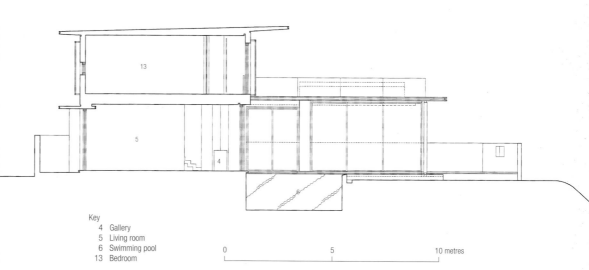

Key
4 Gallery
5 Living room
6 Swimming pool
13 Bedroom

0 5 10 metres

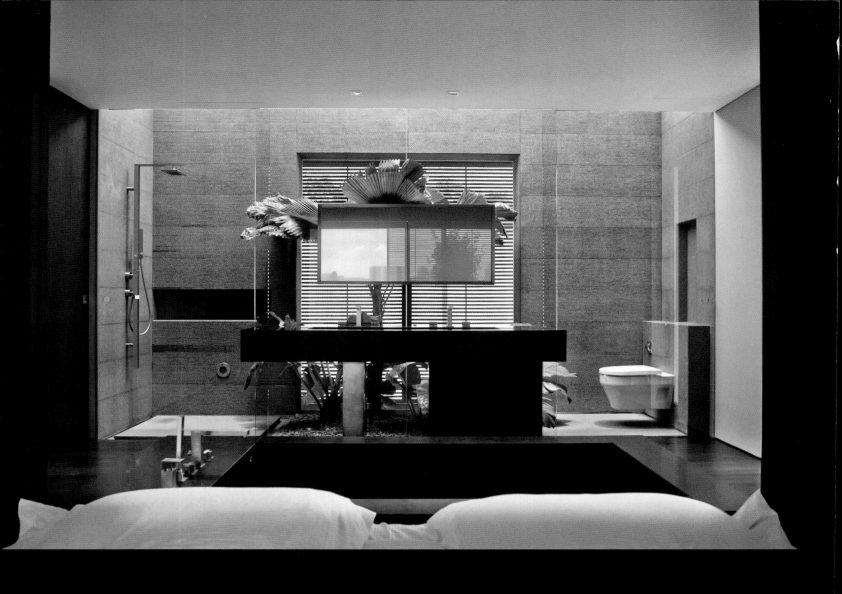

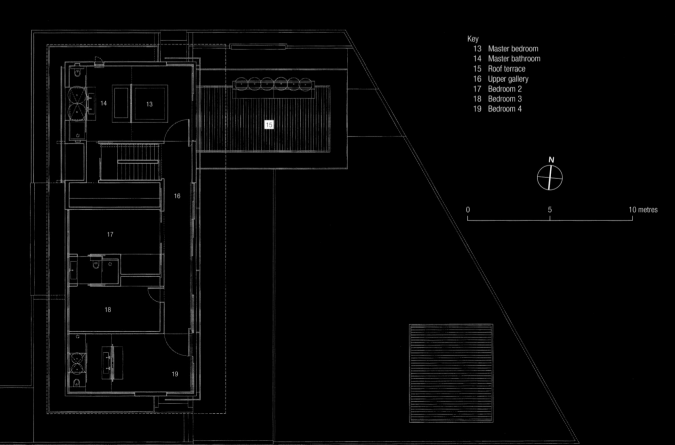

Key
13 Master bedroom
14 Master bathroom
15 Roof terrace
16 Upper gallery
17 Bedroom 2
18 Bedroom 3
19 Bedroom 4

N

0 5 10 metres

Left The master bathroom.

Below left Second storey plan.

Left Detail of timber staircase risers and treads.

Right The house elevations exhibit a harmonious and well-proportioned juxtaposition of stone, aluminium and timber.

Below left The dog-leg stair ascends around an off-form concrete spine wall.

Below right The master bathroom with the master bedroom beyond.

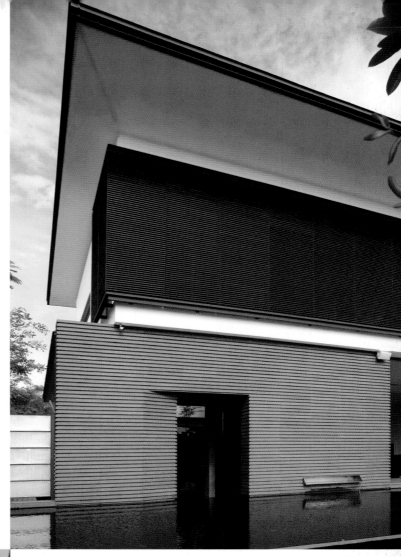

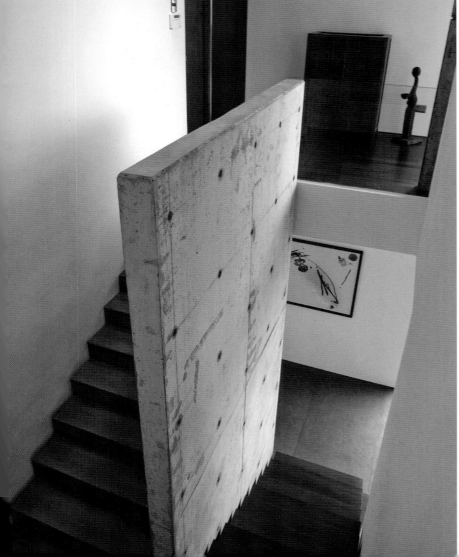

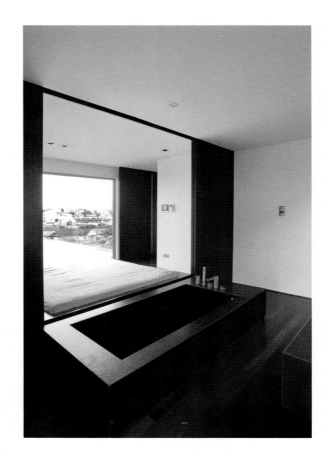

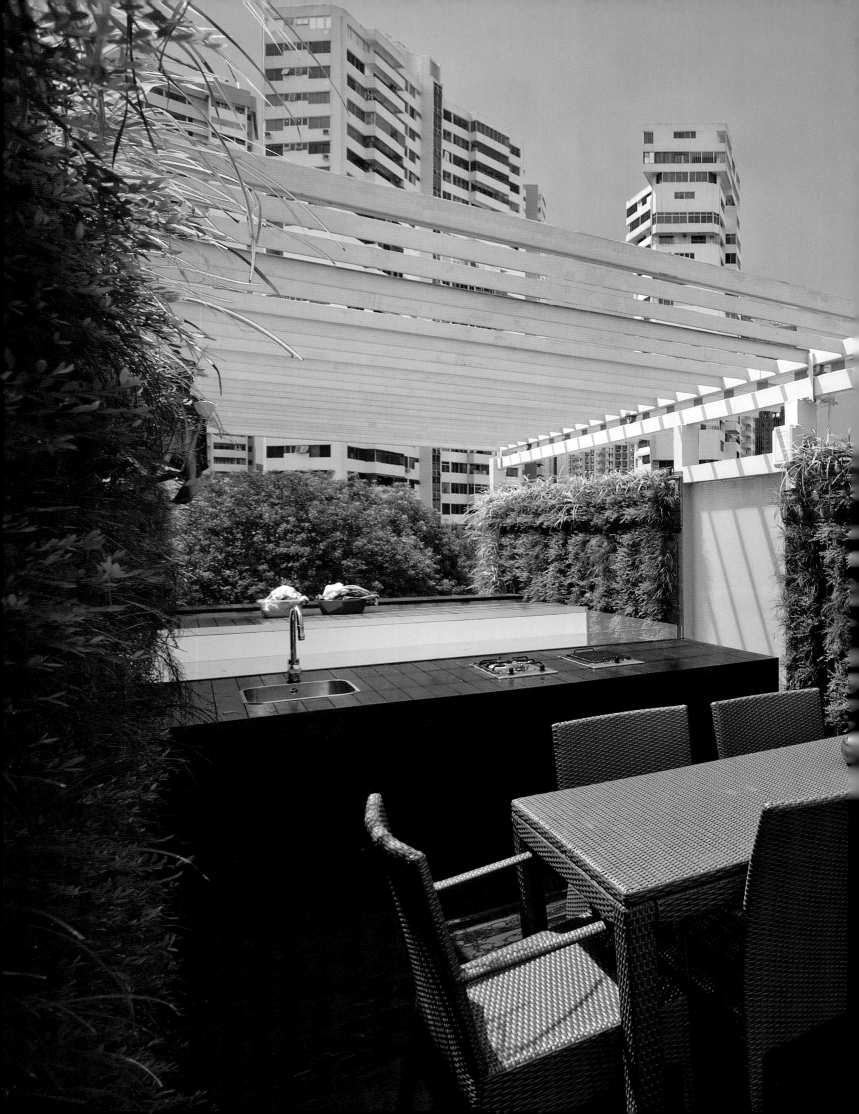

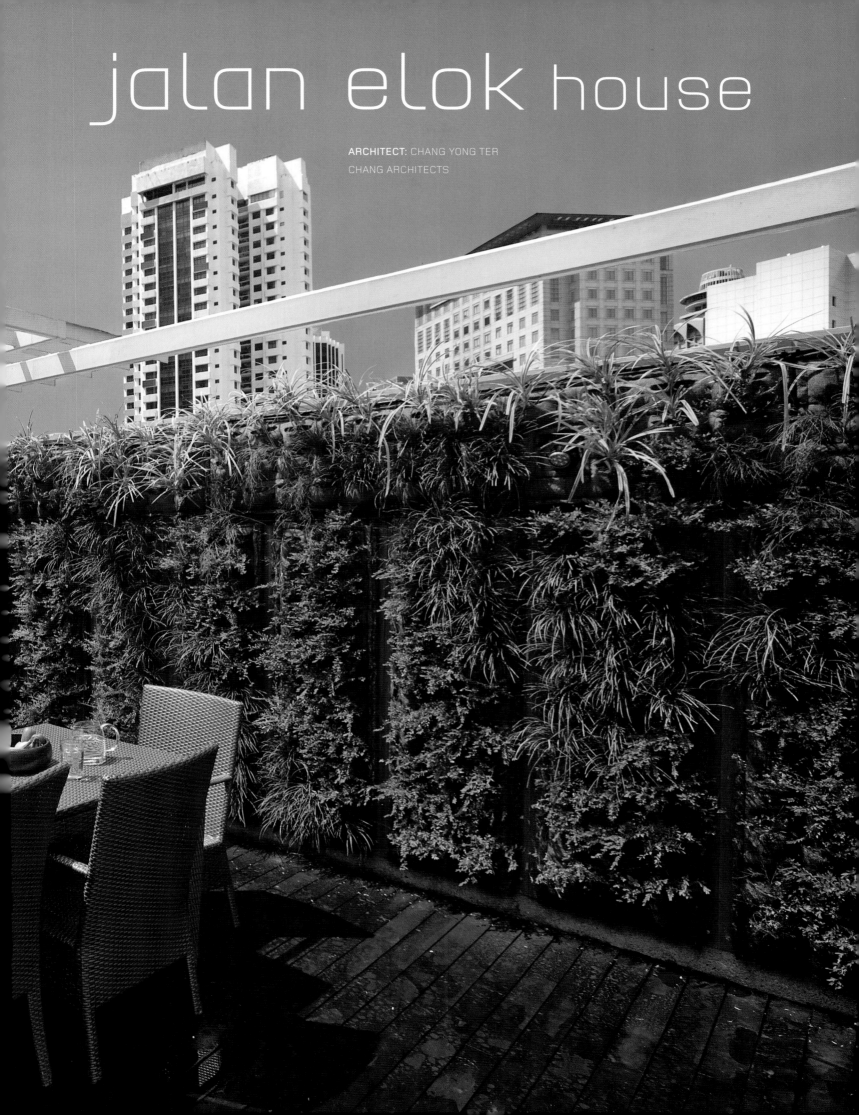

jalan elok house

ARCHITECT: CHANG YONG TER
CHANG ARCHITECTS

Chang Yong Ter studied at the School of Architecture at
the National University of Singapore, graduating in 1996.
His final year mentor was the influential Asian scholar,
Associate Professor Pinna Indorf, one of the foremost
authorities on Thai and specifically Buddhist temple archi-
tecture. She typically emphasized clarity in the plan form.
Chang is a quietly spoken young Singaporean with a remark-
able talent, and when discussing his inventive approach to
design it comes as no surprise to learn that he spent his
intern year with SIA Gold Medal-winning architect Tang
Guan Bee, returning to work with the radical designer for
five years (1996–2000) after graduation, before setting
up CHANG Architects in 2000.

'The years at NUS were exciting (for me) because each
tutor had his/her own areas of interests and specialties,
and it was always intriguing when different minds meet.
Pinna Indorf was a delight in that she opened up new ways
of perceiving form and space, one that also included other
dimensions – time and causation. Her teachings could have
influenced me subconsciously.'

Asked to recall the designers who have influenced his work,
Chang reels off a surprisingly long list. 'Frank Lloyd Wright
and Peter Illyich Tchaikovsky are two masters whose works
have been consistently inspiring. Subconsciously, I've always
thought that they are two of the same person, creating
similar dimensions of works but via different means. I've
always appreciated great works of art and architecture.
Artists have also been my source of inspirations, not only
their works, but also their personalities and their world
views, for example, Gao Xingjian, Salvador Dali and many
locals, such as Tang Da Wu, Tan Swee Hian, Teo Eng Seng, Ng
Eng Teng, Han Sai Por and S. Chandrasekaran, plus a great
bunch of them who were members of the defunct group
known as the Artist Village. Besides artists I am also inspired
by singers, dancers and composers, including playwrights
Kuo Pao Kun and William Teo, fashion designer Issey Miyake
and sculptor Isamu Noguchi.'

'TANGGUANBEE Architects was a culture of its own. Anyone
who has been through the portals of TGBA would probably
associate with it. The office setting, the topics of conversa-
tion and the architectural dialogue, often in Tang's mother
tongue, Hokkien, probably define this culture. His unique ar-
chitectural design approach is possibly due to the fact that
designs were often discussed and conceived in Hokkien.'

Jalan Elok is an unexceptional terrace of houses located in
close proximity to Orchard Road, but No. 19 has undergone
a remarkable transformation. The plan essentially reverses
the conventional arrangement in a Singapore residential
terrace house where one enters through a reception/living
space, then passes by a transverse staircase located in the
centre of the house, then through a dining room to a rear

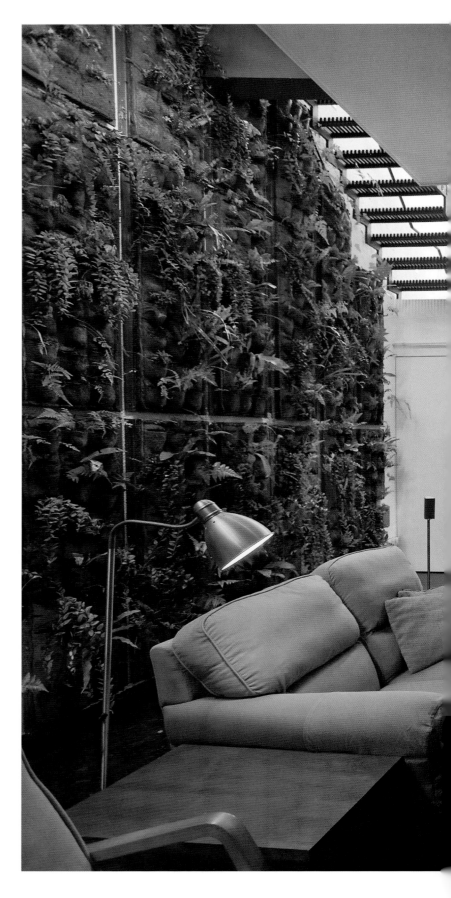

Above Green walls flank the living
room.

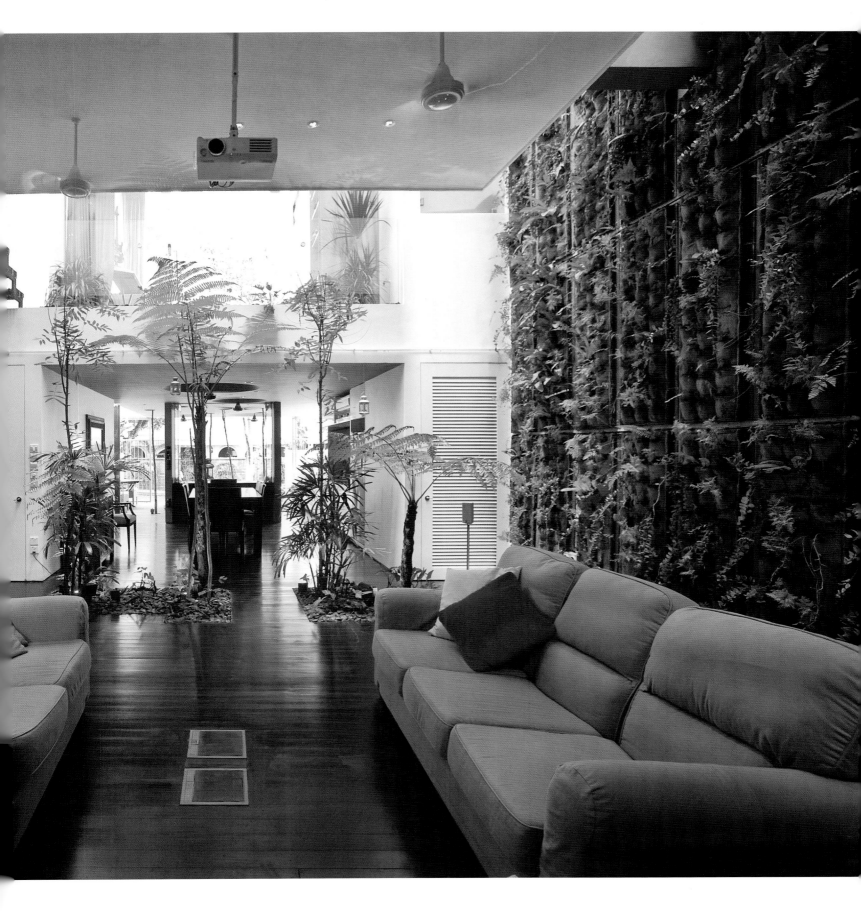

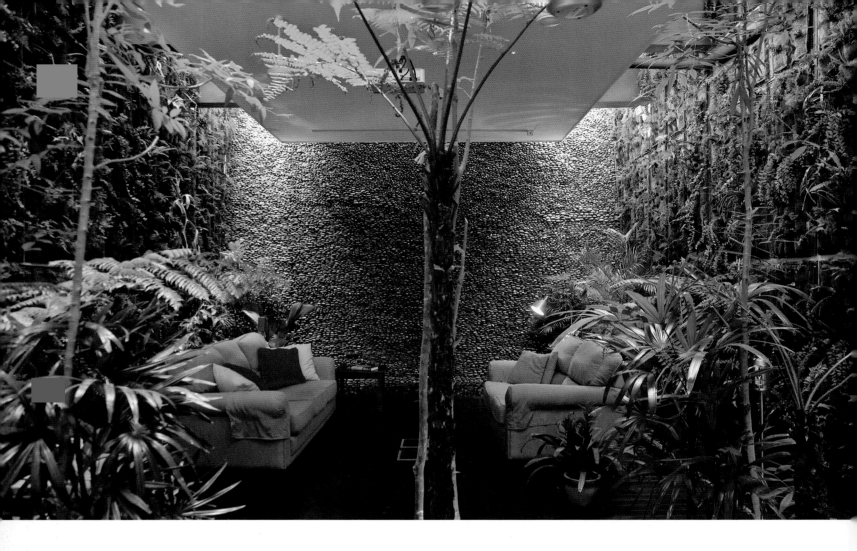

kitchen, possibly a wet kitchen, and the maid's quarters. Houses of this type are typically six metres wide, with the living room facing the street and the kitchen at the rear overlooking the rear service yard.

In reconfiguring the house form, Chang has created a central linear zone four metres wide with one-metre-wide linear light and ventilation wells along both sides of the site. Chang essentially creates a matrix with three zones laterally and four zones in the depth of the building. 'It is not at all Singaporean,' says Chang, 'but the clients, Richard Wong and Clara Hue, placed a greater value on volumetric expression than on Gross Floor Area.'

Chang has placed the open kitchen right up front, immediately upon entry from the carport. There is no front wall, and the first line of security is a sliding grill with vertical wire 'bars'. The kitchen worktop runs along one side of the reception area, where a number of slender trees penetrate through the second-storey roof above.

The kitchen and the entrance coalesce and share a timber deck. The principal space for meeting visitors is the kitchen and, therefore, instead of being hidden away at the rear of the house, it is up front. An added advantage is that the maid observes all who approach the house and is immediately able to answer the door to callers. The breakfast area is located laterally beyond this point, with sliding doors

ingeniously hidden from view that can be closed for security purposes at night.

The formal dining room is flanked by a dry kitchen, including refrigerators. The underlying ideas here may have their source in Pinna Indorf's teaching because there is a central axis although progress through the house is always to the side rather than along this axis. Beyond the dining area is the *piece de resistance* of the first storey – a living space flanked by luxuriant 'green' walls. This is a sublime and exotic use of emerging green technology, for while many architects extol the ecological benefits of this form of 'vertical garden', very few actually succeed in persuading their clients to accept the radical concept. Finally, the rear wall of the house is faced with small smooth pebbles set in cement. Rain is allowed to wash down this wall, which is open to the sky.

An open-riser staircase commences in the dining area and ascends in the fissure alongside the northern party wall, through four storeys to roof level. At the first landing level, a path of stepping stones leads through a dry garden to sliding glass doors that give access to the eldest son's room – an amazing space that overlooks the landscaped roof over the reception area. The trees that spring from the lower level emerge through apertures in the roof and are interspersed with a shallow water garden. Yet another straight flight emerges at the parents' room. Ascending the

Left The living area culminates in a rear wall that is formed of small pebbles set in cement. Rainfall is permitted to descend into a shallow pool.

Right An open-riser staircase on the flank of the house gives access to the upper floors.

Far right The central lightwell is a modern interpretation of a traditional shophouse feature.

Below Slim saplings grow from the entrance lobby/kitchen through apertures in the roof.

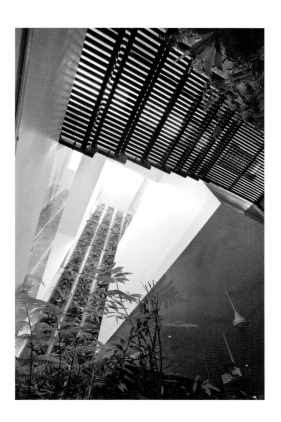

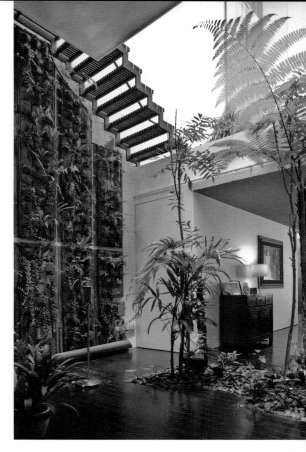

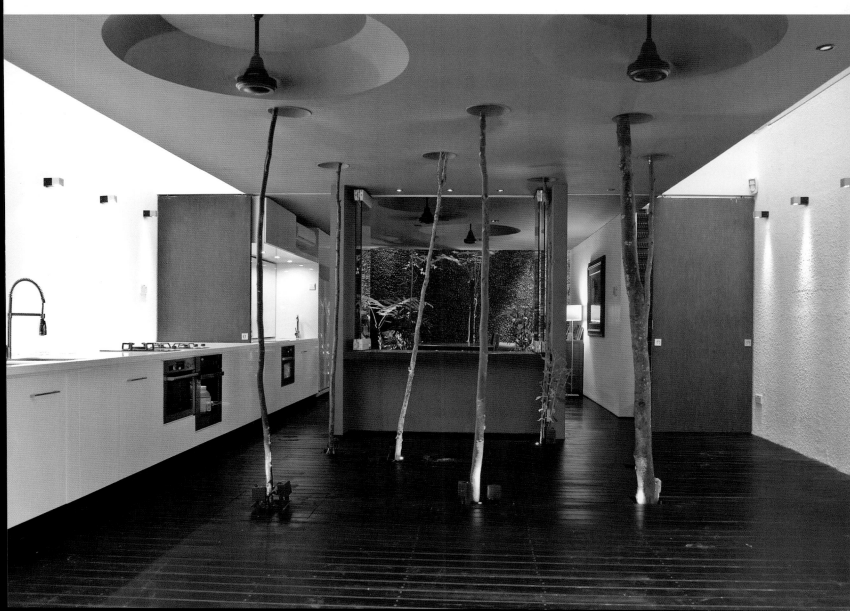

stair again brings one to another landing with rooms for the two youngest children. Between the two bedrooms is an open-to-sky lightwell that rises through all floors of the house to bring in daylight and natural ventilation.

Chang explains that 'The way the rooms/spaces are defined could have contributed to the congeniality of this house. There was a need for privacy for the couple and the children, but not total separateness. The parents' room has its opening towards the green walls, while it has a blank wall facing the eldest son's room. This was deliberate so that the son would not, consciously or subconsciously, feel that his parents were constantly watching him. The rooms of the other two children are on a level higher than the parents' room. The younger son's room, in particular, is suspended and seems to float in its own private realm. It is connected by a bridge to his sister's room.'

The insertion of a rooftop terrace for entertainment, together with a service area for laundry, is eminently sensible. The roof level is really the back of the house and yet it is also a great place to escape to; in the evening, there are cool breezes and a view over the neighbouring rooftops. Another ingenious piece of design is an electrically operated trellis mounted on rollers that can be moved over the lightwell. Creepers will be grown on this trellis to form a 'green canopy', effective as a sunshade.

The design is a brilliant reappraisal of one of the most basic of Singapore dwelling typologies. The house has a rational plan form with an underlying orthogonal grid, and yet there is a complex interweaving of spaces in section. Chang's 'upside down and inside out house' amounts to a major strategic rethinking of the terrace house, which is transformed into a cube floating inside a rectangular space.

Prompted to explain the departure from the norm, Chang explains: 'It could be a result of logical, pragmatic thinking to meet the clients' needs and a stringent budget; and an intuitive heart that sets out from the beginning to make this intermediate terrace house "less intermediate". Certainly, the clients' pro-eco stance and their preference to "live with nature" have greatly influenced the conceptualization of this house. The house was conceived as a three-dimensional landscape installation where the spaces and living areas were inserted. Green walls are an alternative to planting horizontally. In an intermediate terrace house setting, where one doesn't have the luxury of vast lawns, the "vertical forest" setting seems apt.'[1]

There is a genuine spirit of innovation in the design of this house that promises a successful career for its creator. Chang is deferential and respectful when discussing his work, yet it is apparent he has developed persistence, a necessary attribute for success in architecture. The house was the worthy winner of the 2008 Singapore Institute of Architects Design Award in the Single Residence Category.

[1] Chang Yong Ter, in e-mail correspondence with the author, 9 June 2008.

Right The open-riser staircase ascends in the narrow defile alongside the party wall.

2nd and 3rd right A bathroom and toilet are in close proximity to the vertical gardens.

Far right The central lightwell.

Below Vertical planting ascends the wall to the rear of the bed in the master bedroom.

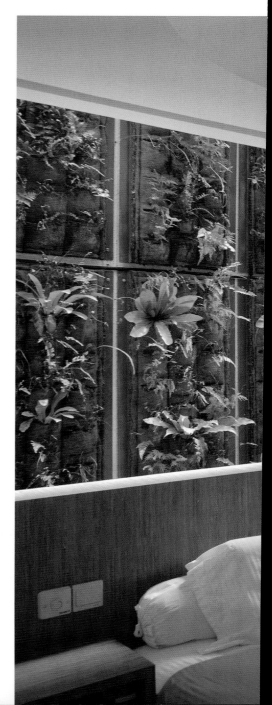

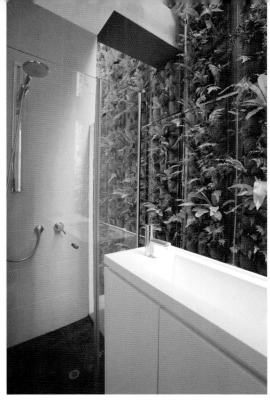

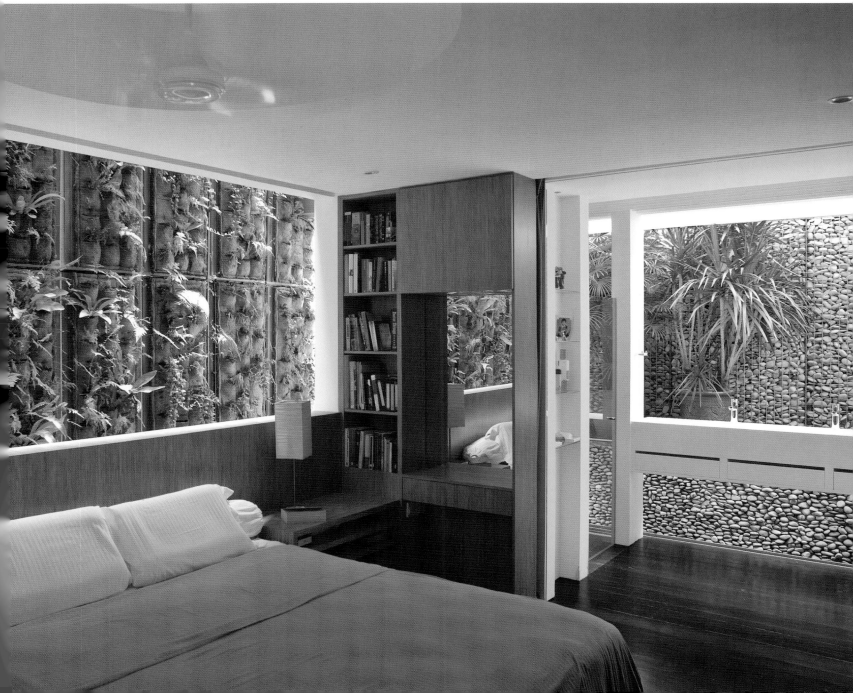

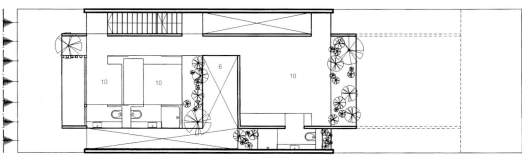

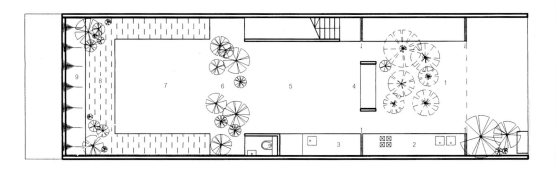

Key
1 Front park/Porch 6 Atrium
2 Wet kitchen 7 Living room
3 Dry kitchen 8 Pond
4 Casual dining area 9 Waterfall
5 Dining room 10 Bedroom

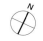

0 5 10 metres

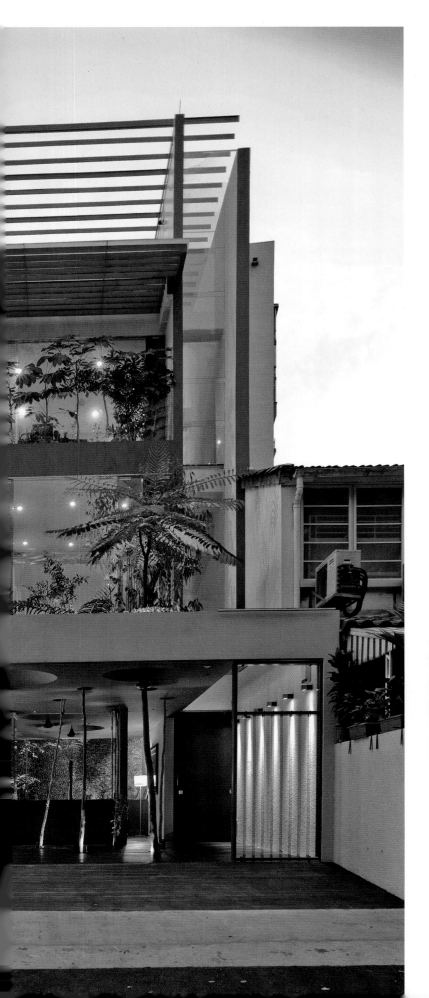

Opposite left Vertical gardens ascend the party walls.

Opposite right A stone path leads to the eldest son's room.

Opposite below First and third storey plans.

Left The façade reveals the design to be a total reinvention of the residential shophouse.

Below Daylight penetrates to the lower floors through the central lightwell.

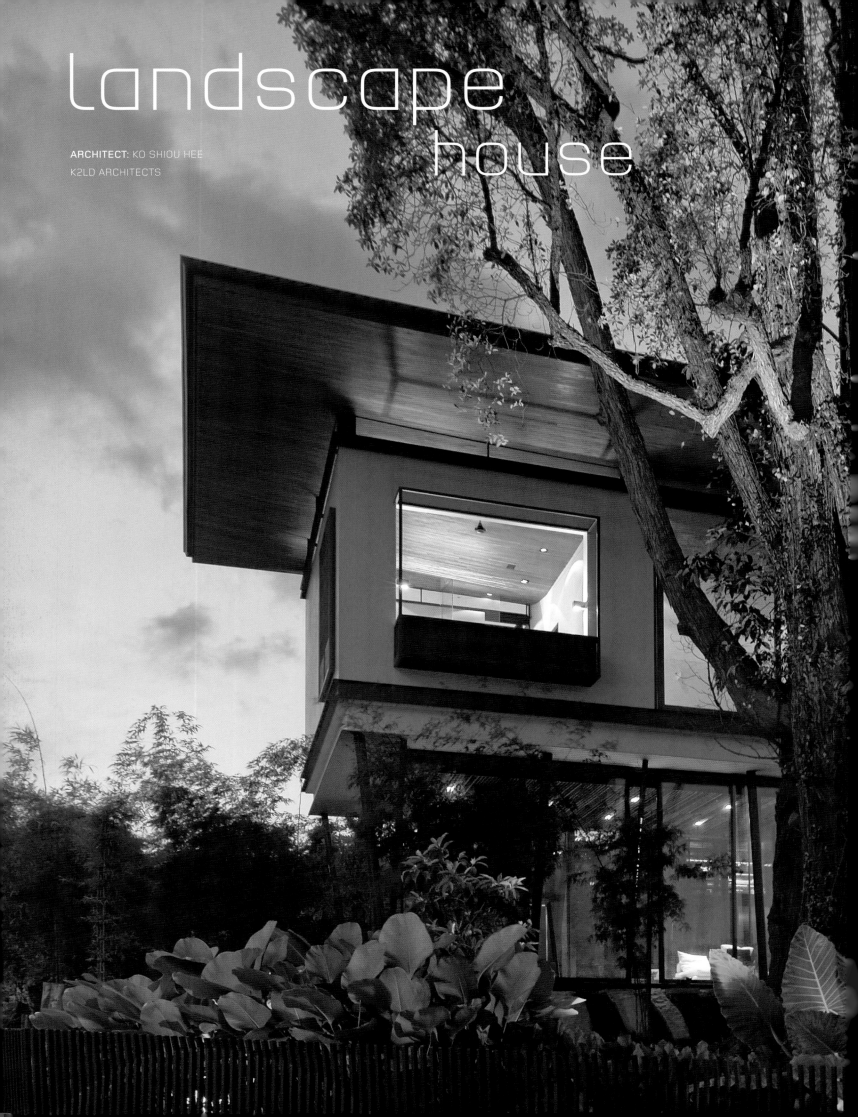

landscape
house

ARCHITECT: KO SHIOU HEE
K2LD ARCHITECTS

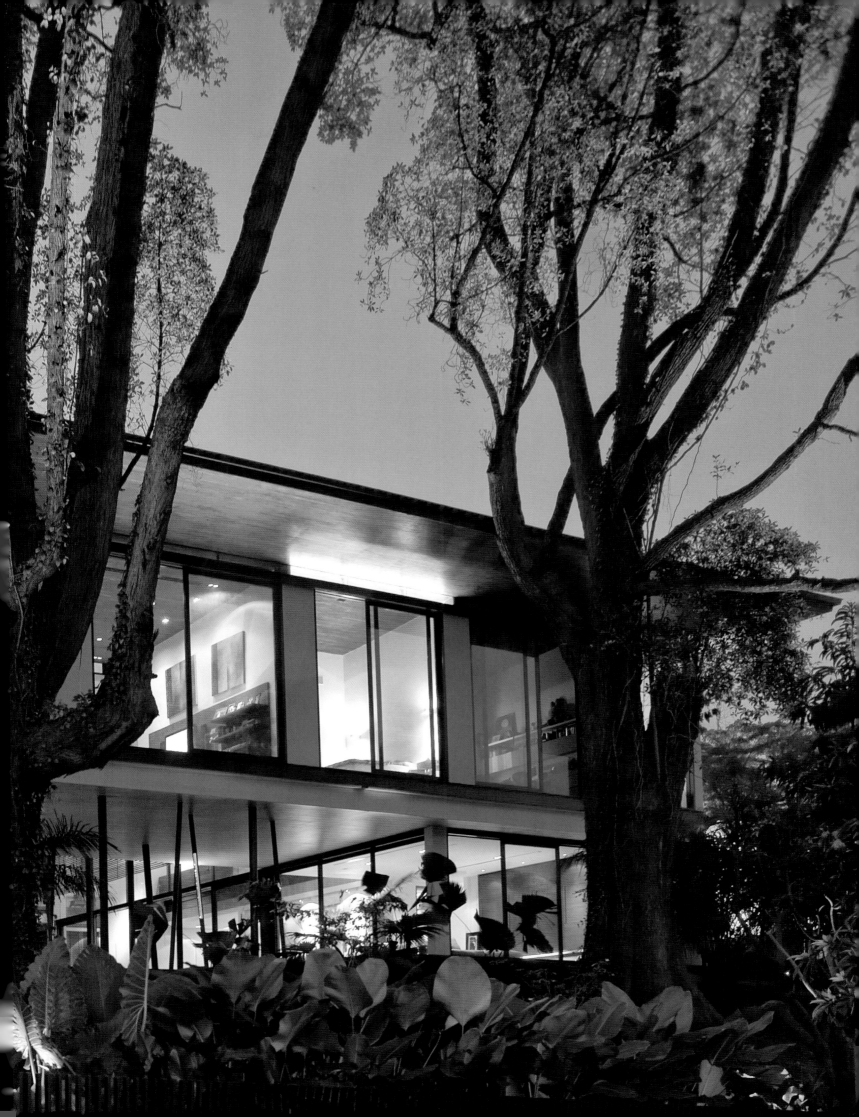

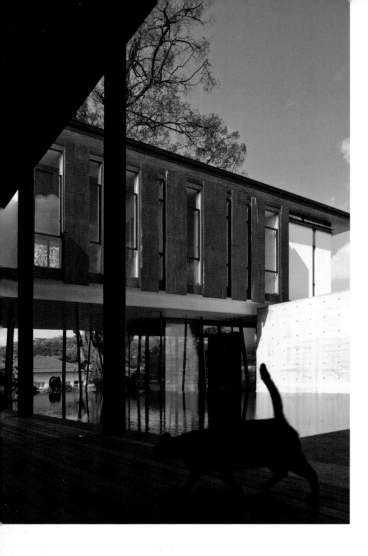

by two majestic Tembusu trees. An arborist determined that one other Tembusu had to be felled, allowing the main dwelling space on the second floor to pivot parallel to the remaining Tembusu, thus facing the north–south direction. The remnants of the demolished tree were fashioned into a sculptural artefact by artist Tony Twigg, while sawn timber from the tree was recycled as vertical cladding.

From a short driveway the house is entered via a dramatic staircase constructed from huge slabs of basalt stone from Fujian. At the head of the staircase, and immediately alongside the entrance door, is a giant Buddhist prayer wheel from Bhutan, commissioned by the owners. Recycled timber planks from a demolished house in Chiangmai are used for flooring, and circular columns from the same source are incorporated in a screen alongside the entrance. The grey stone 'skin' on the pavilion next to the entrance was painstakingly selected by the architect from a quarry in Xiamen. These materials and artefacts speak of the owners' deep interest in Asian cultures, as does the music pavilion where the principal instrument is an Indonesian *gamelan*.

The plan of the two-storey house is 'U'-shaped, embracing an infinity pool. The language employed is totally modern while incorporating traditional responses to the monsoon climate of Singapore. The living room, dining room and reception area open out to a broad terrace flanking the swimming pool. Yet, these spaces can also be enclosed and air conditioned, a necessary response to protect the extensive library of books arranged along an open gallery overlooking the main living space.

This is a house designed to suit the tropical climate – open and naturally ventilated during the cooler monsoon seasons or closed and air conditioned for the hot and humid period of the year. Its flexibility and blurred delineation means life takes place within the so-called 'in-between' space at the interface of the interior and exterior. With this underlying philosophy and the use of recycled components, the house is overwhelmingly sustainable – a key requirement of contemporary design.

The sensitivity towards texture and colour of the landscape influenced the expressive choice of a wide range of materials. While the large, precisely crafted double-glazed windows enhance the notion of transparency, the surgically fitted surface-weathered cut stone makes a powerful yet sensual balance. The chunky proportioned timber cladding and sunshade delicately weave in between, giving the surface more depth and shadow.

One other unusual feature that differentiates the design is the use of large sheets of Corten steel to clad the pool changing room/toilet facing the main road. The orange-red rusty metal is assembled with *wabi-sabi* imperfection and is

Ko Shiou Hee is a graduate of Rice University in Houston, Texas. He gained experience with Morphosis, Kohn Pederson Fox and I. M. Pei in the USA before working in Japan from 1991 to 1993. On his return to Singapore, he worked with A61 for five years, leaving in 2000 to set up K2LD. While in Japan, Ko was introduced, via the work of Hiroshi Hara, to the architecture and writing of Steven Holl. Holl's book, *On Phenomenology*, had a deep influence on Ko, and when I reviewed his work in 2000, he quoted a passage which seems relevant to the Landscape House.[1]

'Perception of architecture entails manifold relations of three fields: the foreground, middle ground and distant view are united in one experience as we observe and reflect while occupying a space. Merging of these fields of space brackets very different perceptions. In the intertwining of the larger space with its forms and proportions and the smaller scale of materials and details lies architectures power to exhilarate.'

Cluny Hill is an area of large mature trees and lush undergrowth. Shiou Hee opines that 'the stunning landscape called for a dwelling that would "disappear" into its surroundings'. He invokes an expression that is widely associated with Glenn Murcutt's houses in Australia, which drew upon the aboriginal view that dwellings 'must touch the ground lightly'.

The house is located in a prominent position on rising ground. It is highly visible yet set back from the road and flanked

Above The bedroom wing is carried on an array of slender, circular steel columns.

Right A dramatic double-height living room overlooks the swimming pool terrace.

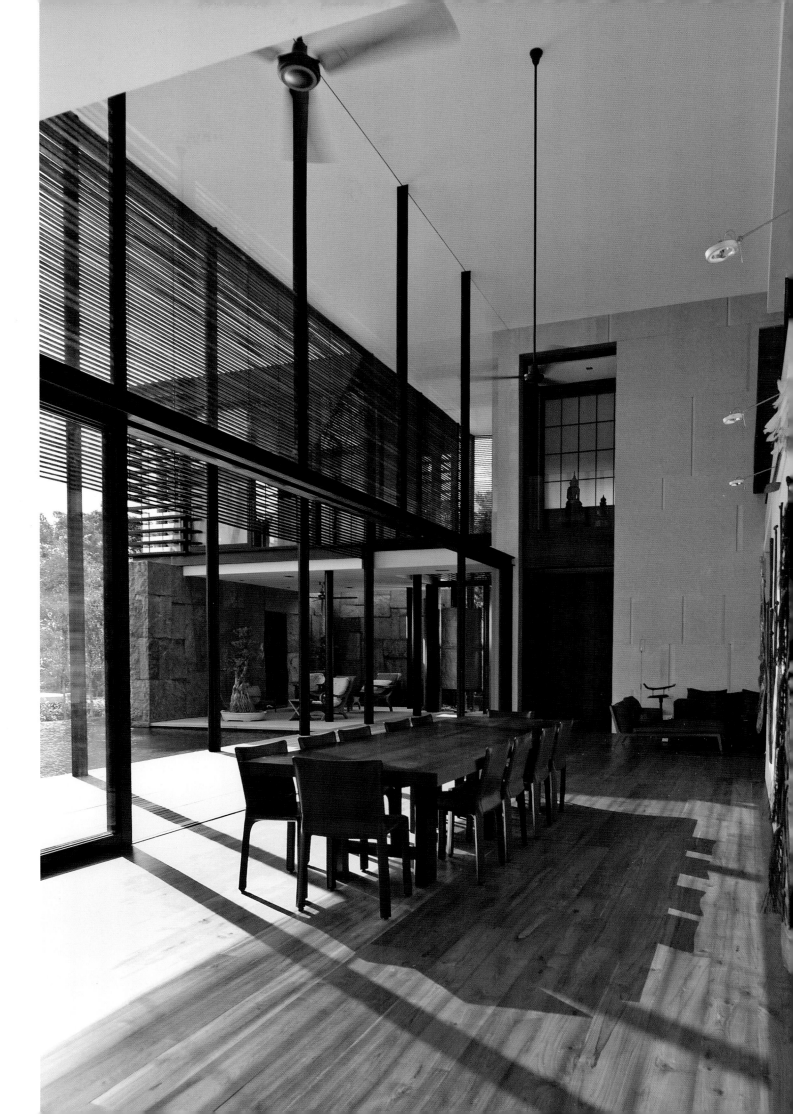

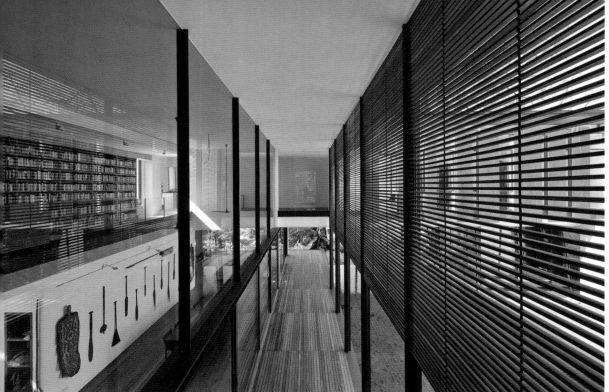

remarkably attractive. The colour is very much in harmony with nature. Seemingly randomly located slender, circular steel columns support the bedroom wing, simulating, to some extent, a grove of bamboo and integrating benignly into the landscape.

Alongside the *gamelan* room is an informal 'performance space', with a white-walled backcloth, that can be viewed across the infinity pool from the living room terrace. This space instantly summons up visions of *wayang kulit*, the shadow play performances of Indonesia.

A unique feature, certainly for Singapore, is the incorporation, on the rear façade of the house, of a six-metre-high climbing wall. The house, says Ko Shiou Hee, was intended to have 'an elusive edge. It is a collage of planes and volumes.' Transition is defined with changes in floor level. The ground floor is a series of transparent, interconnected spaces that flow easily from interior to exterior. The more private spaces of the house are lifted to treetop level supported on planes and slender, circular, inclined columns that merge with the landscape. 'The project,' explains Ko, 'explores the theme of visual and phenomenal transparency, through strategic spatial organization and abstraction of form and materials.'

The notion of phenomenology continues to be central to Ko Shiou Hee's architecture. The Landscape House is a wonderful tactile design and there is a growing maturity in the architect's work. In this instance, a capable assistant architect – Kee Jin Zhi – aided Ko. For the architectural critic, the house appears to be perfectly 'tailored' to the specific requirements of the owners, with the incorporation of multiple programmes.

[1] Robert Powell, 'Space, Light and Materiality', *SPACE*, No. 1, Singapore: Panpac Media, March 2001, pp. 76–81..

Above An extensive library occupies the gallery overlooking the dining and living area.

Opposite top left Asian artefacts are displayed against white walls with sensitive natural lighting.

Opposite top centre An off-form concrete wall forms a backcloth for informal performances.

Opposite top right A projecting window in the master bedroom frames a giant Tembusu tree.

Right Traditional implements from all over Asia adorn the walls of the dining room.

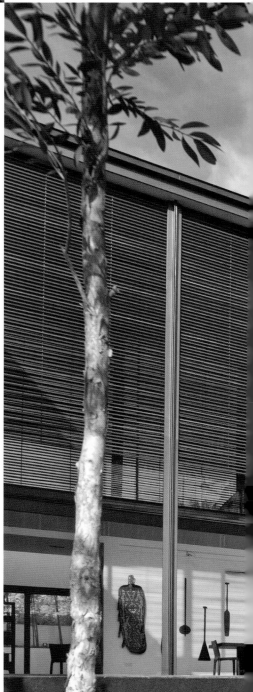

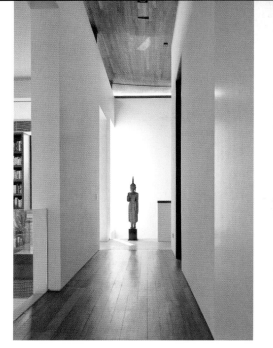
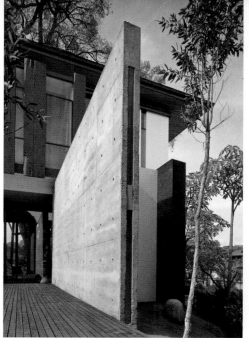
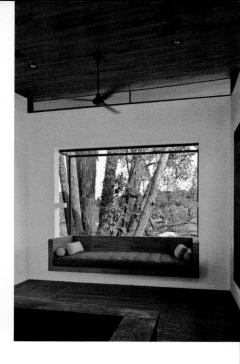
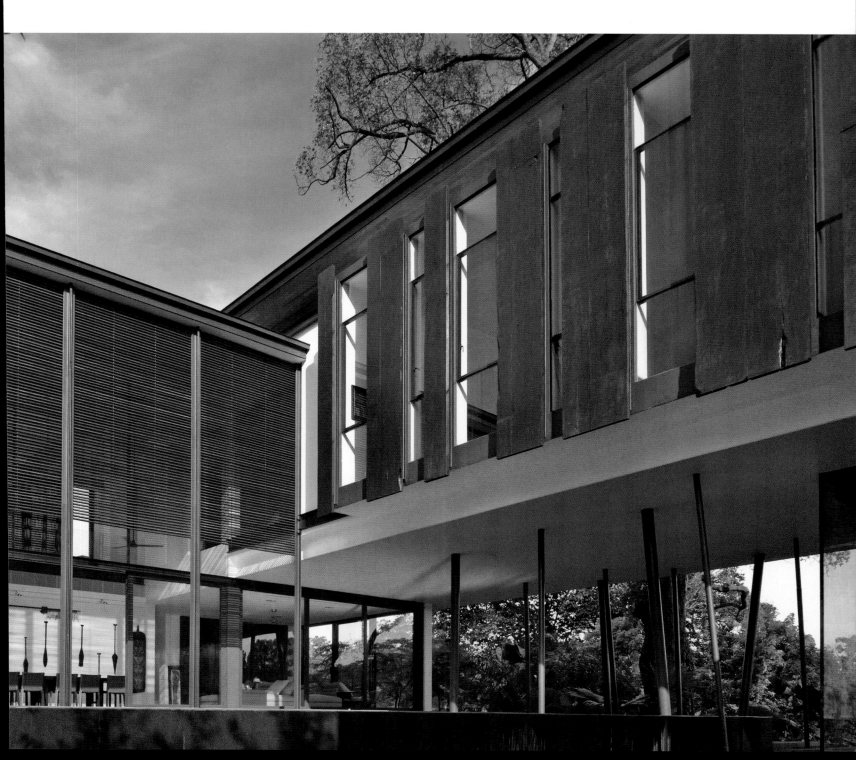

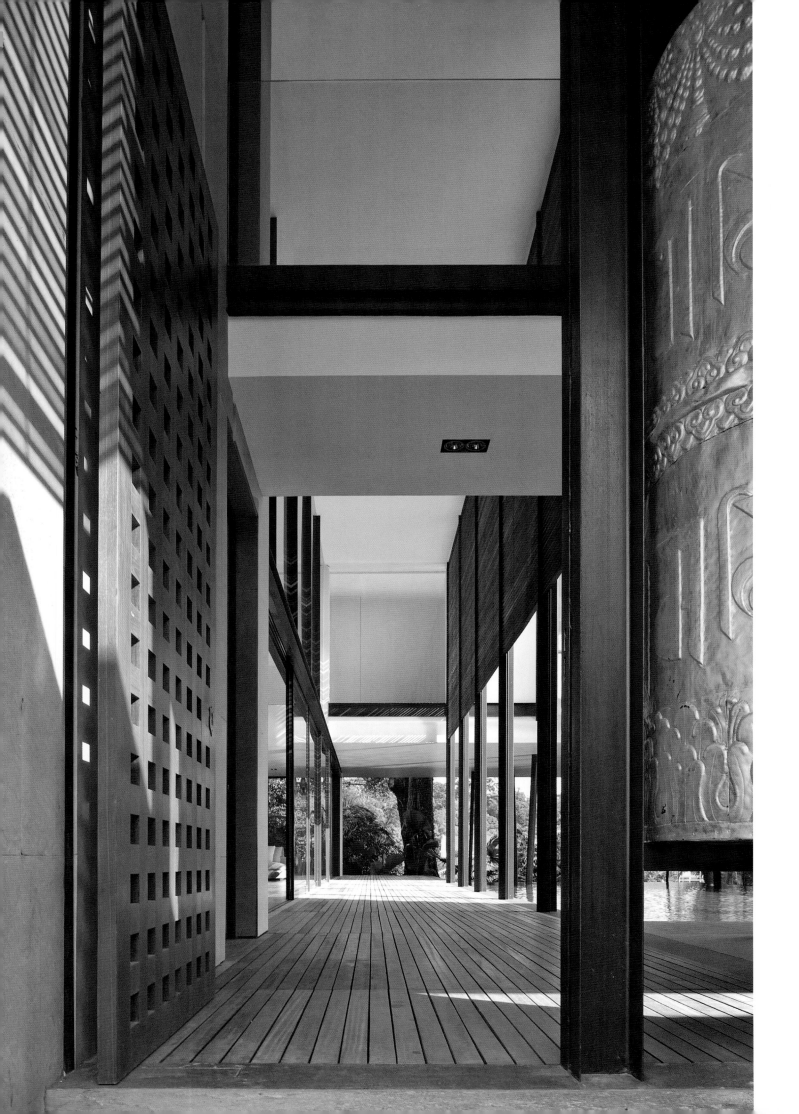

Left A giant prayer wheel from Bhutan flanks the entrance to the house.

Right Large slabs of grey stone from Xiamen are used to clad the pavilion alongside the entrance.

Far right Corten steel is used to clad the pool changing room.

Below The swimming pool deck viewed from the undercroft of the bedroom wing

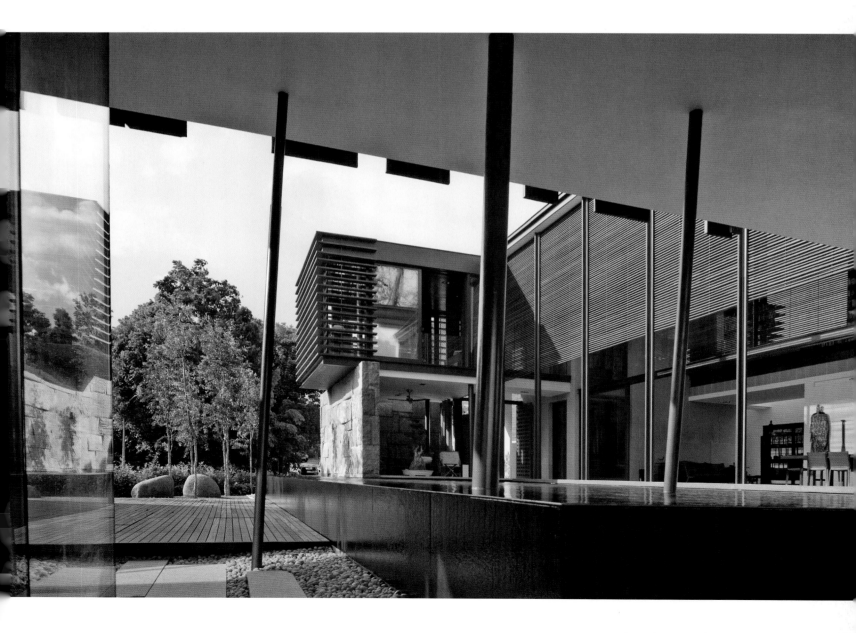

Key
1 Dining room
2 Dry kitchen
3 Wet kitchen
4 Library
5 Corridor
6 Swimming pool
7 Pool deck
8 Pool bath

0 5 10 metres

Above The section indicates the dining room and terrace overlooking the swimming pool.

Right The designer's intention was that the house should 'disappear' into the landscape.

Below The white concrete wall of the pool changing room defines an outdoor performance space.

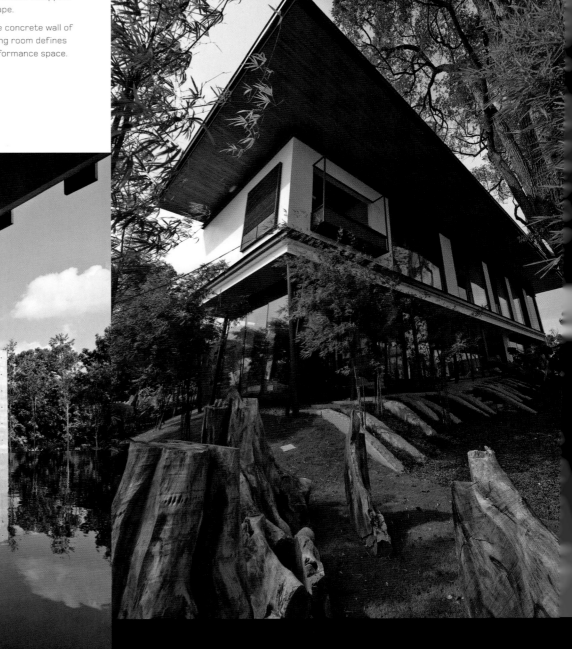

Left At the rear of the house is a six-metre-high climbing wall.

Above Huge slabs of basalt stone from Fujian feature in a dramatic entrance stair.

Below Two huge Tembusu trees form a backdrop to the house.

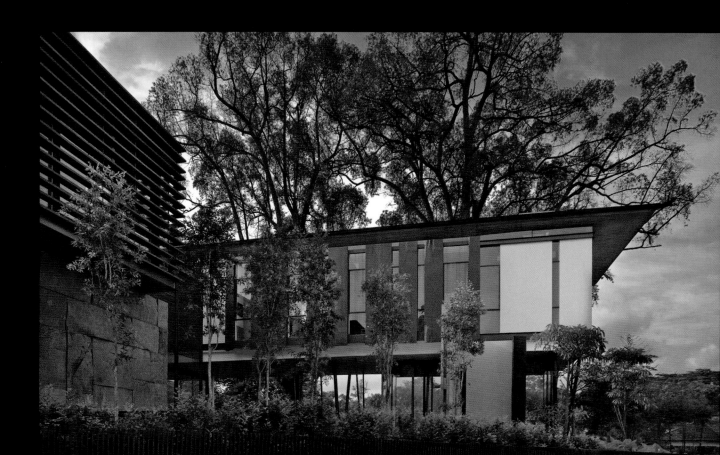

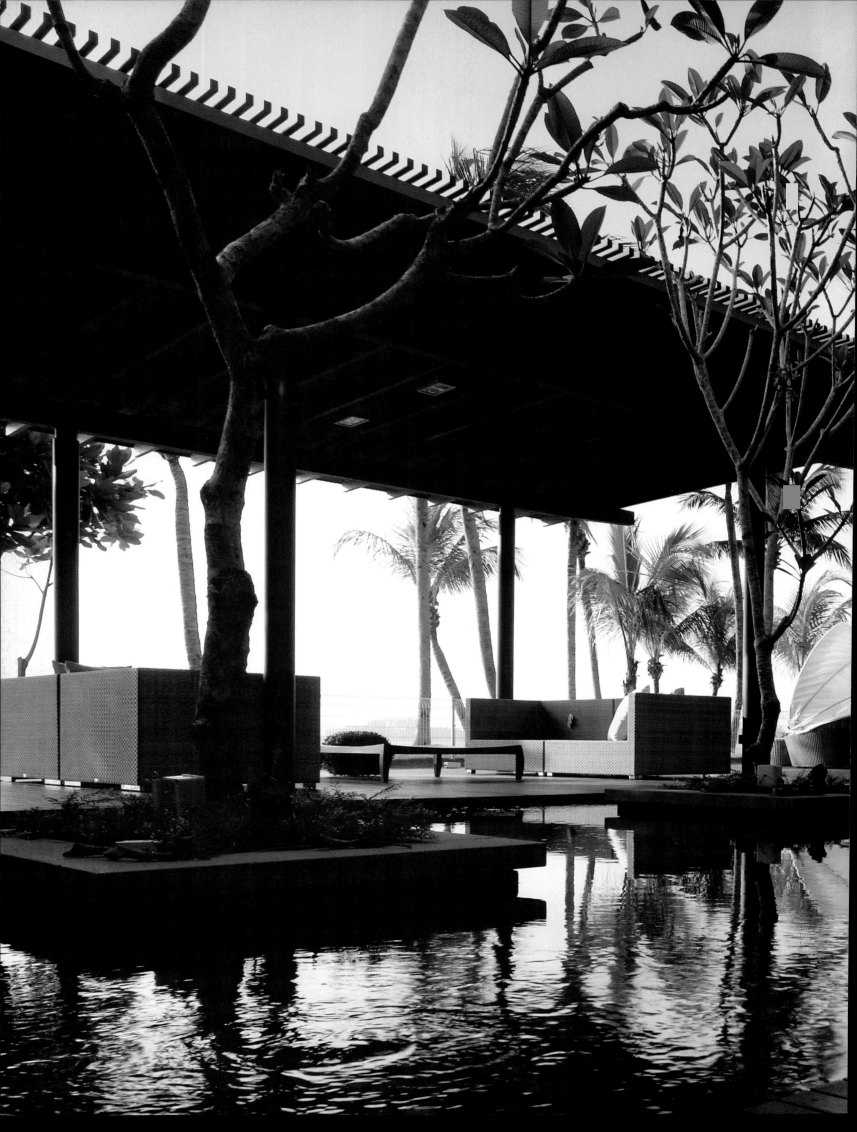

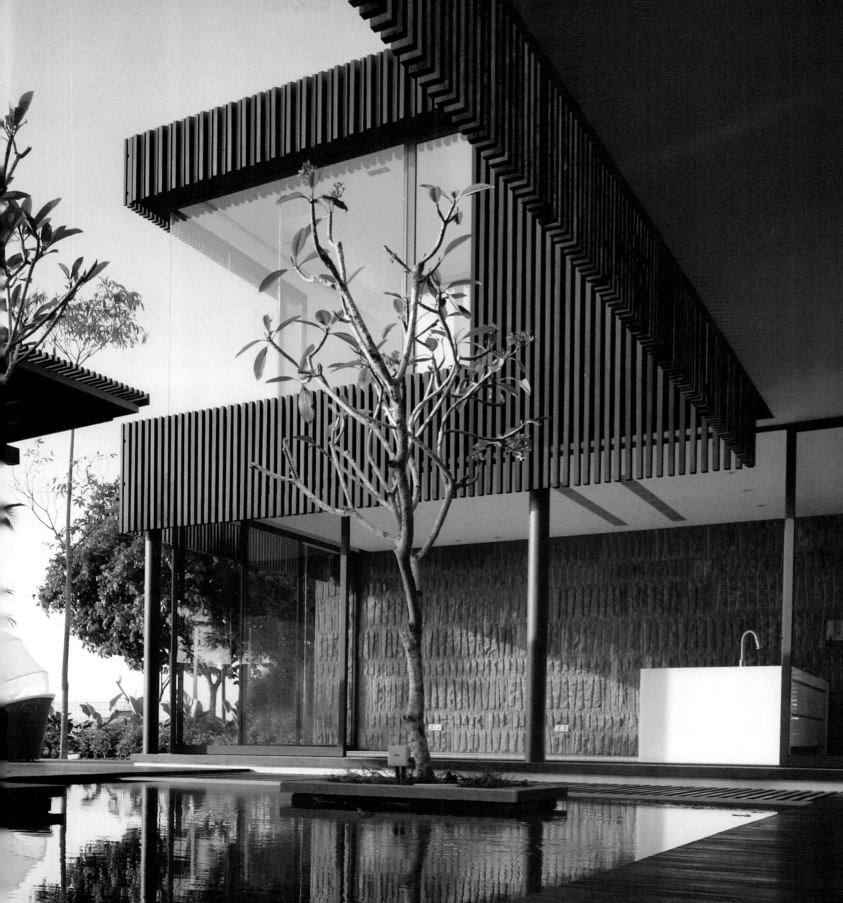

ARCHITECT: CHAN SOO KHIAN
SCDA ARCHITECTS

House 229

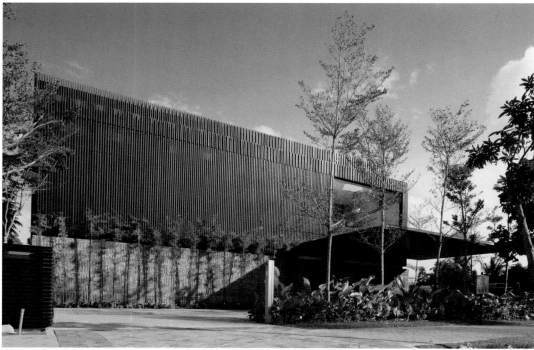

Born and raised in Penang, Chan Soo Khian received his architectural training at Washington and Yale universities. Against a backdrop of diverse design philosophies at Yale's School of Art and Architecture, Chan set out to acquire a grounding in classicism. It was the classical language of architecture that was to significantly influence his development as an architect. It was also a focus from which he went on to appreciate the works of the modern masters. Two art galleries at Yale by Louis Kahn were a point of reference for him to develop a structural and spatial vocabulary – a language of volumes and planes enhanced by light and structural order.

Chan worked as an intern with Kohn Pederson Fox in the USA before returning to Asia where he joined A61 Architects in Singapore, leaving to set up his own design studio in 1995. Two years later, he established SCDA Architects, and the practice has subsequently established a reputation for designing buildings that explore a modern language rooted in the Southeast Asian context.

House 229 is a compactly planned weekend retreat at Sentosa Cove, which looks southeast towards the island of Kusu, with its celebrated Taoist Temple dedicated to Tua Pek Kong, and beyond to Pulau Bintang and the northern fringe of the Indonesian archipelago. The 'L'-shaped plan embraces a landscaped courtyard with a reflecting pool, frangipani trees and a flat-roofed pavilion. Beyond, a palm tree-lined pedestrian path and cycle way lie between the house and the ocean.

Underlying the plan and section of the house is the notion of duality. This is first evident in the contradictory nature of the northwest and southeast elevations. The public façade is closed and 'secure' with a rough-textured masonry wall

Above The public façade is closed and secure with vertical timber cladding above a rough texture masonry wall.

Opposite top left Daylight filters through a pergola to a subterranean court.

Opposite top right The pavilion looks out to the island of Kusu and beyond to Pulau Bintang.

Right The open-sided pavilion enjoys an exhilarating waterside location.

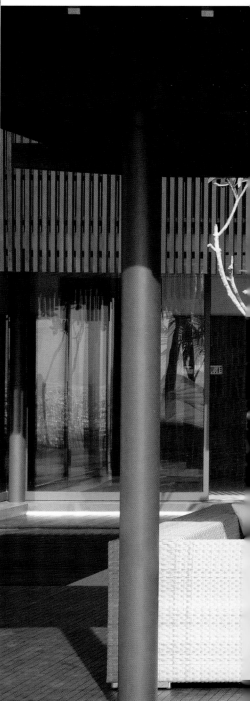

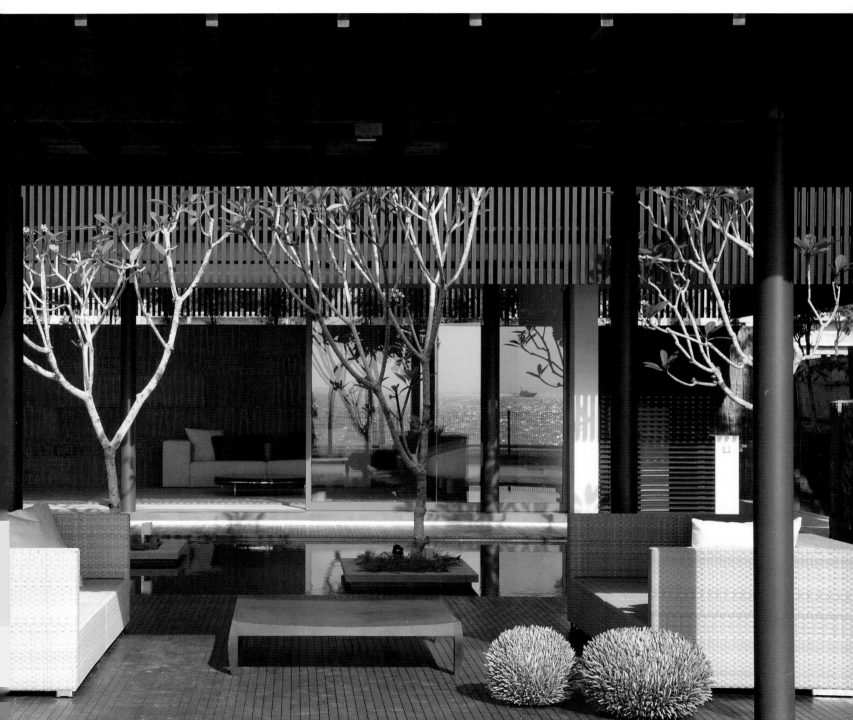

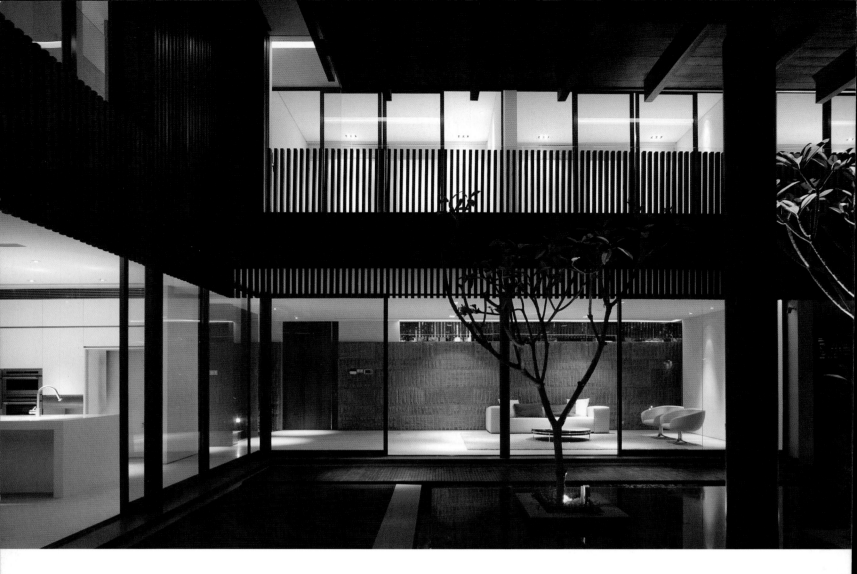

with narrow glazing 'slots' facing Ocean Drive, whereas the private façade is open and transparent, giving a panoramic vista of the shipping lanes and anchorage. Fronting the house is a flat-roofed carport entered from a short drive.

The duality is also evident in the layout, where the first storey is conceptualized as a single open space. The living room, dining area and kitchen coalesce and look into the courtyard and beyond to the ocean. In sharp contrast, the second storey, containing four bedrooms, each with an *en suite* bathroom, is a compartmentalized, box-like container with incised windows that cantilevers over the lower structure. There is also a subterranean basement with a ground-level lightwell illuminating the guest bedroom and gym.

Duality is further evident in the cladding system. A veil of vertical timber louvres wraps around the second storey and monopitched roof. By day, the louvres appear as a dark, almost impenetrable shroud, but at night, with the rooms illuminated within, the effect is akin to a magical lantern.

The selection of materials and meticulous attention to orchestrating movement through space, coupled with the introduction of daylight, highlights the modern sensibility brought to this reinterpretation of a seafront residence in the tropics.

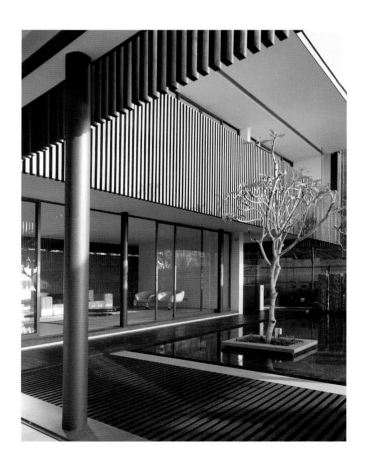

Left At night, the house has the appearance of a magical lantern.

Opposite below The enclosed second storey contrasts with the transparency of the first storey.

Right First storey plan.

Below The house presents an open façade to the coastal pedestrian and cycle path.

Key
1 Entrance driveway
2 Carport
3 Living room
4 Dry kitchen
5 Dining area
6 Reflecting pool
7 Outdoor pavilion

0 5 10 metres

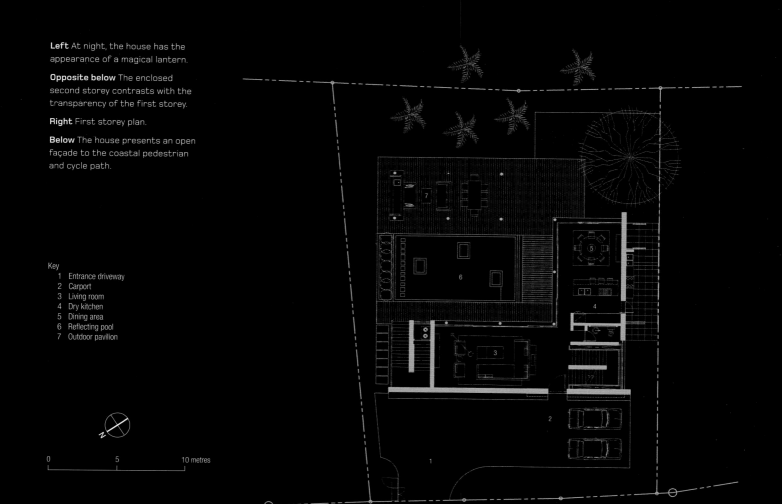

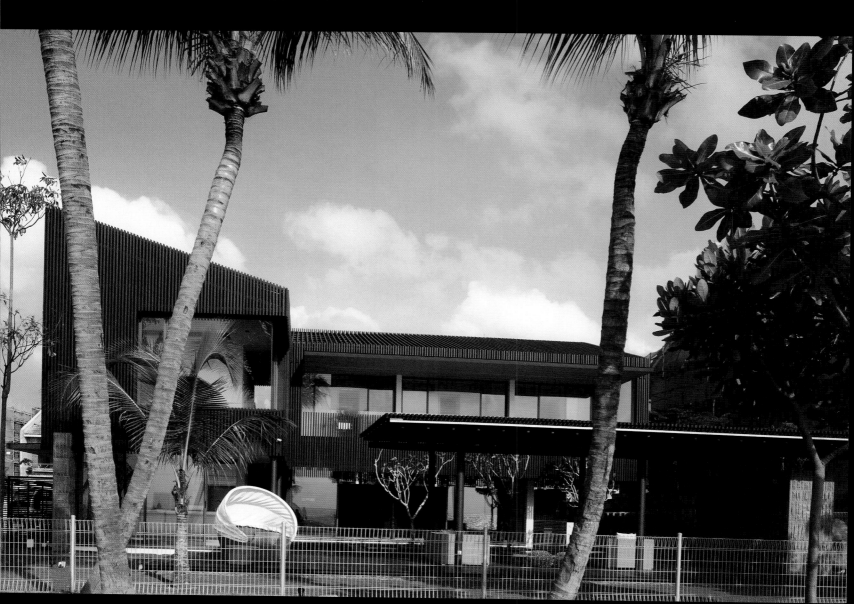

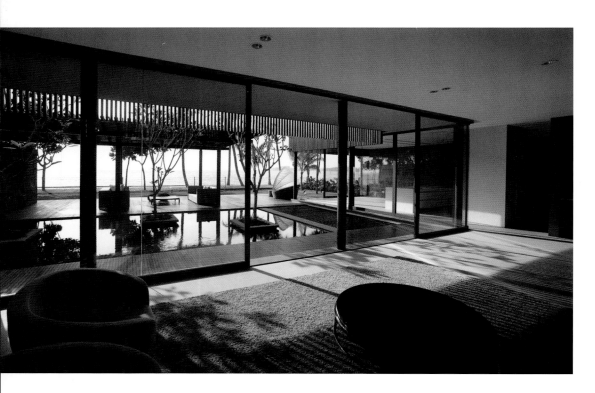

Left The seafront residence is planned around a rectangular pool court.

Below The dining room (left) projects forward and enjoys views of the sea.

Right A powder room.

Far right The second storey is enclosed in a veil of vertical timber slats.

Opposite below Second storey plan.

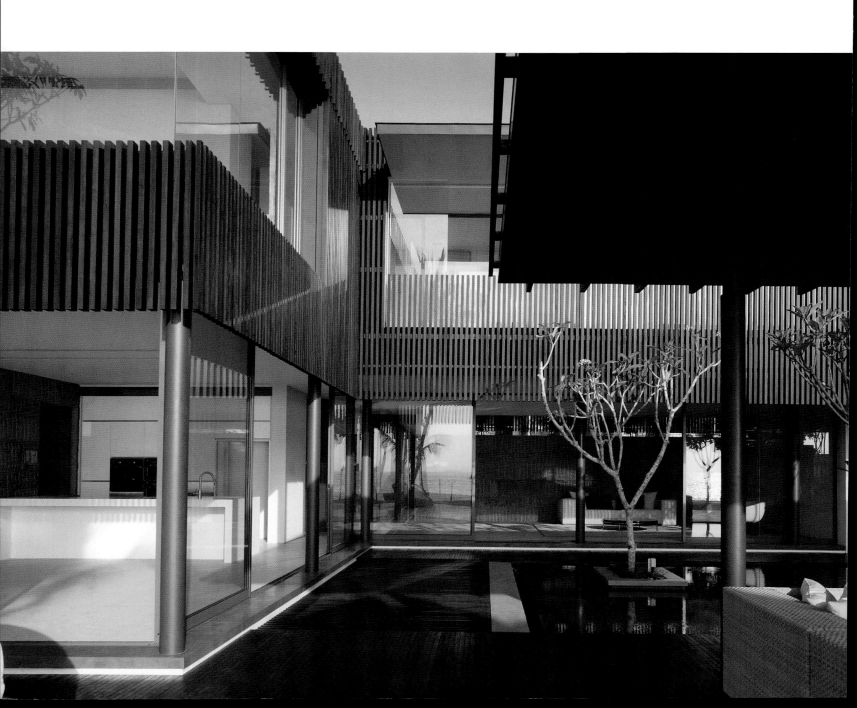

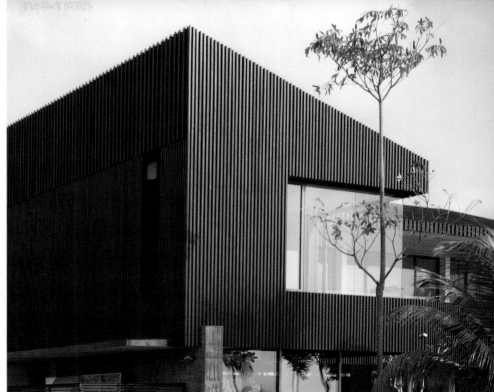

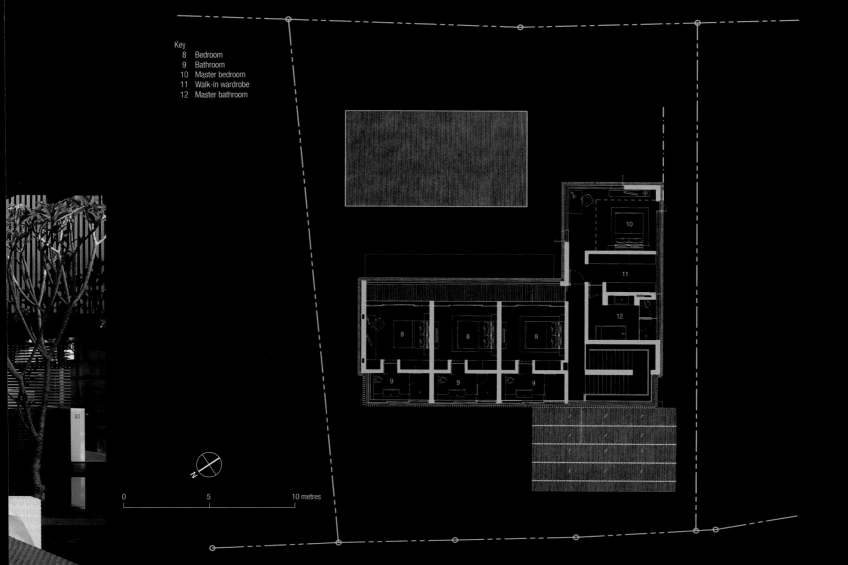

Key
8 Bedroom
9 Bathroom
10 Master bedroom
11 Walk-in wardrobe
12 Master bathroom

0 5 10 metres

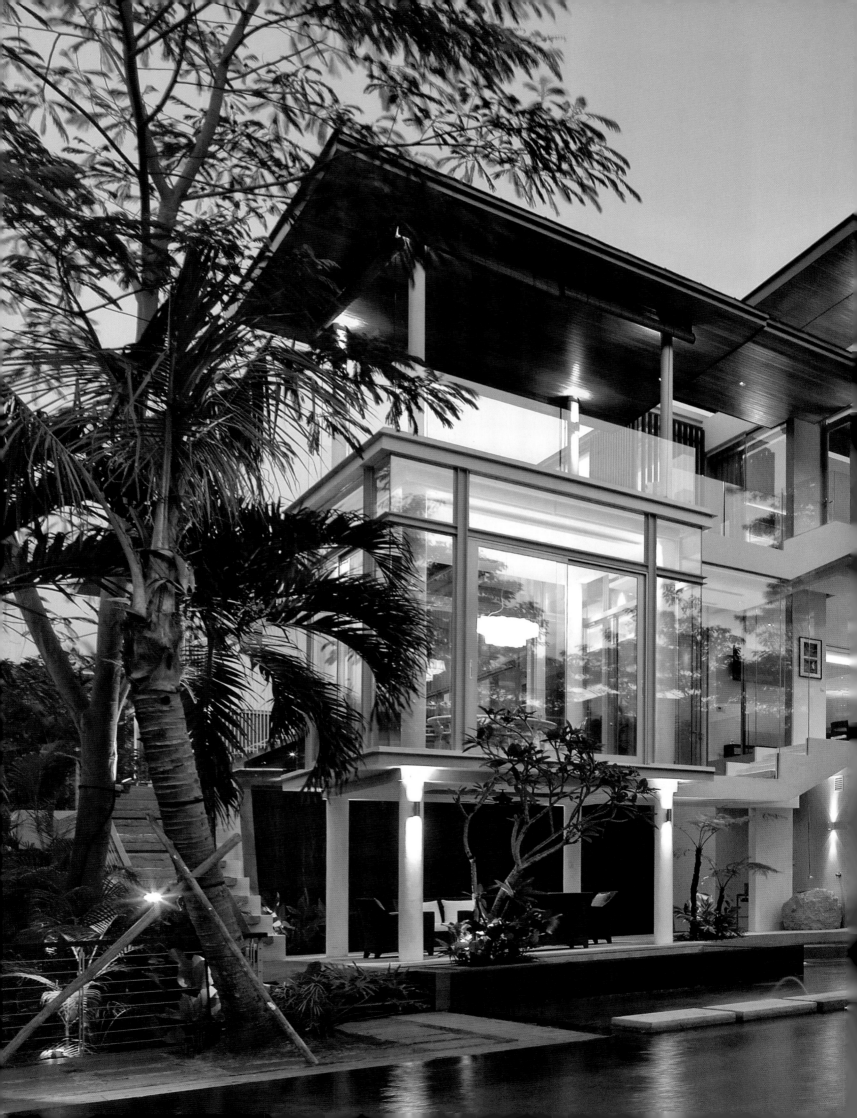

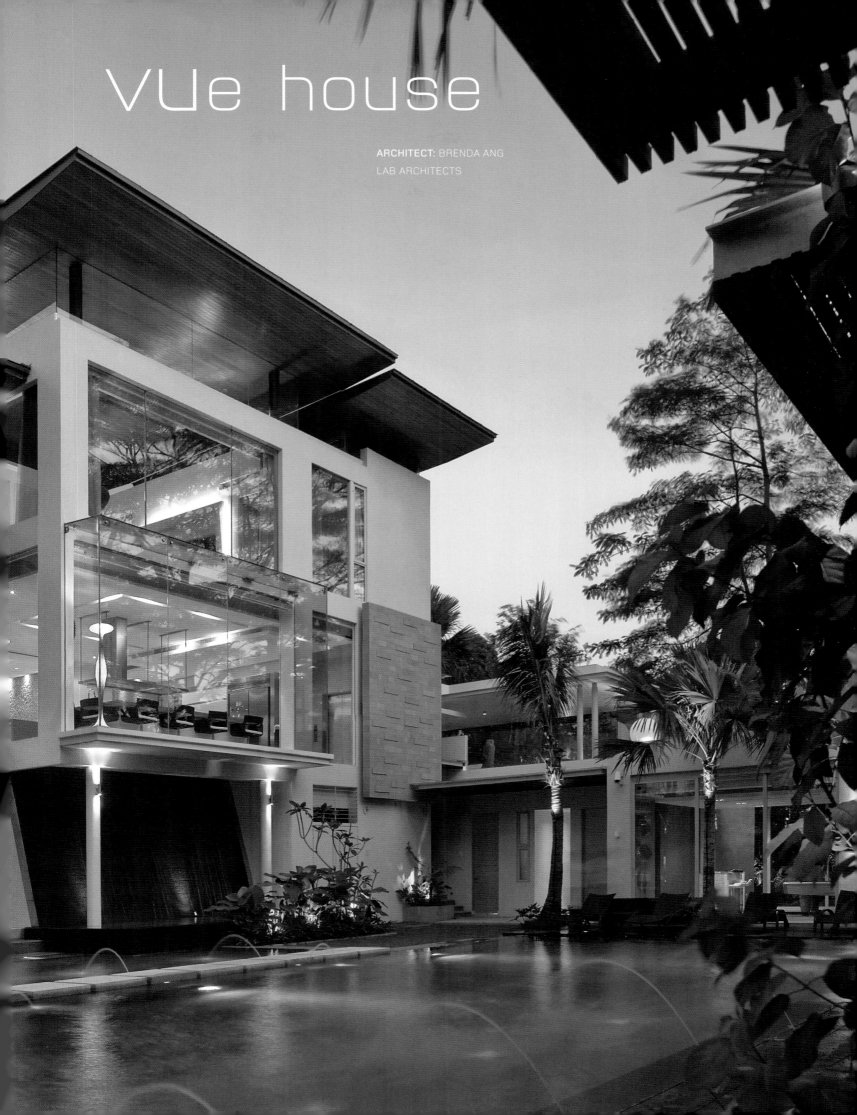

vUe house

ARCHITECT: BRENDA ANG
LAB ARCHITECTS

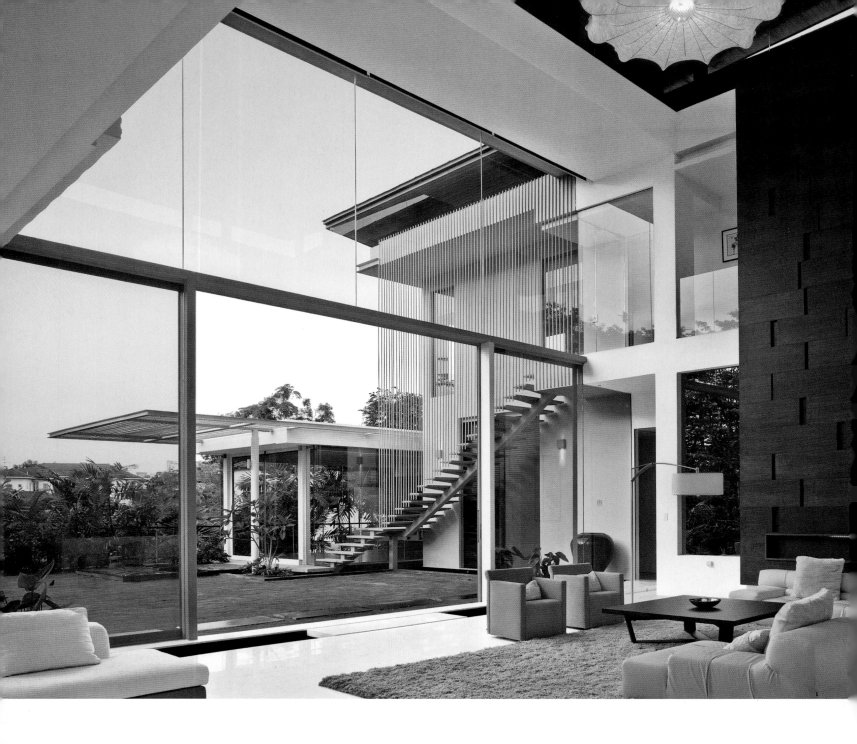

Brenda Ang graduated from the School of Architecture at the National University of Singapore in 1994. Like Mok Wei Wei, Randy Chan and Chang Yong Ter, whose work is also published in this book, the influential academic Pinna Indorf mentored her in her final year. She credits Associate Professor Indorf and the author of this book with exposing her to different cultures and encouraging her to assimilate them with an open mind. Louis Khan and Balkrishna V. Doshi are architects whose work she aspires to emulate, and she also follows with interest the output of Jean Nouvel, Rem Koolhaas and Norman Foster.

Ang worked with several companies, including DP Architects, after completing her studies and gained experience on projects such as the Laguna Golf Club and the homes for directors of multinational companies in addition to resorts

in Indonesia and China. In 2002, she moved on to set up LAB Architects with Bob Aw under the umbrella of the multi-disciplinary firm AEP Design (S) Pte Ltd.

The VUe House is one of a series of remarkably assured designs by this relatively young architect. The house is a large dwelling but the architect has skilfully welded together rich and contrasting milieus as settings for everyday life, and in the process imparted a sense of intimacy. Elements of an older house on the site have been incorporated into the plan.

The house has a coherent 'E'-shaped plan on a site that descends sharply from east to west. The principal spine, connecting all parts of the house, is arranged parallel to the southern boundary and projects northwards. Attached to the spine is a central core with parallel east and west wings. Several flat-roofed elements in the plan have green roofs.

The plan is arranged to create visual connections between the various parts of the dwelling. There are different viewpoints from which to perceive the house as it gradually unfolds. The façade facing the public road is relatively impermeable, while the private, north-facing elevation is more open and transparent. Despite the expanse of glass on the northern elevation, the house is cool internally.

The house form embraces two large courts of contrasting character. The eastern court, at the upper level, is landscaped with turf and plants. It is an open extension of the living/reception space and allows family and guests to spill out into the garden in the evening.

In complete contrast, the lower court at the western end of the site is a magical space filled with water and lush vegetation. Timber decks, pergolas and pavilions encompass a glittering blue-green swimming pool and a smaller child's pool with gushing fountains, waterfalls and *koi* ponds, reminiscent of a Balinese water court. There is an element of surprise as one moves from the upper court to the lower level. Forest reserve land on the western boundary appears to extend the length of the garden.

Above The principal living space opens out to a grassy court.

Right The two-storey living area is a surprisingly intimate space.

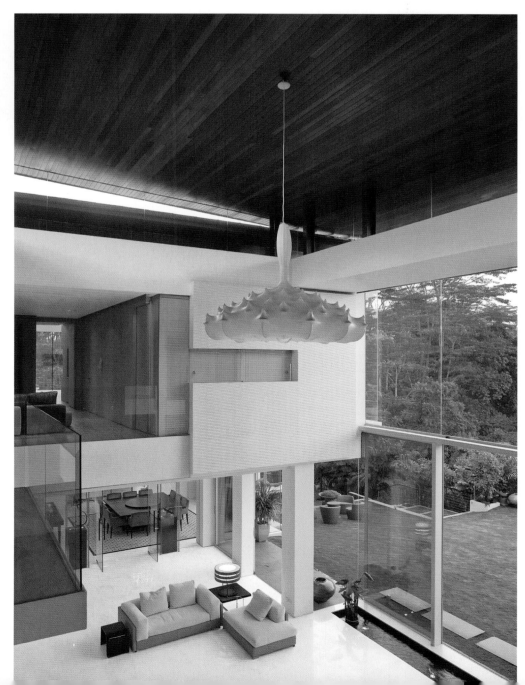

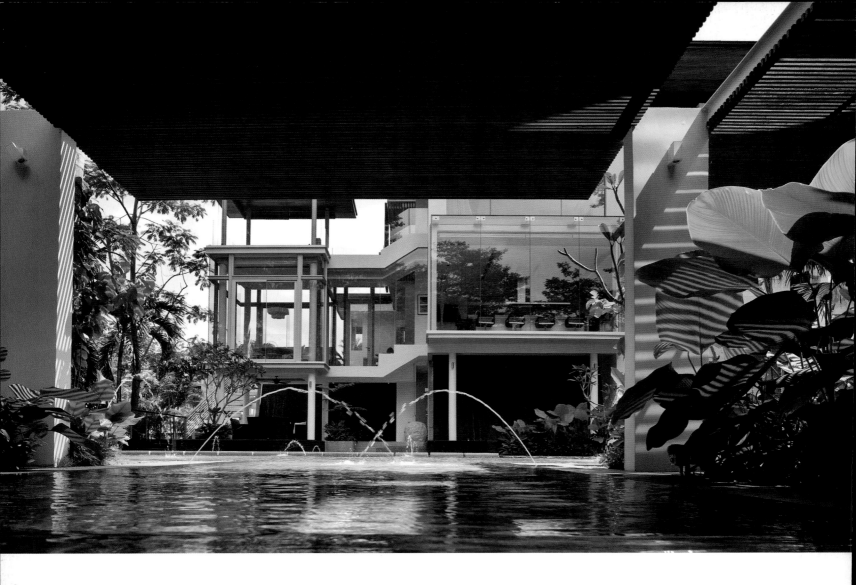

At the heart of the house is a state-of-the-art open-plan kitchen. The owner is happiest when entertaining on a grand scale, and guests are invited to join him at a splendid U-shaped table that surrounds the purpose-designed cooking range. Thus seated, they are able to witness the preparation of their meal and to converse with the 'chef'. From this vantage point he is also able to survey the entrance to the house, the reception area and the patio of his son's dwelling across the western water court. The house is keyless and fully biometric, with automated lighting, security, sound and music. A centrally located elevator ensures that the house caters for access for the elderly.

Projecting north from the kitchen is a glass pavilion for informal family dining. From this vantage point there are views down to the water court and back across the garden court to the living area. The living room itself is a high-ceilinged space overlooked on two sides by a broad gallery at second storey. Double-height windows look north to the landscaped court, and at the very centre of the room is a modern, eye-catching chandelier. The architect has done well to create an intimate atmosphere within such a large volume while composing a series of shifting viewpoints. An open staircase on the south side of the room creates a dramatic vertical link to the upper level where the family room is located.

Located at the western extremity of the site is the semi-independent dwelling of one of the owner's sons. Physically connected to the main house via the gym, or accessed across a turfed roof garden, privacy is achieved. At the same time, the son is closely linked to his parents and in visual contact. The ancillary dwelling has direct access to the water court and the poolside pavilion.

The house is one of several featured in this book that skilfully accommodate an extended family. It is a trend that appears to be flourishing in Singapore where land costs are rising all the time and where bringing a family together on one site makes sound economic sense, in addition to the benefit of strengthening family ties.

Ang is now much in demand. LAB Architects have completed a master plan for a town in Oman consisting of condominium apartments, villas, retail premises, and theme parks. She is also working in Brunei and China on both commercial and residential projects.

Above Dinner guests look over a Balinese-style water court.

Opposite top First storey plan indicating an 'E'-shaped plan with two north-facing courtyards.

Right At the heart of the plan is the owner's pride and joy – a cooking range surrounded on three sides by seating for ten dinner guests.

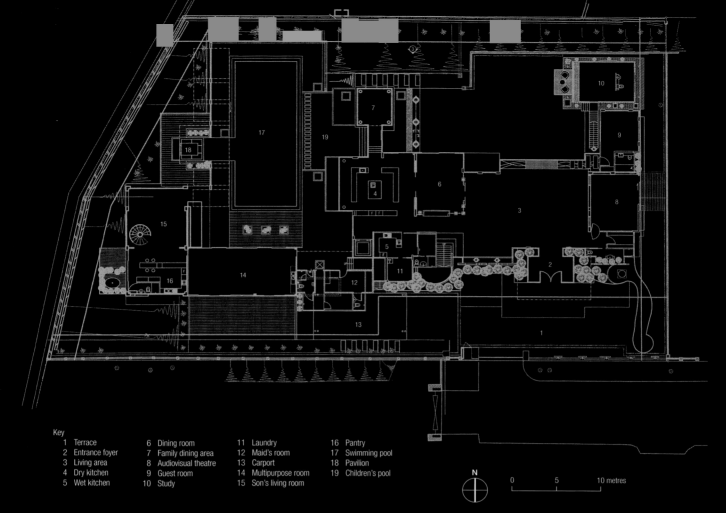

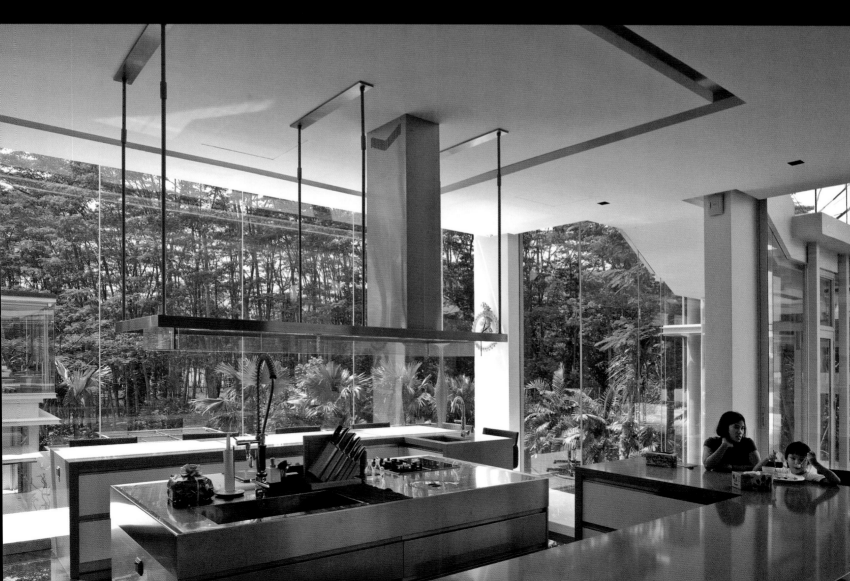

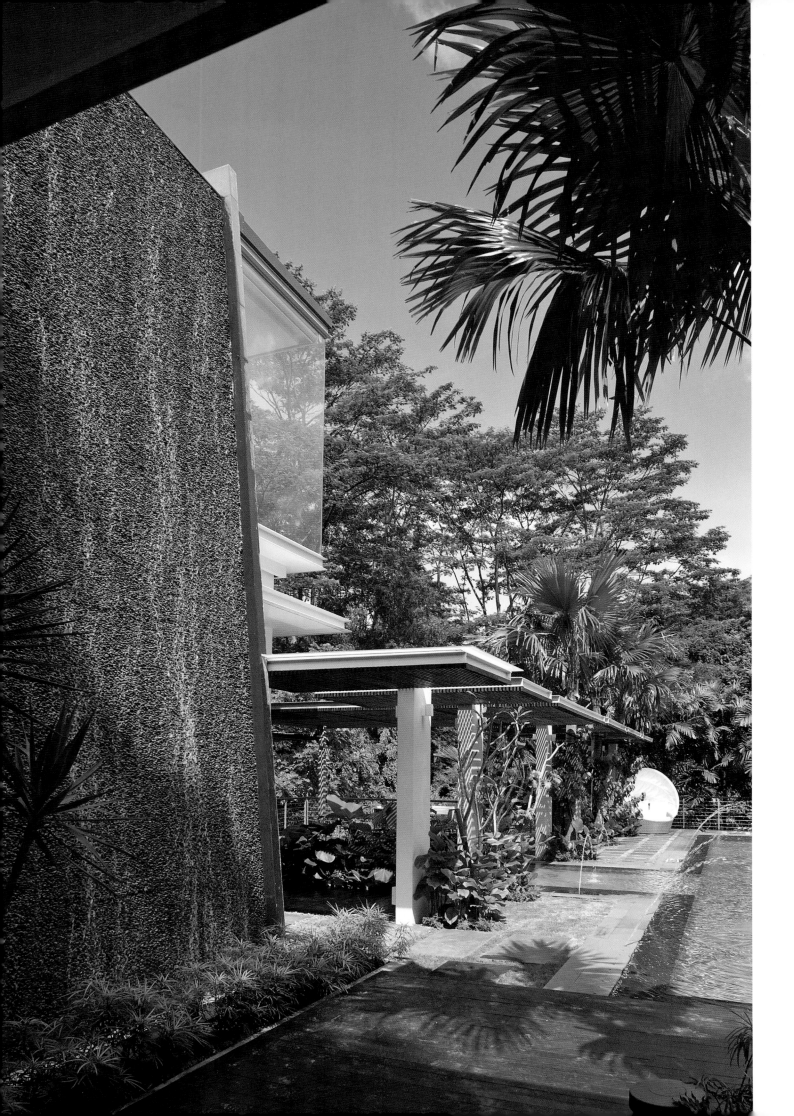

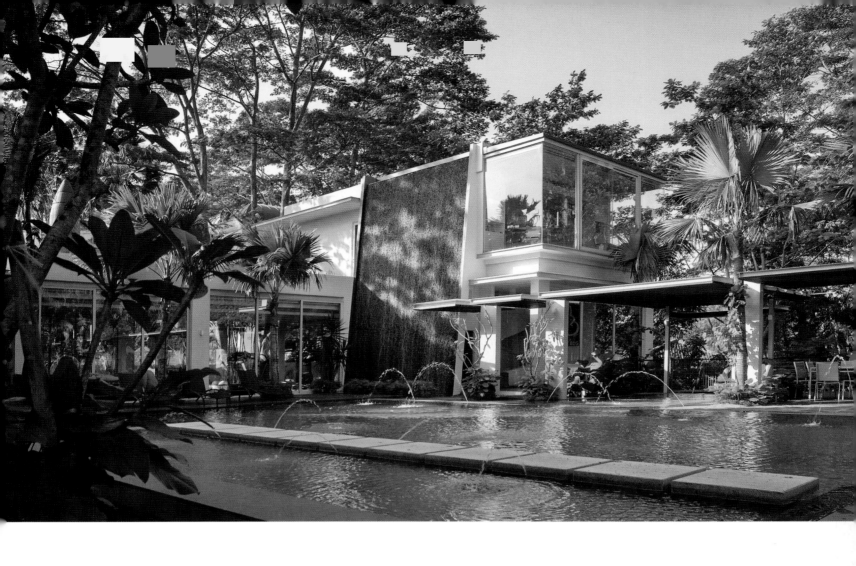

Opposite A waterfall, numerous fountains and pavilions create a resort-like ambience.

Above An annex occupied by the owner's son is attached to the main house and shares the pool.

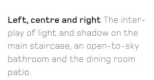

Left, centre and right The interplay of light and shadow on the main staircase, an open-to-sky bathroom and the dining room patio.

Key
20 Master bedroom
21 Master bathroom
22 Bedroom
23 Playroom
24 Family area
25 Library
26 Son's bedroom
27 Roof garden
28 Games room
29 Roof terrace

N

0 5 10 metres

Opposite top The public façade is relatively closed, with little evidence of the openness of the interior.

Opposite bottom Second storey plan.

Right and far right Detail of the family dining pavilion overlooking the water court

Below left The entrance lobby viewed from the portico.

Below right An exquisite circular staircase in the son's annex gives access to the mezzanine floor.

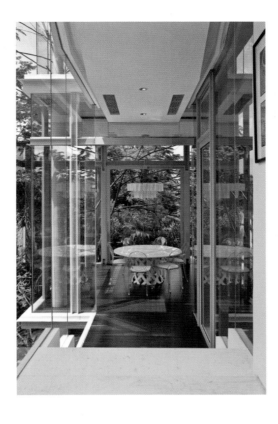

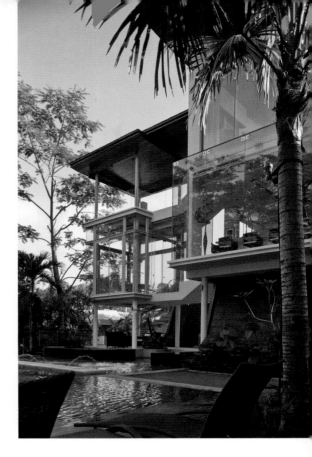

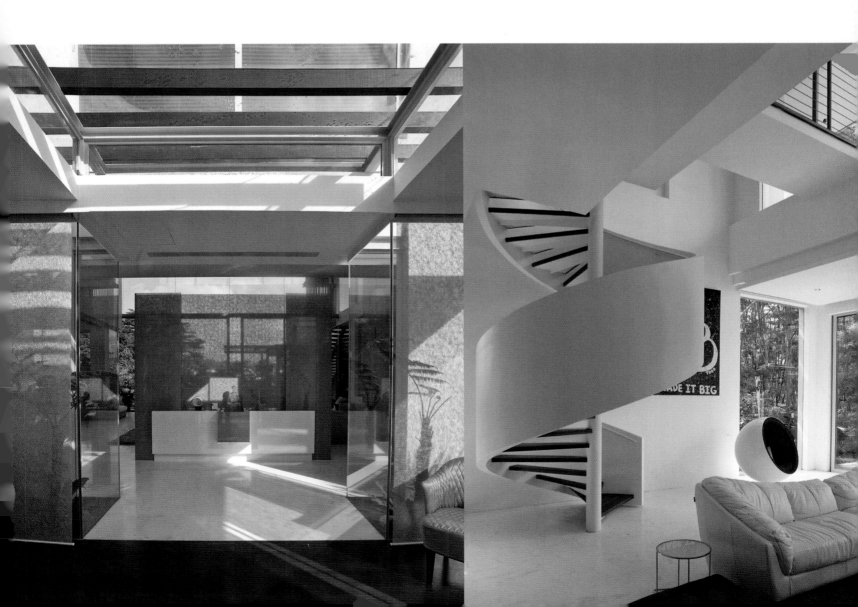

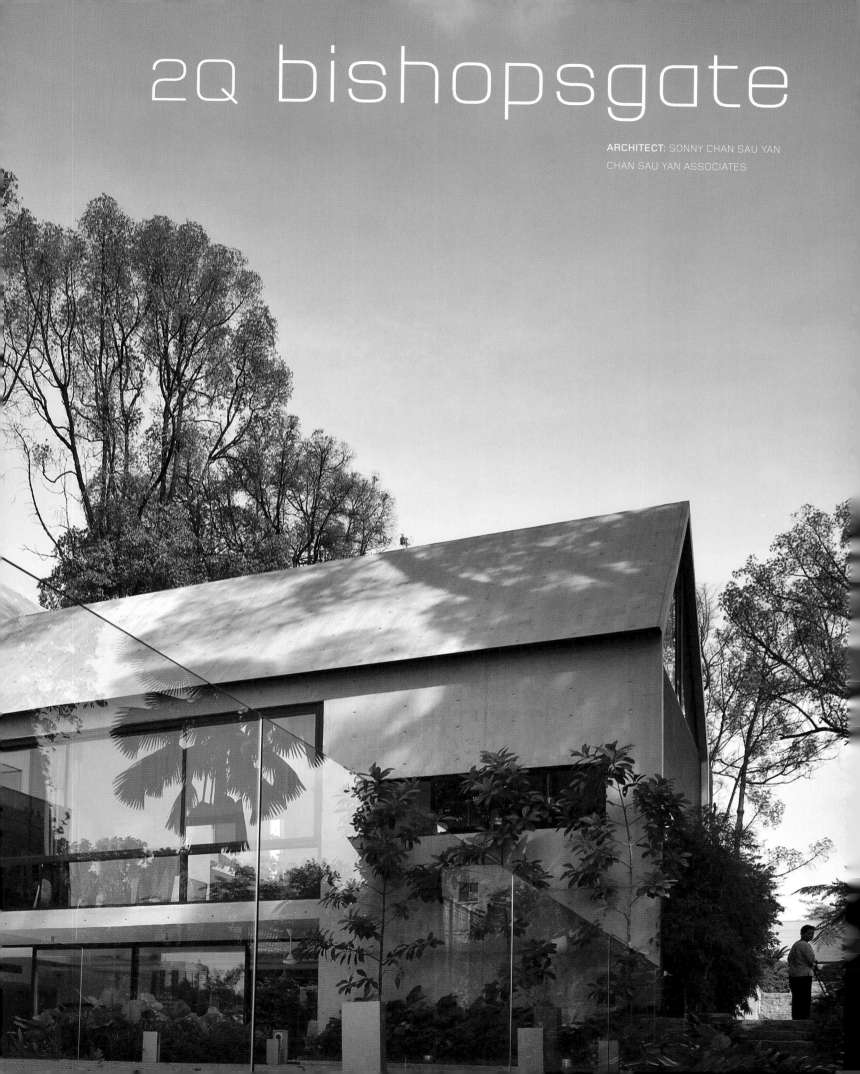

2Q bishopsgate

ARCHITECT: SONNY CHAN SAU YAN
CHAN SAU YAN ASSOCIATES

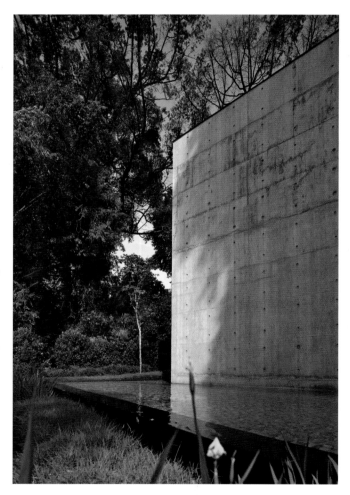

Sonny Chan has produced a succession of beautifully craft-ed and innovative architectural works over the past forty years, initially with Kumpulan Akitek (1964–93) and since 1993 as principal of Chan Sau Yan Associates (CSYA). Chan trained at the North London Polytechnic School of Archi-tecture (1959–63) and completed his education at the AA Tropical School under Otto Koenesberger, where students had to familiarize themselves with designing buildings in different climatic zones, and thus their consciousness of climatic imperatives was heightened. After the AA experi-ence, Chan joined Arup Associates in London where he worked for a year before heading back to Asia in 1964.

Malaysia had achieved its independence and Singapore was about to become independent. The first batch of locally trained architects had graduated from Singapore Polytech-nic, while others, like Chan, were educated in England and Australia, and a few in America. Chan and those of his gen-eration had a mission – to build up the capability and stature of the local profession.

While at the AA, Chan became committed to designing expli-citly for Asia. 'Around that time,' he recalls, 'the works of the modern Japanese architects like Kenzo Tange and Kikutake were featured in architectural design magazines and their buildings were beautifully crafted in reinforced concrete but reflected timber construction. The language used was so powerful. One could see a national identity realised in modern Japanese architecture. It was so powerful that I felt that I should also address that in my own work.'[1]

'I remember reading about Tange trying to discover his roots in the modernist movement,' continues Chan. 'His early memorial for Hiroshima was very much influenced by Le Corbusier and Oscar Niemeyer. Subsequently, he did works, like the Kurashiki Hall, which were more Japanese in terms of imagery. He had to consciously search for the primal force of building in Japan, which liberated him from Western imagery. His Yoyogi Stadium, which I visited in 1970, represented to me a watershed in modern Japanese architecture. Yoyogi was concrete and steel, and yet the form is reminiscent of Japa-nese building because of the domination of the roof.'

Describing the form of the Bishopsgate House as 'the simple expression of an idea', Chan concedes that there are refer-ences to the high-pitched geometric language of Shaker houses. 'It is,' says Chan, with tongue-in-cheek humour, 'my "revenge" on the well-known American architect Hugh Newell Jacobsen. The clients were attracted to his barn-like clapboard houses and their daughter left several of his publications in our library. What impressed the clients were the lofty ceiling interiors. I decided to accept that as a point of departure but our design would be of *in situ* fair-faced concrete!' Japanese influences are simultaneously evident in the clarity of the form and the refinement of the finishes.

In the completed house there are actually two dwellings in one, a theme that occurs several times in this book. It is a growing phenomenon in Singapore, where the escalating cost of land has forced potential house owners to look at

Top The house displays a distinctly modern language.

Above The form of construction is smooth off-form concrete with an applied water-based acrylic silica-resin coating.

Opposite A splendid screen of mature trees surrounds the house.

inventive ways of maximizing their investment. The Asian notion of filial piety is evident, too, in this solution that combines within one house a dwelling for the owners and a separate, though integral, dwelling for their daughter's family, which includes three children. The two units interlock, and while there are separate kitchens there are also opportunities to dine together. The entrance lobby is astutely handled, with separate entrances but one stairway shared by the two dwellings.

A splendid screen of mature trees surrounds the house and it is evident they have been influential in locating the building on the site. Chan has spent many vacations on the southeast coast of Sri Lanka, on one occasion taking his entire staff on a study tour. It is perhaps not surprising, therefore, that there is evidence of Geoffrey Bawa's influence in the manner that views are framed and courtyards embraced.

But what is ultimately most striking about the house is the form of construction. The principal material is smooth off-form concrete applied with a water-based acrylic silica-resin coating, clear for the main building, stained charcoal for the powder room block and white for the lift core. The external walls are 200 mm thick with integral insulation.

The client was receptive to Chan's experimental ideas, and the outcome is an exceedingly bold statement of primary forms, while internally the exposed concrete walls and ceilings express unambiguously the construction technique.

Chan Sau Yan is one of Singapore's most enduring design orientated architects. Eschewing the architectural gymnastics or the corporate conformity of many of his contemporaries, he has consistently produced work distinguished by elegant spatial arrangements and a high standard of finishes. One of the defining characteristics of his architecture is the sense of pleasure that he derives from making buildings, which is transferred to the objects themselves.

At an age when many of his contemporaries have retired from practice to write or to intermittently teach, he has an enthusiasm for architecture that is infectious. This has been conveyed to a younger generation at various times in his role as Adjunct Associate Professor at the School of Architecture at the National University of Singapore, as an active member of AA Asia, and as the mentor of a younger generation of architects who have worked in his office.

[1] Lai Chee Kien and Tan Kok Meng, 'Chan Sau Yan Associates', *Architecture + Design 93–94*, Singapore, 1994, pp. 4–6.

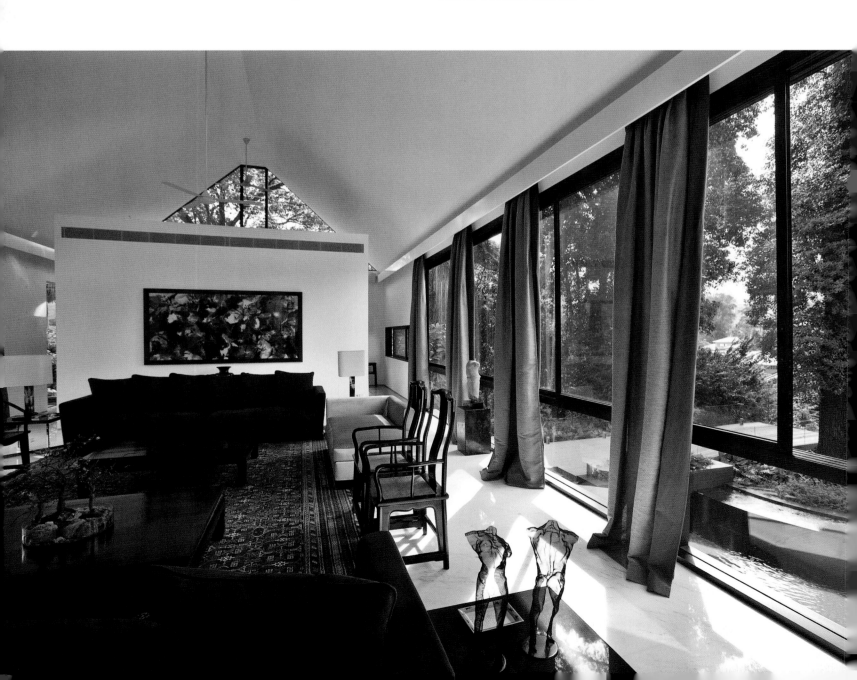

Opposite below Lofty ceilings are a feature of the interior of the house.

Left The refined off-form concrete finishes suggest Japanese influences.

Right An austere, though remarkably beautiful guest bathroom, with smooth concrete finishes.

Below First storey plan.

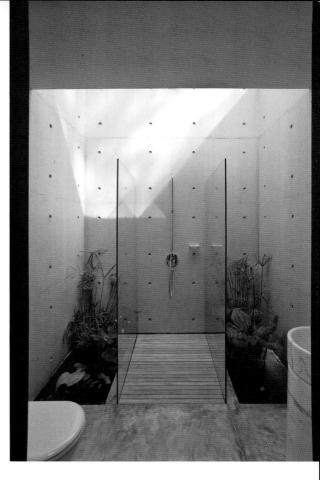

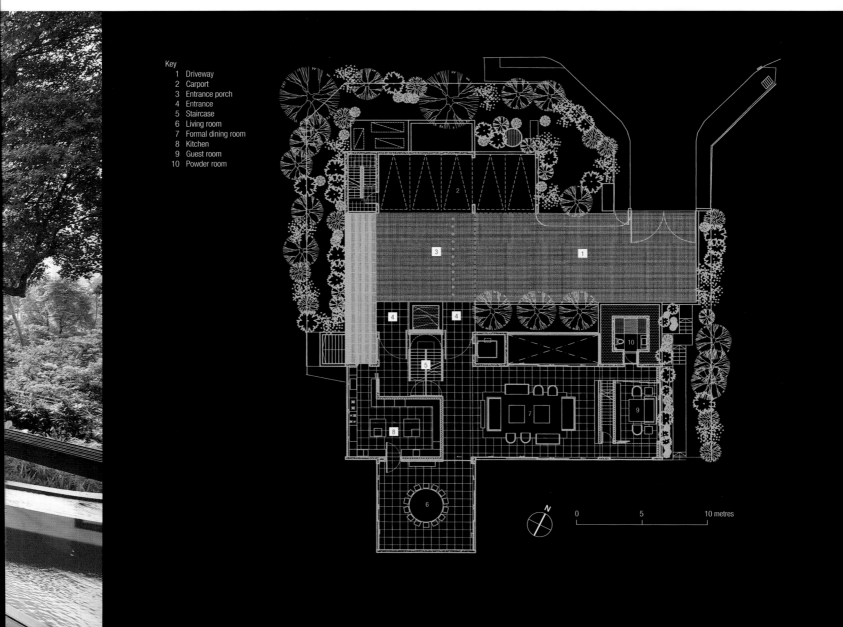

Key
1 Driveway
2 Carport
3 Entrance porch
4 Entrance
5 Staircase
6 Living room
7 Formal dining room
8 Kitchen
9 Guest room
10 Powder room

0 5 10 metres

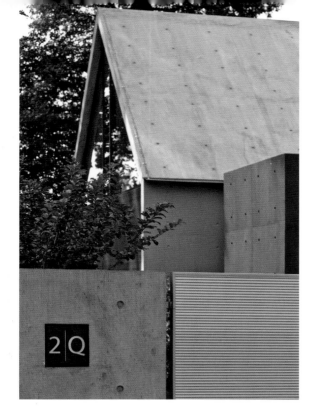

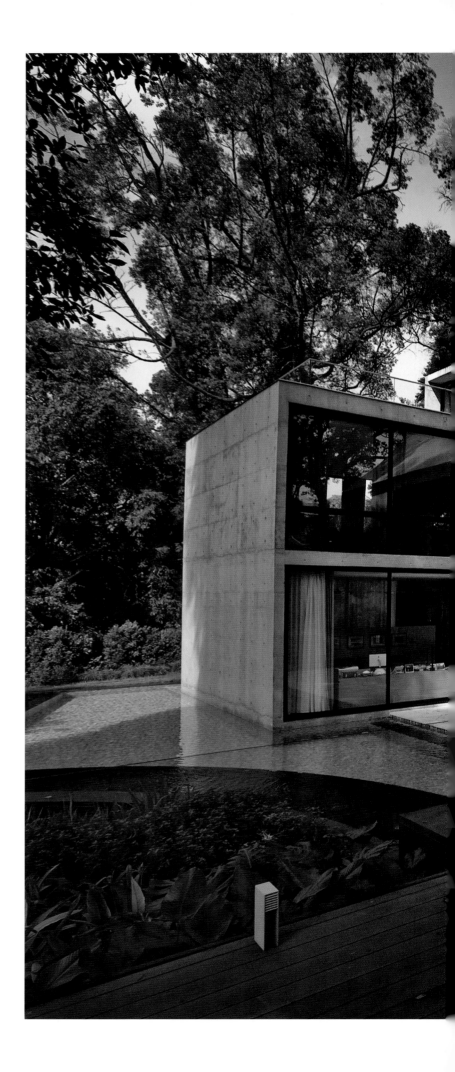

Top The house display a harmonious range of materials and colours.

Above The architect employs a modernist language.

Right The distinctive form of the house makes reference to the high-pitched geometric roofs of Shaker houses.

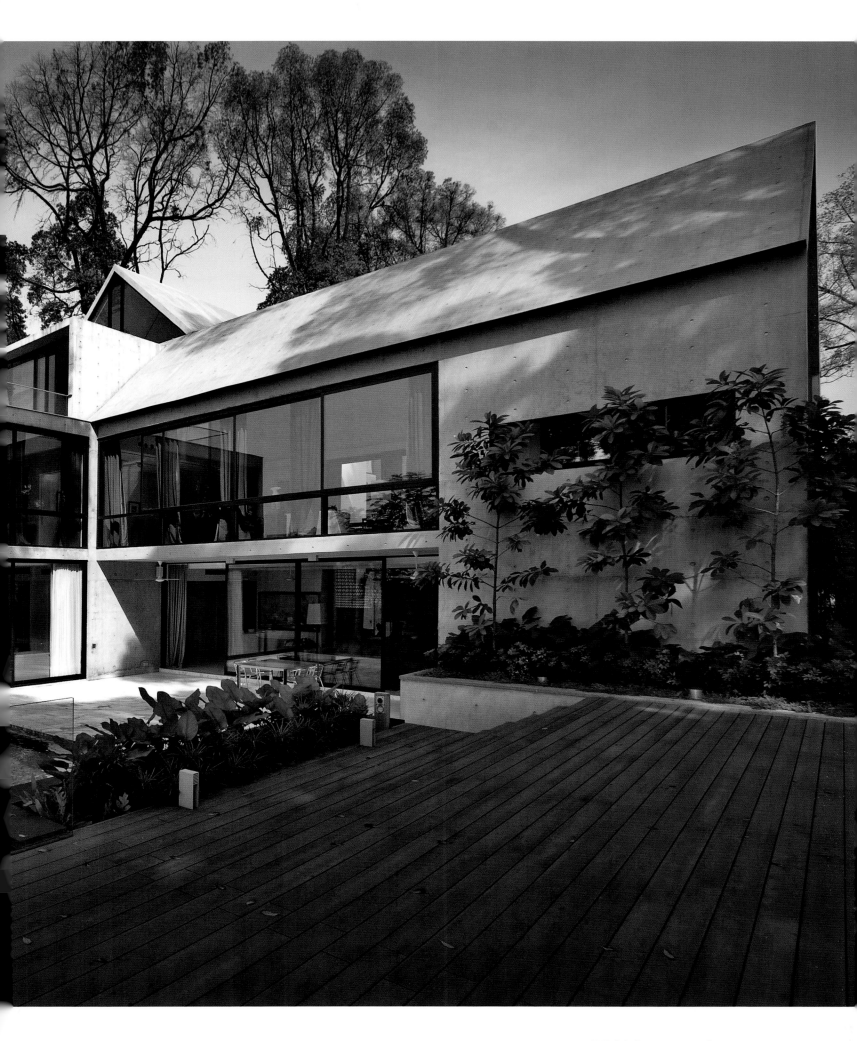

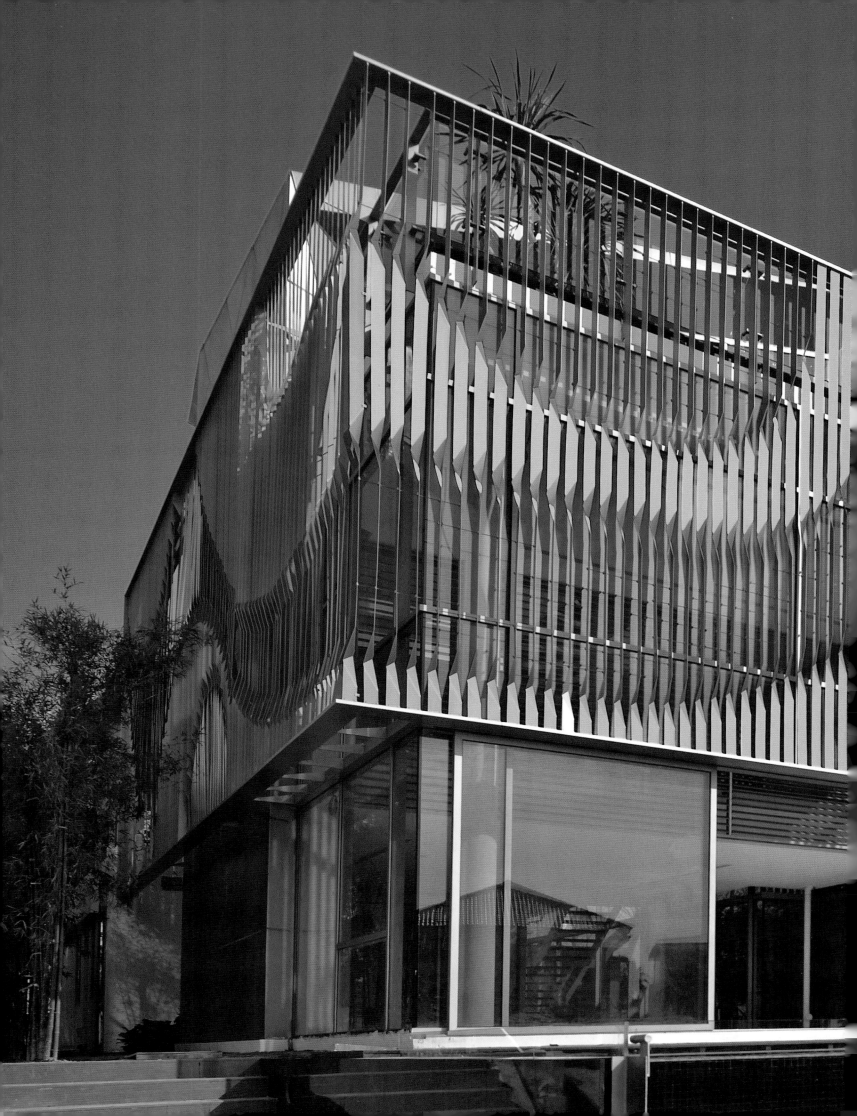

ocean drive
house

ARCHITECT: TEH JOO HENG
TEH JOO HENG ARCHITECTS

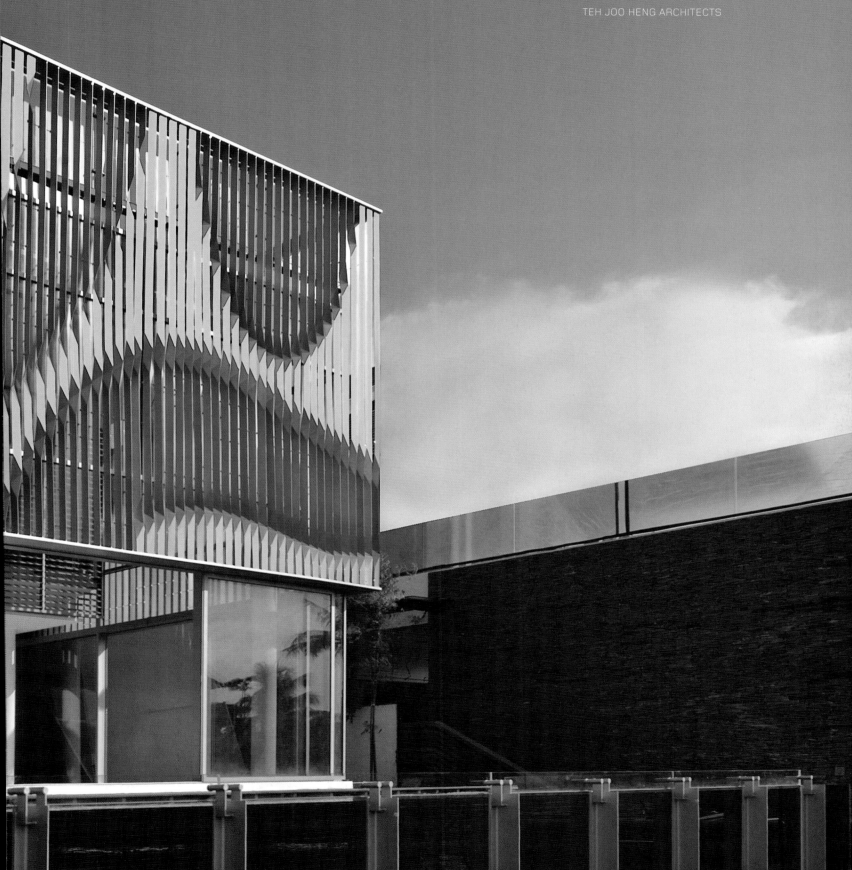

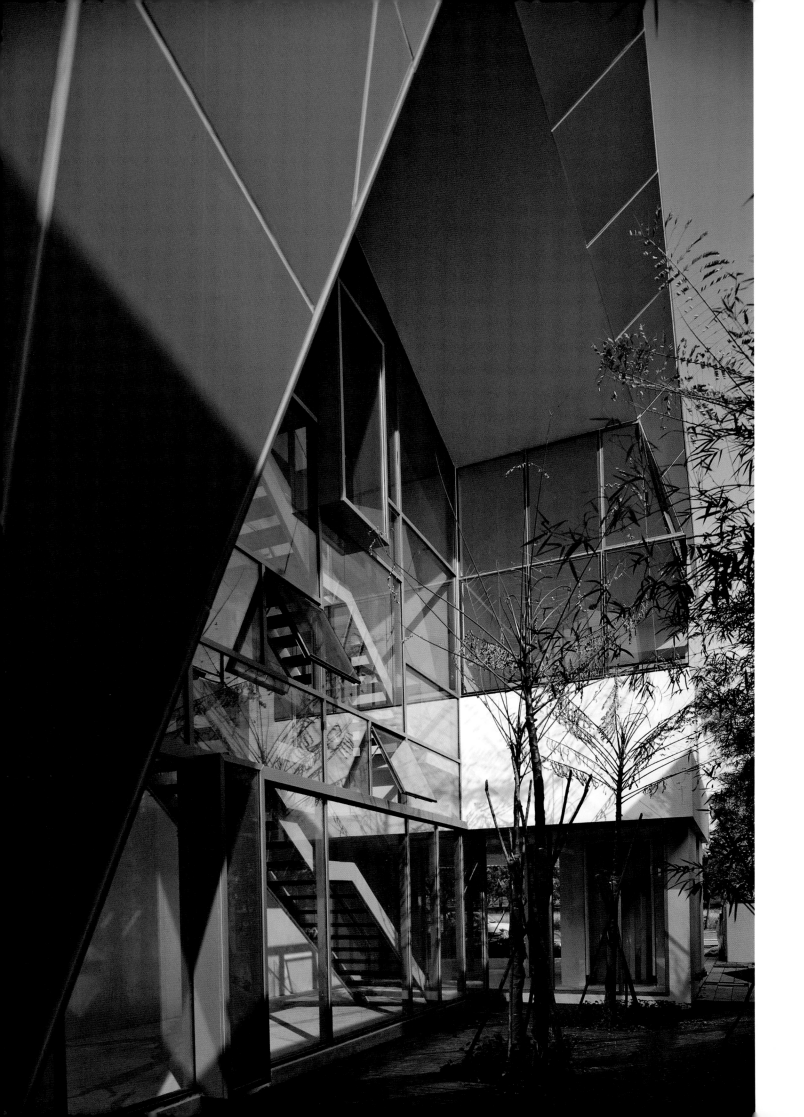

Malaysian-born architect Teh Joo Heng graduated from the National University of Singapore School of Architecture in 1985. Teh's final year thesis design for the Kedah Islamic Secondary School received the King Fahd Award in 1986 – an award for Excellence in Design in Islamic Architecture from the International Commission for the Preservation of Islamic Cultural Heritage and the Secretariat of the King Fahd Award.[1] Teh recalls that in addition to his final year tutor, the British architect Derek Goad, he was also influenced by Visiting Professor Ivor Smith, who discussed the concept of symbolism in everyday life and in architectural expression.

After a one-year internship in William Lim Siew Wai's office, Teh embarked on a two-year postgraduate course at the Massachusetts Institute of Technology in the USA. Here, a triumvirate of professors guided his studies: Stanford Anderson was his Masters thesis advisor and taught him methods of enquiry; Ronald Lewcock taught a 'Design with Climate' course and John Habraken taught a course on 'Thematic Design and System Thinking'.

Asked to name his favourite architects and their buildings, Teh responds with an unusual combination, naming Frank Gehry for his Bilbao Guggenheim Museum and Le Corbusier for his design of La Tourette. Teh regards Gehry as the most influential living non-Cartesian architect, with an ability to integrate art, landscape, urbanism and programme in a single building, whereas he admires Le Corbusier for his ability to create a wide range of forms with spatial and natural lighting experiences that vary from bright practical space to spiritually uplifting dimly lighted religious space.

On his return to Singapore, Teh rejoined William Lim Associates where he worked alongside Mok Wei Wei and Tan Teck Kiam for a decade. All were encouraged by William Lim to develop an individual approach. When Teh eventually left the practice in 2000 to form Teh Joo Heng Architects, Lim exhorted him 'to continue to explore and be innovative'.

The design of the Ocean Drive House is, first and foremost, as explains Teh, 'an attempt to play with a non-orthogonal geometry', an exercise involving volumes and sections that arise out of a response to the sun path, shade and wind. The result is an innovative form, with a roof that descends and envelops the house, in the process becoming both a wall and a sunshading device. The angled roof wraps over the dwelling and 'falls' in the manner of a veil or headscarf, partially obscuring the interior of the house from its neighbours.

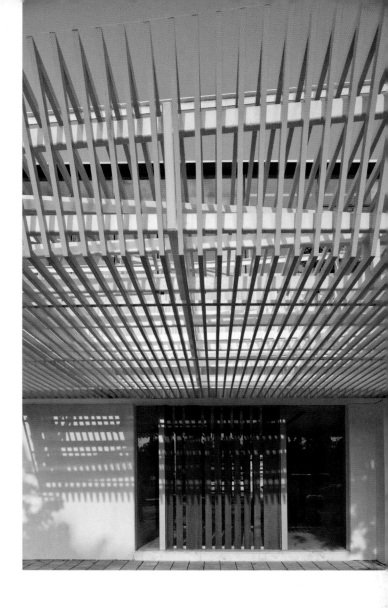

Left The landscaped courtyard on the north façade of the house.

Above An intricate louvred canopy projects above the house entrance.

Teh explains that the design process 'is largely intuitive'. Interlocking double volumes have been created internally, light is captured, and the angled walls encourage the flow of the prevailing breezes. The challenge was to turn the restrictive pitched roof design guideline of Sentosa Corporation and the URA attic guidelines into form generators.

The modest size of the plot means the house is in close proximity to its neighbours; indeed, there is barely sufficient space to comprehend the ingenuity of the form. The full effect of the spatial quality can only really be appreciated from within. The bold roof form and intricate louvred panels are not immediately apparent from the entrance road but are visible from the east across the lagoon.

Entering the house through a single-height lobby and proceeding past the guest suite, kitchen and dining areas, there is dramatic expansion into a soaring double-height living room overlooking a glass pool and the lagoon, with oblique views of the bridge leading to Paradise Island. A landscaped deck on the northern flank of the house provides a space for outdoor living.

From the master bedroom at second-storey level, an exquisitely designed circular metal staircase ascends to the attic

study beneath the folding roof forms. The inventive section and plan form, and a south-facing terrace at second-storey level, encourage cross-ventilation, and the 'stack effect' assists the natural cooling of the interior. The manipulation of double and triple volume spaces visually integrates the house with the waterfront and the sky. It makes the house porous and allows all rooms to fully function with natural ventilation. It also permits all rooms to have a waterfront view within a limited frontage. Climbing to the roof level, there is an east-facing roof deck.

The house has a fragmented and faceted form. Designed for the managing director of a fund management company, it is fashioned like a jewel with immense precision. Vertical aluminium louvres on the east elevation wrap around the south and north façades and create an intriguing pattern of shadows within the living spaces. The house can best be described as a metallic composition beneath an umbrella roof. The sunscreen, other than being a purely functional shading device, serves as a metaphorical response to the ripple of the water and further relates to the curved edges of the surrounding sea wall. It also helps to compose desirable views from the interior.

In the final analysis, the Ocean Drive House is an inventive solution to a dwelling on a restricted site, designed within local building codes that have, for the most part, inhibited lesser architects. The house embodies profound ideas on how to design a modern dwelling that subverts the orthogonal form of much of Western modern architecture that has been widely replicated in Singapore. Moreover, the dwelling contrasts starkly with the general mediocrity and lack of innovation of much of the housing at Sentosa Cove. Teh has, in this respect, taken up the mantle of William Lim Siew Wai and is arguably the most intellectually challenging architect of his generation in Singapore.

[1] Teh's mentor in his final year was the British architect Derek Goad, who taught for three years in the School of Architecture at NUS. Goad now lives and works in the USA and is design consultant to the Singapore American School and other American schools in Kuala Lumpur and New Delhi.

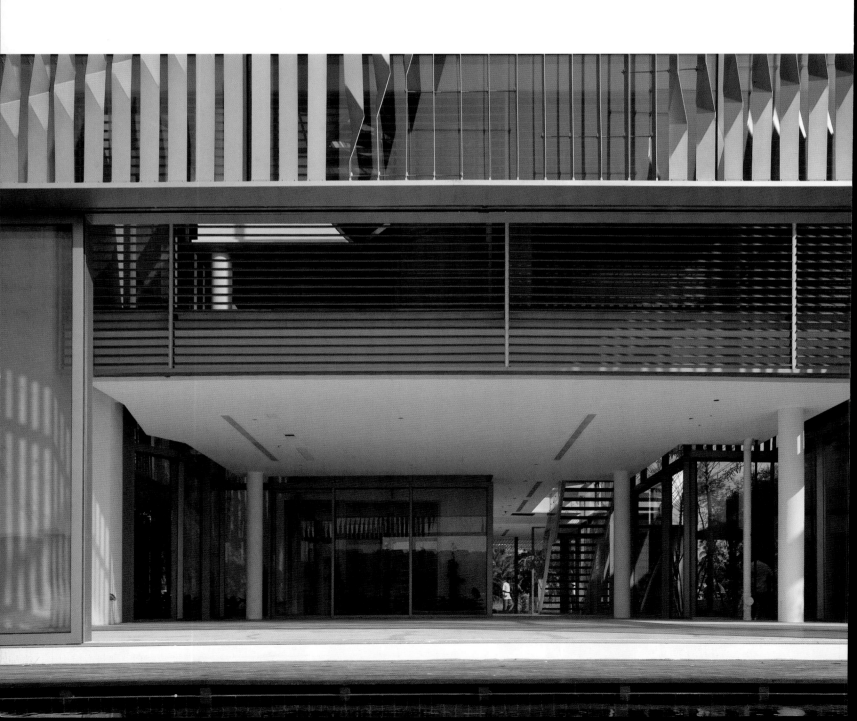

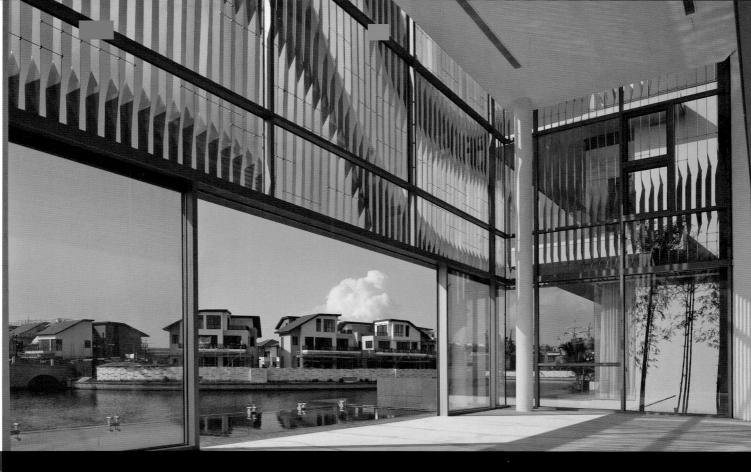

Left The living room windows open up to a view over the waterfront at Sentosa Cove.

Above The living room has views to the southeast across the lagoon.

Right First and second storey plans.

Key
1 Carport
2 Foyer
3 Boat store
4 Defence shelter
5 Guest room
6 Maid's room
7 Laundrette
8 Dry kitchen
9 Wet kitchen
10 Landscaped deck
11 Green sculpture
12 Dining room
13 Bar
14 Living room
15 Lap pool
16 Master bedroom
17 Walk-in wardrobe
18 Terrace
19 Family room
20 Pantry
21 Bedroom

0 5 10 metres

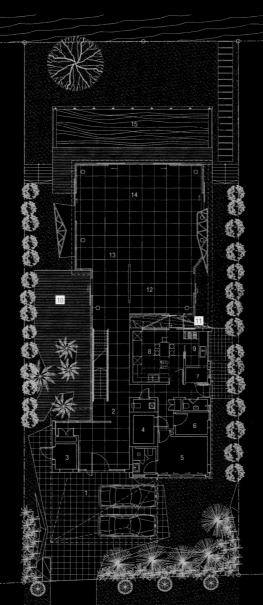

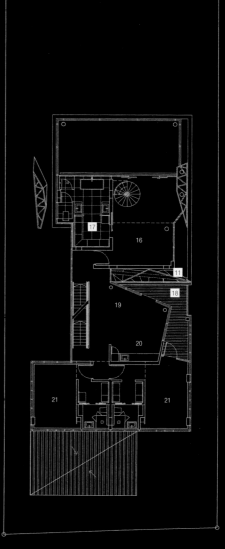

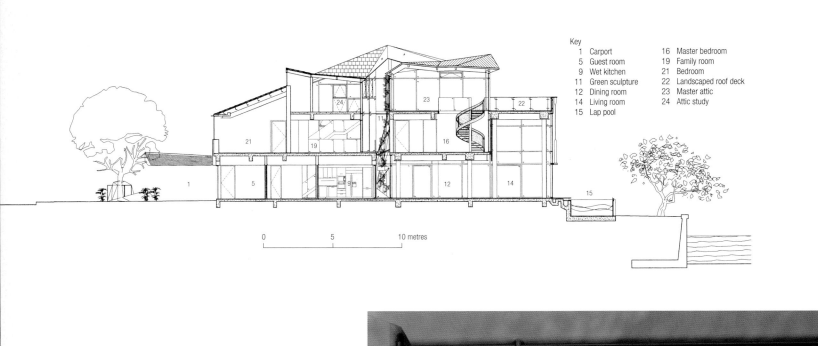

Key
1 Carport
5 Guest room
9 Wet kitchen
11 Green sculpture
12 Dining room
14 Living room
15 Lap pool

16 Master bedroom
19 Family room
21 Bedroom
22 Landscaped roof deck
23 Master attic
24 Attic study

0 5 10 metres

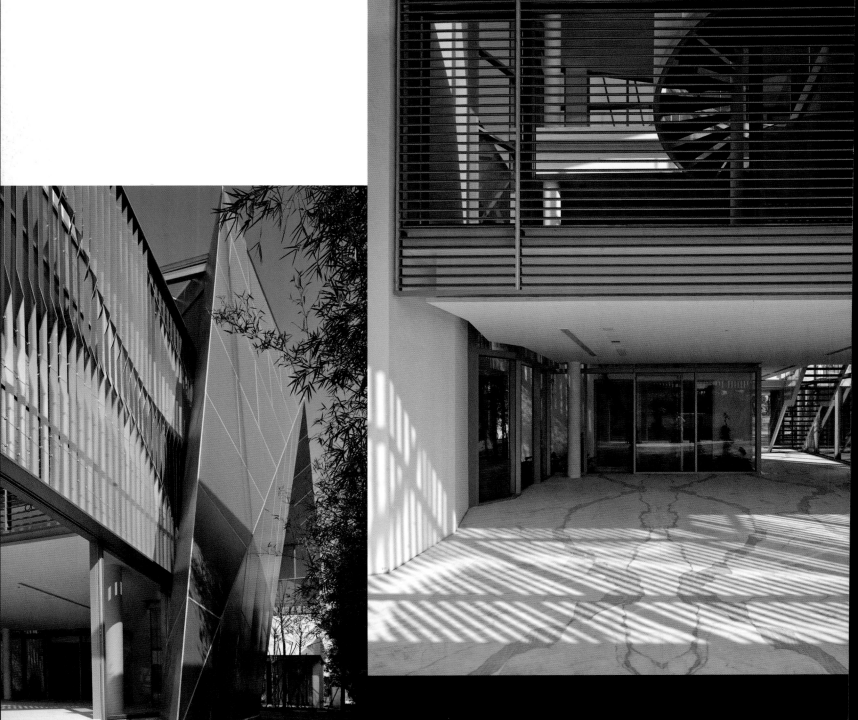

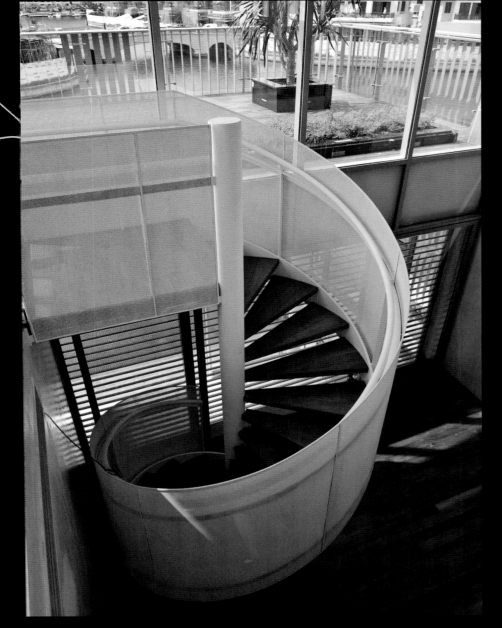

Opposite top Section through the principal living areas and the pool.

Far left The roof wraps over and falls like a veil on the northern flank of the house.

Left The louvred façade creates an intricate pattern of shadows across the interior.

Above left A circular staircase ascends to the roof garden.

Above right The house has a distinctive character that sets it apart from the generally disappointing residential architecture at Sentosa Cove.

Right Looking southeast over the waterfront from the roof deck.

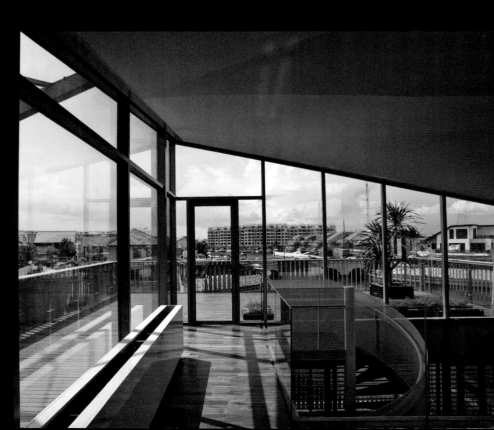

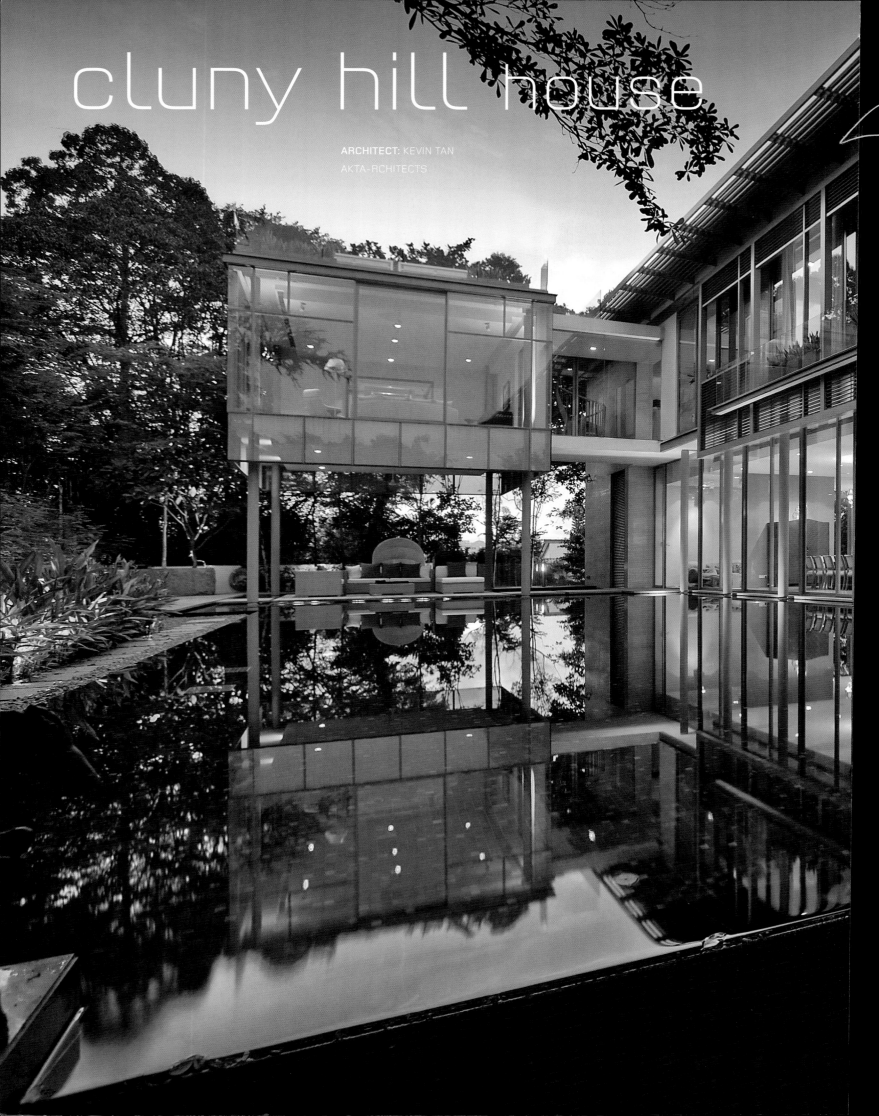

cluny hill house

ARCHITECT: KEVIN TAN
AKTA-RCHITECTS

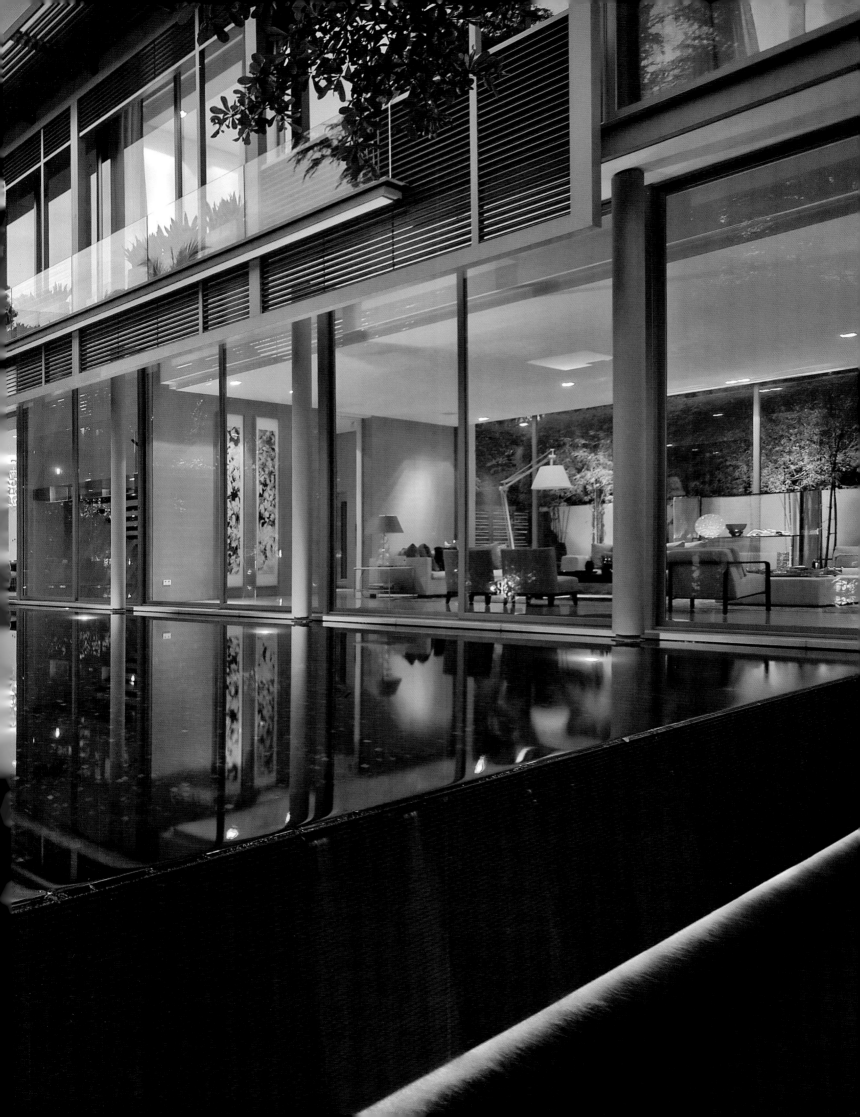

Kevin Tan, a 1990 graduate of the School of Architecture at the National University of Singapore, is a gifted designer. He had his training at a time when the department was nurturing a specially talented cohort of students. He gained experience of international practice with Llewelyn Davies (now Llewelyn Davies Yeang) in London and P&T (formerly Palmer and Turner) in Hong Kong. In his final year, his tutor was the author of this book, to whom he attributes an appreciation of design in the urban context. He also gained insights from the Thai architect Mathar Bunnag,[1] who taught him 'to think out of the box and return to first principles', and warmed to the environmental consciousness of Dr Suthipanth Sujarittanonta, another Thai academic teaching at the National University of Singapore.[2]

Tan had the immense good fortune to come under the influence and guiding hand of Ernesto Bedmar, who was at that time an external tutor in the School of Architecture. Soon after graduating in 1990, Tan joined the Argentine-born Bedmar's design-orientated practice and honed his compositional skills under the architect's mentorship before leaving some ten years later, in 2001, to set up his own firm.

Tan frequently refers to the influence on his work of the early modern masters, perhaps to distance himself from any nostalgic references to tradition and possibly to affirm, as with most Singaporeans born after independence was achieved in 1965, that he is of a generation with little attachment to the past and who are generally orientated towards a future with a global outlook. He insists that his designs have always been 'pure modernism' and that he has 'never wished to indulge in vernacular tradition'. Tan lists his primary influences as the early modern masters, particularly Louis Kahn for the timelessness and serenity that he brings to his buildings. He also admires a number of contemporary architects, including Norman Foster for the clarity he brings to his work, Renzo Piano for his craftsmanship and Herzog & de Meuron for their freshness and bravado.

Tan combines a ready charm with candour, which enables him to relate well to his clients. Like many architects of his generation, he is in a hurry and his success has bred an aura of confidence. 'I believe there is a real and practical brief for each house,' says Tan. 'There is also an invisible brief which comes through conversations and observations. I have been fortunate to encapsulate this unspoken brief sometimes more successfully than others.'

The Cluny Hill House is unashamedly modern, employing masonry, metal and glass cladding on a concrete frame in a strictly orthogonal composition. The L-shaped ground floor is remarkably transparent, with living and dining spaces that face south to embrace a swimming pool. The house is located close to the summit of Cluny Hill and entry is from the east directly into a paved vehicle court. Vehicles sweep down into a basement car park where visitors alight. They first view the house reflected in the pool and then turn north to ascend a short flight of steps to a square portico.

Above Beneath the master bedroom suite is a shaded deck surrounded on three sides by water.

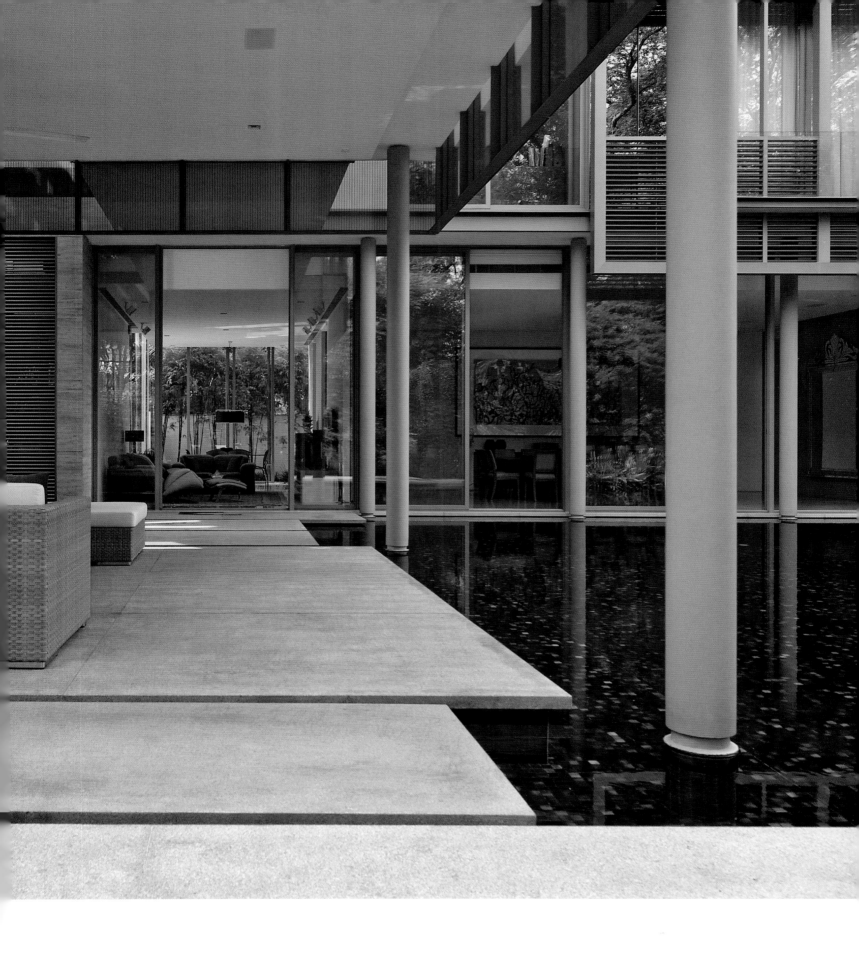

After pausing to remove their shoes, visitors turn 90 degrees to face west and enter the main reception and living space that looks south over the swimming pool. Thereafter, the accommodation is arranged in linear fashion, with a stair and elevator core followed by the formal dining room for sixteen people. This also overlooks the pool and runs parallel with the kitchen that is located on the north elevation. The plan of the north wing is completed by a smaller sitting room and a study that look south over the pool deck. In the north west corner of the site is a *koi* pond.

Set at right angles to the north wing is the shorter west wing. Beneath the master bedroom suite, which forms the shorter 'leg' of the L-shaped plan, is a shaded deck surrounded on three sides by water. In the southwest corner of the deck are a barbecue stove, a servery and a bar for outdoor entertainment. Above the master bedroom is a landscaped roof deck designed to capture the evening breezes. The Cluny Hill House is a large dwelling but there is nevertheless a sense of intimacy and of connection between the different spaces and activities.

The house celebrates the language of modernism with its orthogonal form, flat roof and first storey raised above the transparent base on circular pilotti. Viewed from the south, it appears to 'float' above the pool. Shading devices in the form of horizontal louvres reinforce the modernist tectonics, and the combination of metal, glass and grey concrete completes the aesthetic. Tan sees the house as 'a fresh modern, sharp yet understated and comfortable house with all the practical needs of a young growing family and live-in grandparents'.

In a relatively short time, Kevin Tan has built up a substantial practice with a series of original and visually compelling designs. A large proportion of the work of aKTa-rchitects is residential commissions, and he is currently working in China, India and the Middle East. The most intriguing commissions are the remodelling of a 100-year-old Victorian dwelling in Kolkata to meet the requirements of a modern Indian family, and a desert oasis dwelling in Dubai.

[1] Mathar Bunnag is a Thai architect. He graduated from the University of Manitoba with an M.Arch. and went on to complete a Masters in Urban Design at Harvard University. He lectured in the School of Architecture at NUS from 1984 to 1986. In 1988, he set up his own successful practice in Hong Kong and subsequently moved it to Bangkok in 1990.

[2] Dr Suthipanth Sujarittanonta taught Environmental Design in the School of Architecture at NUS. He subsequently returned to Thailand and was appointed Dean of the Faculty of Architecture at Sripatum University.

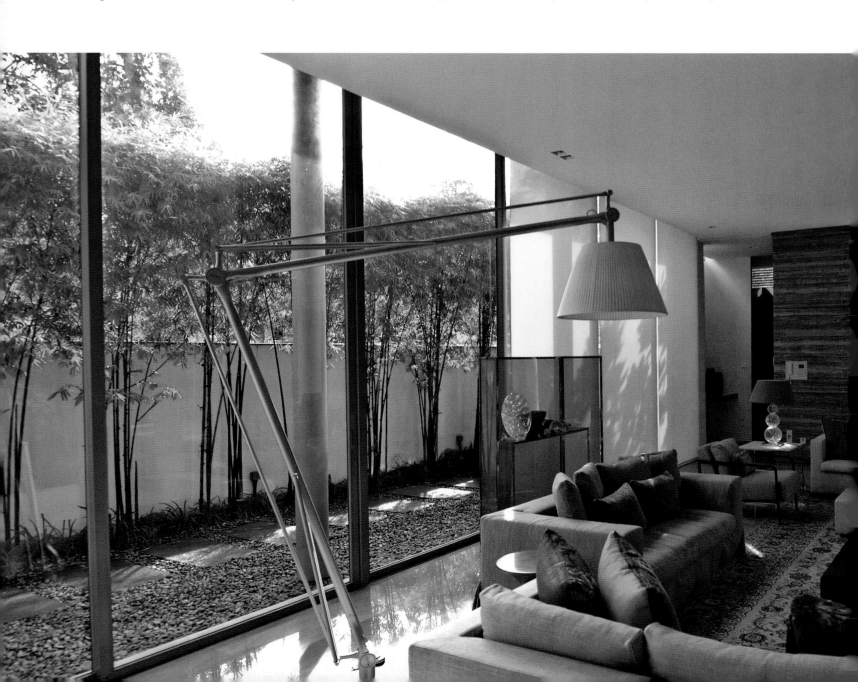

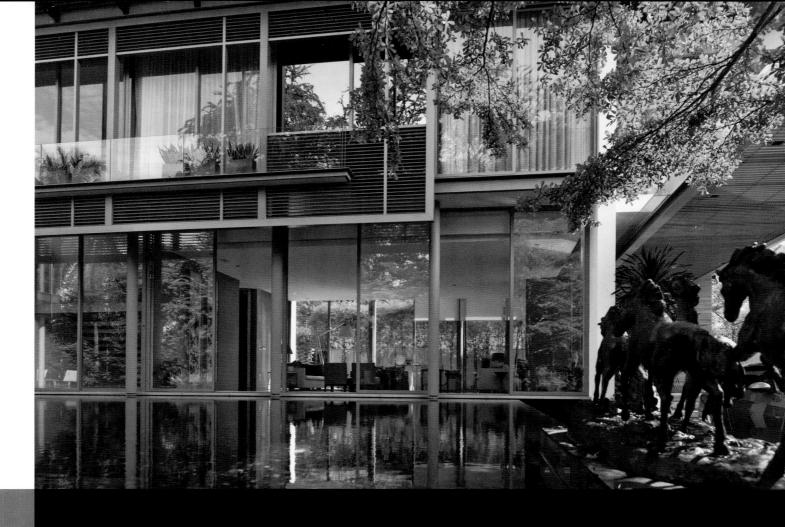

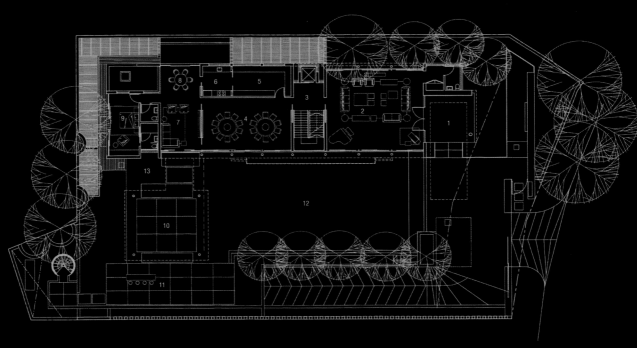

Left The Cluny Hill House is a large dwelling but there is nevertheless a sense of intimacy.

Top The house is a celebration of the language of modernism.

Above First storey plan.

Key
1 Lobby
2 Living room
3 Staircase lobby
4 Dining room
5 Dry kitchen
6 Wet kitchen
7 Family room
8 Breakfast corner
9 Father's bedroom
10 Covered deck
11 Entertainment deck
12 Swimming pool
13 Jacuzzi and children's pool

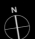

N

0 5 10 metres

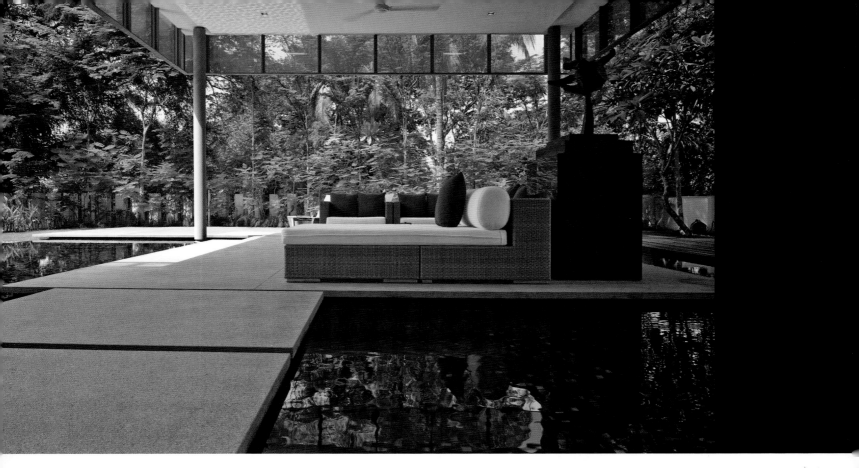

Above The house is surrounded by a screen of mature trees and more recent plantings.

Right The secluded entertainment area and barbeque deck.

Opposite top left Second storey plan.

Opposite top right A quiet area for calm reflection.

Opposite bottom The link to the master bedroom and, on the right, the staircase leading to the roof terrace.

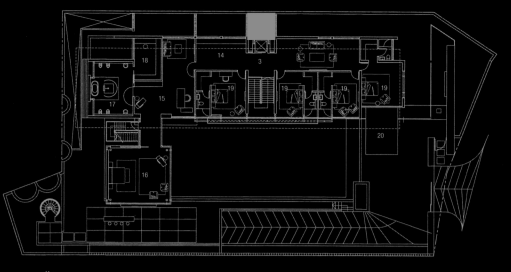
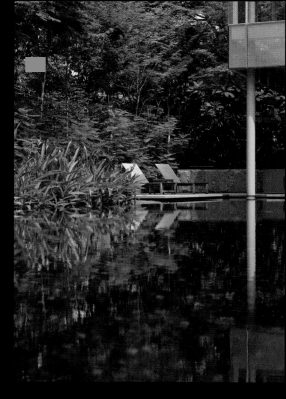

Key
3 Staircase lobby
14 Pantry
15 Study
16 Master suite
17 Master bathroom
18 Walk-in closet
19 Bedroom
20 Glass canopy

N

0 5 10 metres

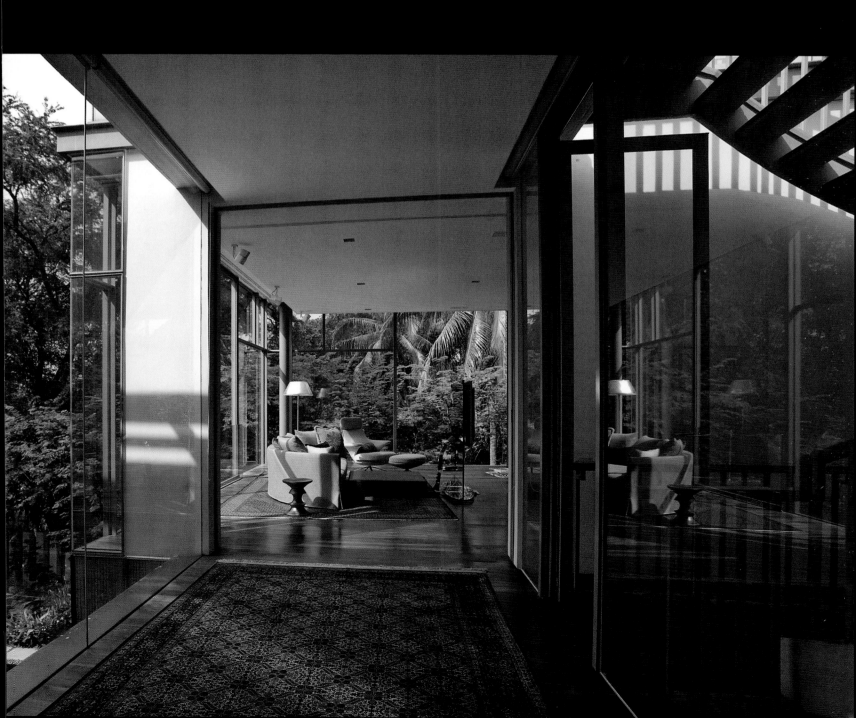

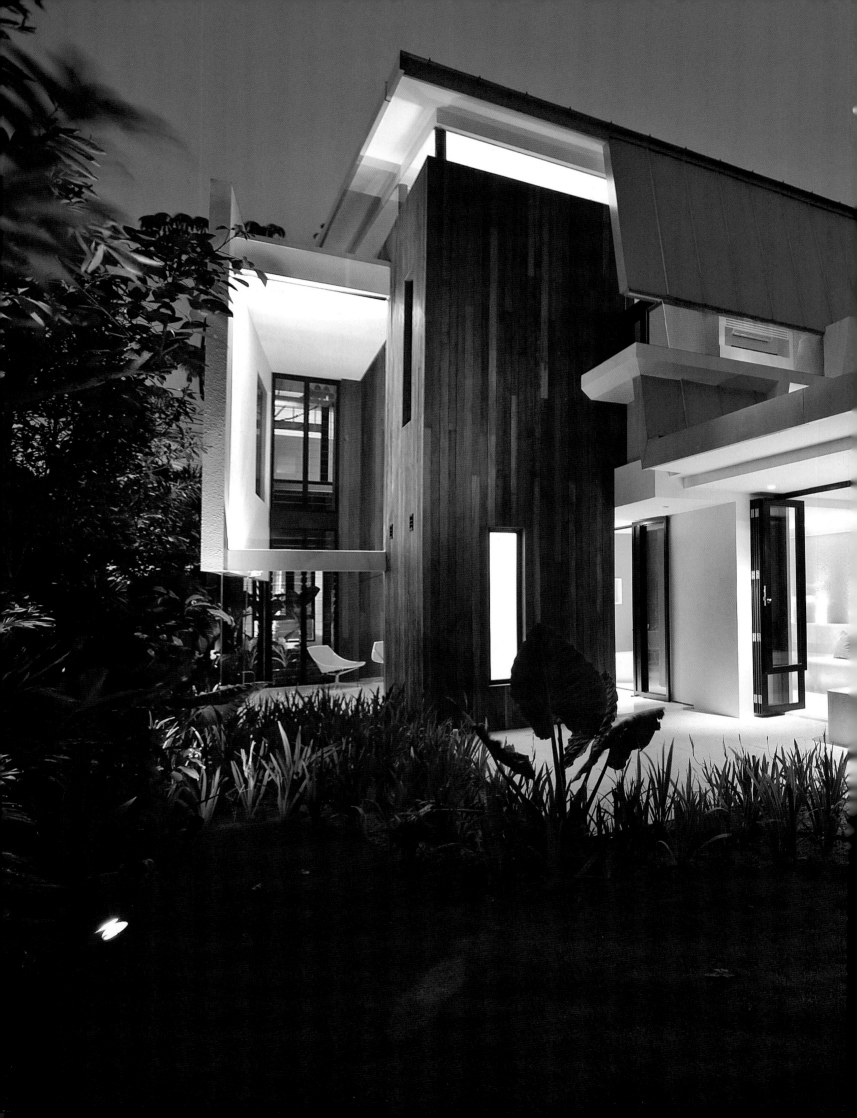

jalan sed⬚p
house

ARCHITECT:
formerkz architects

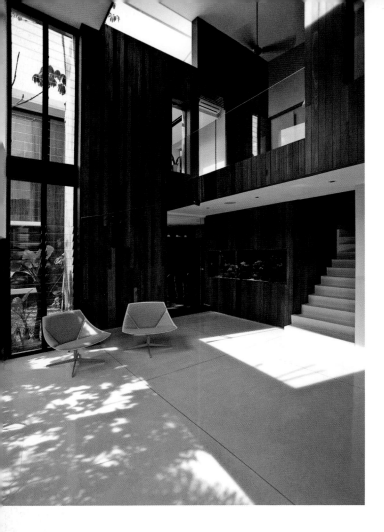

recalls that her thesis design 'was cool, with none of the histrionics associated with high architecture. At the time, the architecture of Kazuyo Sejima was still not widely known but Gwen Tan's work seemed to embody some aspects of Sejima's aesthetics.[2] I don't know whether this is good or bad, but certainly at the time it was very refreshing.'

The Jalan Sedap House is a major reconstruction of an existing terrace house for a banker. The client's brief was simple: 'Every space in the house must fulfil a purpose.' In effect, the house was designed from the inside out, with intensive interrogation of the function of every square metre. This applies equally to the garden space. This has parallels in the 'Pattern Language' approach of Christopher Alexander.[3] The result is a very simple plan form that, at the same time, embodies extraordinary complexity. The patterns that emerge include 'a place for playing the piano' and 'a place for watching fish' that coalesce into a whole.

Take, for example, the guest bedroom. The guest bed is raised high above the floor permitting suitcases to be stored beneath. The space also serves as an open wardrobe with a hanging rail hidden below. The bed is concealed behind a sliding folding door and is accessed by a steep 'ladder'. When the door is closed, the space becomes a music room with an upright piano beneath purpose-built storage shelves filled with classical CDs. Amazingly, a tree grows through a void in an otherwise redundant corner of the room.

Other 'patterns' that emerge are 'a space for entertaining guests' and 'a place for reading and contemplation'. Alongside the entrance is a TV viewing room with banquette seating. It serves a dual purpose, for it can be used to greet visitors or opened out to host a small gathering of friends under the covered carport.

On the upper landing there is a spacious purpose-designed reading chair looking towards what the owner describes as a 'framed picture' where the adjacent house is obscured and the owner can observe a horizontal strip of blue sky and a square of green where a tree has been planted. The landing also serves as a 'gallery' above the music room, while an L-shaped bay window on the front façade is also customized for the purpose of reading at a different time of day.

But the house is built around and primarily celebrates the owner's love of classical music. A Singapore President's Scholar who had dreamed of being a concert pianist but somewhat reluctantly settled for a more pragmatic career in finance, he worked in London for nine years and for one year in Moscow where he took the opportunity in his leisure time to study under a renowned Russian piano teacher. Consequently, at the heart of the house is a double-storey space occupied solely by a grand piano. This is the defining feature of the house, a modern music 'salon' where the grandeur of a concert hall is encapsulated in a modest space.

Although formerkz architects work as a co-operative, the design of the Jalan Sedap House was principally the responsibility of one of the four partners, Gwen Tan, a year 2000 graduate of the National University of Singapore. In her early years she was deeply influenced by the Turkish historian Dr Gulsum Nalbantoglu[1] and the notion of narrative architecture, which is considered quite apt for residential design because houses often tell a story.

In her year out, Tan gained practical experience with Ang Gin Wah, a Singapore-based architect who does most of his work in Japan and in Australia where he qualified. Waro Kishi was an occasional visitor to the office and Tan developed an affinity with Japanese architecture. 'An architect I greatly admire,' she says, 'is Kazuyo Sejima whose works tend to have an ephemeral quality and the most beautiful and simple plans. What is admirable is that she made her mark in a male-dominant industry and in a male-dominant society. Her success was inspiring for female architects.'

Tan travelled widely prior to returning to her studies. She was intrigued by the spatial experience of Gaudi's works in Barcelona and the work of Alvaro Siza. She remarks that 'Rem Koolhaas, MVRDV and Herzog & de Meuron were the heroes for many of us at that time, principally for exploring new ways that buildings are put together.'

Her mentor in her final year in the Department of Architecture was Associate Professor Bobby Wong Chong Thai, who

Above A gallery overlooks the principal living space.

Right At the heart of the house is a double-storey space occupied by a grand piano.

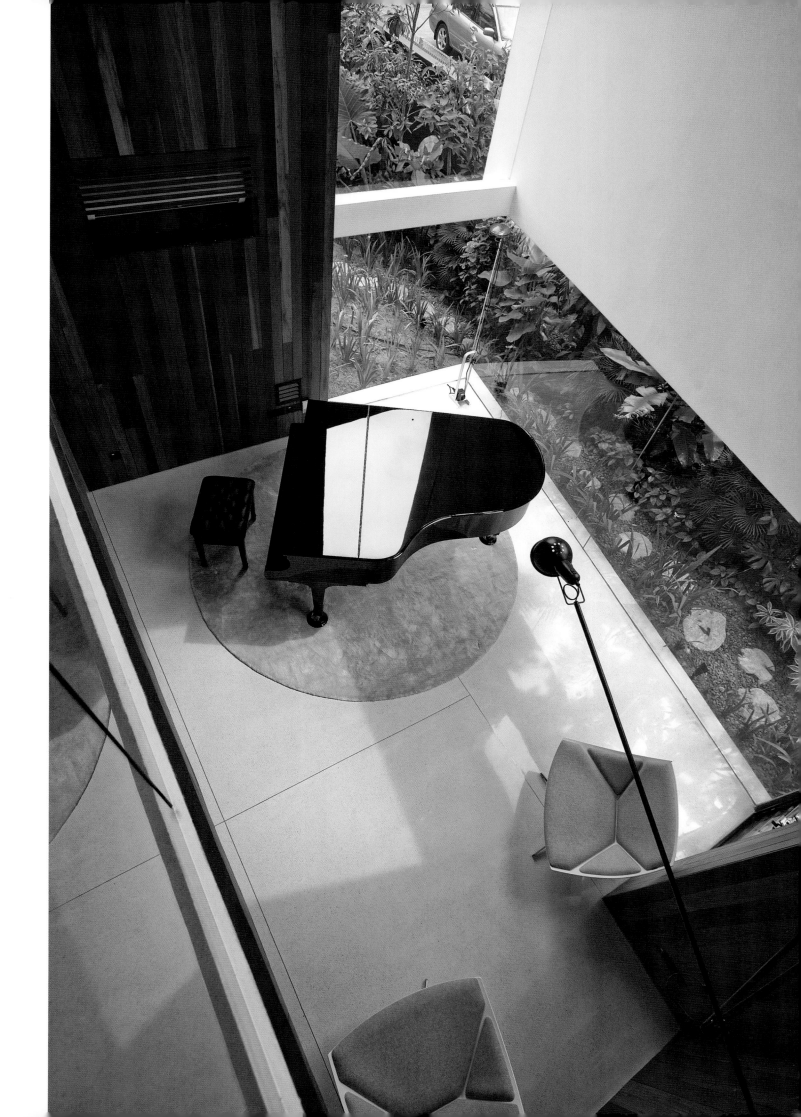

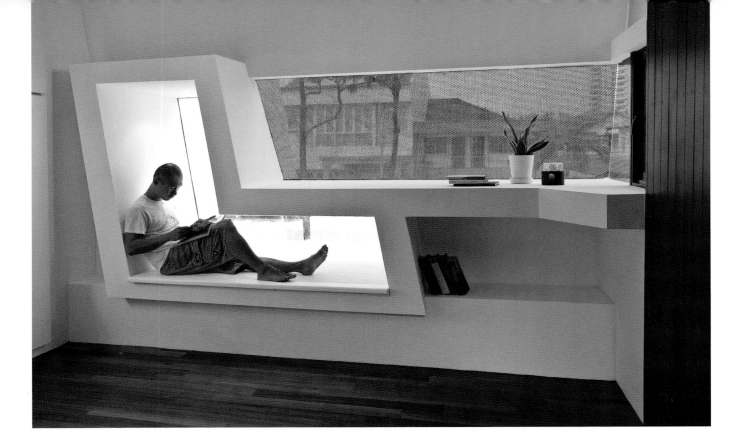

Another of the owner's passions is tropical fish, attested to by two huge aquariums. One is located in the ground floor living space but its reverse side can also be viewed within the powder room. The second aquarium is located in the bathroom off the master bedroom suite, so that the first object that the owner's eyes alight on each morning is the darting movement of numerous exotic fish.

The impression is of a meticulous client and his encounter with an architect bent on providing a unique, personalized solution to his requirements. As Tan explains, 'When designing houses, we start by dissecting the client's lifestyle or interests. Like a novel with a narrative that binds it, the individual pieces start to fit into the plan with a purpose.' What transpires is a brilliant piece of bespoke design 'tailored' exactly for an individual who has a clear notion of what the important things are in his life. He is a very organized individual with clear priorities, described by the architect as a perfectionist. The plan and section are the result of a complex interweaving of the client's requirements.

Referring to some of the challenges of designing a bespoke house, Tan notes that 'The house had to be climatically controlled by industrial-grade dehumidifiers and a thermostat-controlled automatic heat exhaust due to the very precise and very limited range of temperatures and humidity that the client demanded for his pianos and aquariums. Ironically, the two work against each other; the aquariums produce a lot of humidity, which is bad for his pianos. Hence the inclusion of hidden glass sliding panels that partition the house into different zones for mechanical and electrical equipment, which work independently to achieve the desired results.'

'For the heat exhaust to work, natural ventilation is needed, even when there is no one at home. Louvred glass panels were therefore incorporated to supply inward airflow. Openings to the west were deliberately kept to a minimum, and where large openings were needed for visual connection to the gardens, there were sufficient overhangs that were not shielded by the neighbour's house. Air conditioning is available for almost all spaces in the house but is only used when the owner is at home.'

'Typically,' adds Tan, 'houses are designed for a couple or family, but when it's a single-person dwelling, it opens up new opportunities for spatial planning. The client was very particular about the technical requirements and functionality of the house. He also had very high expectations of the end product as it was intended to "compensate" for his detachment from his close friends in London when, for family reasons, he had to relocate back to Singapore.'

The owner confirms that this is his 'dream home', for it embodies all the pleasures that he imagined in a dwelling designed specifically for delight – a garden, reading spaces, aquariums and a piano. The dining room is a small, intimate space overlooking a courtyard, and the tiny galley kitchen reflects the fact that the owner does not place much emphasis on cooking. According to Tan, 'The house recounts the story of the client's love for his garden, for nature, for tropical fish, for music and for reading; all are linked together in a form of spatial poetry.'

[1] Dr Gulsum Nalbantoglu is currently Professor and Head of the Department of Architecture at the Izmir University of Economics, Turkey.
[2] Kazuyo Sejima was born in 1956 in Ibaraki, Japan, and graduated in 1981 from Japan Women's University. She began her career with Toyo Ito, leaving in 1987 to set up her own practice, Kazuyo Sejima & Associates. In 1995, she founded SANAA with Ryue Nishizawa. Among her many projects are several exemplary dwellings in Japan, namely Y-House, Katsura, Chiba (1993), Villa in the Forest, Chino, Nagano (1994), N-House, Kumamoto, Kumamoto Prefecture (1994), S-House (with Ryue Nishizawa) (1996), M-House, Tokyo (with Ryue Nishizawa) (2000) and Small House, Tokyo (2001).
[3] Christopher Alexander, A Pattern Language, New York: Oxford University Press, 1977.

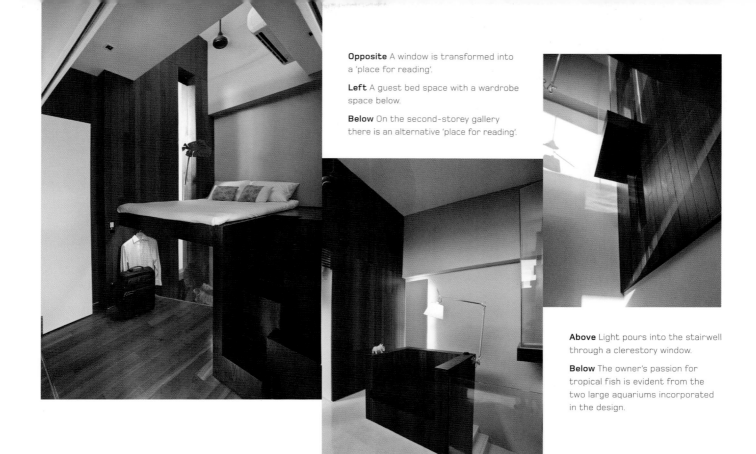

Opposite A window is transformed into a 'place for reading'.

Left A guest bed space with a wardrobe space below.

Below On the second-storey gallery there is an alternative 'place for reading'.

Above Light pours into the stairwell through a clerestory window.

Below The owner's passion for tropical fish is evident from the two large aquariums incorporated in the design.

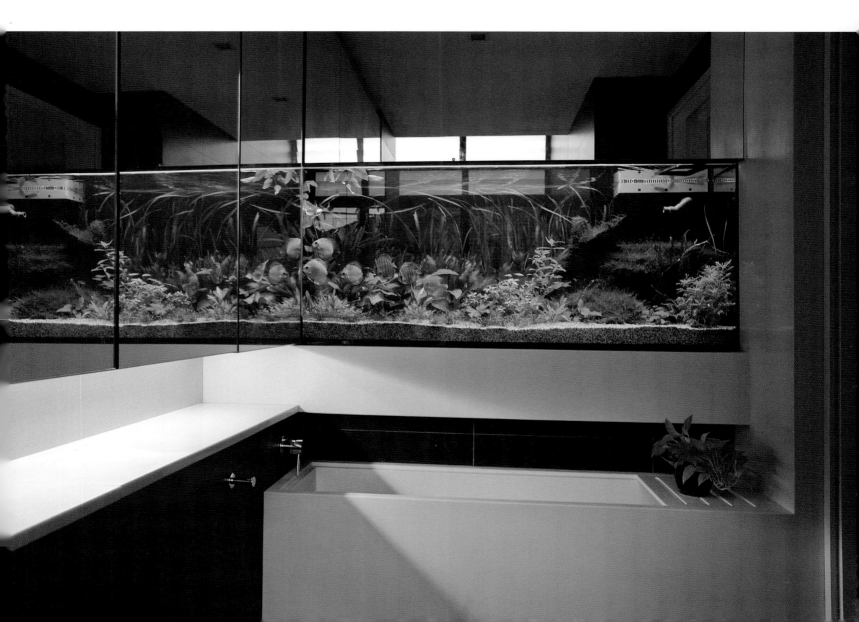

Key
 1 Carport
 2 Garden
 3 Garden deck
 4 Storage room
 5 TV lounge
 6 Living room
 7 Powder room
 8 Dining room
 9 Bar/Pantry
10 Bedroom
11 Bathroom
12 Wet kitchen
13 Utility room
14 Laundry area

Above The first storey plan.

Below One aquarium is located in the living room, with the reverse side visible from the powder room.

Right A tall window makes a visual connection between the living room and the wider urban context.

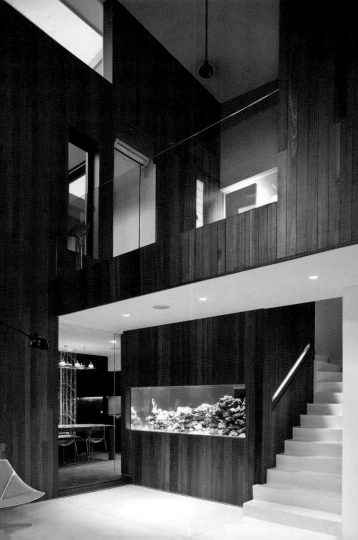

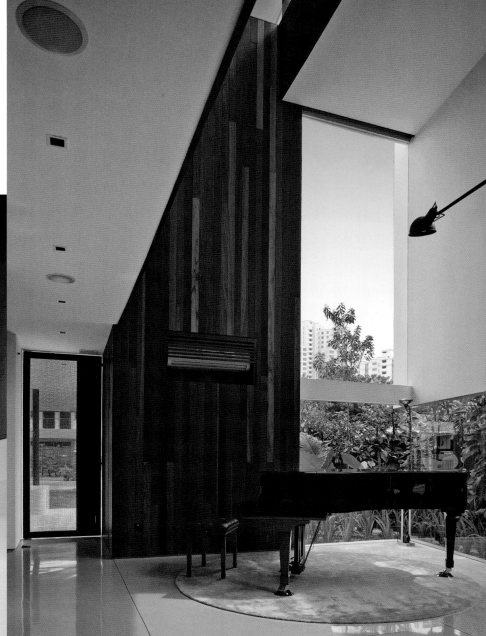

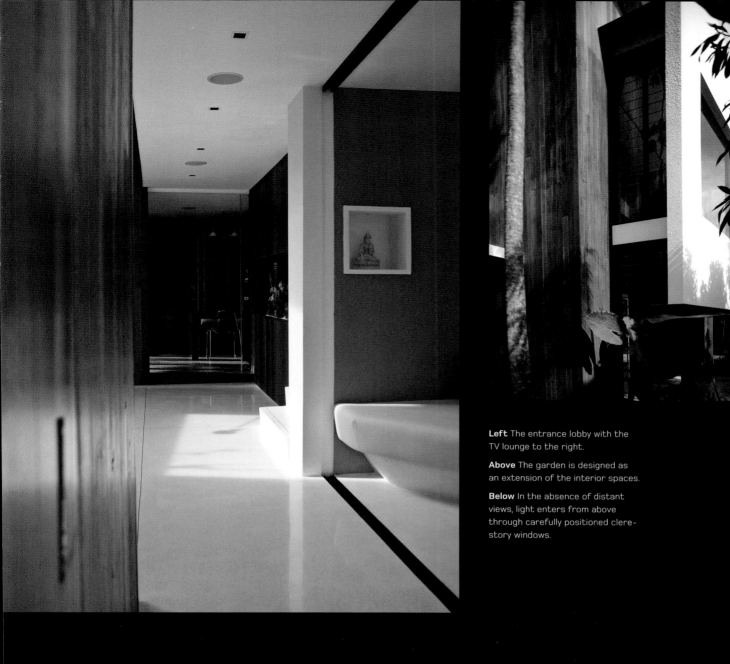

Left The entrance lobby with the TV lounge to the right.

Above The garden is designed as an extension of the interior spaces.

Below In the absence of distant views, light enters from above through carefully positioned clerestory windows.

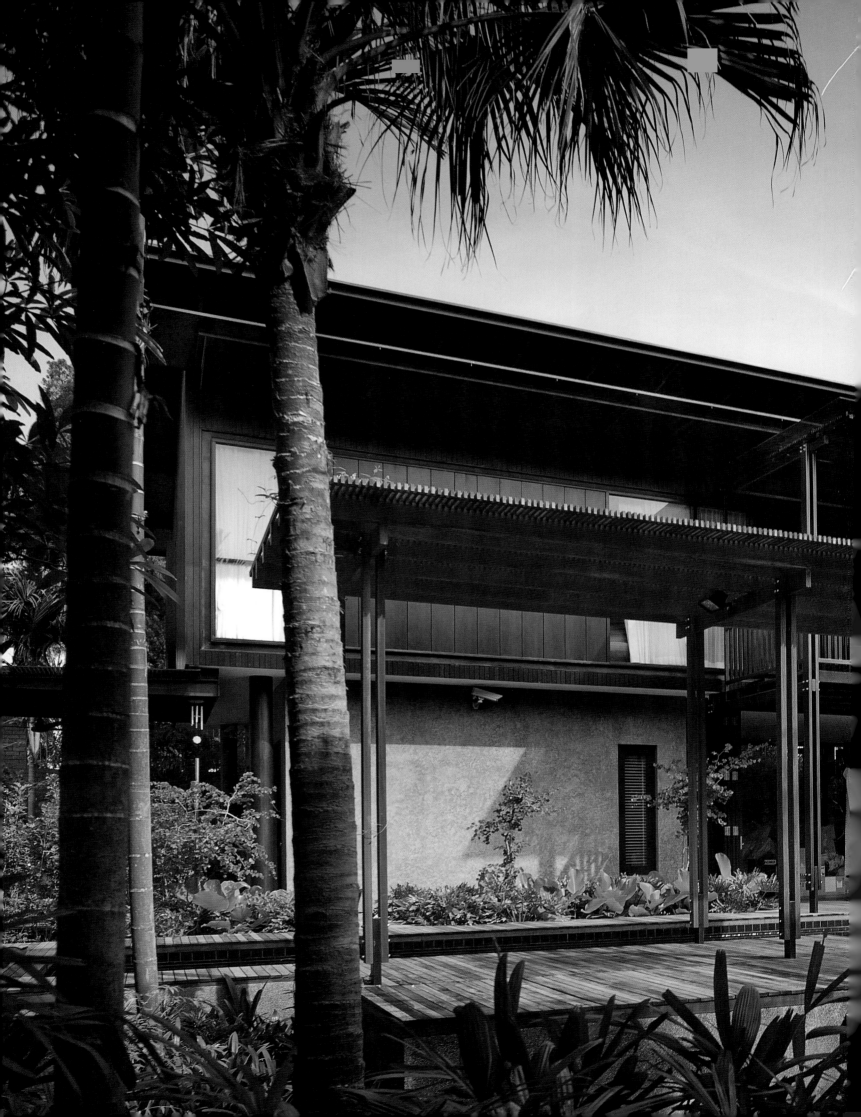

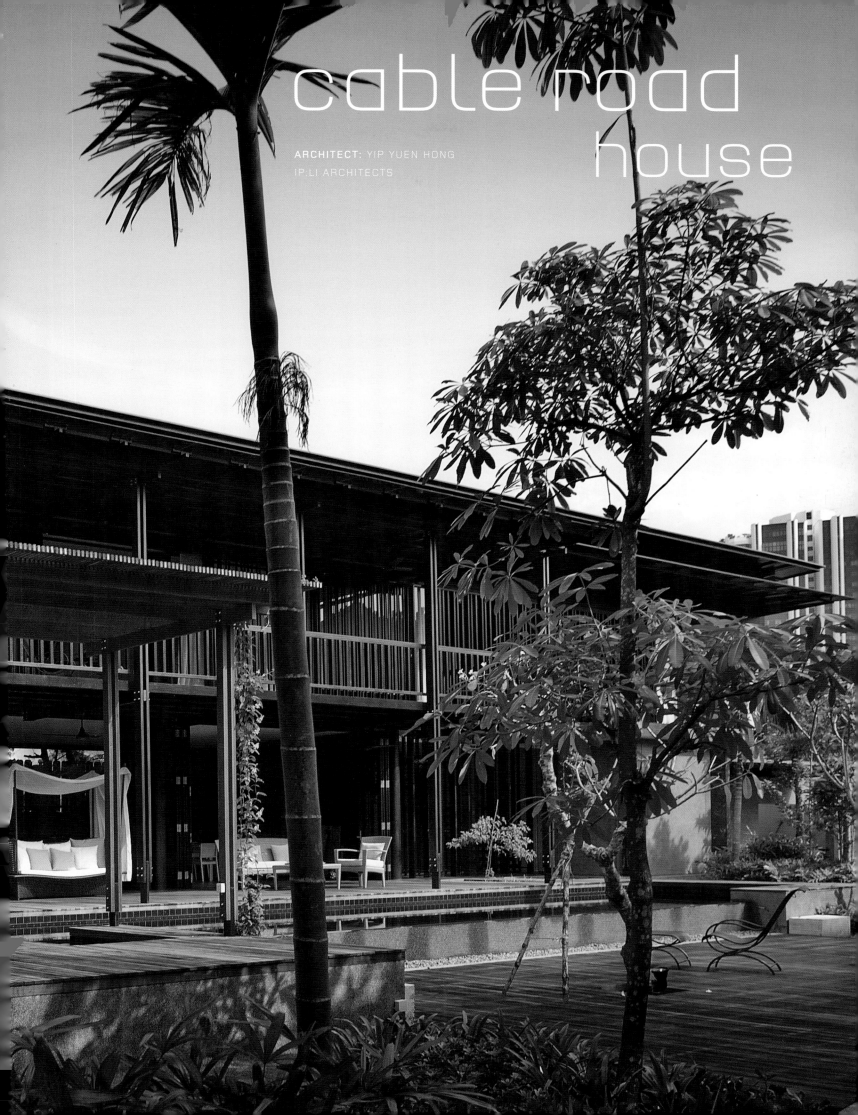

cable road house

ARCHITECT: YIP YUEN HONG
iP:LI ARCHITECTS

Yip Yuen Hong's strong affinity with both materials and craftsmanship is evident in his body of work, in which ordinary materials are given new expression. His projects are meticulously interrogated and detailed. Problem areas and limitations are perceived as avenues to stretch the creative process. This affinity with detail and appropriate scale was apparent even in his final year project (1987) at the National University of Singapore in his reconstruction of an Ellenborough Street shophouse (see page 217).

Yip has a particular interest in tropical architecture and is developing and refining a contemporary tropical language. He refers, perhaps in jest, to his residential projects as 'modern kampong houses'. The Cable Road house is best described as a 'pavilion in a garden'. The organization of the plan shows sharp clarity – at ground level, a long, rectangular pavilion houses a guest suite, the kitchen, the dining area followed by the living area, and a bedroom suite in a linear form.

This strong axial quality contrasts with the lateral views into the garden. Entry is via a linear entrance lobby on the southern flank, and immediately the quality of detailing is evident. Vertical glazed louvres form the south wall of the lobby, permitting natural ventilation.

The spacious living and dining area is flanked by sliding timber shutters on both the north and south elevations. The shutters are generally drawn back during the day, allowing the living space to extend out to timber verandahs and the luxuriant garden that encircles the house. The house is comfortable without the use of air conditioning, and when the shutters are open there is a constant gentle breeze. When a storm breaks, the ambience is enthralling as rain-water gushes off the pitched roof and plunges as a vertical sheet of water into the surrounding ponds.

Essentially, the house is a timber box perched atop a transparent base, with grey textured concrete planar internal walls and circular columns. Other materials used in constructing the house include timber, polished granite and hammercoat plaster. The location of the house does not permit any long vistas; consequently, the focus is inwards, with immediate views of landscaped courtyards, pools and lush gardens and a wonderful interplay of levels. The garden itself is 'under-designed', with an emphasis on simplicity, while the boundary of the site has been heavily planted to obscure the neighbouring properties.

Yip professes himself to be 'anti-design' in the sense that he believes design should not be placed on a pedestal and that it should be accessible to all. This is the most recent of four houses in which he has attempted to 'reinvent the kampong'. To do this, Yip looks to clues arising from the locality as well as regional influences. He seeks an 'organic adhockedness', yet the plan of the house has a disciplined grid. He looks for 'richness without overdoing it'.

The house is designed for a typical extended Asian family, with the upper floor primarily occupied by the owner and his partner and the lower floor seen as the domain of his mother. There is also a room for the owner's sister when she visits from the UK. Meals are taken communally on the lower floor.

In two decades in the profession, Yip has worked on a wide variety of projects, from individual dwellings to public housing. In discussing design, he speaks softly but with passion about the responsibilities of architects. There is a quiet rebelliousness in him, and it is perhaps no surprise that he worked for William Lim and Tay Kheng Soon, for who could not be infected by their zeal for reform in architecture and interest in cultural issues? He has also absorbed some of the social conscience that drew Liu Thai Ker to work in the relatively unglamorous sphere of public housing.

Yip's particular target is what he terms 'the culture of excess' in Singapore. He speaks passionately against excessive size, excessive Gross Floor Area (GFA) and excessive use of materials. 'Architects have a responsibility to build without being wasteful,' he asserts. He is appalled at the amount of waste that our modern lifestyle generates. 'To change things you have to start somewhere,' he continues. The parallels with like-minded architects in Malaysia, such as Kevin Low, is apparent, as is the choice of a name for the ip:li architects, which employs only a lower-case font (Low practises under the title 'small projects'). There is also a similar element of mid-career questioning of 'What am I doing?' and 'Where are we going?' Yip concludes, 'I am tired of prettiness.'

Left The linear swimming pool serves as a cooling device when the breezes blow from the south-west.

Right The house has wide eaves, permeable walls and shaded verandahs.

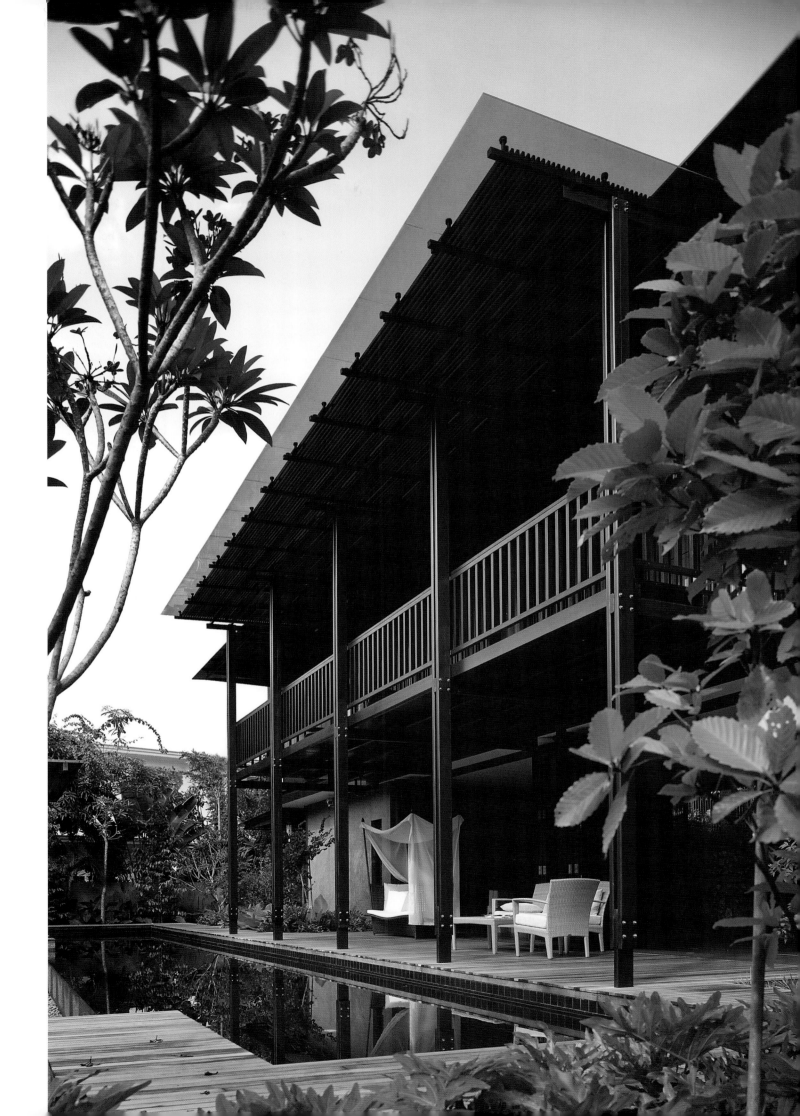

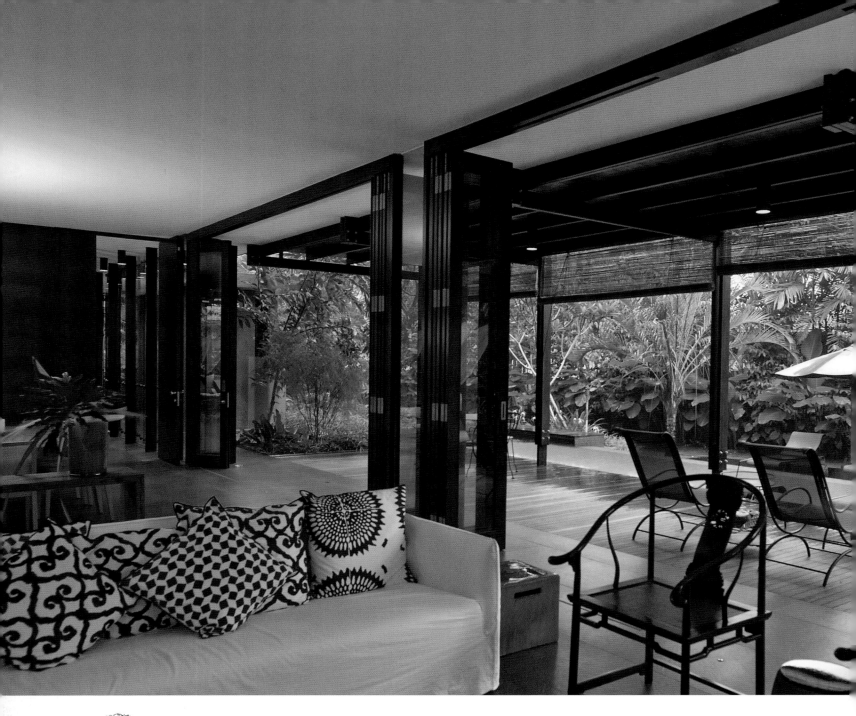

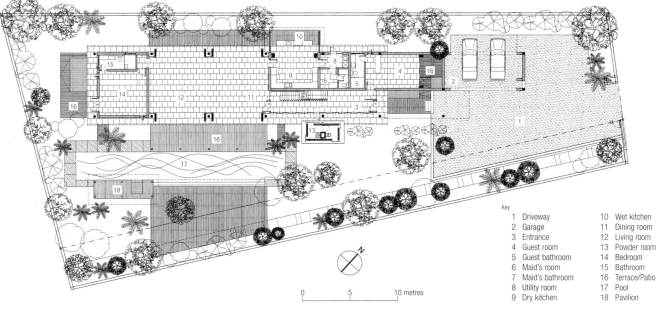

Key

1	Driveway	10	Wet kitchen
2	Garage	11	Dining room
3	Entrance	12	Living room
4	Guest room	13	Powder room
5	Guest bathroom	14	Bedroom
6	Maid's room	15	Bathroom
7	Maid's bathroom	16	Terrace/Patio
8	Utility room	17	Pool
9	Dry kitchen	18	Pavilion

0 5 10 metres

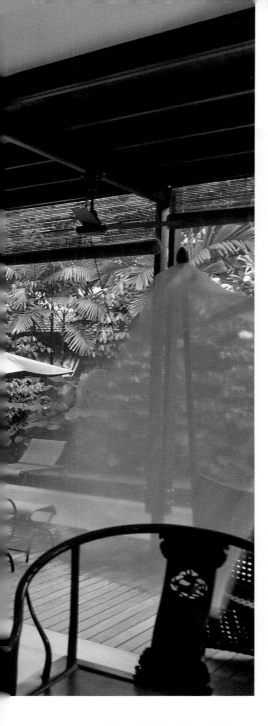

Above Orientated towards the south, the living room enjoys effective cross-ventilation.

Left First storey plan.

Right In the absence of long-distance views, the focus of the house is inwards, towards the landscaped garden.

Above The architectural language of the carport contrasts sharply with the dwelling.

Right The house has the openness of a kampong house or a twentieth-century 'Black-and-White' house.

Opposite top left Second storey plan.

Opposite top right The entrance lobby.

Opposite bottom The family room balcony overlooks the pool deck.

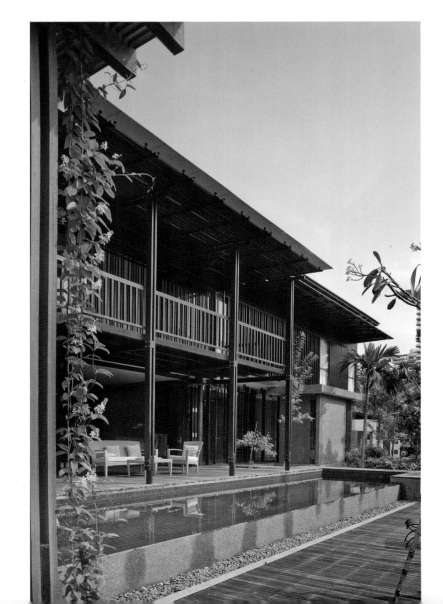

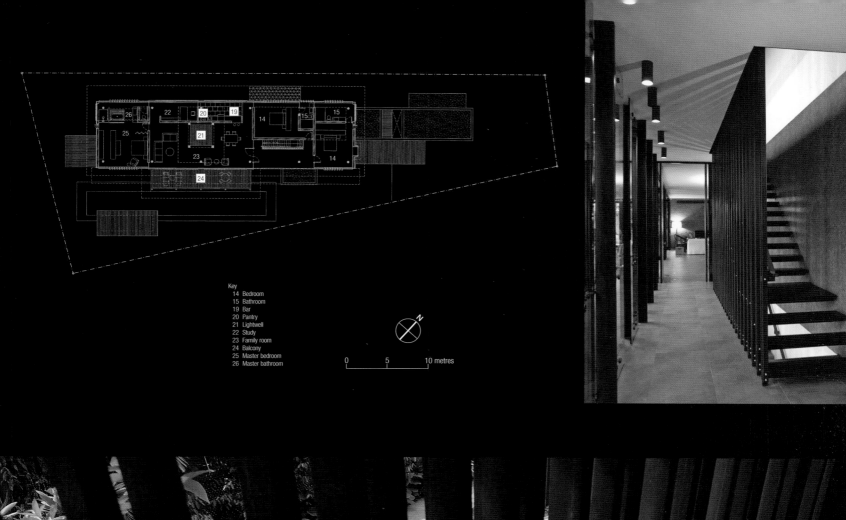

Key

14 Bedroom
15 Bathroom
19 Bar
20 Pantry
21 Lightwell
22 Study
23 Family room
24 Balcony
25 Master bedroom
26 Master bathroom

0 5 10 metres

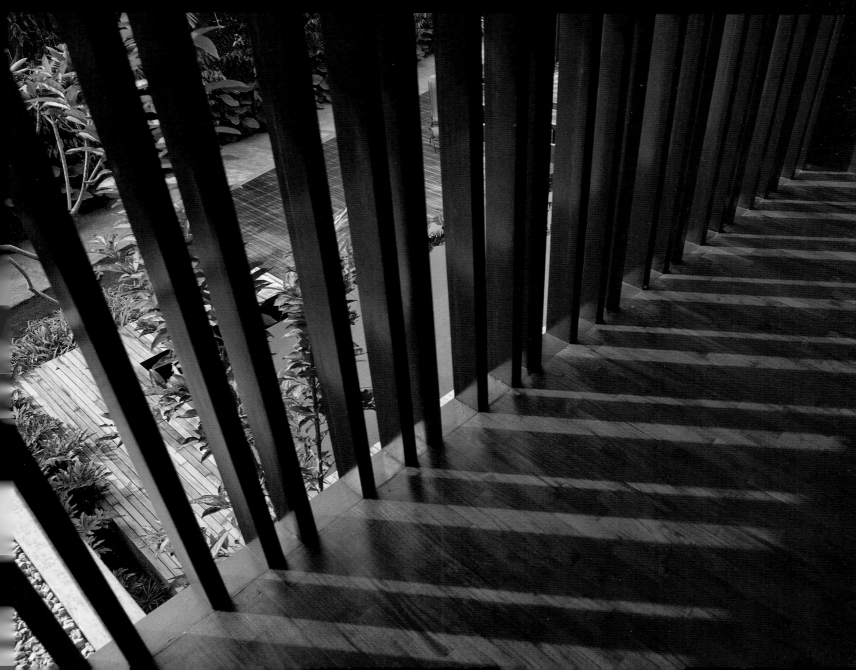

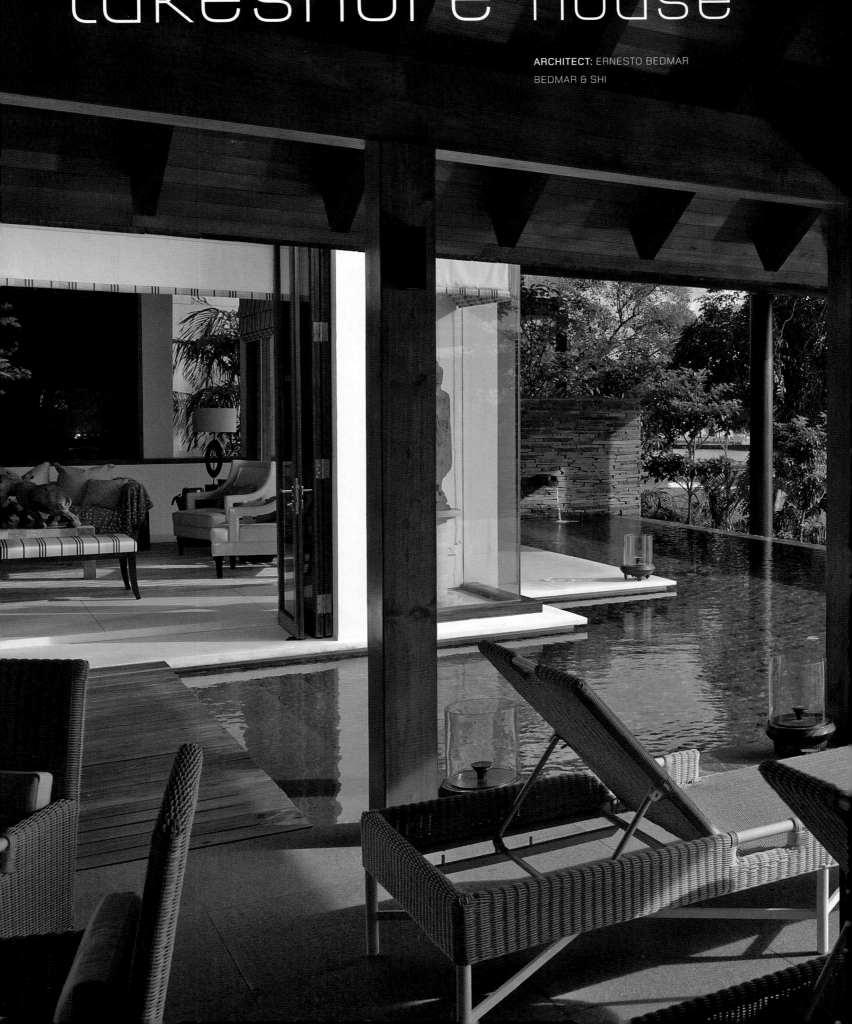

lakeshore house

ARCHITECT: ERNESTO BEDMAR

BEDMAR & SHI

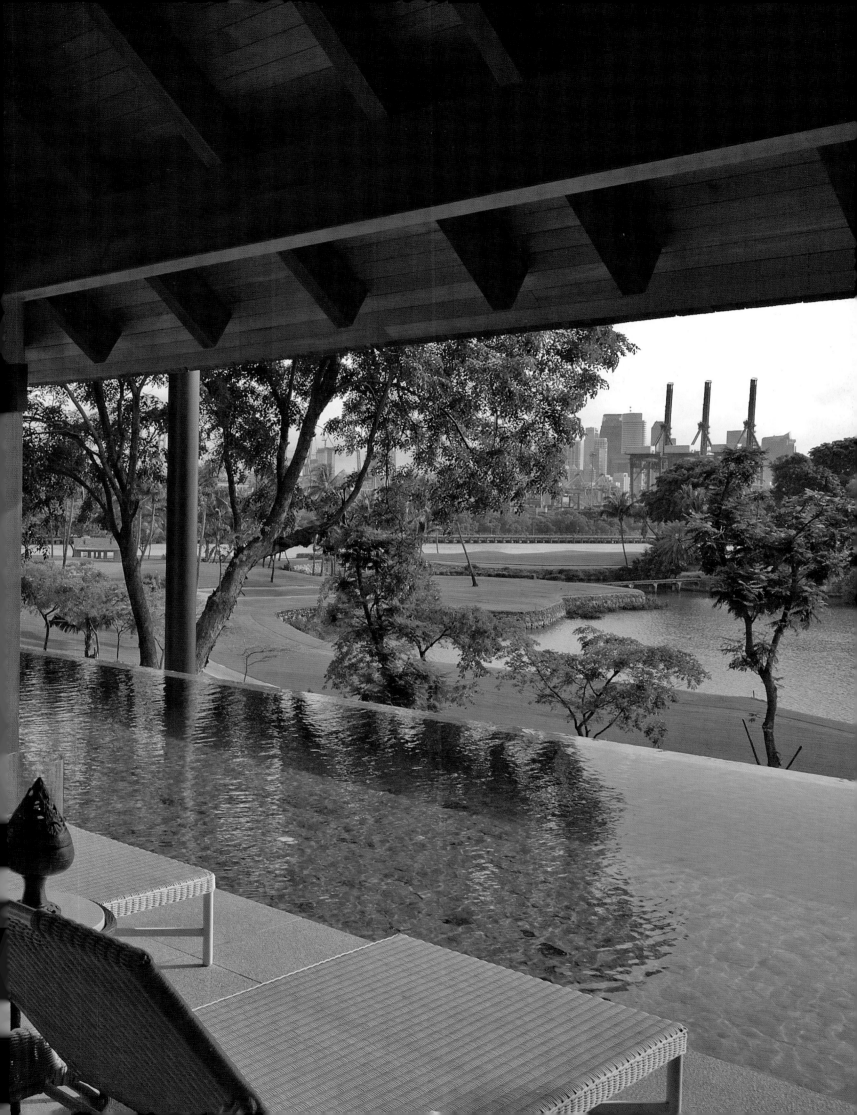

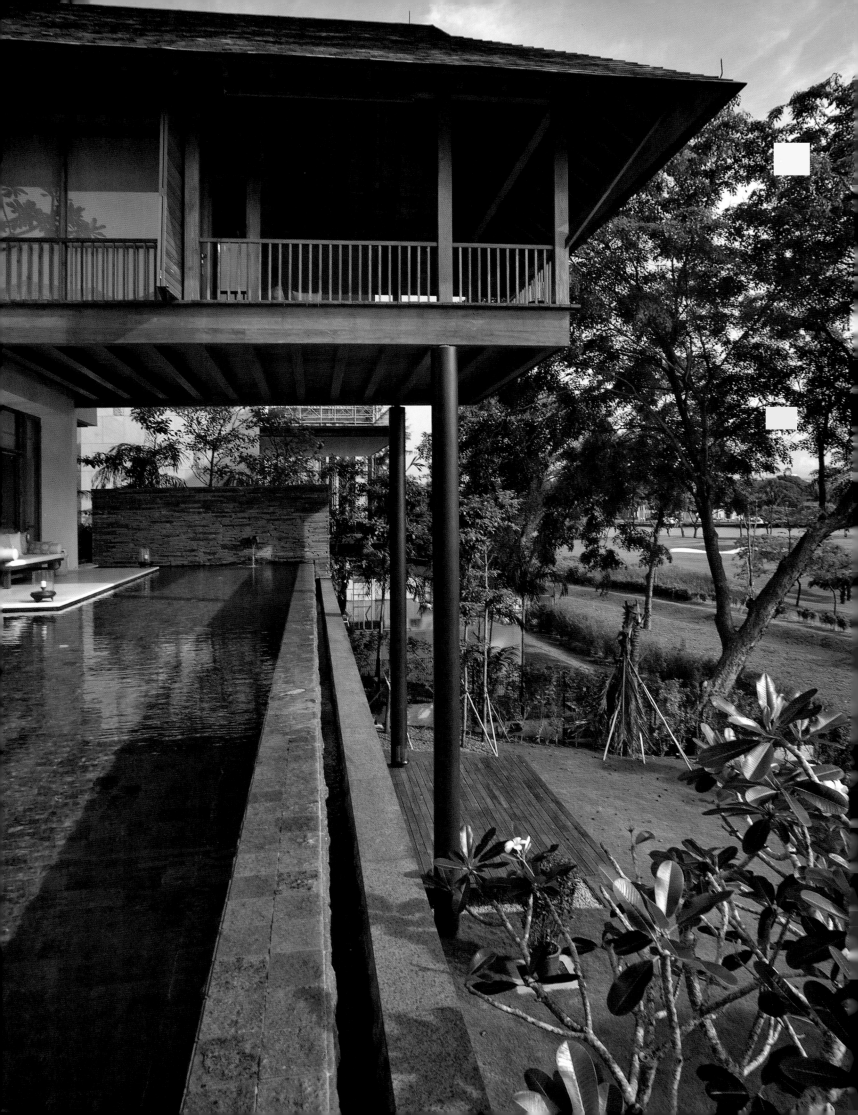

A graduate of the University of Architecture and Planning at Cordoba in Argentina, Ernesto Bedmar arrived in Singapore in 1984 via Hong Kong, where he worked in the office of his compatriot Miguel Angel Roca. Three years after his arrival and following a period of employment with SAA Architects and freelance work with Kerry Hill Architects, Bedmar and interior designer Patti Shi founded Bedmar and Shi Designers. Since then, he has been at the forefront of residential design in Southeast Asia and has acquired a reputation for architecture of understated elegance and sophistication. His tranquil dwellings and interiors are widely published.

Bedmar has always exhibited a remarkable ability to subtly condense memories within a dwelling. One of his earliest designs was the seminal Eu House (1993), which is often credited with changing the direction of residential design in the city-state of Singapore.

Upon entering the Lakeshore House, there is an immediate sense of calm that precedes a dramatic journey through a myriad of carefully orchestrated spaces, culminating in what is debatably the most stunning coastal view in Singapore, east over the Straits of Singapore and the merchant ships lying at anchor in the Eastern Anchorage.

Bedmar has opted for a contemporary vernacular form. He employs a familiar palette of materials and elements, including stone, timber columns, pergolas, projecting windows, louvres and cedar shingles on the pitched roofs.

As with his design for the Sadeesh House in Kuala Lumpur,[1] the joy of this house lies in its vertical and horizontal movement through space, the numerous 'surprises' along the route, the unexpected niches and places for quiet contemplation, the gushing fountains and placid dark ponds, the strategically placed vantage points, the unanticipated breezes, the interplay of roof forms, the penetration of light through a pergola, the sensuous ripple of waves on the pool, and ultimately, the kaleidoscopic effect of all these events. This is Bedmar's forte: architecture for the senses.

The house clings to the hillside. Essentially, all the major rooms look east towards the sea. Directly ahead, on entering the house from the entrance drive, is a spacious lobby that gives access to an anteroom preceding the master bedroom suite, with a covered verandah cantilevering over the lower floors. Turning sharply right, a sheltered walkway alongside a linear *koi* pond leads to two guest bedrooms.

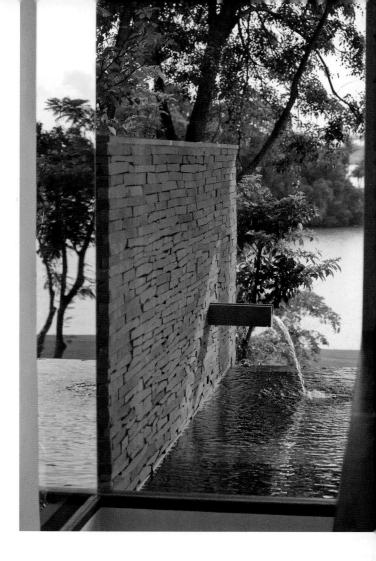

The backdrop to the pond is a substantial wall of uncoursed masonry, dramatically lit by sunlight filtered through a pergola. Above the guest bedrooms, at the very pinnacle of the house, is the owner's study, a veritable 'crow's nest', with a panoramic view of the horizon and a glimpse to the north through a horizontal slit window of protected forest.

Ahead and to the left of the entrance lobby, a flight of stairs descends along the northern flank of the house to the principal living areas that are assembled around three sides of a glittering swimming pool. The house is designed for an active client, but in anticipation of a time when the stairs become problematic, they are equipped with 'stair lifts'.

A spacious living area with an east-facing terrace forms the bulk of the accommodation at this level, but at the rear of the house, set hard against the hillside, is the formal dining room with framed views over the infinity pool. The kitchen is tucked away to the side of the dining room. The composition is completed by the addition of a gazebo or *sala* on the southern flank.

One level lower, and accessed by a further flight of stairs along the north flank, is an exercise and meditation room and a third guest bedroom with access via a timber deck to the lower garden adjoining a golf course. Beyond is the ocean. Viewed from below, the house, with its cantilevered master bedroom, supported by two tall, circular columns,

Left The master bedroom suite projects over the lap pool, supported on tall, circular columns.

Above A water spout cascades into the swimming pool.

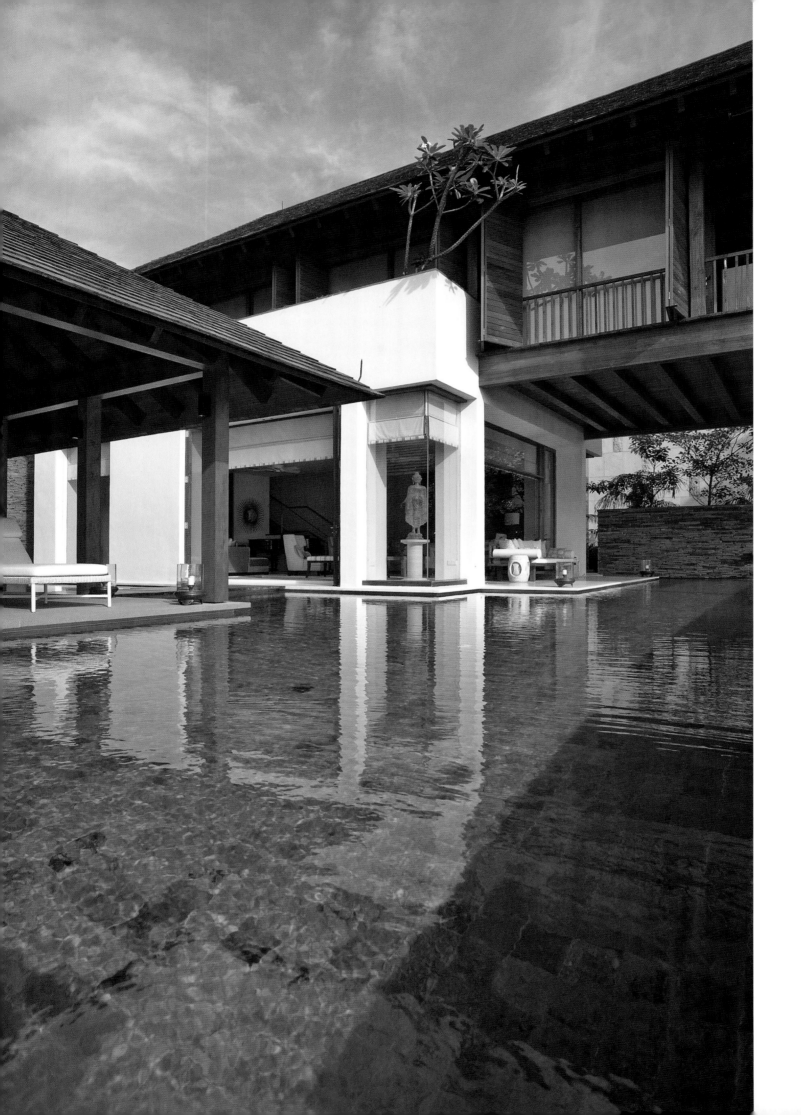

bears an uncanny resemblance to the renowned Datai Hotel at Langkawi designed by Bedmar's good friend Kerry Hill.

The Lakeshore House is a poetic solution arising out of a response to the site, the climate and a dialogue between global and local culture. The house has the intangible quality that Bedmar increasingly imparts – a spirit that is gentle and tranquil but never soporific.

While most of Ernesto Bedmar's work is located in Singapore, he has a body of work that extends throughout Southeast Asia. He has also received commissions in New Delhi, Lhasa (Tibet), London and New York. An exquisite monograph of his work, *Bedmar and Shi: Romancing the Tropics*,[2] was published in 2008, acknowledging Bedmar's recognition on the international stage.

[1] Robert Powell, *The New Malaysian House*, Singapore: Periplus Editions, 2008, pp. 58–65.
[2] Geoffrey London (Foreword Robert Powell), *Bedmar and Shi: Romancing the Tropics*, New York: Oro Editions, 2007.

Left A calm ambience pervades the house.

Right The guest bedrooms are accessed through a top-lit water court

Below left The dining room doors are thrown open to allow the prevailing breezes to enter.

Below right The lobby preceding the master bedroom.

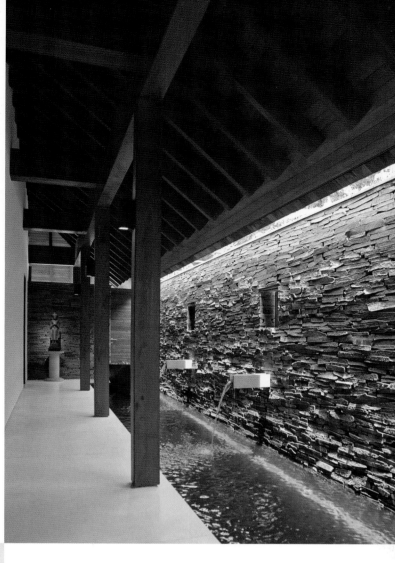

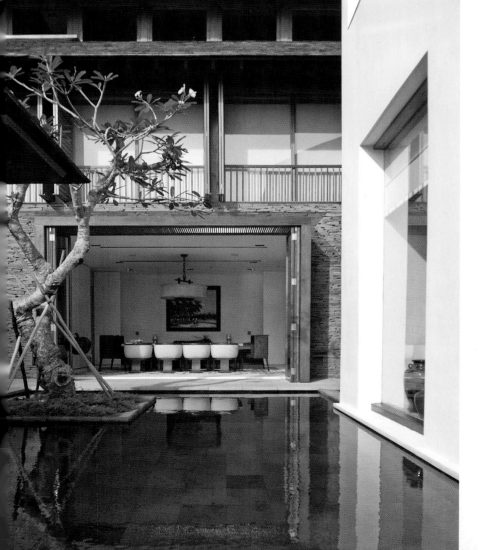

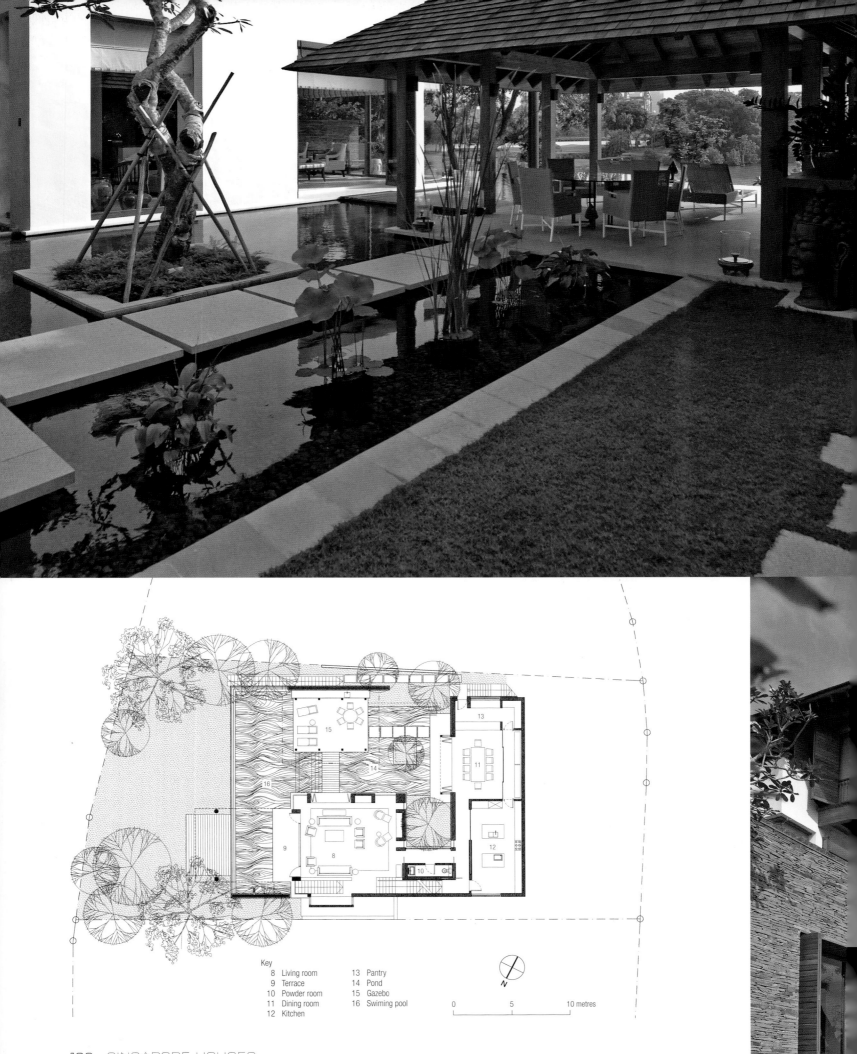

0 5 10 metres

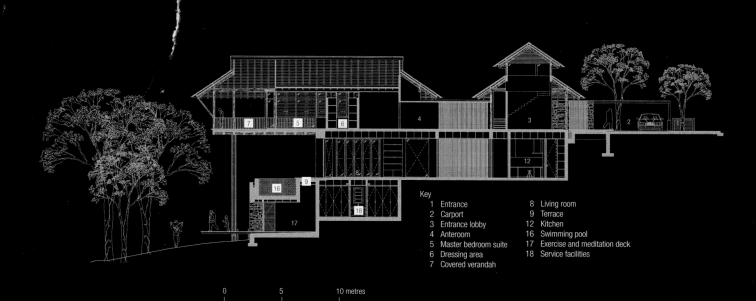

Key

1	Entrance	8	Living room
2	Carport	9	Terrace
3	Entrance lobby	12	Kitchen
4	Anteroom	16	Swimming pool
5	Master bedroom suite	17	Exercise and meditation deck
6	Dressing area	18	Service facilities
7	Covered verandah		

0 5 10 metres

Opposite above Three pavilions surround the water court.

Opposite below First storey plan.

Top Section through the steeply sloping site.

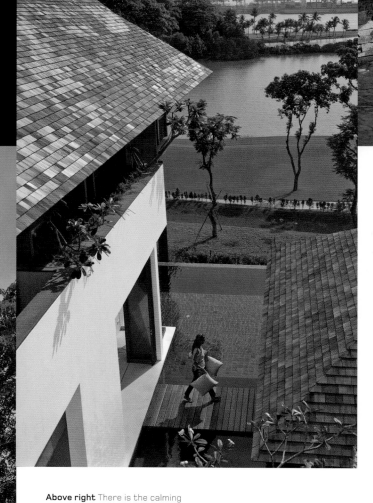

Above right There is the calming presence of water in a myriad forms.

Above View to the east from the study at the summit of the house.

Left An exercise and meditation deck projects into the garden.

bukit timah
house

ARCHITECT: RENÉ TAN
RT+Q ARCHITECTS

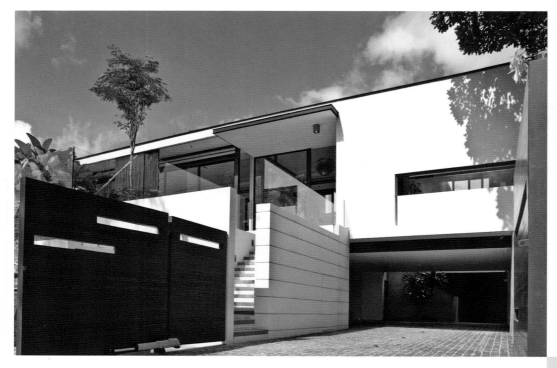

Upon graduation from Princeton in 1990, René Tan worked for four years, from 1990 to 1994, with Ralph Lerner in the United States. Earlier, as a student, he had spent three years working as an intern in the office of Michael Graves. In 1996, he returned to Southeast Asia and worked for seven years with SCDA Architects (1996–2003) before setting up the architectural firm RT+Q, in 2003, with veteran Singapore practitioner Quek Tse Kwang.

The years between 1994 and 1996 were important ones for Tan as he taught architecture for the first time, initially at Berkeley and then at Syracuse. They were pivotal and formative years in other ways. At Syracuse he met the late Werner Seligmann, who was not only a close colleague but also an inspired interpreter of Le Corbusier and Frank Lloyd Wright.

It is evident from his designs that Tan wishes to put some stylistic and philosophical distance between his work and that of his contemporaries. RT+Q are developing what he terms an 'alternative approach' towards the making of architecture, treating it more as a 'sculptural plastic art' than as an 'applied art' or a 'decorative art'. Tan believes that form, rather than materials, narrative or tectonics, is 'the true progenitor of architecture'.

Tan believes that it is the clarity and simplicity of forms in his work and the rigour in the execution of the details that attract clients. He also believes that while there is consistency in the output of the office, there is also a fresh and unpredictable aspect to every project. Operating like a studio, Tan and his partner Quek Tse Kwang are very 'hands on' and are involved in every aspect of the work, from concept to execution. In the execution of the Bukit Timah House,

Above The primary entrance is via a broad flight of stairs from the driveway.

Opposite top left An elegant circular stair descends from the entrance lobby to the carport.

Opposite top right A more private route to the central court.

Right The secondary entrance to the house from the rear of the carport.

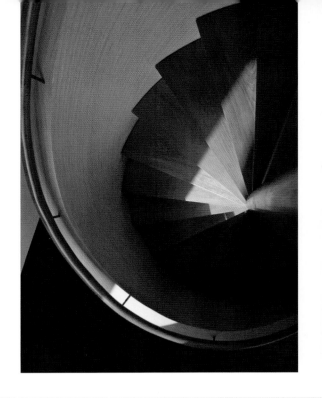
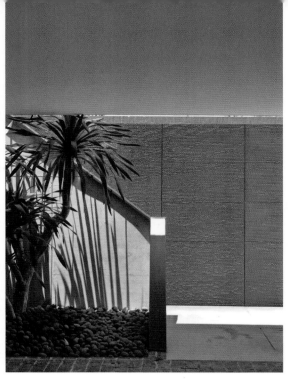
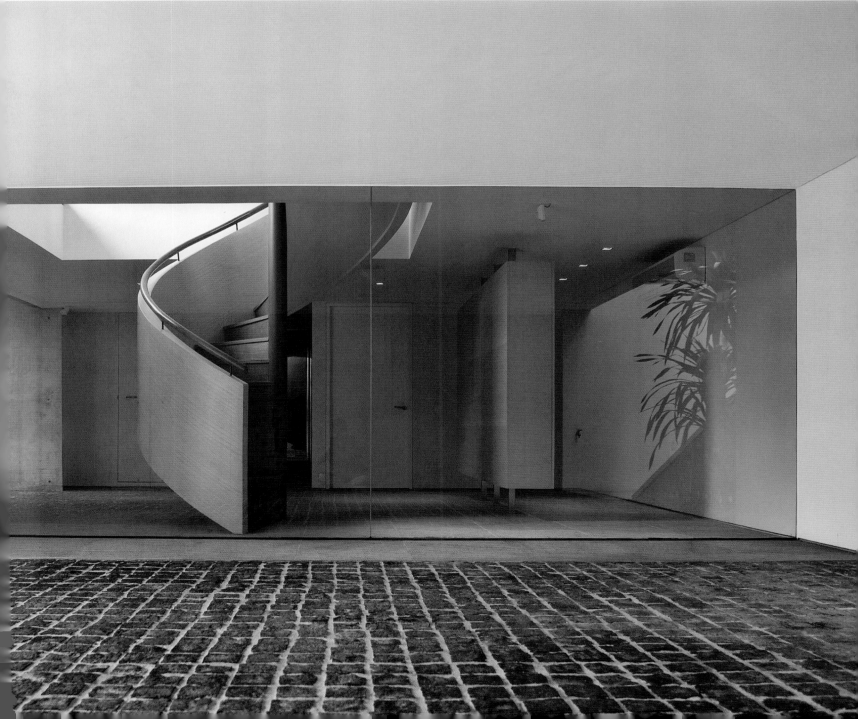

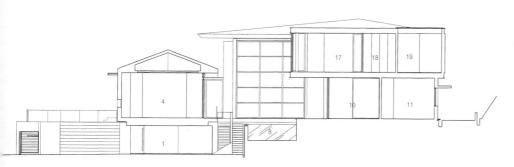

Key

1	Carport	11	Bedroom
4	Study	17	Master bedroom
8	Swimming pool	18	Master wardrobe
10	Family room	19	Master bathroom

0 5 10 metres

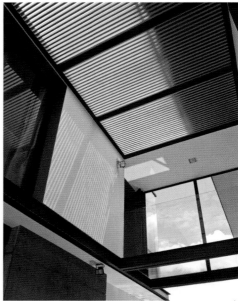

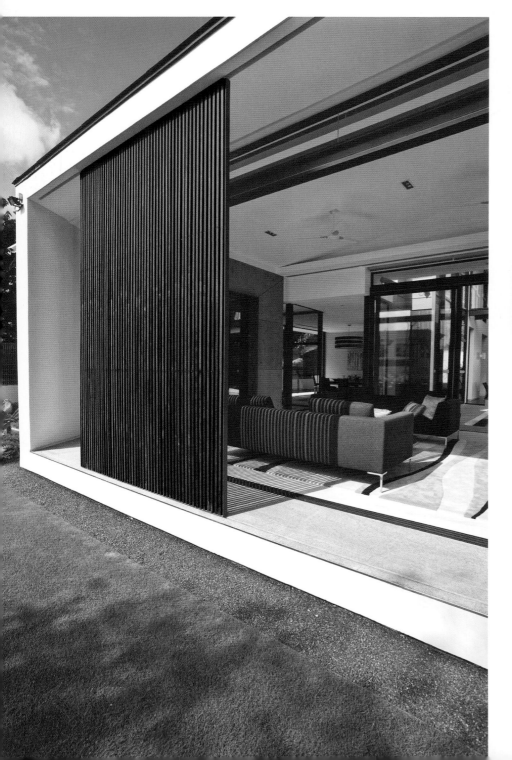

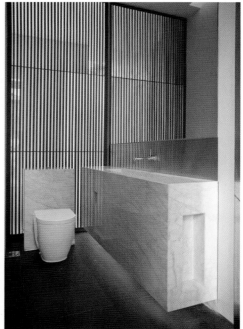

Top left Section through the pool court.

Top right Rooftop louvres filter sunlight.

Left The deeply recessed veran-dah outside the east-facing living room.

Above Detail of the powder room.

Opposite The single-width living room permits excellent cross-ventilation.

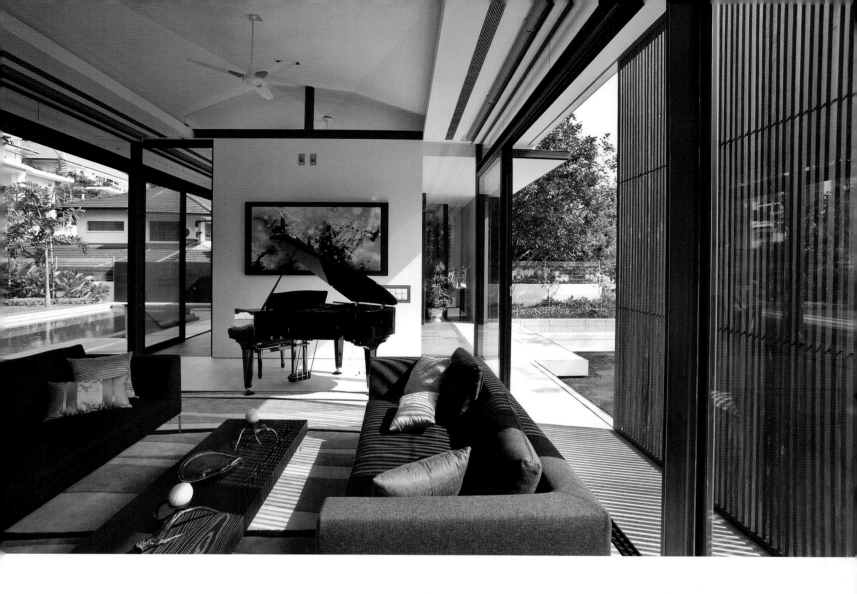

Tan was assisted by Angeline Yoo. The intimate size of the office, with 12–15 employees, enables and encourages a strong work ethic. In the design process, Tan employs free-hand sketches, computer graphics and 3D modelling as well as the more traditional and tangible cardboard and plastic modelling.

The Bukit Timah House, designed for two bankers, is entered at street level, one floor below the mean site level. From the sub-basement there are three options for ascending to the upper floors. An external flight of stairs located immediately to the right of the entrance gateway emerges at the first-storey entrance porch, while in inclement weather entry can be obtained from the undercroft into a spacious glass-fronted hall that is connected via an exquisite veneered circular timber stair to the first-storey lobby. A third option is revealed at the rear of the car parking bays – a narrow staircase climbs steeply to emerge in the central courtyard alongside the swimming pool, in the process bypassing the reception area.

The first storey consists of three pavilions arranged around the swimming pool. The 'public' spaces in the house are located in a single-storey, pitched-roof pavilion facing the road. The pavilion includes a home office, the principal reception area, which contains a grand piano, and the upper level of a two-storey wine cellar.

Crossing a short bridge to a two-storey pavilion, access is obtained to the formal dining room surrounded by a narrow water channel, and thence, via a wide circulation corridor skirting the swimming pool, to the spacious kitchen. Adjacent to the dining room is a staircase giving access to the family room and two bedrooms at the upper level. Finally, a third pavilion, this also a two-storey structure, contains a sitting room that opens to a timber deck projecting out to the swimming pool, a guest bedroom and the master bedroom suite, accessed via a glass bridge at the upper level.

René Tan describes the design as 'an exercise in abstraction and the plasticity of form' where 'the house examines the notion of architecture as a plastic event'. It nonetheless performs the functions of traditional architecture with its overhanging eaves and cantilevered roofs.

The success of RT+Q in the design of single dwellings has led to larger commissions in Singapore. The practice is also working on office buildings, resorts and condominiums in Malaysia and Indonesia.

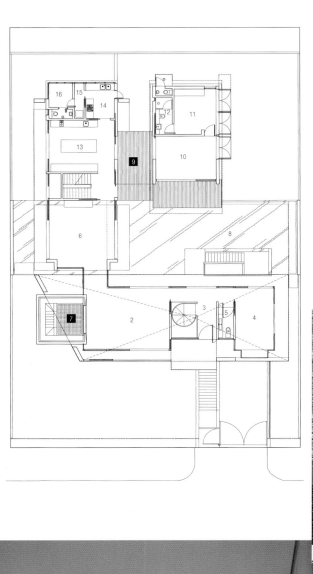

Key
2 Living room
3 Upper foyer
4 Study
5 Powder room
6 Dining room
7 Wine cellar
8 Swimming pool
9 Breakfast patio
10 Family room
11 Bedroom
12 Bathroom
13 Dry kitchen
14 Wet kitchen
15 Laundry
16 Maid's room

Left First storey plan.

Below left Careful attention is
paid to the design of bathrooms
and powder rooms.

Below right The private route
to the central water court.

0 5 10 metres

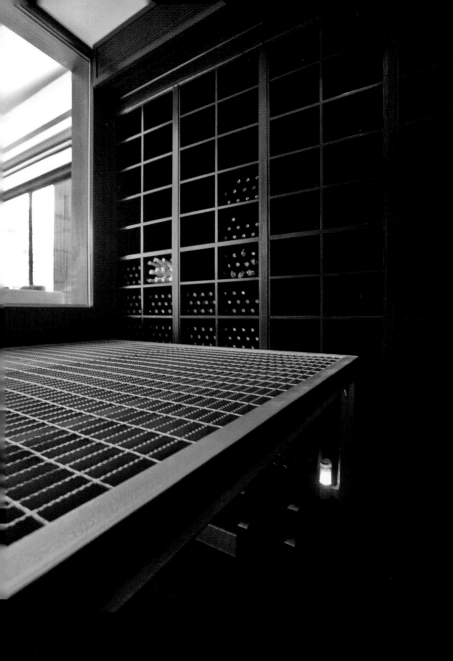

Left The well-stocked two-storey wine cellar.

Above A broad flight of stairs ascends to the entrance lobby.

Below Evening view across the pool to the study and living room.

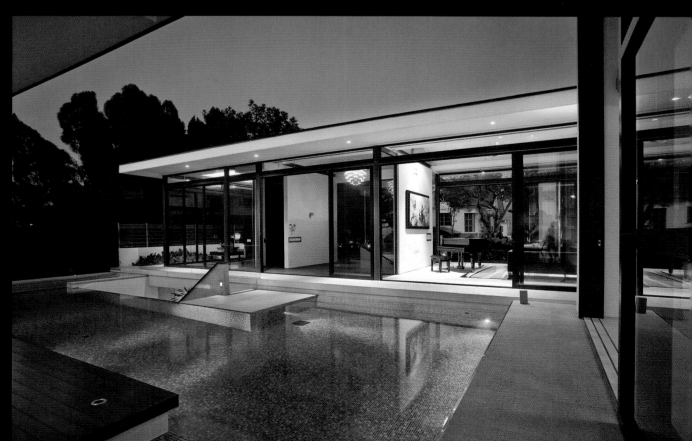

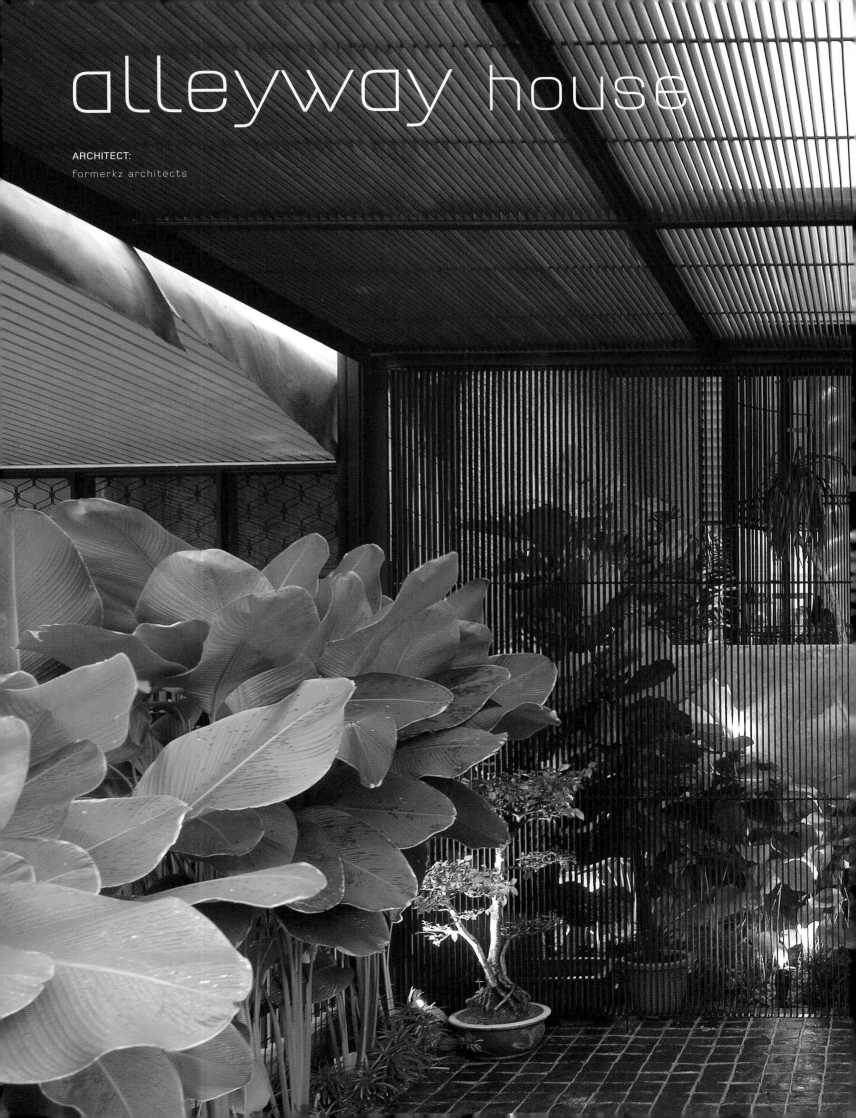

alleyway house

ARCHITECT:
formerkz architects

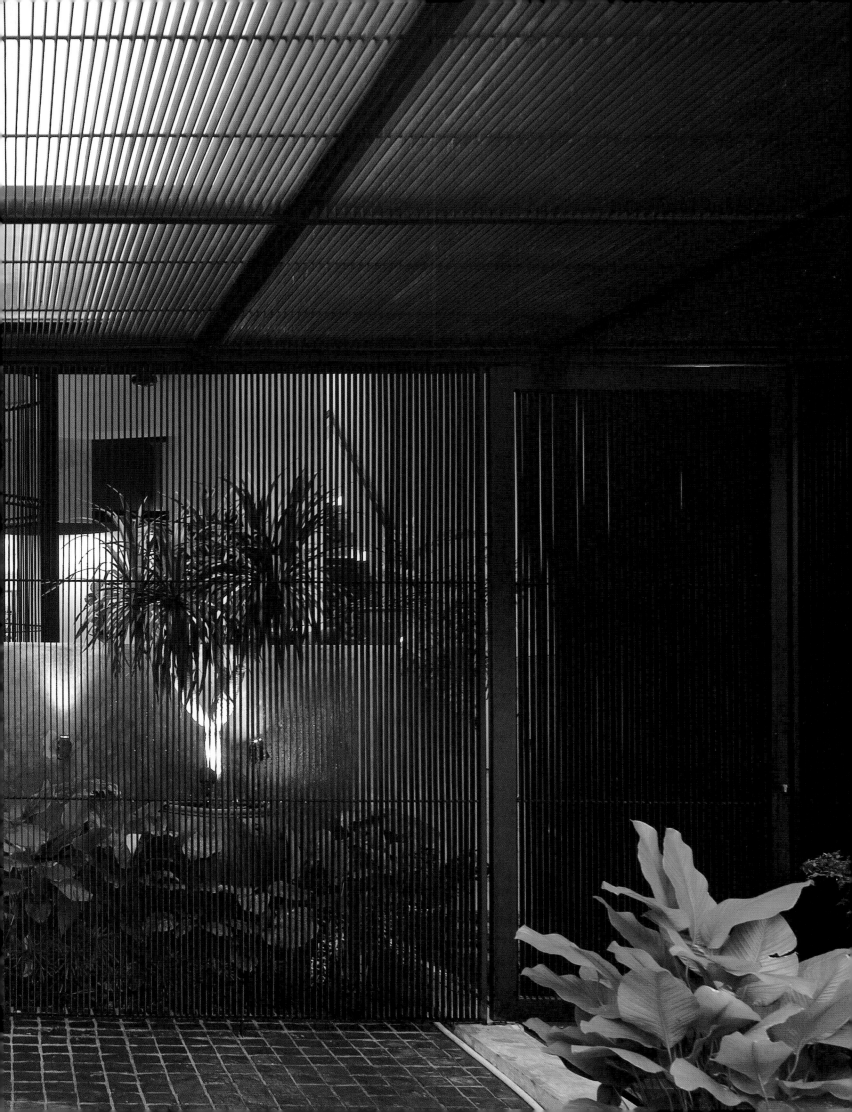

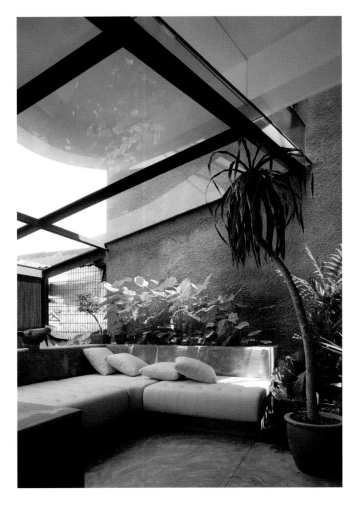

Top A circular aviary is at the very centre of the first-storey plan.

Above The front wall of the house is a fixed mild steel screen.

Opposite The floor and table are finished in polished cement.

Formwerkz architects is a co-operative where each of the four partners share equally in the workload and proceeds. Alan Tay, Gwen Tan, Berlin Lee and Seetoh Kum Loon, four graduates of the National University of Singapore, set up the firm in 2005. 'Initially we develop projects together and subsequently one of us will manage the construction,' says Tay. 'Even if we do handle a project individually, we constantly critique each other's work.'

Tay graduated in 2000. His final year tutor was Associate Professor Jim Harrison, who had a deep interest in architecture that addressed social issues, and Tay went on to work with Aamer Tahir Design Studio before setting up formwerkz architects. He was joined by Gwen Tan, another graduate of 2000, who studied under Associate Professor Bobby Wong Chong Thai; Berlin Lee, who graduated in 2001 and is currently involved in the business development of the company, and Seetoh Kum Loon, a 2002 graduate, whose mentor was Professor Heng Chye Kiang.

They collectively refer to Rem Koolhaas, Steven Holl, Geoffrey Bawa, Carlo Scarpa, Oscar Niemeyer and Glenn Murcutt as sources of inspiration and *S,M,L,XL* and *The Invisible City* as the books that have been most influential on their ideas.

The Alleyway House (otherwise known as the Carmen Terrace House) is designed for a household with a passion for pets. The family owns three small dogs and two parrots. The animals are very much a part of the family, so much so that the house is designed around provision for animals and humans and considers how they interact. The house is unusual in that it is not merely a dwelling for people but is equally a home for their pets. The physical and psychological needs of both are carefully interwoven, and the life of the parrots and the dogs is integrated into the lifestyle and routine of the household.

This is a radically different approach; usually, human needs are dominant and the animals are secondary, but the care and attention given to the latter is expressed everywhere in the planning of the dwelling. A circular parrot cage forms the central feature of the house. It is a two-storey vertical iron structure that enables the two parrots considerable freedom. The two birds are frequently the subject of conversation and occasionally interject a phrase of their own.

Similarly, the three excitable small dogs are demanding of attention and have an inordinate interest in visitors' feet. They compete for attention but are not given to quarrels. The house is akin to an animal sanctuary, and in some ways recalls a lost rural heritage when animals were a much larger and more important part of Singapore households. Woven around this is the life of the human occupants – a businessman, his wife, a newly born baby, his mother and his sister, who is mostly 'outstation'.

This is essentially a small, very informal terrace house. Its designers describe it as 'the Alleyway house', and indeed it evokes memories of the life that often took place in the rear lanes in Jalan Besah, Kampung Glam and Chinatown, which

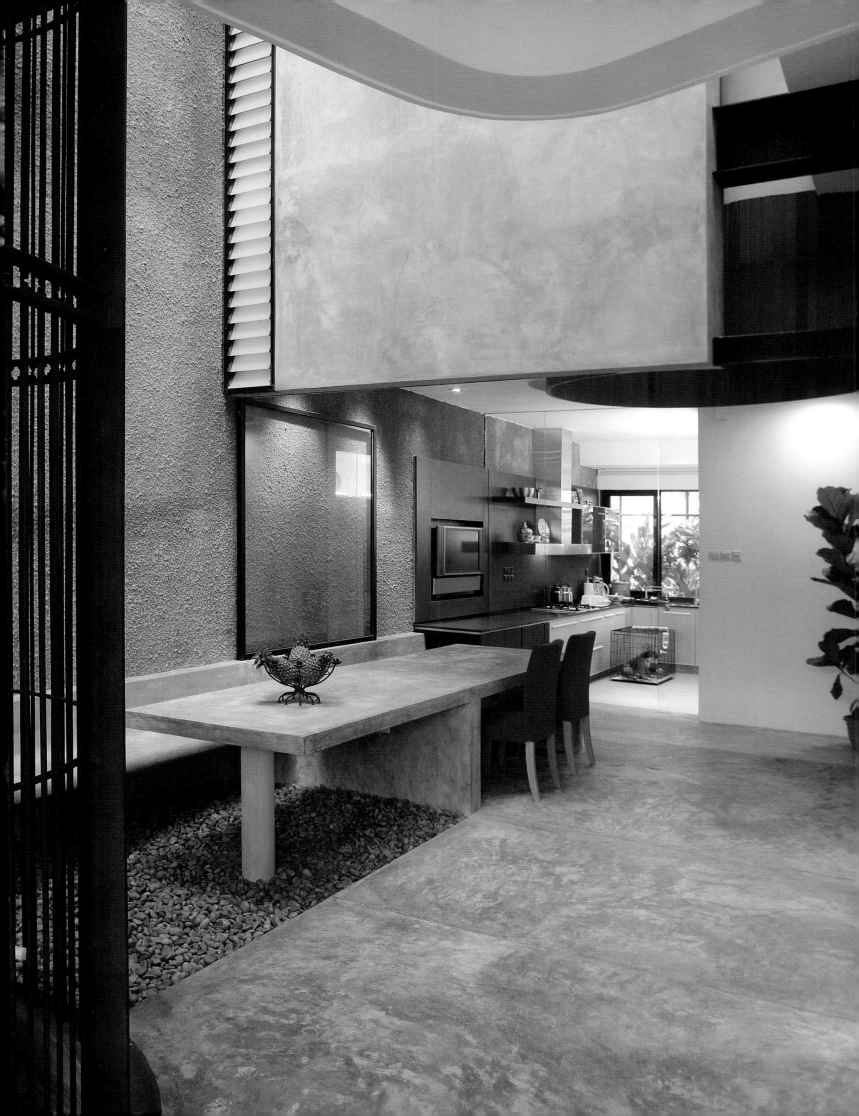

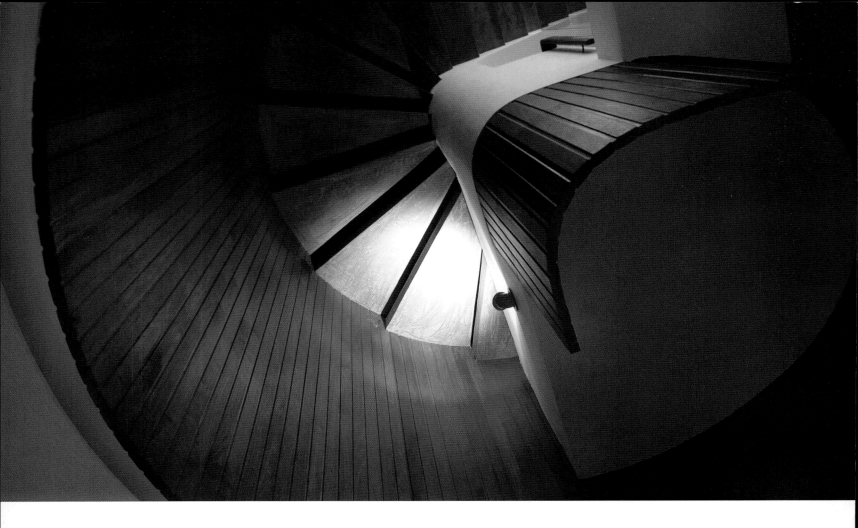

saw the extension of family life into the 'public' space. These connections to the past are made deliberately.

Even with the best of intentions, pets can have 'accidents', and so the floor at first-storey level is made of polished cement screed to allow for easy cleaning. The environmental requirements of a house designed with potential 'odour' has led to a completely open cross section, with no door at the front of the house and no wall at the rear.

The front wall of the house is a fixed mild steel screen, very much like a veil, that integrates with the main access door of the house. It allows for security and cross-ventilation all through the day. The rear of the house, which faces the neighbour's yard, is also open, with security provided by a metal fence. This openness also allows the owner's mother to converse with her neighbours 'over the wall'. This traditional aspect of neighbourliness is often erased in contemporary housing concerned with setbacks, privacy and security. There is a delightful informality about the house that exactly matches the lifestyle of the occupants. This is enhanced by a strong sense of materiality.

Internally, there is an engaging interplay of space and form. The design revolves around the circular iron cage that is extended upwards to become a tower housing a shower cubicle in a tall, glazed drum that also conceals a water tank. The high party wall on the west side of the terrace house assists in channelling breezes. The wall is rough plaster

render to permit climbing plants to grow on its surface. A landscaped internal garden is flooded with daylight from above in much the same way that a traditional lightwell operates, while at roof level there is a 'secret' garden.

Alan Tay writes of the house: 'Situated in an unfashionable low-rise neighbourhood, the two-and-a-half-storey terrace house is landlocked, with party walls on both flanks and another property at the rear. The house is conceptualized as a linear space containing multiple activities, such as the polished concrete table that grows out of the ground, the open kitchen, the flat screen TV on the party wall and the central parrot cage. Light fittings are set into the walls. The porosity of this linear space is crucial for effective ventilation.'

Gwen Tan adds: 'Carmen Terrace was a very special project for our firm as all the partners contributed to various aspects of the house in terms of ideas or details. We had intense debates and also numerous late night sessions working on it, as we wanted to dissect, explore and reinvent a terrace house typology. We spent many hours resolving materials and developing details on site due to the complexity of spatial volumes.'

In 2008, the house received a Design Award from the Singapore Institute of Architects. The strength of the firm lies in its ability to move away from generic residential solutions to individually tailored one-off solutions that reflect the individuality of their owners.

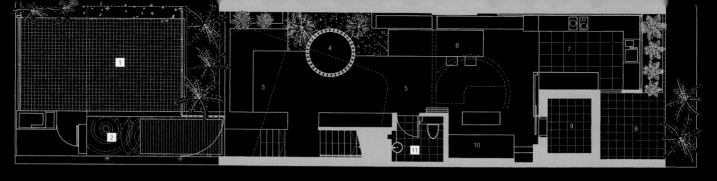

Key
1 Carport
2 *Koi* pond
3 Living area
4 Parrot cage
5 Court
6 Dining area
7 Kitchen
8 Yard
9 Defence shelter
10 Family lounge
11 Powder room

0 5 10 metres

Opposite The circular aviary extends up to form a tower.

Top First storey plan with the aviary at the heart of the family space.

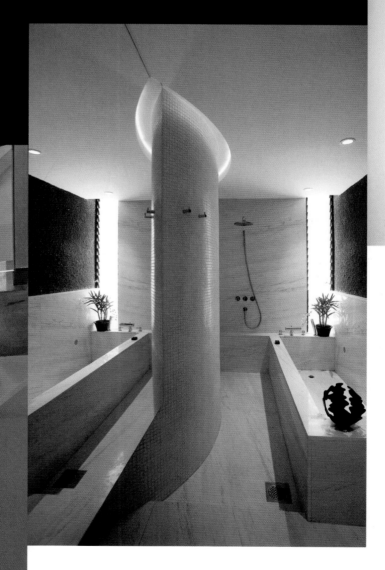

Left Detail of the open-riser staircase.

Above The second-storey bathroom.

Above right An elegant handrail detail.

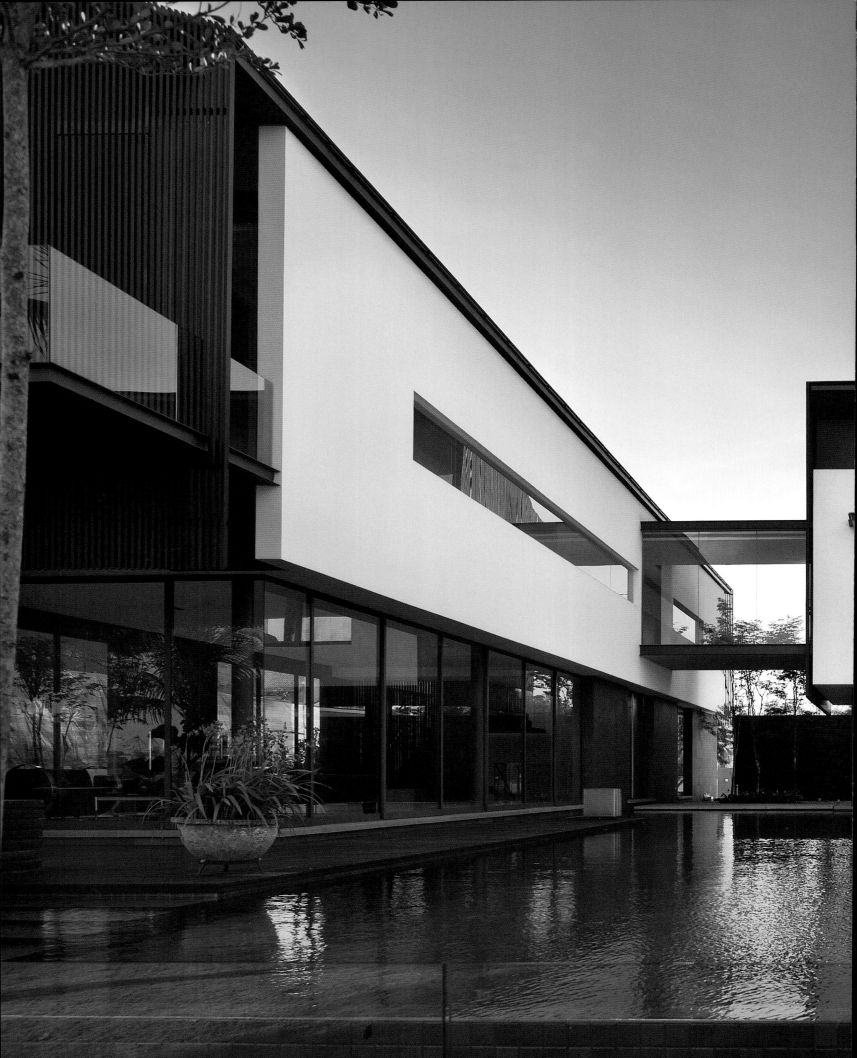

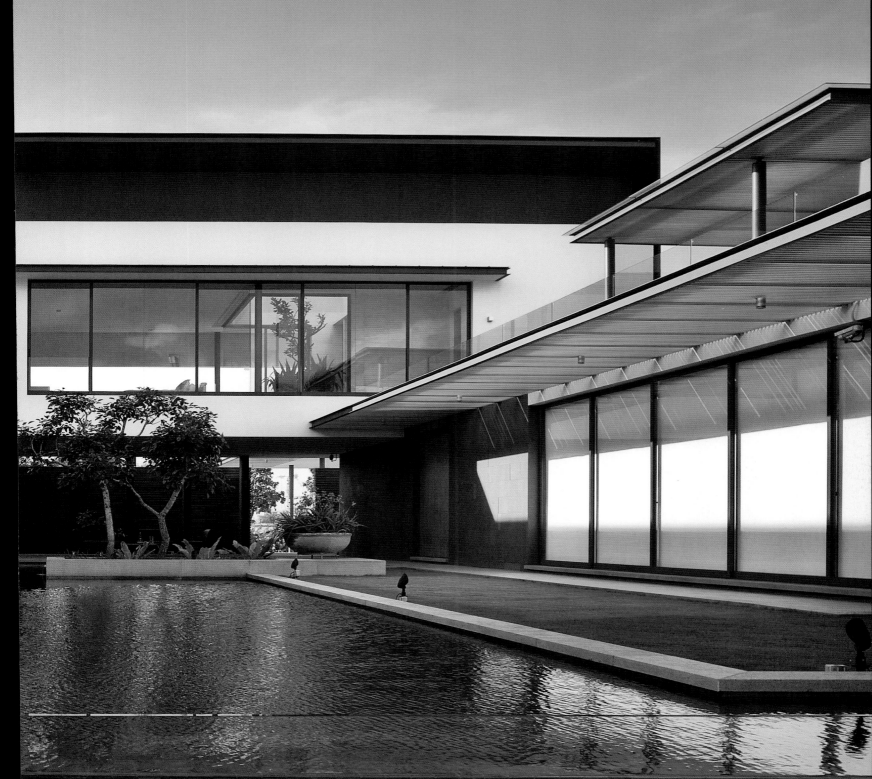

harbour view
house

ARCHITECT: CHAN SOO KHIAN

SCDA ARCHITECTS

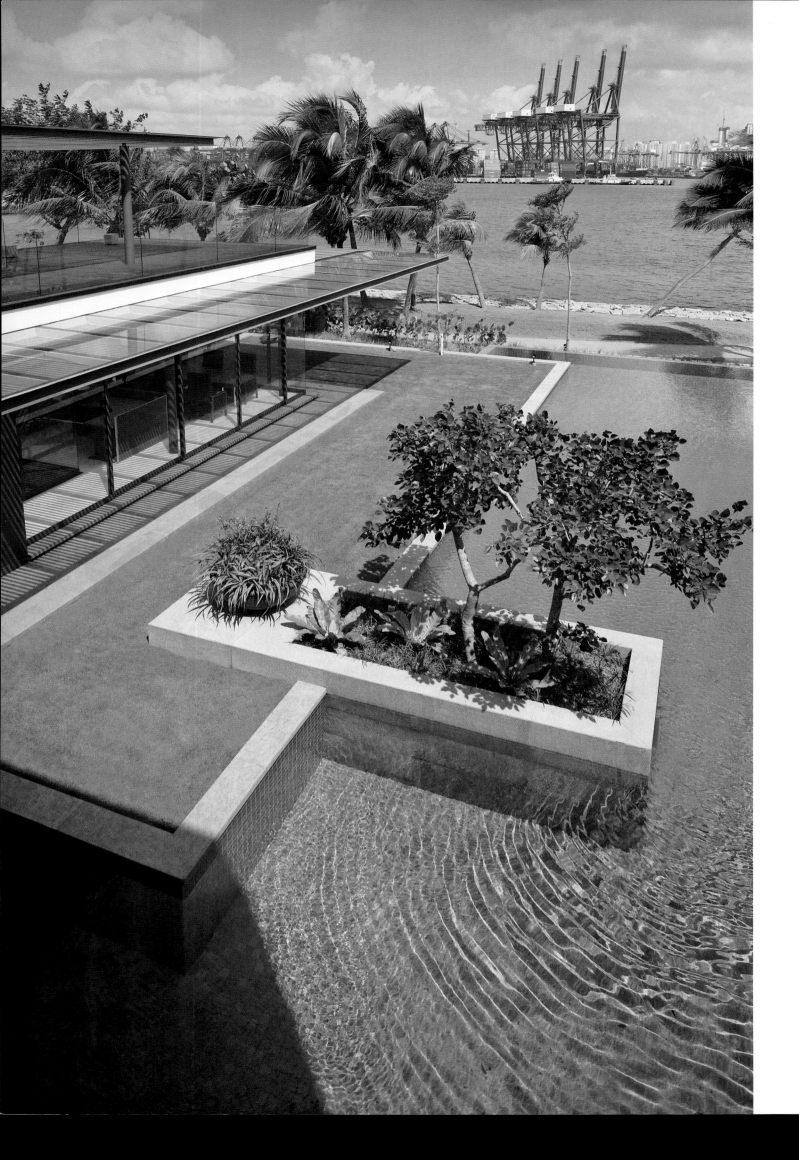

Located on the north shore of Sentosa Cove, the Harbour View House enjoys one of the most breathtaking sites on the island, with spectacular views directly across the water towards Pulau Brani, an extension of the Tanjong Pagar container port – the *raison d'être* of Singapore's existence – and the constant movement of container vessels.

Designed as a second home for an avid golfer, this spacious seaside dwelling is used for entertaining an extended family, friends and business partners. The house has a 'U'-shaped plan consisting of two wings (east and west) connected by an entry pavilion on the southern façade, which are organized around a deep courtyard. The two-storey east wing houses the main living areas, while the single-storey west wing is assigned to a home office and entertainment areas. Linking the two is the entrance patio, with the master bedroom suite above.

Entry to the house is expertly choreographed through a series of spaces in the inimitable style that is the hallmark of Chan Soo Khian's architecture. A stone wall faces the vehicular driveway and initially conceals the entry court. The monopitched roof of the two wings 'floats' above this wall. Formed with aluminium sections, the roof wraps around the sides of the second storey, creating a strong datum. Crossing a stone bridge, through an aperture in the anterior wall, the visitor arrives at an entry pavilion surrounded by a pond. The space extends to embrace a swimming pool and lawn. The seafront view beyond the pool is 'stretched' by the large expanse of reflective glazed areas on the ground floor of the east and west wings.

Arriving at the 'centre' of the plan, the visitor turns to the right and encounters the larger of the two wings, which contains the principal living and dining areas. This wing is entered across a stone platform beneath a flying bridge that links the east wing to the south wing. The experience of the interior is delayed and anticipation is heightened. The bedrooms on the second floor are placed on the east-facing elevation, while the corridor on the west has a horizontal slit window that offers a dramatic view over the broad court to the shipping lanes.

To the west is the more 'public' wing, where a meeting room, working space and entertainment room are located. This is a single-storey structure with a timber roof deck and viewing gallery, which looks out over the port. Accessed via a steel spiral staircase, the deck is partially covered by a glazed roof. This secondary roof, together with deep projections over the extensively glazed ground floor, provides shade from the sun and protection from the rain. The master bedroom suite, located above the entrance pavilion, has an open plan with an open-to-sky internal courtyard that brings natural light and ventilation into the master bathroom and walk-in wardrobe areas.

Restrained in its language, the Harbour View House stands out for its precision and clarity of form among a disparate assortment of recently constructed dwellings.

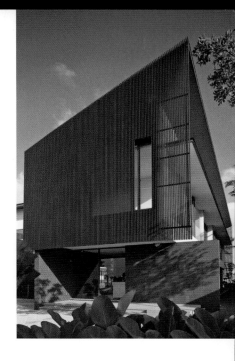

Opposite Superb views of Singapore's container port – the life-blood of the island.

Right The upper floor floats above a transparent first storey.

Below Entering from Ocean Drive, there are framed views of Pulau Brani.

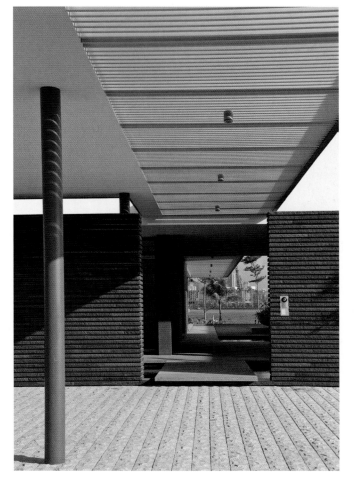

In 2002, Chan received the Architecture Review (UK) Merit Award for Emerging Architecture, an award that confirmed his growing international reputation, a judgement endorsed by the selection of SCDA by Architectural Record (USA) as one of their Year 2003 Design Vanguard firms. In 2006, Chan was presented with the SIA-Getz Architecture Prize for Emergent Architecture in Asia.

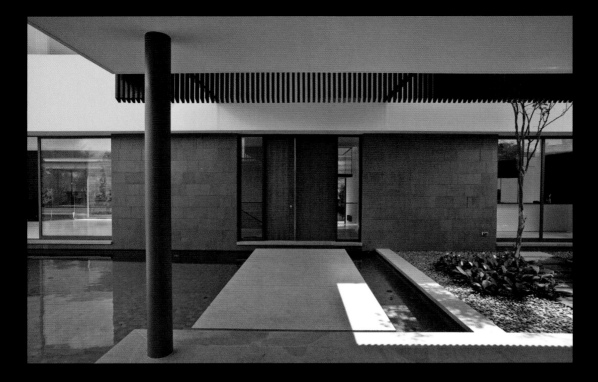

Above Access to the east wing from the entrance pavilion.

Below The kitchen at the back of the house.

Opposite top With the constant arrival and departure of container vessels, the evening view from the living room is magical.

Opposite bottom Second storey plan.

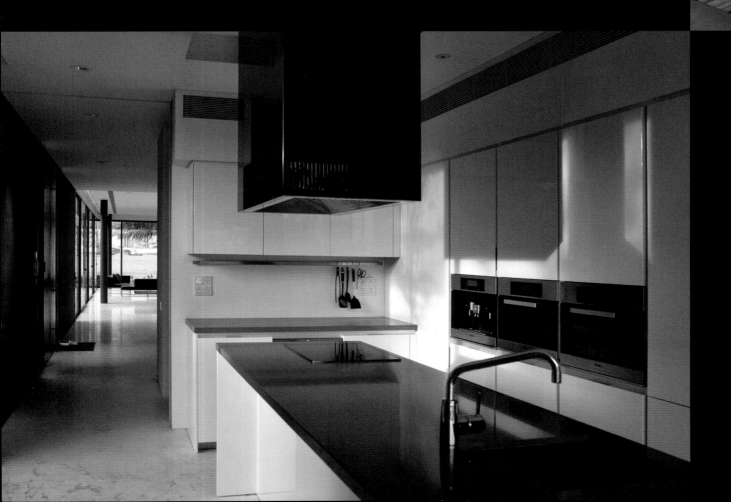

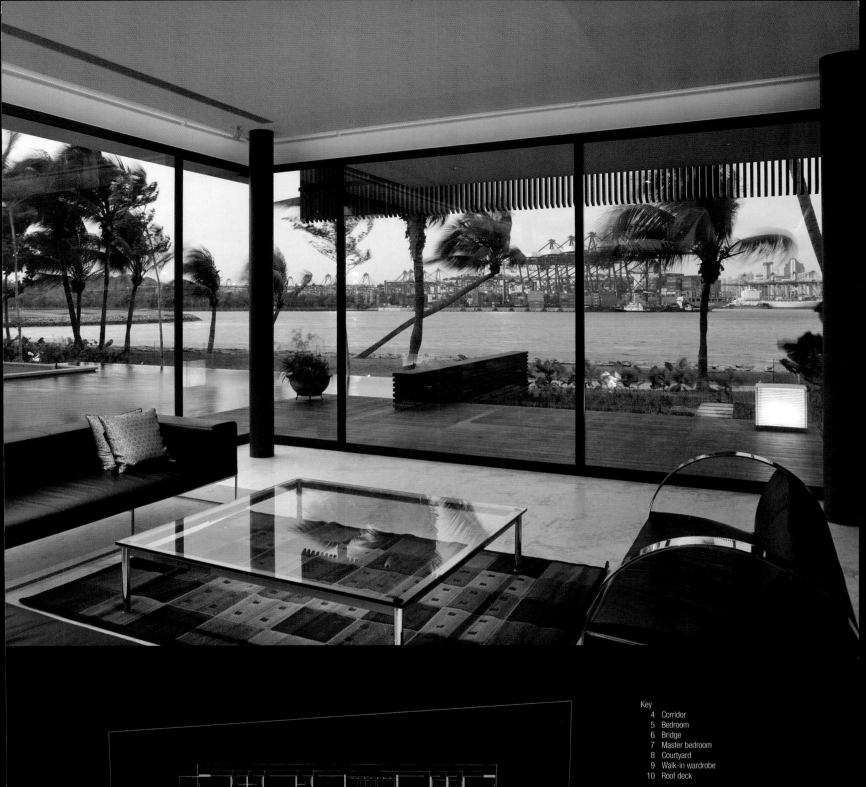

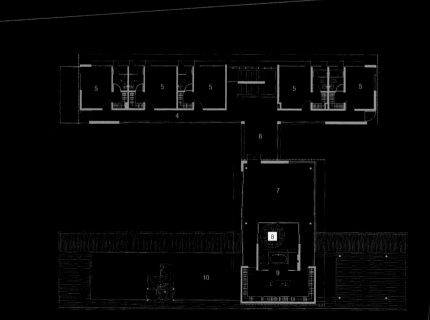

N

0 5 10 metres

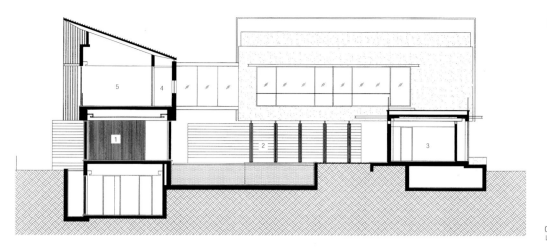

0 5 10 metres

Above Section through the pool court.

Below The bridge from the entrance pavilion to the entertainment pavilion.

Right The west wing of the house accommodates a meeting room and working and entertainment spaces overlooking the pool.

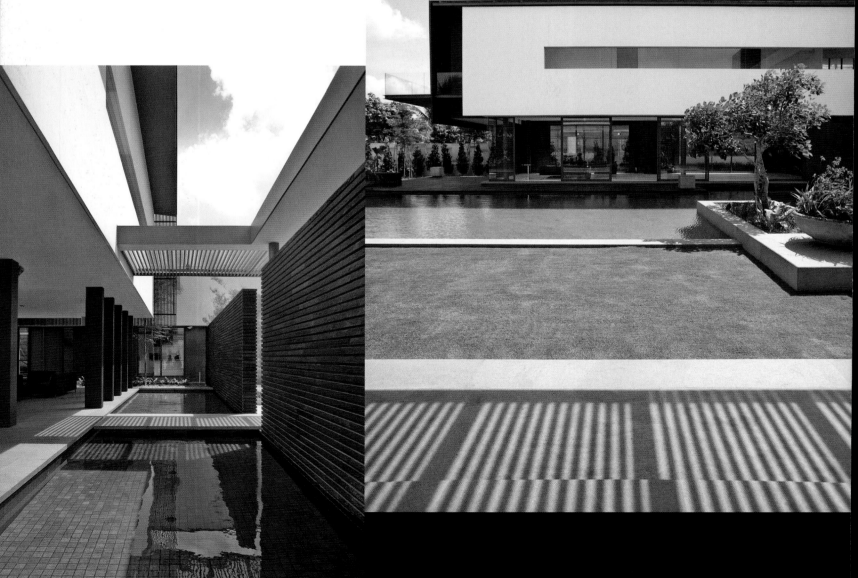

Left A circular steel staircase gives access to the roof deck that looks over the harbour.

Above Detail of a bathroom.

Below left and right Precision detailing and harmonious materials are employed throughout.

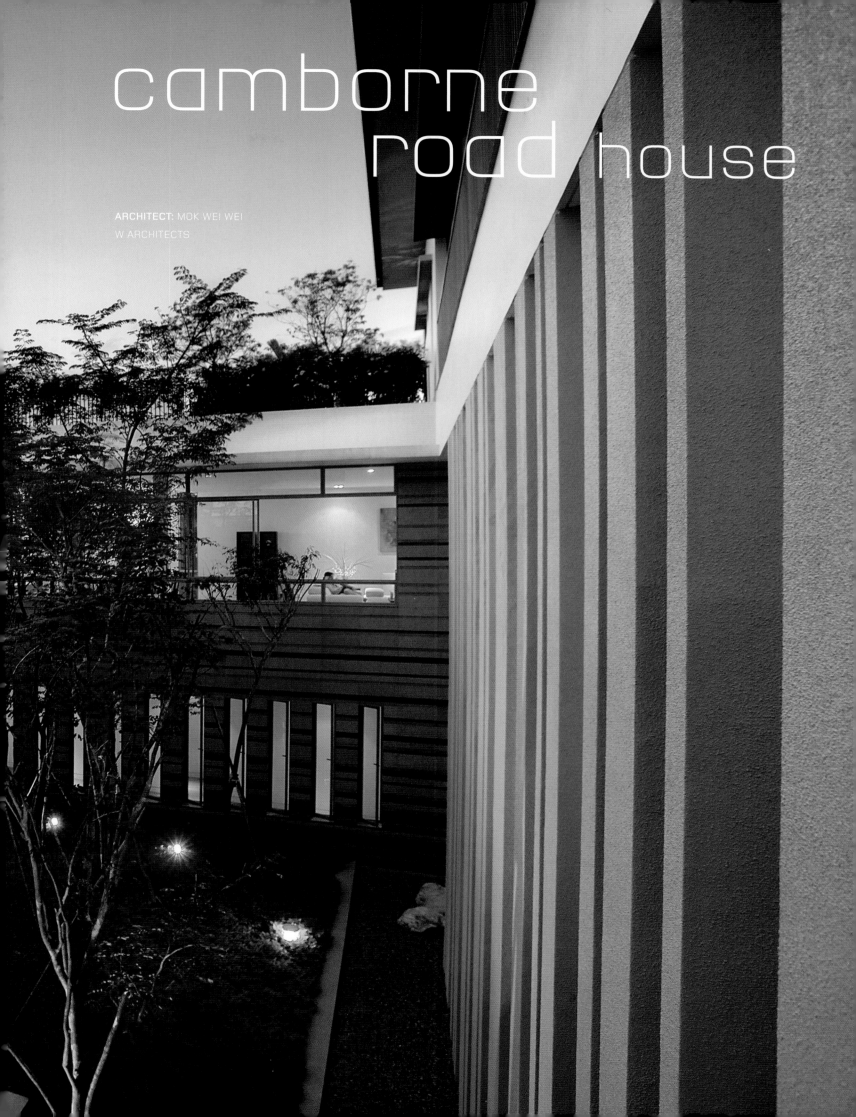

camborne
road house

ARCHITECT: MOK WEI WEI
W ARCHITECTS

The Camborne Road House was built for a successful entrepreneurial husband and wife and their two grown-up children who are both working. The owners have a strong interest in Chinese art forms – the wife enjoys Chinese painting while her husband practises calligraphy.

After the couple acquired the 1,500 square metre site, it was divided into two lots, one of 1,000 square metres and the other 500 square metres. The daughter will occupy the house on the 500 square metre lot when she eventually sets up a family. Meanwhile, it is rented out. The 1,000 square metre lot has two dwellings on it – the parents' house and the son's 150 square metre self-contained dwelling (comparable in size to a city apartment). The brief reflected the family's strong traditional Asian values and their desire to live together as an extended family. It was an extremely pragmatic decision because the land value has been maximized.

The mean level of the site is a storey above road level. Thus, entry is via a basement that is on grade with the road. The two lots are composed as one large house with three self-contained entities.

These are grouped around an open-to-sky courtyard that organizes the space from basement to rooftop. The unit intended for the daughter forms one wing of the complex. The basement entry is shared by the parents and son, whose dwelling forms an apartment-like annex facing Camborne Road, with a spectacular western view over an infinity pool towards the Singapore Command House, Ong Teng Cheong's workplace when he was President of the Republic.

The parents' house is an 'L'-shaped single-storey structure at the rear, embracing the courtyard. The living/dining area is constructed down the long side of the 'L', and shares a patio and the 20-metre-long pool with the son's living/dining area. At the centre of the rear wing, facing the internal courtyard, is the parents' study, overlooking their son's house. The study is given the central position in the composition to reflect the cultural and aesthetic values that underpin the family. It was originally designed as the only double-volume space in the house but the internal spatial quality was compromised when the daughter requested a room in her parent's house. This was inserted in the upper part of the study.

The three-level central courtyard around which the house is organized provides different experiences on the various levels. As one enters the house from the basement, it is framed in apertures and revealed in part. At the second level, the parents' house enjoys a full view of the courtyard from different angles within different rooms. At this level, the son's house looks out to the swimming pool and does not share the courtyard view. At the third level, both the son's and the daughter's dwellings look down and into the central court. The roof of the parents' house, a landscaped terrace, provides another space where the family can interact.

The design of the family compound of 'three houses in one' attempts to resolve the demands of complex traditional

Above The living room of the son's unit offers spectacular views towards Singapore Command House.

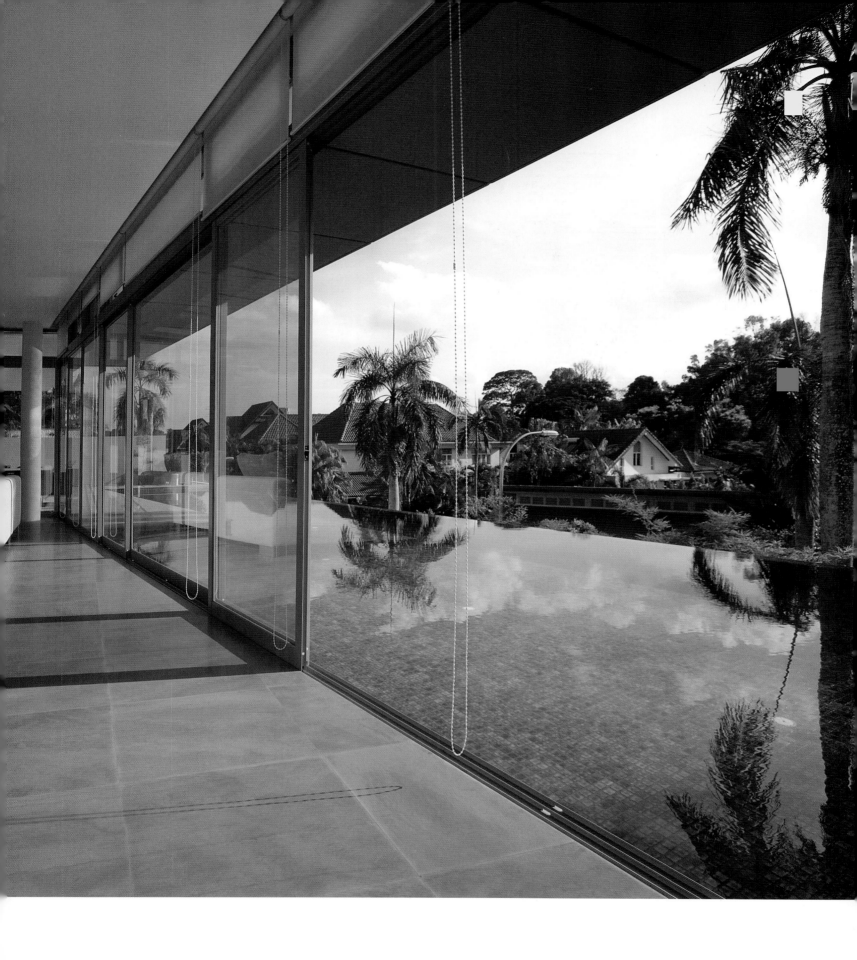

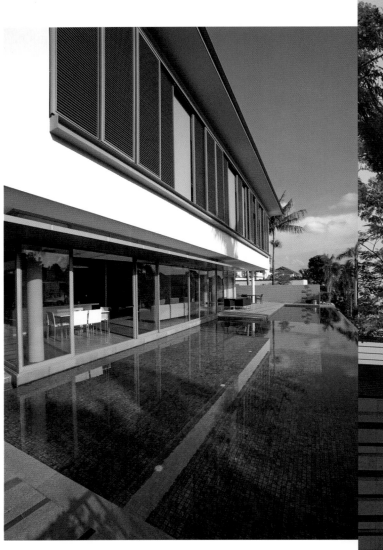

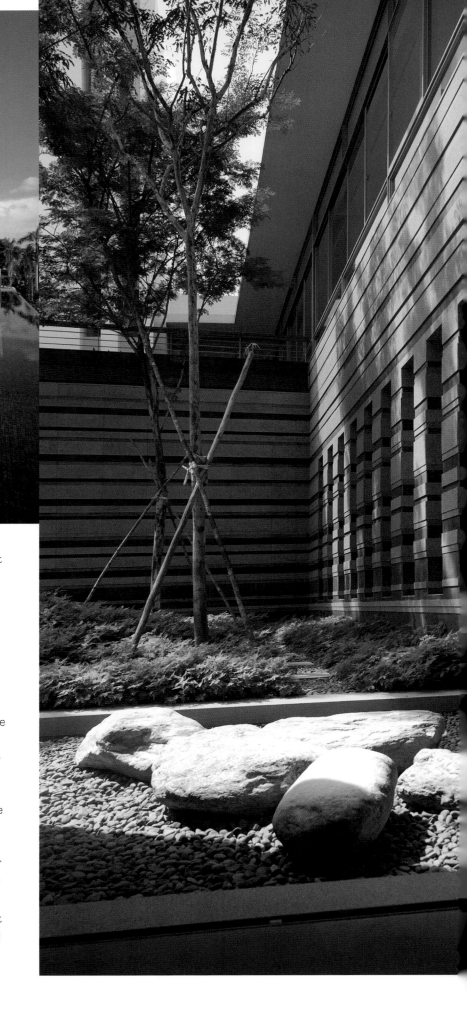

values into a coherent whole. It solves to some extent what Leon van Schaik has described as the 'culture of knowing and not knowing'.

The house is deliberately low key when observed from the road. Notwithstanding its excellent detailing, it could be missed by passers-by, for there is no attempt to proclaim its presence loudly. The entrance is through a wide, sliding door into an underground car park and from here, via a partially concealed door, into the house lobby.

Here, the mood changes dramatically, for at this point there is a visible shift in the architectural intentions. Beyond the glazed inner wall of the lobby, the three-storey-high court-yard has almost civic proportions, with semi-mature trees, striated grey granite walls and layers of private space. The entrance lobby marks a key threshold in the house, because at this point there are two possible routes. The parents can elect to bypass the shared areas of the multigenera-tional house and proceed along a gently ascending corridor to the rear of the site, where they emerge at the entrance to their own unit.

This is a very modest house when seen from the street but within is an utterly surprising courtyard and a processional route that loops around the court and, via a long gallery, reaches the parents' dwelling. The deep courtyard is the

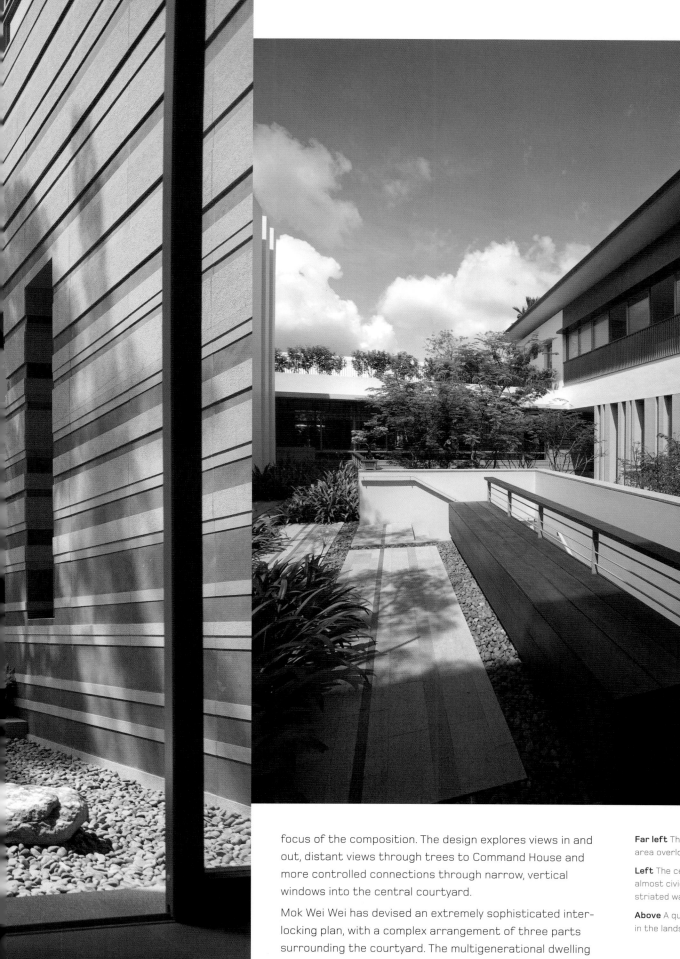

focus of the composition. The design explores views in and out, distant views through trees to Command House and more controlled connections through narrow, vertical windows into the central courtyard.

Mok Wei Wei has devised an extremely sophisticated inter-locking plan, with a complex arrangement of three parts surrounding the courtyard. The multigenerational dwelling is experienced quite differently by the various users and the design concept explores the interaction and negotiations between the generations.

Far left The son's living and dining area overlooks the lap pool.

Left The central courtyard has almost civic proportions. Its grey striated walls are slightly austere.

Above A quiet place for reflection in the landscaped courtyard.

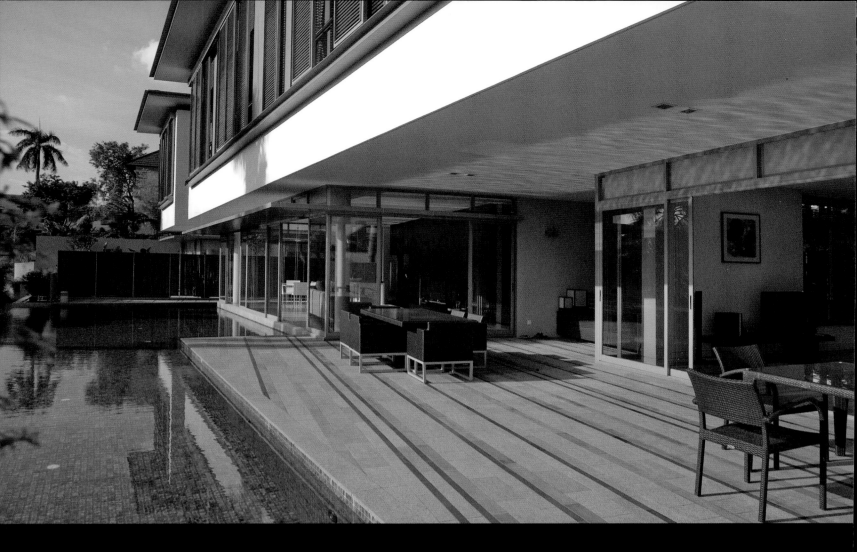

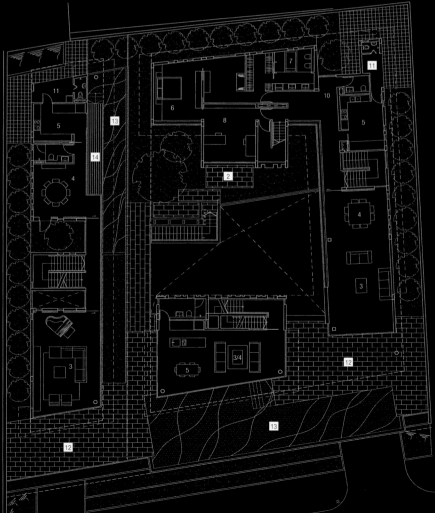

Key

2　Landscaped courtyard
3　Living room
4　Dining room
5　Kitchen
6　Master bedroom
7　Master bathroom
8　Study
10　Powder room
11　Utility room
12　Patio
13　Lap pool
14　Pool deck

0　　　　5　　　　10 metres

Left top The west-facing patio shared by the parents and their children.

Left bottom The house has a sophisticated interlocking plan as shown by the first storey plan.

Right The rooftop terrace above the parents' dwelling links to the son's unit.

Below Section through the central courtyard.

Bottom The entrance elevation is deliberately low key.

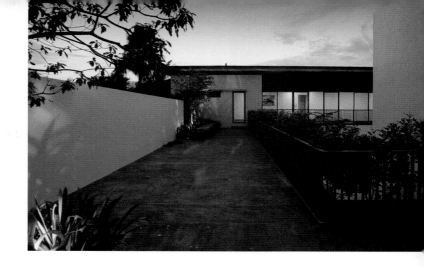

Key
1 Carpark
2 Landscaped courtyard
3 Living room
4 Dining room
6 Master bedroom
7 Master bathroom
8 Study
9 Bedroom
13 Lap pool

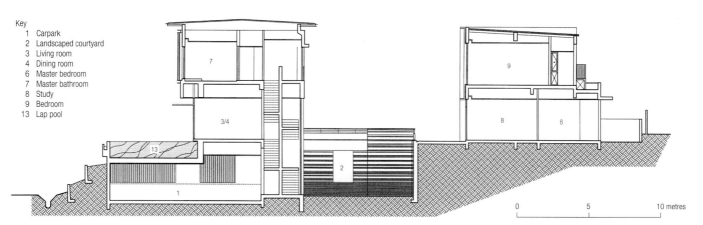

0 5 10 metres

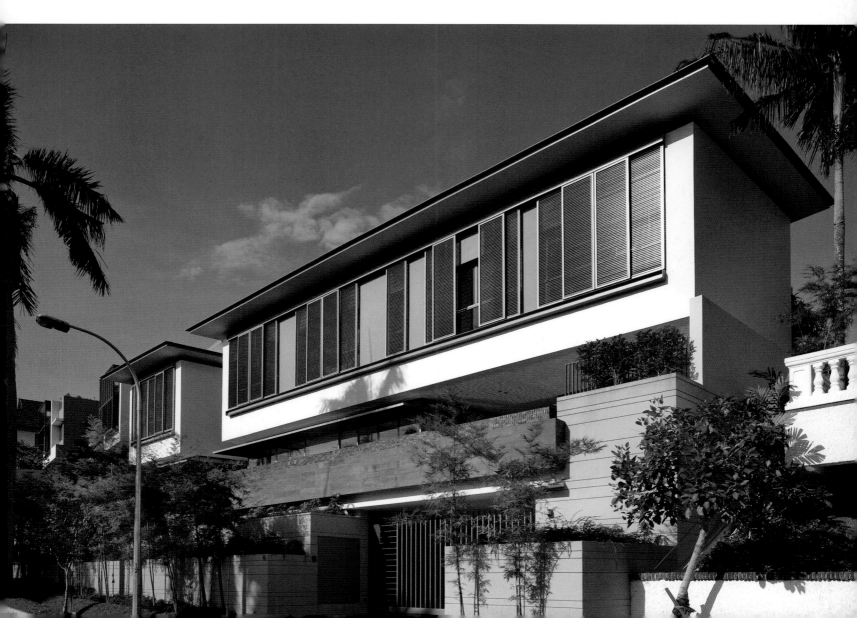

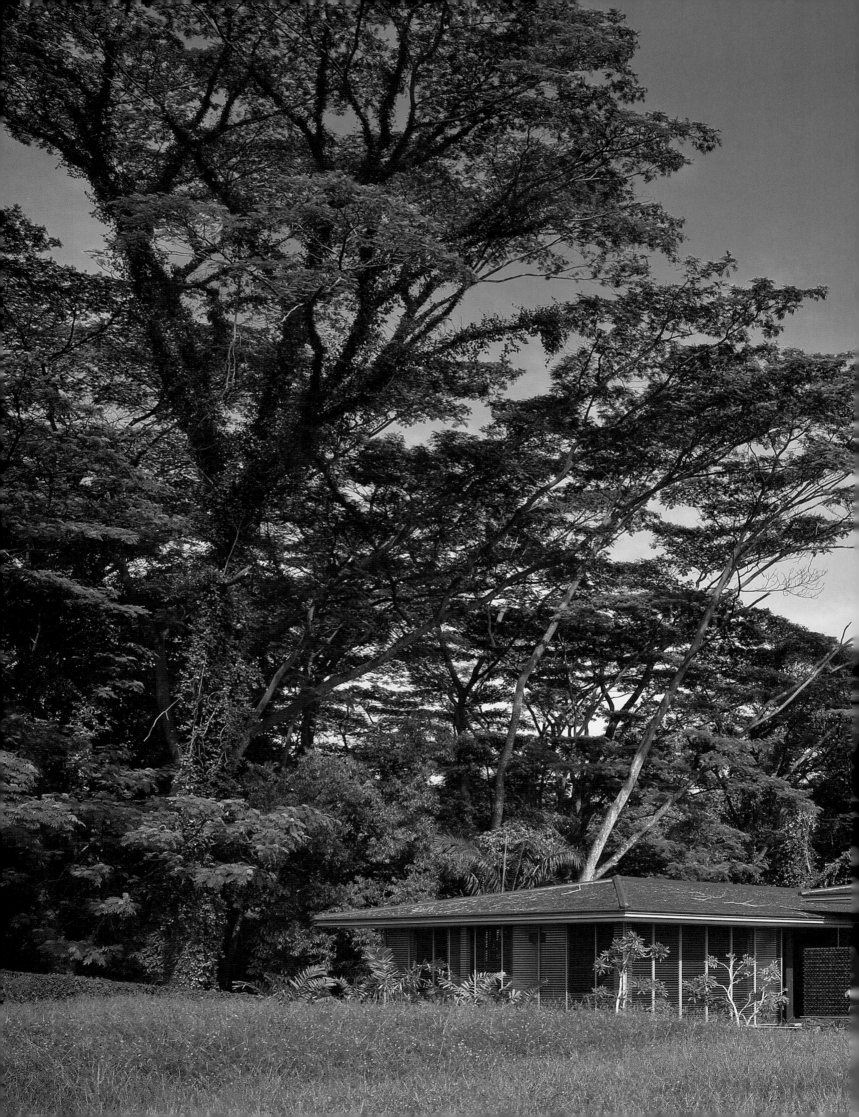

jervois hill
house

ARCHITECT: LIM CHENG KOOI

AR43 ARCHITECTS

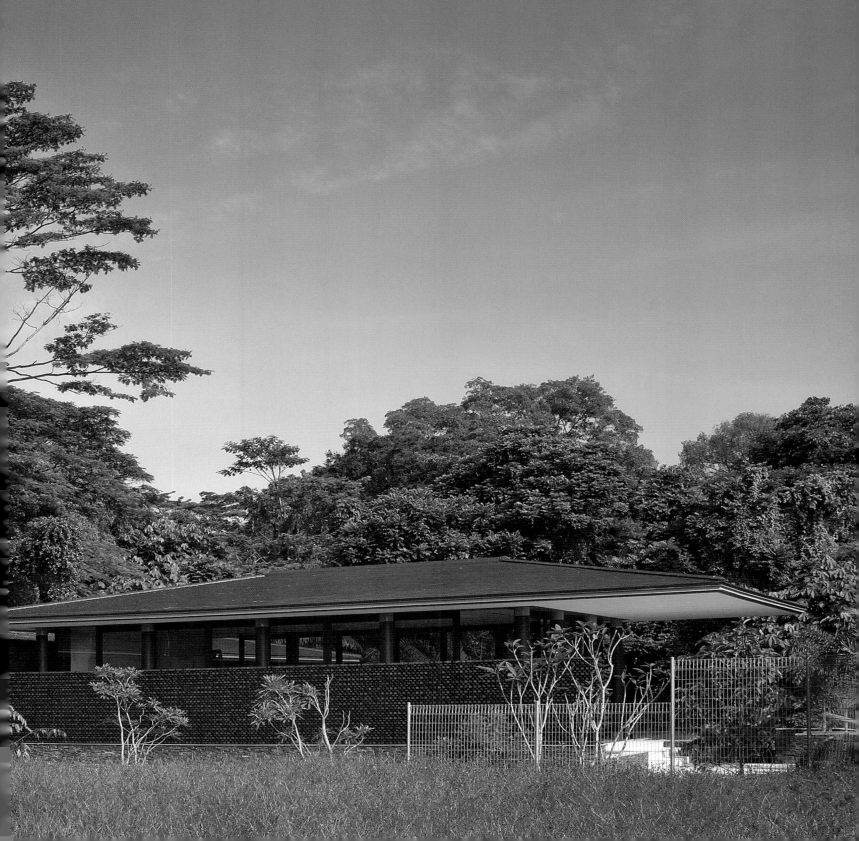

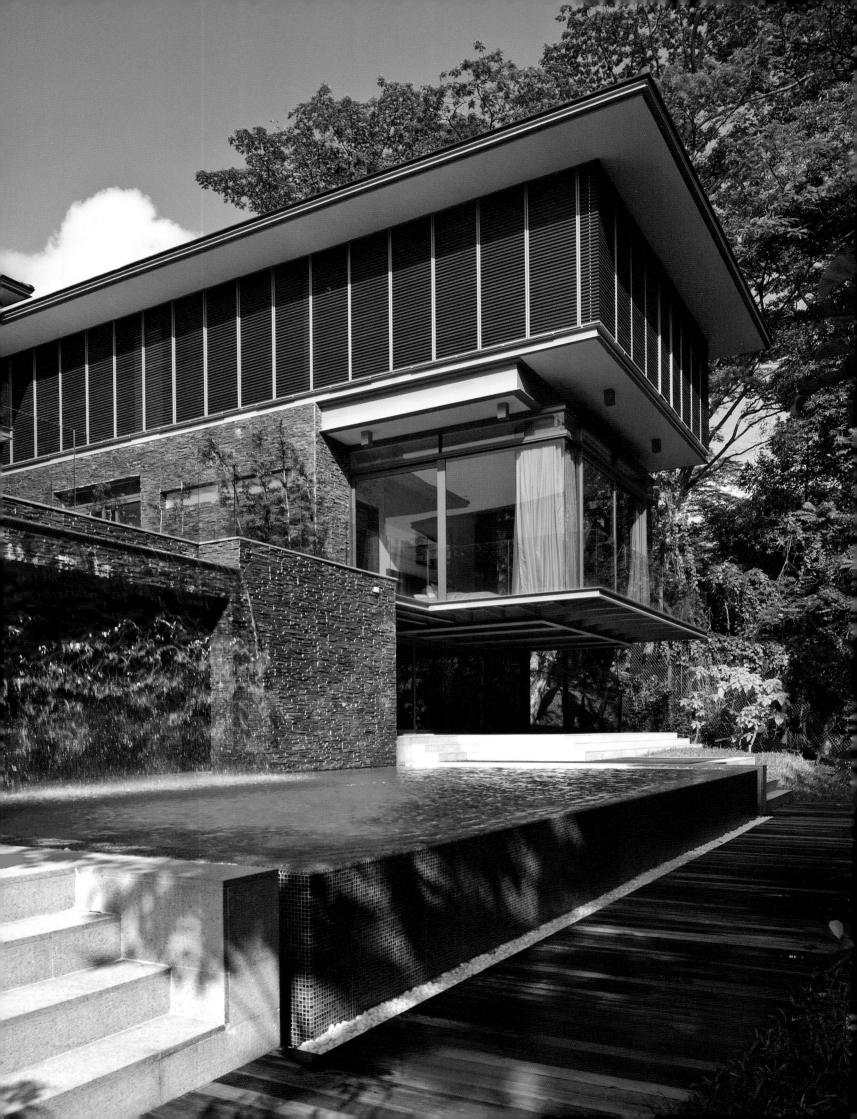

Lim Cheng Kooi was born in Penang, Malaysia, and raised in Kedah. He received his architectural education at the Universiti Teknologi Malaysia and graduated in 1988. 'During my formative years at UTM,' says Lim, 'the teacher who had the greatest influence on me was Syed Sobri. He was an AA graduate and is currently a partner in GDP Architects in Kuala Lumpur. He encouraged me to express emotion through my work and pushed me to be inventive.'

Immediately after graduating, Lim moved to Singapore and joined William Lim Associates where he worked for five years on a number of award-winning projects, including the extension of the Central Market in Kuala Lumpur. He followed this with another year under the mentorship of the controversial architectural designer Tay Kheng Soon at Akitek Tenggara until 1994 when he moved again to team up with Tan Kok Hiang and Ho Sweet Woon at Forum Architects. During his twelve years with Forum, he was involved in a variety of projects, many of which received awards and recognition through architectural journals.

Speaking of influences on his architecture, Lim alludes to the work of past masters such as Frank Lloyd Wright, Le Corbusier and Carlo Scarpa, while among contemporary architects he is enthusiastic about the work of Herzog & de Meuron, Renzo Piano and Jean Nouvel. 'The early modern masters impressed me with their visionary forms and awesome spaces, while the current ones thrill me with their avant-garde ideas and highly original works.'

In 2006, Lim set up AR43, and the house at 21 Jervois Hill (in collaboration with Mozaic Architects) is one of the first projects to emerge from this independent practice. The clients, Dr Leong See Odd and Dr Loh Lih Min, are both medical practitioners who have a young daughter. Captivated by the extraordinary serenity of the Jervois Hill site, a real find in densely populated Singapore, they entreated Lim to design a 'sanctuary' in the natural setting.

The Jervois Hill house is set in a mature landscape on steeply sloping land. Huge rain forest trees form the backdrop. Retired medical practitioner Dr Easaw Thomas, an expert in tropical plants, has carried out the verdant garden design. Dr Thomas has designed a 'wild' jungle-like landscape similar to one he first introduced in his own house, completed in 2000.[1] This house also boasts indigenous Malayan jungle plants grown by an expert who succeeded where the British failed – in growing jungle plants outside the jungle.

The dwelling design is conceived as a 'retreat' within the city. Although the location was a challenge, from the outset it also presented significant opportunities. The terrain

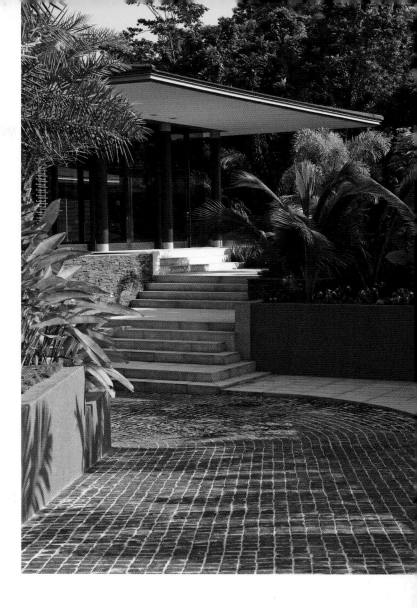

descends steeply, almost 10 metres, from the entrance to the forest reserve on the northern boundary, and the house steps down the slope with three contrasting terraces.

The approach to the house is via a short access road leading to the entrance court where a broad flight of stairs ascends to the elevated pavilion containing the living space. Beyond the living room, a linear axis leads between two large tropical fish tanks, the wine cellar and a bar to the dining room. Looking north from the elevated living room, there is a panoramic view beyond the garden terrace towards the nature reserve.

Located perpendicular to the main pavilion, the bedroom 'wing' is a slightly lower building, with windows in close proximity to the trees on the western boundary. The principal bedrooms cantilever out dramatically from the northwest corner of the house, while at the mid level there

Opposite A substantial waterfall cascades into the pool at the lowest level of the site.

Above The entrance drive ramps down to the vehicle court.

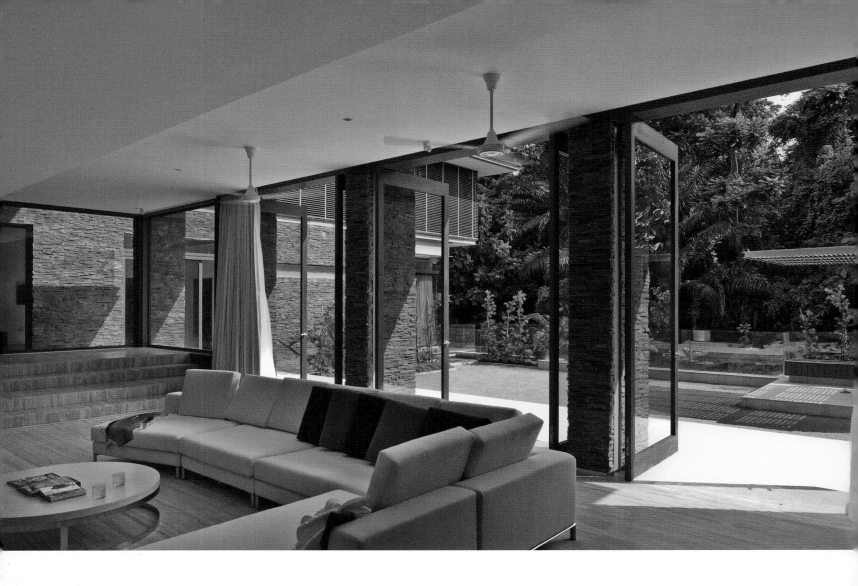

is a large family room with direct access to a landscaped terrace. A dance studio for the clients' daughter is located at the lowest level of the site, along with a swimming pool, changing rooms and a timber deck. Water cascades from the mid-level garden into the swimming pool and beneath the waterfall is a cool, cave-like verandah.

The living spaces in the house are orientated towards the Forest Reserve beyond the northern boundary. Large openings, framed with either stone or timber, are strategically positioned to view the 'borrowed landscape'. Generous overhangs are provided on the east and west façades to eliminate the low-angled morning and evening sun; as a result, the house is pleasantly cool and well ventilated. The guest suite is located beneath the entrance stairs and can be independently accessed.

The house is designed, to quote Lim, 'to look crisp and modern', yet it also exudes a tactile quality with the use of a palette of natural materials. Stone and timber echo the rich textural patterns of the site, enabling the modern architecture to blend with its tranquil setting.

The bedroom façades are enclosed with pivoted timber screens, permitting controlled natural light into the inner spaces while simultaneously providing complete privacy. The changing rhythm of vertical frames and horizontal slats and the articulation of the solid and transparent walls convey a feeling of inscrutability.

Lim Cheng Kooi's works include commercial, residential and hospitality projects in addition to interior design. He has also carried out charitable projects, such as the Karuna Home for the Disabled in the district of Mysore, Karnataka State, in South India. An avid self-taught artist, he devotes his time not only to the practice of architecture but also to painting and sculpture. His designs are, he says, 'an act of continual exploration based on knowledge and experience gained from the many influences on my life'.

The Jervois Hill House is a major success embodying great clarity in its planning and poetry in its execution. The influence of Geoffrey Bawa is evident in this beautiful dwelling that is designed to work with the land forms and steps down the slope. It also displays what might be termed 'a Malaysian sensibility', with its close affinity to nature and richness of materials.

[1] Robert Powell, 'Architecture and Nature: Wilby Road House', SPACE, No. 6, Singapore: Panpac Media, December 2000, pp. 50–6..

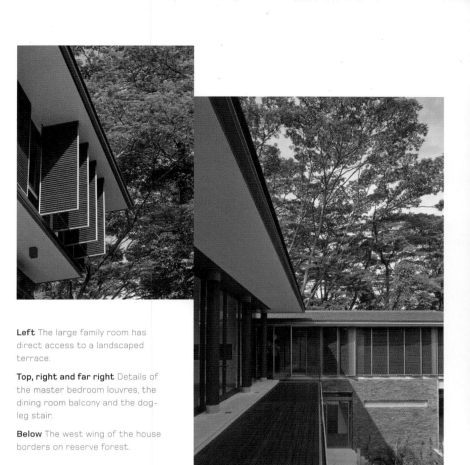

Left The large family room has direct access to a landscaped terrace.

Top, right and far right Details of the master bedroom louvres, the dining room balcony and the dog-leg stair.

Below The west wing of the house borders on reserve forest.

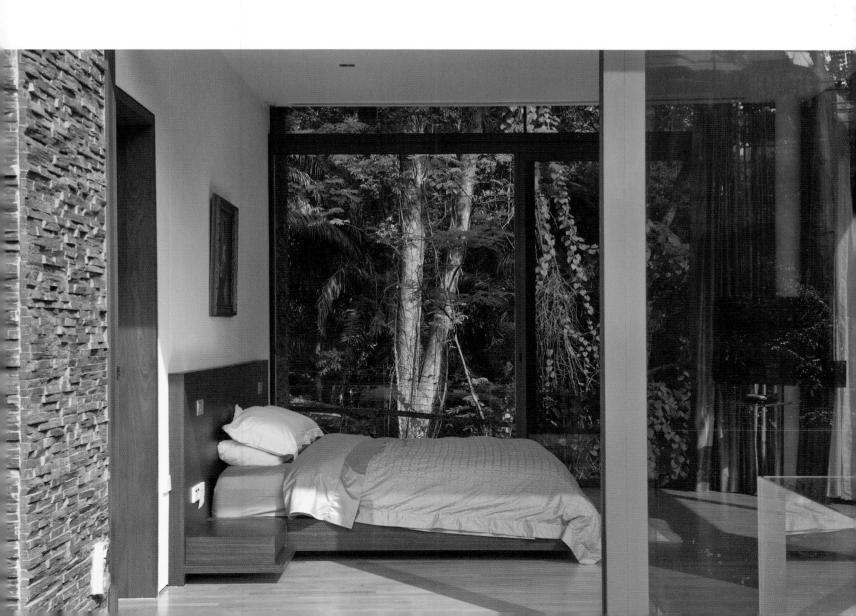

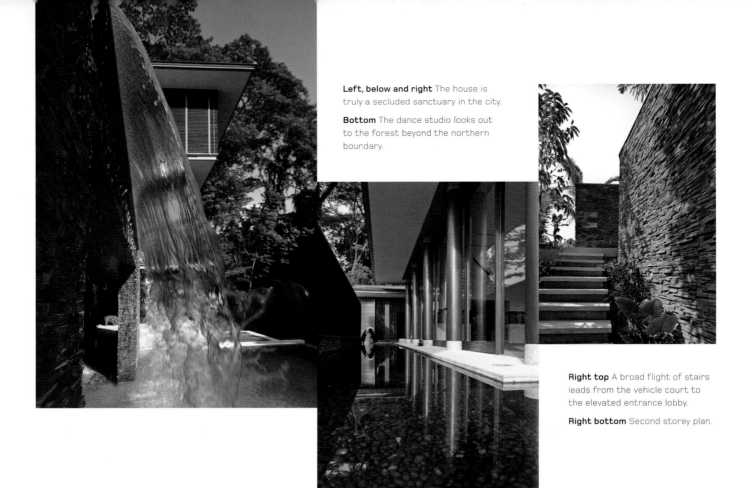

Left, below and right The house is truly a secluded sanctuary in the city.

Bottom The dance studio looks out to the forest beyond the northern boundary.

Right top A broad flight of stairs leads from the vehicle court to the elevated entrance lobby.

Right bottom Second storey plan.

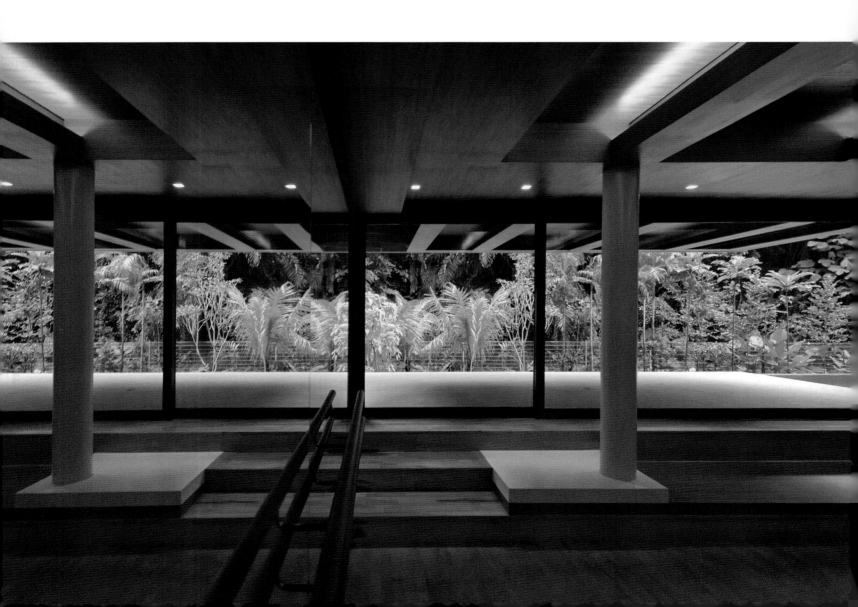

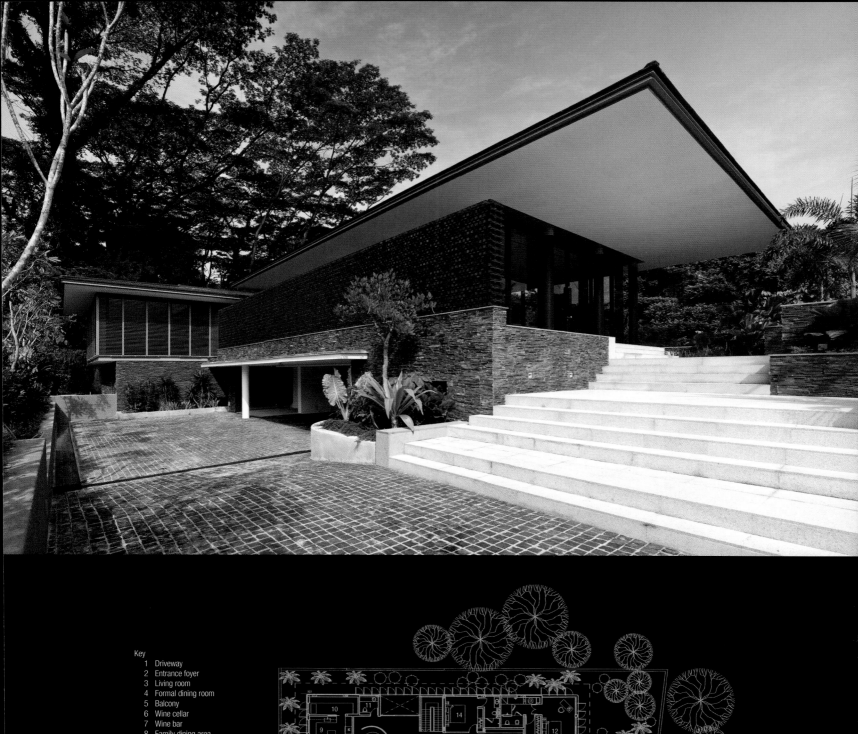

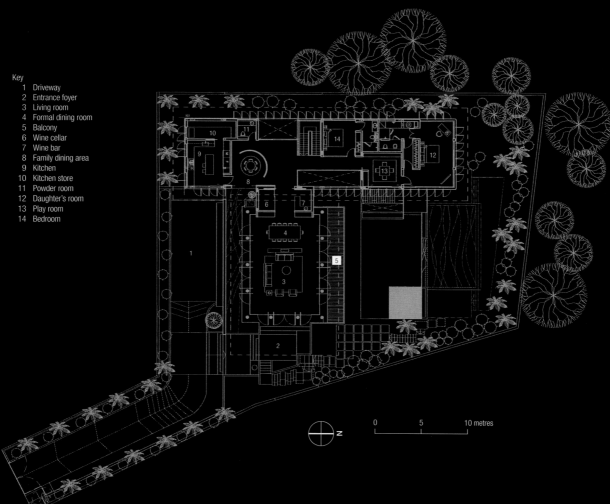

Key
1 Driveway
2 Entrance foyer
3 Living room
4 Formal dining room
5 Balcony
6 Wine cellar
7 Wine bar
8 Family dining area
9 Kitchen
10 Kitchen store
11 Powder room
12 Daughter's room
13 Play room
14 Bedroom

0 5 10 metres

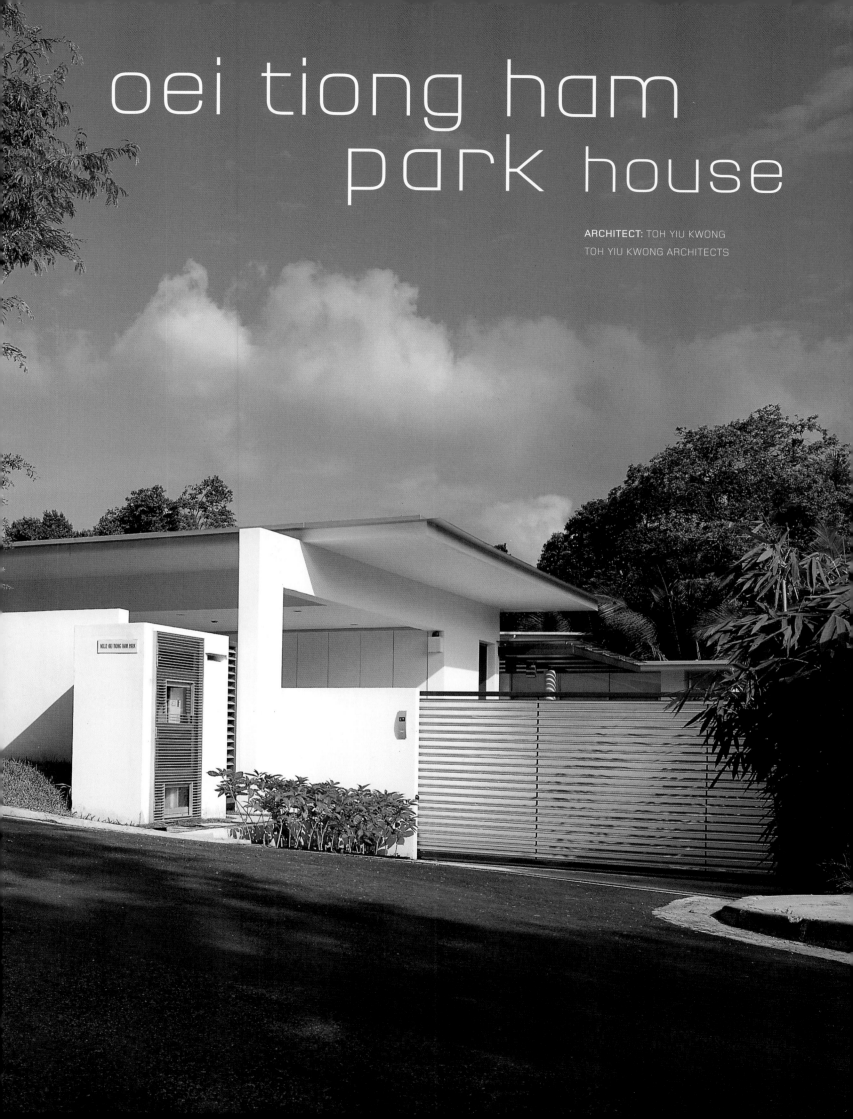

oei tiong ham park house

ARCHITECT: TOH YIU KWONG
TOH YIU KWONG ARCHITECTS

Some of Toh Yiu Kwong's earliest memories are of growing up in an open-plan house designed by his father, architect Toh Shung Fie. The dwelling had efficient natural ventilation and the interior and exterior were seamlessly linked. The house was a major influence on Toh's decision to follow in his father's footsteps.

Toh graduated from Curtin University of Technology, Western Australia, in 1985. Before he commenced his formal studies, he read *Fountainhead* by Ayn Rand, in which the protagonist is an architect with uncompromising ideals. Toh still finds the book inspirational. It led him to read about Frank Lloyd Wright. The simplicity and elegance of Wright's prairie houses moved him tremendously, so that when he commenced his architectural education in Perth, it was something he could relate to, especially in the Western Australia landscape where space seems infinite.

Toh's memories of Curtin are not specifically of academic mentors but of George Gunter, a perspectivist/illustrator who paid the utmost attention to perfection and detail in his drawings, and of Michael Michelidis, an architect in practice who left a lasting impression through his construction detailing, which was simple and concise. Kerry Hill was also influential in Toh's architectural education as he exposed him to Geoffrey Bawa's poetical works. Toh was also influenced by Kerry Hill's design sensibilities. Other architects who have influenced his approach to architecture include Mies Van de Rohe, Le Corbusier, Glenn Murcutt and Harry Seidler. In addition to Kerry Hill Architects, Toh worked with Architects 61 and Raymond Woo Associates prior to setting up his own practice.

The Oei Tiong Ham Park House does not make a grand statement; indeed, the profile is deliberately kept low and

is intended to be invisible from the highway. But what appears initially to be a modest single-storey bungalow adjusts to two storeys as it steps down the sloping site. In that sense it is not unlike an earlier house designed by Toh, located in Victoria Park Road,[1] that works with the topography and exploits axial routes. The two houses have other similarities: the earlier house was designed for a three-generation family as is the Oei Tiong Ham Park House.

This house has a rational linear plan, with all the functions accessed from the central axis that runs from east to west, perpendicular to the site contours. This direct processional route allows one to immediately comprehend the spatial arrangement.

The entrance to the house is via a square, flat-roofed portico alongside a *koi* pond. This *serambi*-like space, with an informal grouping of chairs, some doubling as side tables,

is used for greeting guests who subsequently proceed through wide timber doors on the central axis. Progressing along the axis, the living space is on the left while to the right, beyond a series of sliding doors, is the external pool deck. Next on the left is the dining area, and following this, the glass-walled kitchen. Varied ceiling heights and the use of clerestory windows, combined with tall floor-to-ceiling clear-glazed windows on both flanks, create a remarkably light and transparent dwelling where components are joined employing simple junction details.

The house owners are Edmund Wee, one of Singapore's foremost graphic designers, and his wife Tan Wang Joo, a former journalist. Wee is a passionate cook and loves to entertain friends for dinner. The kitchen is consequently located at the very heart of the ground floor of the house overlooking the living room, dining area and outdoor deck.

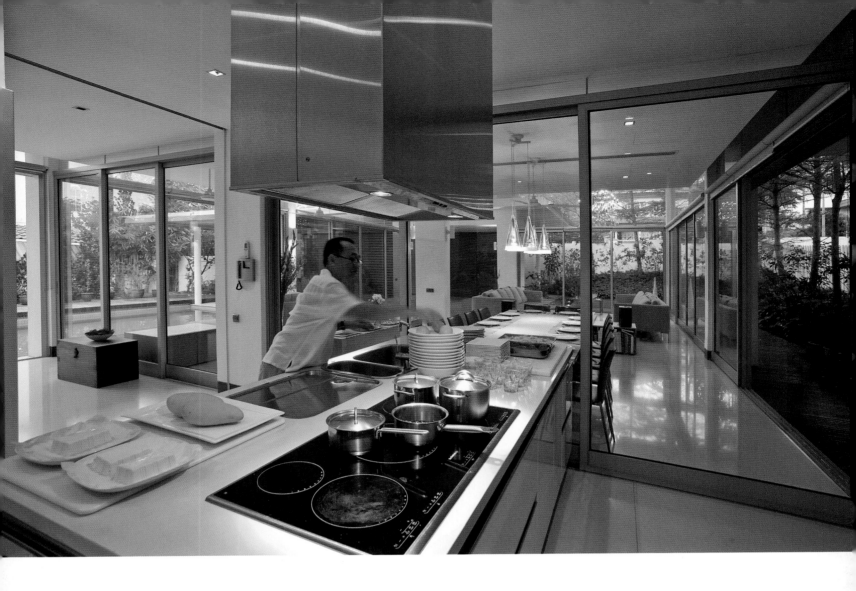

The host is thus visible when cooking for guests; he can see everything from the kitchen and everyone can communicate with him.

Proceeding beyond the kitchen, the swimming pool is located to the north of the central axis, followed by three bedrooms for the owners' two children and a grandparent. The central axis culminates in an elegant linear staircase that descends to the sub-basement where the owners' bedroom suite is located along with the principal bathroom and dressing room. The master bedroom looks back into a water court that is enlivened by a waterfall flowing over a weir at the end of the swimming pool.

The section through the house reveals the creative way in which the architect has worked with the site and how light is introduced into the house. There is a degree of complexity in the section but, as the owners explain, 'it is a simple open plan with no prettiness'. The owners are content to live below the children's accommodation for the present, although it is not a relationship that most *feng shui* advisors would recommend. For now, it provides the children with large bedrooms and adequate study areas that later can be easily modified. The grandparent's room is easily accessible to the kitchen and dining area.

Wang Joo talks at length about the changes in Singapore society – ageing, women giving up careers to look after children, people learning to cook or rediscovering the art of cooking – issues that increasingly impinge on the design of houses in Singapore. Asian cooking channels are among the most popular on TV and have promoted a new wave of cooks. Youngsters now aspire to be chefs and a surprising number to be restaurant owners. Another cultural change is the extent to which wealthy home owners have adopted the 'Western' fondness for wine cellars.

The house is embedded in the landscape and is surrounded by tall trees. Its transparency ensures that the owners experience nature at close quarters. 'We love the quietness,' says Wang Joo, expounding on the visual and auditory benefits of an openable 'glass house'. 'The house is very restful. On a sunny day, we appreciate the lacey pattern of the leaves against the sky. It is also wonderful to hear and see the rain beating down in a monsoon storm.'

[1] Robert Powell, 'Umbilical Connections', *SPACE*, No. 1, Singapore: Panpac Media, January 2002, pp. 79–82.

Pages 206–7 The entrance is via a square, flat-roofed portico leading to a central axis.

Above The husband is an avid cook who enjoys entertaining friends for dinner.

Below A minimalist flight of stairs descends to the sub-basement.

Centre The pool deck on the eastern flank of the house.

Right The *koi* pond alongside the entrance porch.

Bottom The central axis continues alongside the pool, descending via a straight flight of stairs to the sub-basement.

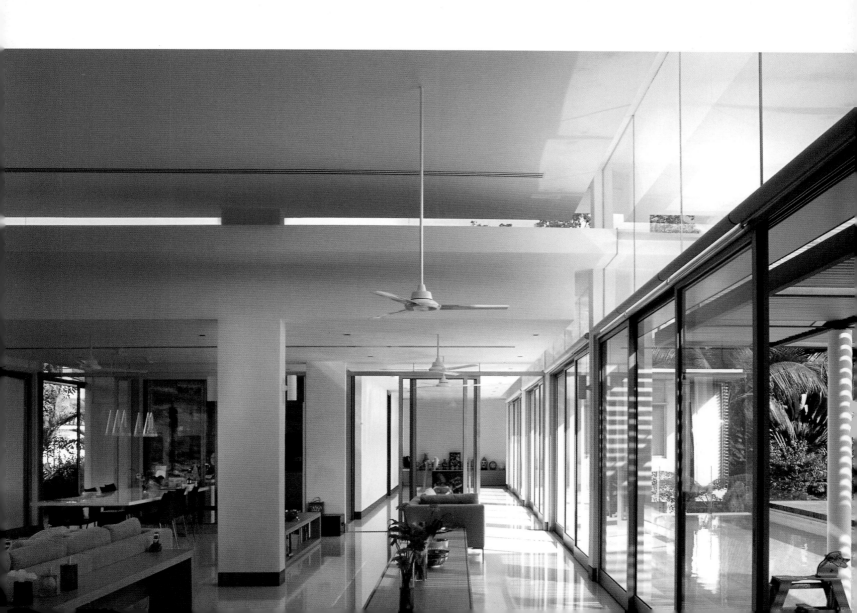

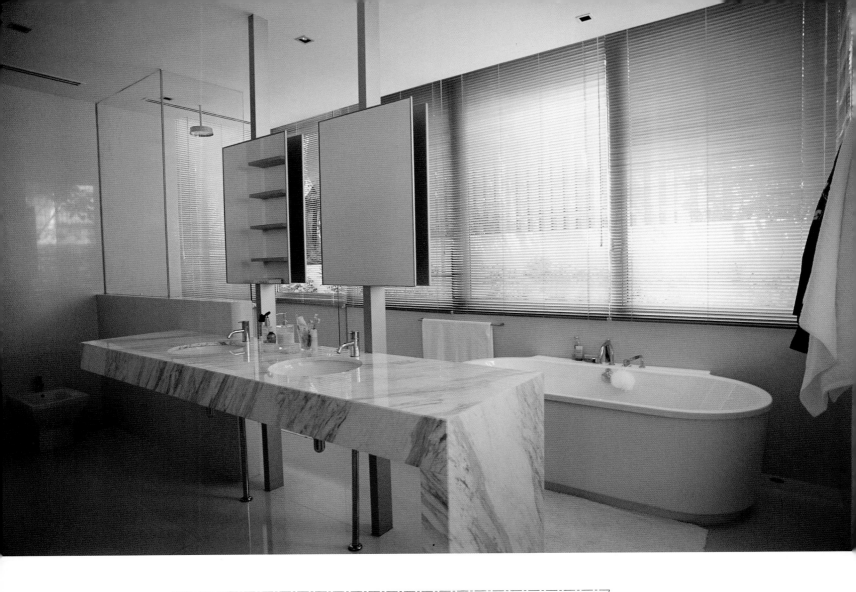

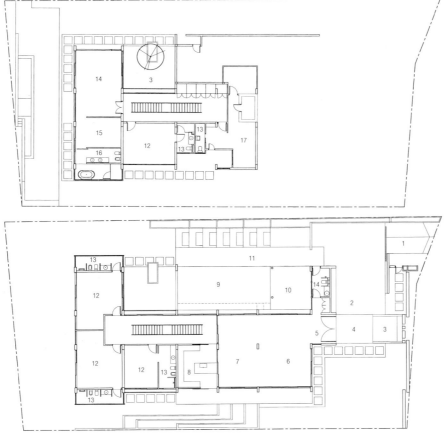

Above The uncluttered modernist aesthetic is carried through to the interior details.

Left First storey (sub-basement) and second storey plans.

Right top The architect employs a disciplined reductive language of planes and voids.

Right bottom Embedded in the landscape, the house is fringed by tall trees.

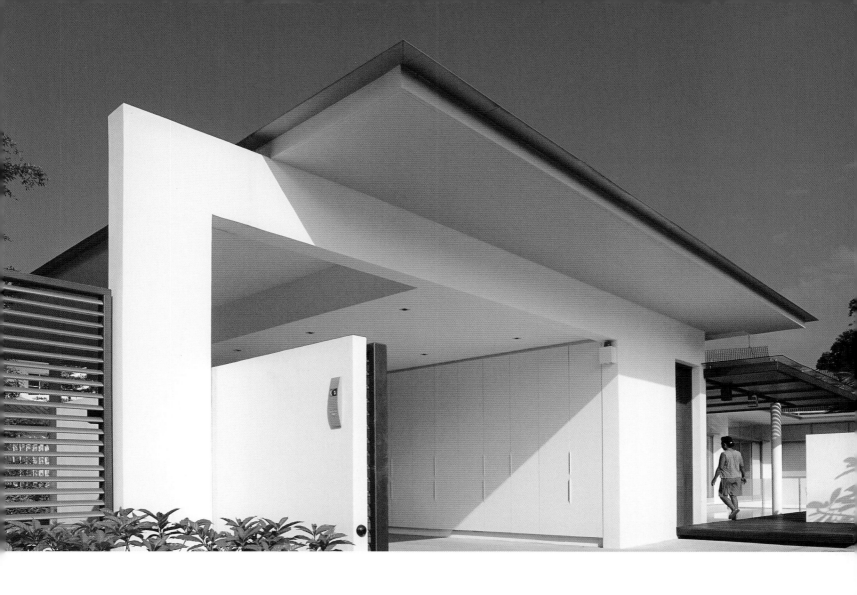

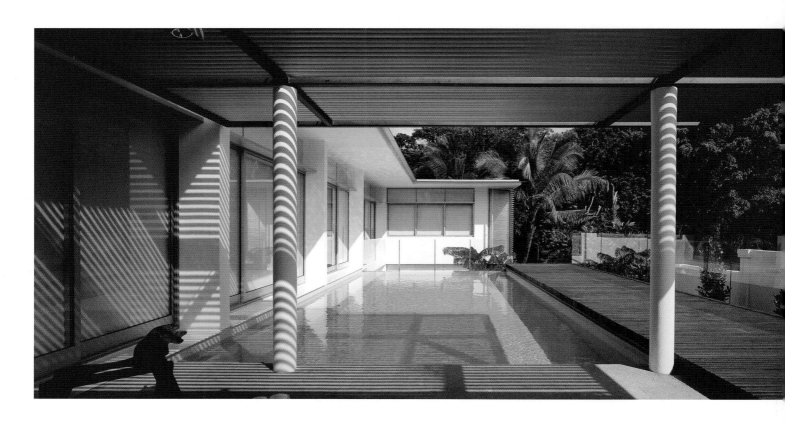

sunset place
house

ARCHITECT: YIP YUEN HONG

IP:LI ARCHITECTS

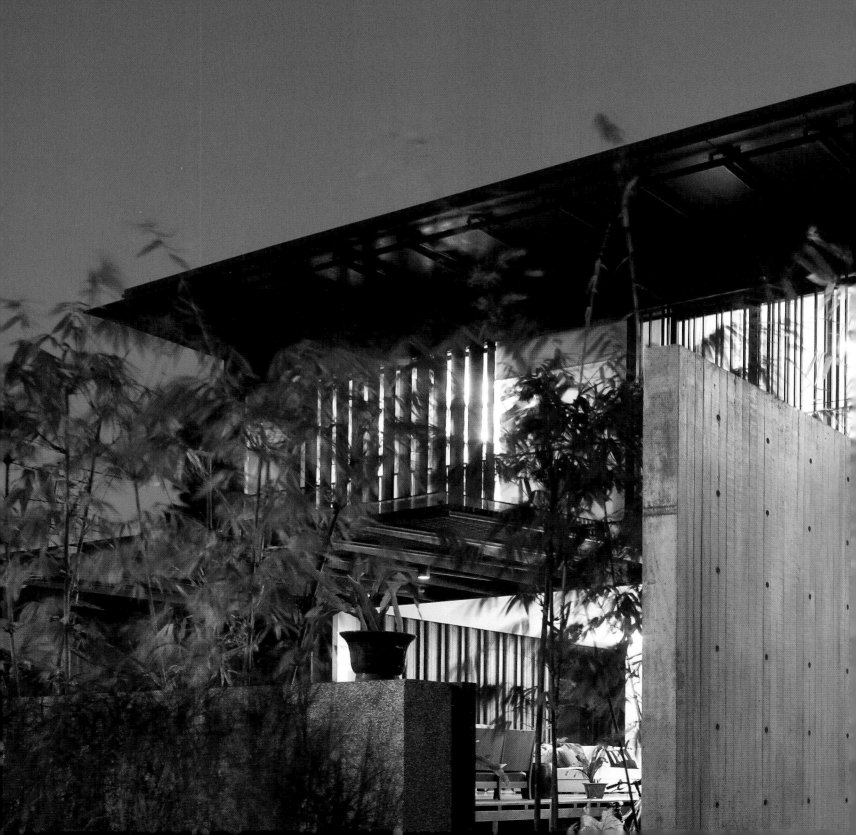

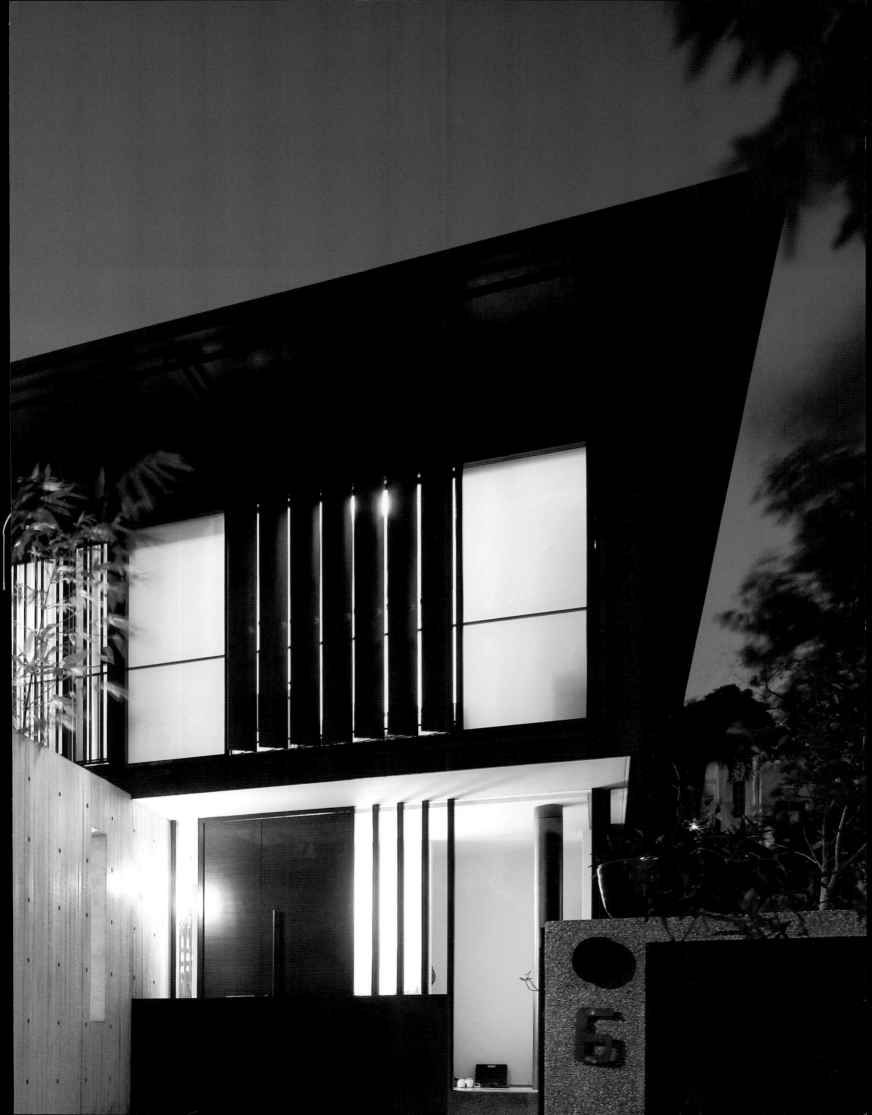

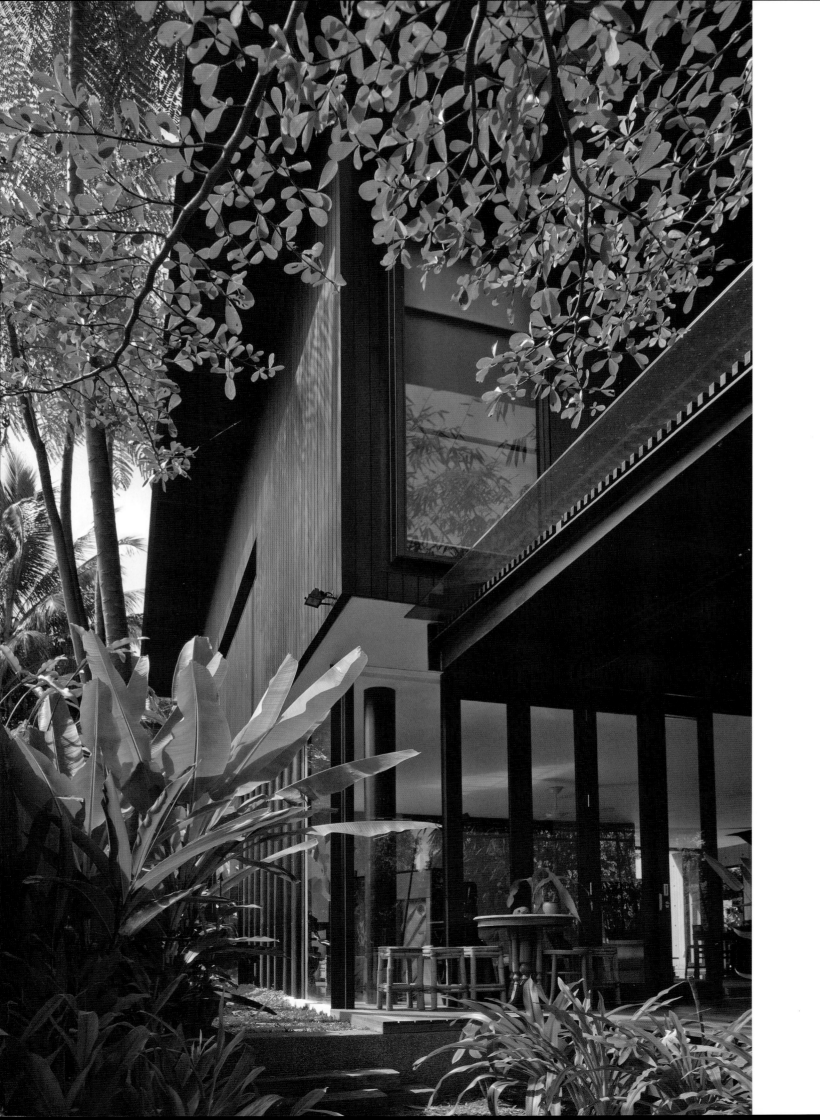

Yip Yuen Hong studied architecture at the School of Architecture at the National University of Singapore in a period of radical change inspired by its dynamic Co-Director, Meng Ta-Cheang. Yip graduated in 1987 under the guidance of his final year mentor, the respected Californian architect Peter Wolfgang Behn, as the top designer of his year.[1] His brilliant final year design thesis examined the rejuvenation of the Teochew district of Singapore's Chinatown. Yip later honed his design skills under William Lim (William Lim Associates (1984–5 and 1987–8), Liu Tai Ker (at the Housing Development Board, 1988–90) and Tay Kheng Soon (Akitek Tenggara, 1990–3). In 1993, Yip set up HYLA Architects with Han Loke Kwang and Vincent Lee and remained there for a decade before moving on in 2002.

Yip entered the profession during a recession (1987) when the salary of a typical architecture graduate was a mere S$750. 'But,' he says, 'all my cohort at NUS wanted to have their own practice,' and so, in 2002, he set up ip:li architects with Lee Ee Lin, a graduate of Robert Gordon University in Aberdeen, Scotland. Yip combines practice with teaching, having been a part-time tutor at LaSalle-SIA College of the Arts (1998–2000) and NUS (1998–2004).

The plan form of the Sunset Place House has a strict orthogonal logic, with six freestanding circular columns. There are illusive memories here of the freestanding circular columns in the Reuter House by William Lim (1990). The house is entered from the street via the carport, turning at right angles to ascend two steps to the entrance porch. Turning again through 90 degrees to enter the living/dining area, the immediate impression is of a rectilinear volume opening to the garden on two sides. The space is light and breezy, with cross-ventilation that eliminates the use of air conditioning. The dwelling is modest in size but the openness and extension of space into the garden make it appear much larger than it is, and the influence of Geoffrey Bawa is evident in the framing of courts and patios.

Extending to the rear is a single-storey kitchen block opening out to the rear courtyard and an outdoor dining area with a timber deck. Above the kitchen is an open rooftop patio accessed from the second-storey family room.

The house has a harmonious spirit and an unpretentious ambience that is the result of a very close working relationship between the architect and the clients. Through the

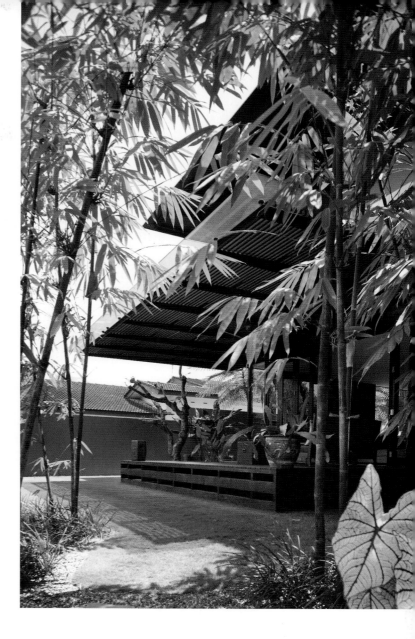

introduction of a designer friend, the owners, a Chinese Singaporean married to a German, with two small sons, approached Yip who simply said he would have a look at the site and see what advice he could offer. In fact, he produced a conceptual sketch scheme that immediately captured the clients' imagination. The chemistry between architect and clients was just right although some design details still needed to be resolved.

The first-storey structure employs off-form concrete with circular mild steel columns. The clients were at first hesitant about the use of fair-faced concrete and also unsure about Yip's proposal to have the north wall in sheet steel. But they decided to go along with those ideas and are extremely happy that they did. The north mild steel folded wall serves not only the practical purpose of cutting off a view of a neighbouring house but is also a surprising and elegant feature. Another unusual feature is the use of vertical mild steel reinforcing bars as a perimeter fence.

Immediately to the left on entering the living/dining area is a sliding/folding glazed timber screen that opens out to a

Left The interior flows effortlessly into the surrounding garden.

Above The timber deck is a wonderful in-between space.

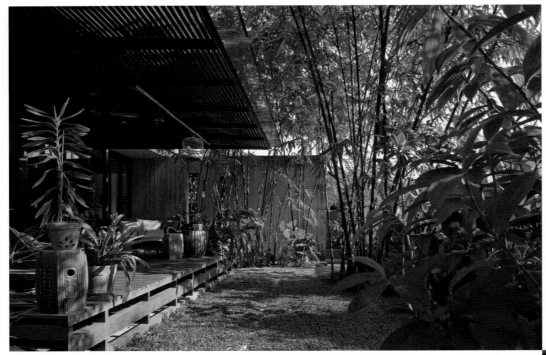

timber deck, with a small in-deck pond. The perimeter of the garden is planted with a screen of slender bamboo. To the right is another glazed screen opening to the back garden and the timber deck adjacent to the kitchen. The open-fronted kitchen is closely linked to the main living/ dining area as well as to the southeast corner of the house, which is devoted to back-of-house activities – the maid's room, service yard, utility area and laundry.

Conceptually, the second storey is expressed as a timber-clad box sitting above a transparent base. The upper floor is less open than the ground floor and is divided into cellular spaces to create a master bedroom with *en suite* bathroom and a linear wardrobe with dressing area along the north façade, children's bedrooms with an attached bathroom, a family room and a TV area. It is more inwardly focused than the lower floor, although there is still an emphasis on natural ventilation with the use of latticework timber screens in the bathrooms. Opening and adjustable timber shutters are incorporated in all the bedrooms and there are internal air-wells in the master bedroom and the children's bathroom.

The house is a comfortable family home, yet uncompromisingly modern in appearance, with off-form concrete and large glazed openings at ground level. After two decades in the profession, there is ample evidence of maturity and refinement in Yip's architecture, and his work possesses an assurance and control that comes with experience. The Sunset Place House was a major breakthrough in this respect, and in 2006 the dwelling received the Singapore Institute of Architects Design Award in the Individual Houses category.

[1] Peter Wolfgang Behn now practises architecture in Oakland, California.

Above The living room patio.

Opposite top left Looking from the garden to the kitchen patio.

Opposite top right The entrance lobby.

Right Cross-ventilation eliminates the need for air conditioning in the living room.

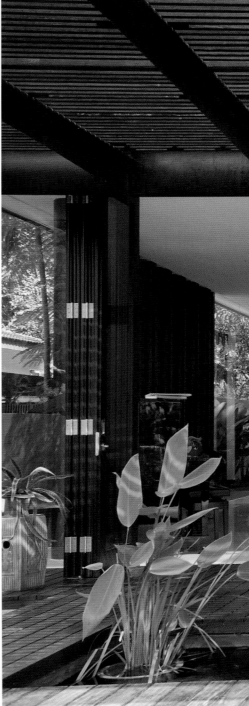

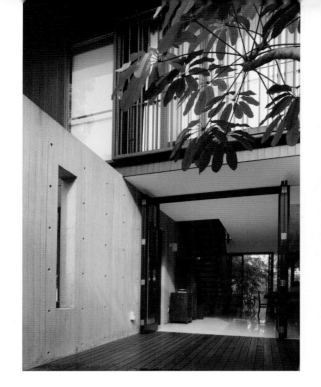
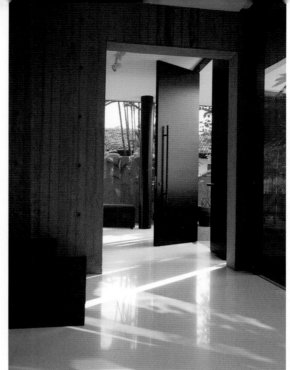
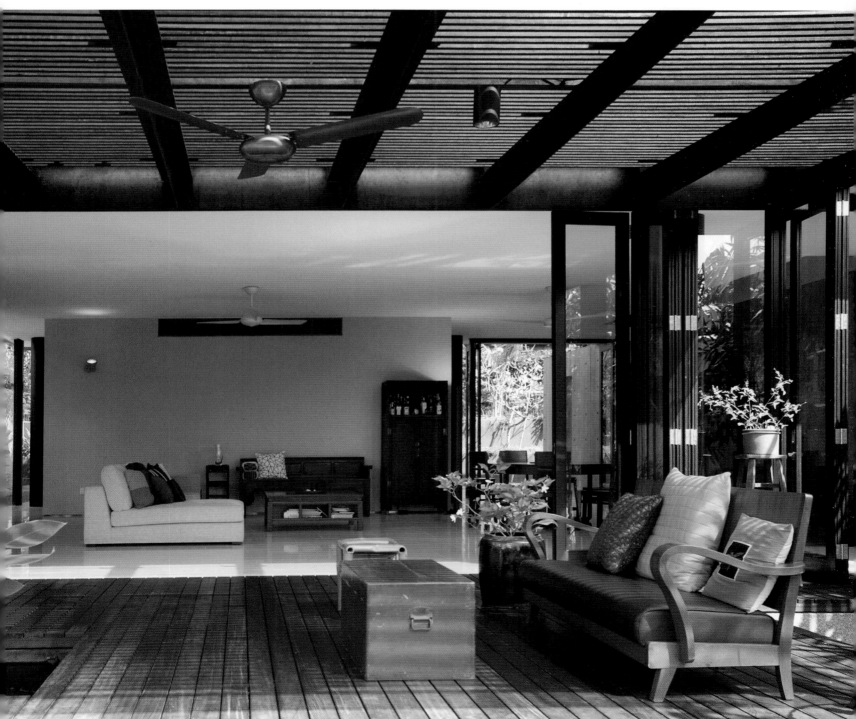

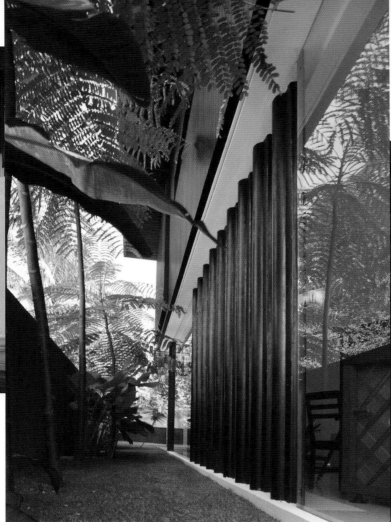

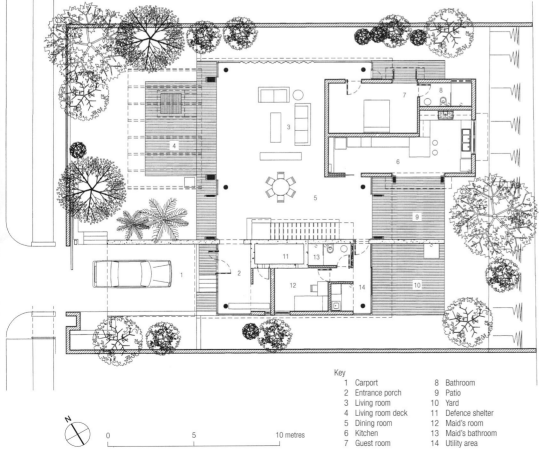

Key
1 Carport 8 Bathroom
2 Entrance porch 9 Patio
3 Living room 10 Yard
4 Living room deck 11 Defence shelter
5 Dining room 12 Maid's room
6 Kitchen 13 Maid's bathroom
7 Guest room 14 Utility area

N

0 5 10 metres

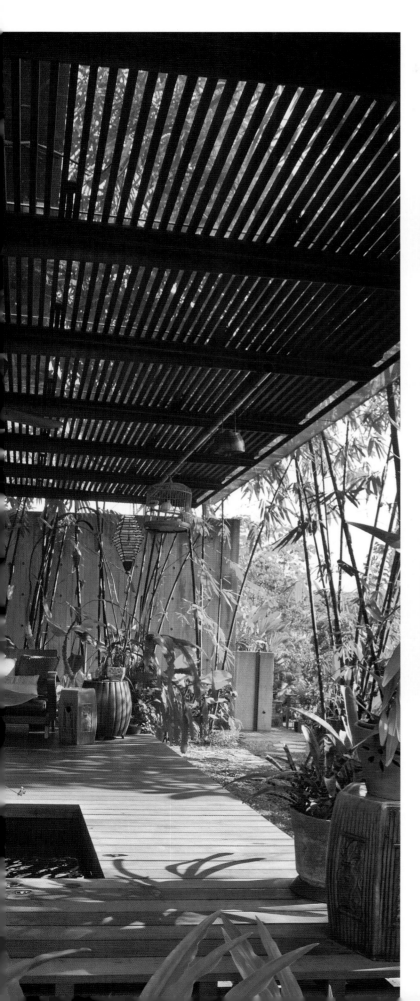

Opposite top left An off-form concrete wall defines the kitchen patio.

Opposite top right A mild steel folded sheet steel wall in the living room cuts off the view of the neighbouring house.

Opposite below First storey plan.

Left The living room deck is a relaxed, informal space.

Below Vertical mild steel reinforcing bars are employed to create the boundary fence.

braemar drive house

ARCHITECT: LING HAO
LINGHAO ARCHITECTS

Left Different areas of the house are personalized to the owners' requirements.

Right The house relies mainly on passive means of cooling. Here, doors are angled to catch the breeze.

Ling Hao, a native of Kuching, East Malaysia, is a graduate of the School of Architecture at the University of New South Wales, Australia. In late 1992, he arrived in Singapore and almost immediately gained employment with Tang Guan Bee. Arguably the most enterprising and daring home-grown designer in the three decades from 1980 to 2009, Tang was the recipient of the Gold Medal of the Singapore Institute of Architects in 2006. It is evident he had a considerable influence on Ling Hao in the latter's formative years in practice and Ling Hao has acquired a similar independent spirit.

'The period with TANGGUANBEE Architects,' says Ling, 'was something else, as the firm was building a range of projects, and you basically learned on the job. It was fuelled by a huge amount of creative ambition. I also did a fair bit of architectural touring with Tang Guan Bee and the office, to Paris and several trips to Japan; they were intense periods of architectural sightseeing.'

During his time with TANGGUANBEE Architects, from 1993 to 1998, Ling Hao worked on cutting-edge projects such as the Windsor Park House, Eastpoint and Fortredale Apartments before leaving to set up HaM Architects with Tan Kok Meng in 1998. The practice was short-lived, but in their two years together they designed B House and Villa O, two remarkable private dwellings that were widely published. Tan, another independent thinker, moved to Shanghai and Ling Hao branched out on his own, setting up Linghao Architects in 2002. 'The collaboration with Tan Kok Meng was again

extremely rich,' recalls Ling. 'Together we devised various ways of thinking, writing about and making architecture.'

Displaying remarkable versatility, Ling Hao has designed for several theatre and art productions, including Spell 7's production of 'BUD' (1998); a Theatre Festival Art Project/Installation, 'Imagined Boundaries: Encounters with New Model Communities' at Marine Parade Community Centre (2000); set design for 'Shadow Houses', a dance performance by Arts Fission (2003); and 'House Full of Dreams', a video installation for The Asian Comments Festival in Copenhagen (2000). He also received a URA Architectural Heritage Award for the Niven Road Project (2007). Ling Hao brings this theatrical experience and slightly offbeat approach to his architectural designs.

The 260-square metre-house in Braemar Drive has been designed for a couple, Donald and Valerie Low, their two daughters and a maid. The house is totally personalized to the clients' requirements. An assorted palette of materials is evident, including corrugated steel, plywood, concrete and steel mesh. It also has a riotous selection of colours – black, pink, silver, yellow and lime green – with orange tiles in the bathroom, pink lacquer on wardrobe doors, silver-painted concrete walls, steel grey paint, a striking yellow stairwell leading to the master bedroom and strobe light fittings at the base of the stairs that constantly change colour. This is akin to a dwelling designed as a stage set. There is a small pool in the living room, a parody of the traditional *koi* pond, with a floating rubber duck on this author's first visit though it had disappeared on a second visit.

'We conceptualized the house in the simplest and almost banal manner,' says Ling, 'with the idea of different materials relating to the different atmospheres for entertaining, dining, sleeping and so on. The project carries this conceptual thinking to its logical extreme. There are, of course, many layers to the project and another idea we explored was to reflect upon the kind of everyday life that one sets up with a plan.'

There is a sense of fun and experimentation in the design, a great feeling of joy but with a serious purpose that challenges the austerity and dourness and the conspicuous excess in many houses. The interior displays a surreal assemblage of colour and light, an almost dream-like quality akin to a film set. In an article in the *Business Times* (April 2006), Geoffrey Eu refers to Ling Hao when writing of the 'new wave of architects and designers who are thinking out of the box and departing from the tropical school'.

Ling Hao has a markedly different attitude to that of many of his contemporaries. Chu Lik Ren says of the work: 'I think what Ling Hao does is the equivalent of Frank Gehry in his early California houses of the 1980s, and what some of the smaller Japanese architects are doing today in terms of an intimate sense of scale and materials. Most Singaporean

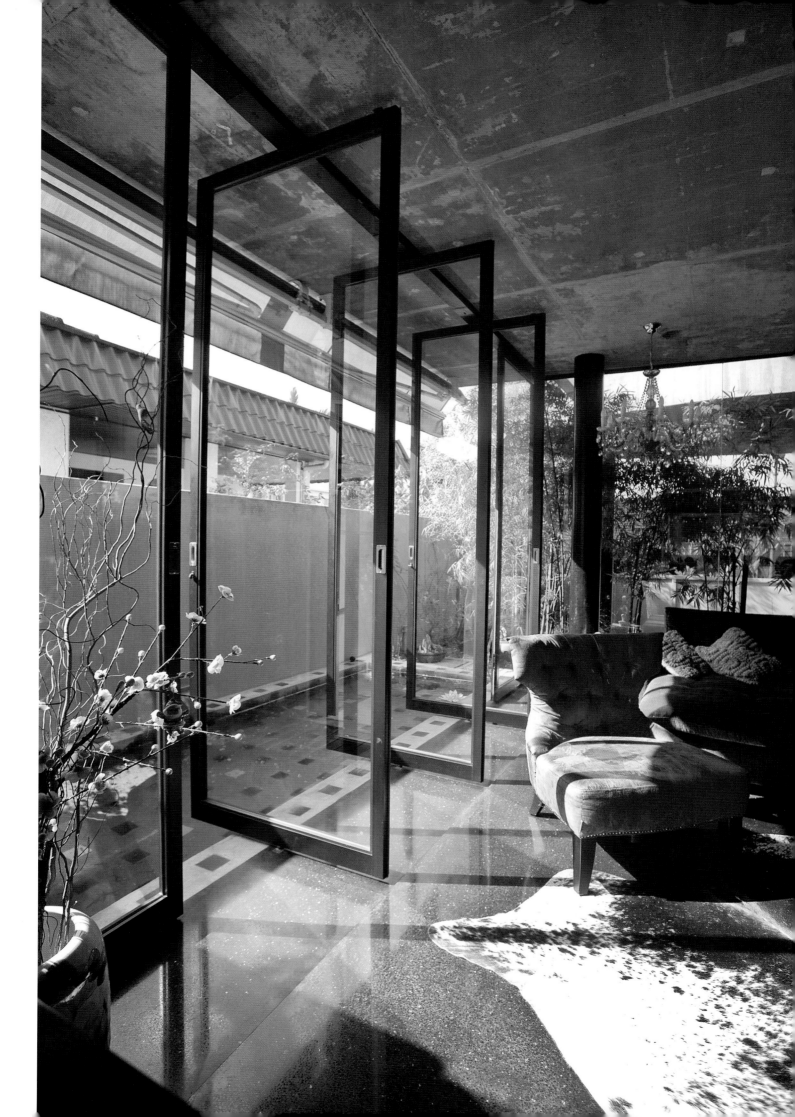

home owners ask for big floor areas and high ceiling spaces, and then insensibly pile on the glass and air condition them.'[1]

The construction of the house tells another story. The basic structure for both the first and second levels was made with concrete columns and flat slab floors inserted with recessed lights and service pipe joints, mainly by builders from China. With this infrastructure in place, various groups of workers came in to set up the different spaces. On top of the attic slab, an oval-shaped bedroom was formed with a steel structure clad with corrugated steel. The second storey was clad in *balau* wood to create a more private and intimate quality for the bedrooms, in contrast to the walls of the first-storey rooms that are glazed and have views into the garden.

In a similar manner, strips of lime-washed timber were laid for the bedroom floors, whereas hard-polished terrazzo in white, black and cream was selected for the first-storey living areas. Finally, a group of joiners from Johor moved in to assemble all forms of wall-papered, mirrored and painted cabinets, shelves and timber-framed enclosures, and to construct bedrooms, toilets, kitchens and living and dining rooms around the concrete structure and services.

The Braemar Drive House is both natural and mechanically ventilated but the family mainly uses the passive mode. The house is rapidly acquiring a patina of age – the exposed off-form concrete carport, the roof garden and the mesh railings are mellowing.

Depending on his mood and the time of day, the husband says that he enjoys being in different parts of the house. He spends a lot of time on the rooftop as well as the family room. 'To me, there is something appealing in every room and everywhere has a different feeling,' says the easy-going Donald Low, who travels often and has seen all manner of houses. 'We like natural things and small things like the way the afternoon sun plays patterns on the staircase wall. It's an unconventional house but comfortable at the same time and it suits us.'[2]

Writing of the house, which was completed in 2006, Ling Hao reflects: 'On the day of the move in, thirteen years of accumulated stuff that had filled the former house on the site were brought back into what had now become a two-storey house with an attic. Over the next few weeks, the various things were fitted into the new house as if they were always designed to be there. In retrospect, the design, which was a kind of assemblage of different effects, had found its home.'

Ling Hao has created a house with immense diversity of experiences as a result of 'imagining the life of the clients, making many worlds and creating individual places for life's dreams to be enacted'.

[1] Chu Lik Ren, in correspondence with the author, 15 January 2008.
[2] Donald Low, quoted by Geoffrey Eu, in 'Personal Space – Imperfect Perfection', *Business Times*, Singapore, 31 May 2008.

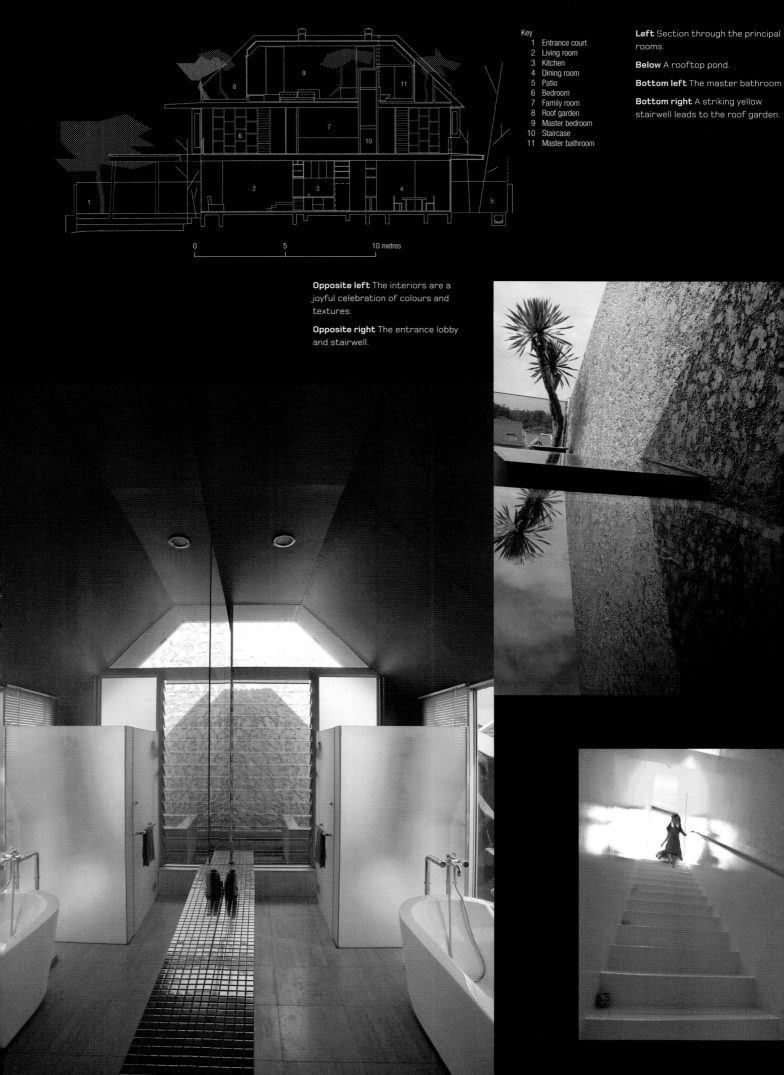

Key
1 Entrance court
2 Living room
3 Kitchen
4 Dining room
5 Patio
6 Bedroom
7 Family room
8 Roof garden
9 Master bedroom
10 Staircase
11 Master bathroom

Left Section through the principal rooms.

Below A rooftop pond.

Bottom left The master bathroom

Bottom right A striking yellow stairwell leads to the roof garden.

0 5 10 metres

Opposite left The interiors are a joyful celebration of colours and textures.

Opposite right The entrance lobby and stairwell.

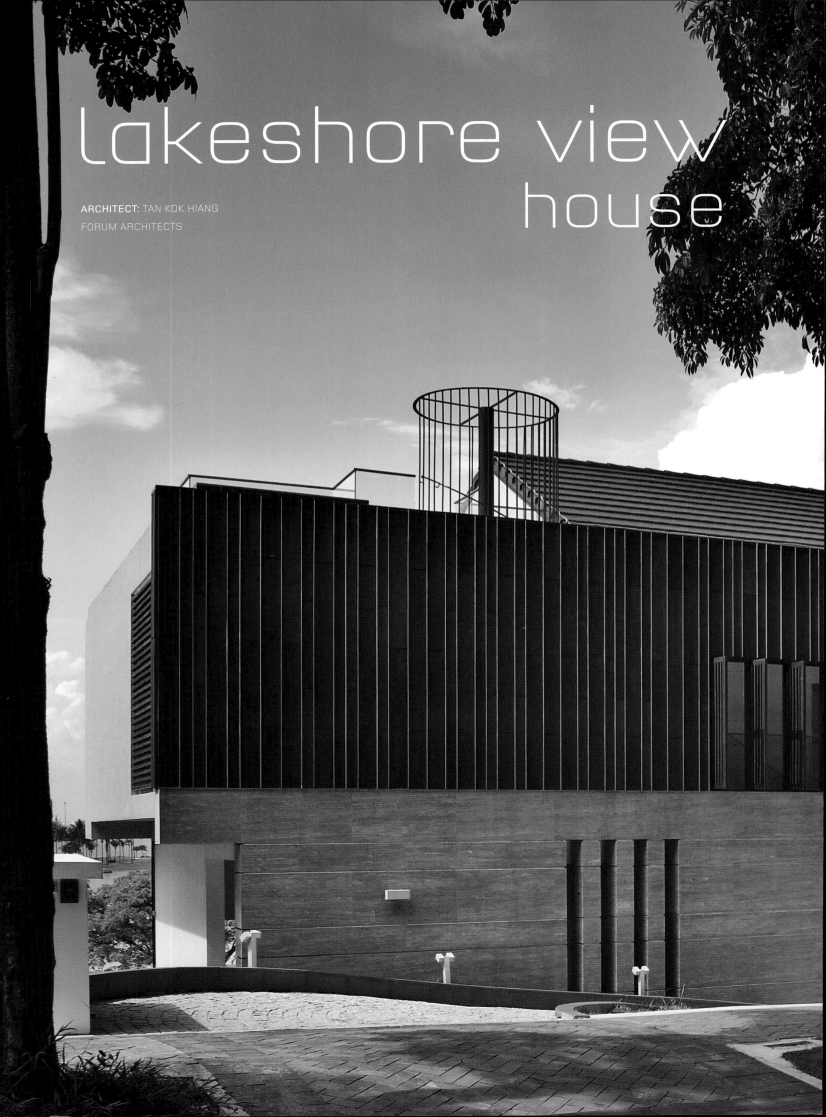

lakeshore view
house

ARCHITECT: TAN KOK HIANG
FORUM ARCHITECTS

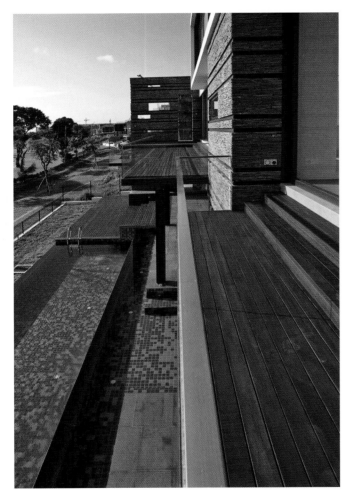

Left The house is located on the steep slopes of Mount Serapong.

Below Balconies project over the pool terrace.

Opposite The east façade is more open and transparent than the western side.

Tan Kok Hiang graduated from the School of Architecture at the National University of Singapore in 1987, with a final year design thesis that examined how traditional design principles can be integrated with modern technology. Upon graduation, he joined the practice of Akitek Tenggara where he worked with Tay Kheng Soon on a variety of projects, including the award-winning Kandang Kerbau Women's and Children's Hospital.[1]

Tan left Akitek Tenggara in 1994 to set up Forum Architects in partnership with his wife Ho Sweet Woon, who had previously worked with Tang Guan Bee, William Lim Associates and Akitek Tenggara. Forum Architects have subsequently developed a reputation for inspired problem solving on difficult sites, such as Cavenagh Fortuna (1999), the Henderson Community Club (2000) and the Assyafah Mosque (2002),[2] the latter developing ideas first formulated in Tan's NUS thesis. The practice has also completed a succession of highly original dwellings, which include the Wilby Road House (2000)[3] and the Sian Tuan House (2001).[4]

The Lakeshore View House, designed by Tan and Lye Yi Shan, is an uncomplicated response to a magnificent site on rising ground facing east towards the Straits of Singapore. The house steps down the slopes of Mount Serapong, with the main rooms orientated towards the sea view and the Serapong Golf Course in the foreground.

The house has a simple linear orthogonal plan stretching along the contours. The four horizontal layers of the house are stacked above each other and punctuated by two vertical circulation elements. A sculptural external staircase is attached to the southeast corner of the house, and a circular metal staircase at third-storey level, which gives access to the roof deck, is visible on the west elevation.

Another organizing element in the plan form is the functional separation into what Louis Kahn referred to as 'the served and servant spaces'. In this house, the 'servant' spaces, that is to say, the bathrooms, access stairs, powder rooms, entrance lobby and maid's quarters, are arranged along the west elevation facing the hillside, while the 'served' spaces, such as the master bedroom and principal living quarters, enjoy the magnificent view of ships lying at bay in the Eastern Anchorage.

The house is entered in the southwest corner at second-storey level directly into the linear living room. Beyond is the open dining room and kitchen. All overlook an east-facing timber terrace. On the western flank of the house, a staircase descends to the first storey, which contains a guest suite, a bar and an entertainment area with a snooker room that can be converted to an additional bedroom. The lower floor opens out to a sheltered patio, a timber deck and an infinity pool.

The second storey is reserved for a master bedroom suite and two additional bedrooms, all of which enjoy access to a roof terrace via the circular staircase. Topped by a pitched roof, the house satisfies by its straightforward response to the site and aspect. A restrained palette of materials adds to the clarity of the architectural massing.

[1] Hee Limin, 'Rhapsody in White: The Kandang Kerbau Hospital', *Singapore Architect*, No. 200/98, Singapore Institute of Architects, December 2008, pp. 18–25.
[2] Assyafah Mosque won an Architecture+ Award (Dubai) in 2004.
[3] Robert Powell, 'Architecture and Nature: Wilby Road House', *SPACE*, No. 6, Singapore: Panpac Media, December 2000, pp. 50–6.
[4] Robert Powell, 'Up on the Roof: The Sian Tuan Avenue House', *SPACE*, No. 2, Singapore: Panpac Media, April 2001, pp. 70–6.

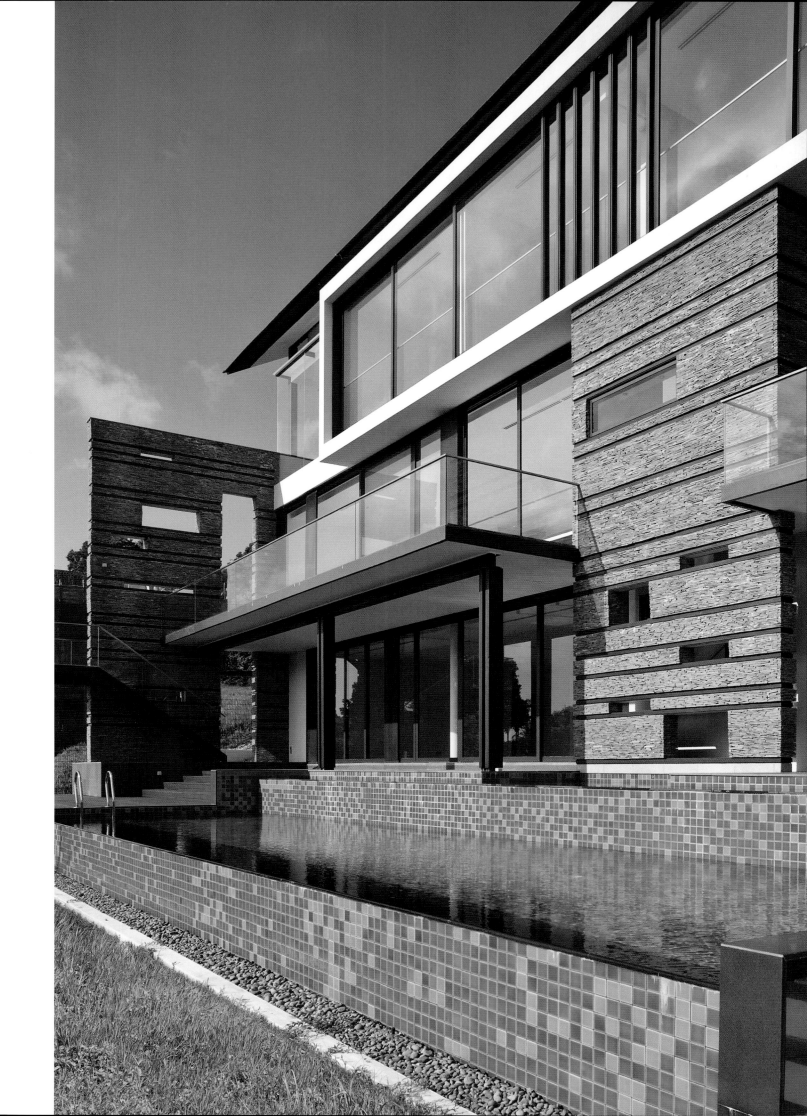

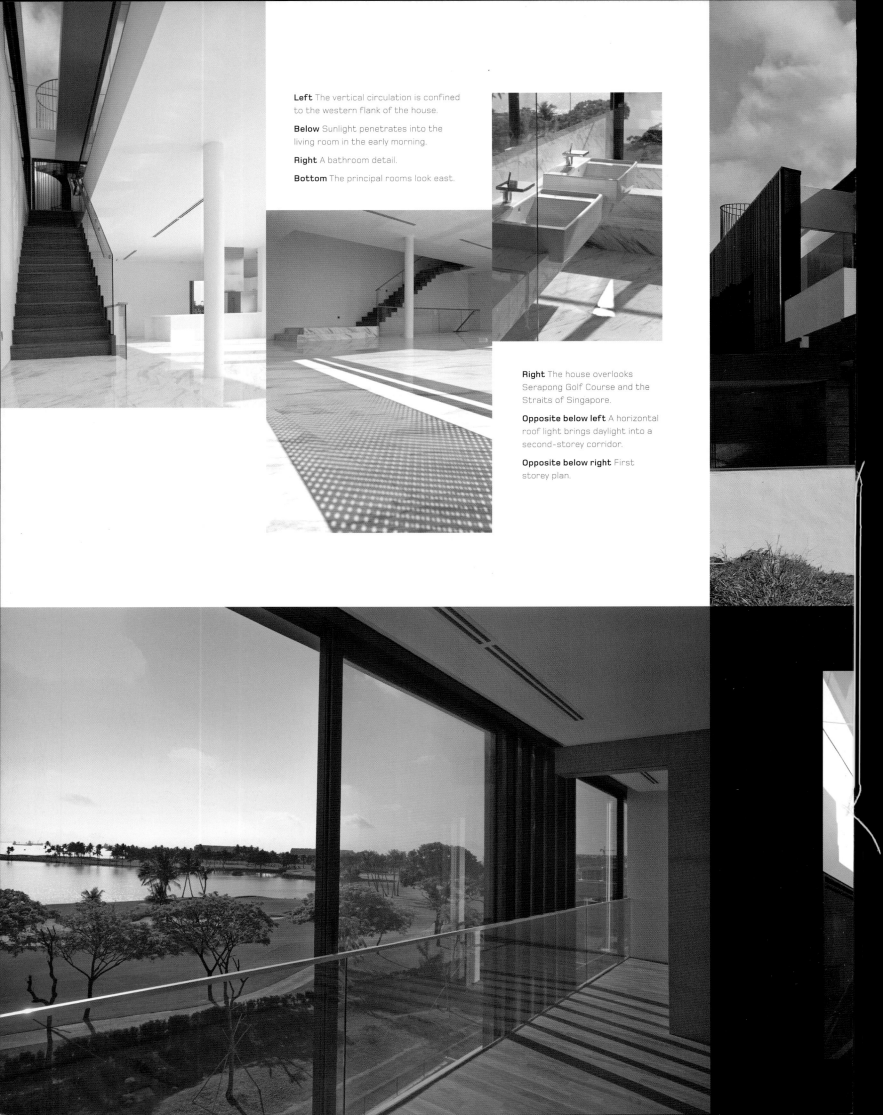

Left The vertical circulation is confined to the western flank of the house.

Below Sunlight penetrates into the living room in the early morning.

Right A bathroom detail.

Bottom The principal rooms look east.

Right The house overlooks Serapong Golf Course and the Straits of Singapore.

Opposite below left A horizontal roof light brings daylight into a second-storey corridor.

Opposite below right First storey plan.

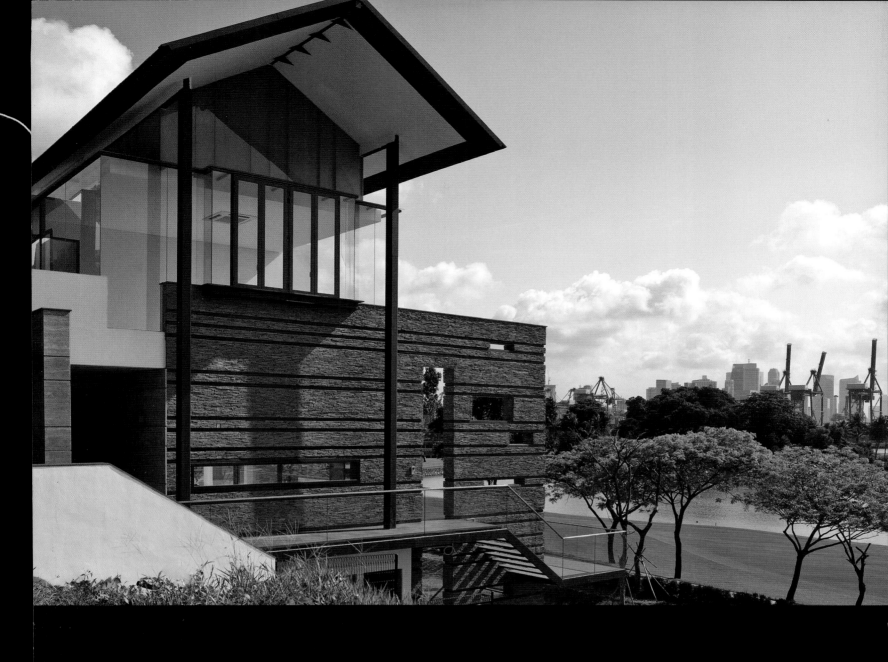

Key
1. Covered carport
2. Side entry
3. *Koi* pond
4. Entry foyer
5. Terrace
6. Living room
7. Dining room
8. Powder room
9. Dry kitchen
10. Wet kitchen
11. Maid's room
12. Laundry

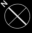

0 5 10 metres

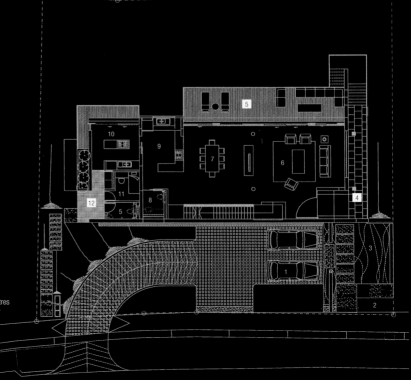

Select Bibliography

Alexander, Christopher, *A Pattern Language*, New York: Oxford University Press, 1977.

Baker, Philippa (ed.), *Architecture and Polyphony: Building in the Islamic World Today*, London: Thames and Hudson, 2004.

Brace-Taylor, Brian, *Geoffrey Bawa*, Singapore: Concept Media, 1986.

Cuthbert, Alexander, *Home: New Directions in World Architecture and Design*, NSW, Australia: Millennium House, 2006.

Edwards, Norman and Keys, Peter, *Singapore: A Guide to Buildings, Streets, Places*, Singapore: Times Books International, 1988.

Eu, Geoffrey, 'Personal Space – Imperfect Perfection', *Business Times*, Singapore, 31 May 2008.

Frampton, Kenneth, 'From Where I'm Standing: A Virtual View', in Tan Kok Meng (ed.), *Asian Architects*, Vol. 2, Singapore: Select Publishing, 2001, pp. 16–17.

Goad, Philip, 'Kerry Hill', in Philip Goad and Anoma Pieris, *New Directions in Tropical Asian Architecture*, Singapore: Periplus Editions, 2005, p. 35.

Goad, Philip and Pieris, Anoma, *New Directions in Tropical Asian Architecture*, Singapore: Periplus Editions, 2005.

Hee Limin, 'Rhapsody in White: The Kandang Kerbau Hospital', *Singapore Architect*, No. 200/98, Singapore Institute of Architects, December 2008, pp. 18–25.

Khan, Hasan-Uddin, 'The Architecture of the Individual House', in Robert Powell (ed.), *The Architecture of Housing: Exploring Architecture in Islamic Cultures*, Geneva: The Aga Khan Trust for Culture, 1990, pp. 165–83.

Knapp, Ronald G. (ed.), *Asia's Old Dwellings: Tradition, Resilience, and Change*, Hong Kong: Oxford University Press, 2003.

Lai Chee Kien and Tan Kok Meng, 'Chan Sau Yan Associates', *Architecture + Design 93–94*, Singapore, 1994, pp. 4–6.

Lim Siew Wai, William and Tan Hock Beng, *Contemporary Vernacular*, Singapore: Select Books, 1998.

Lim, Vincent, 'Nothing but More', *d+a*, No. 14, Singapore: SNP Media Asia, 2003, pp. 16–22.

London, Geoffrey, 'Earthly Paradise', *Monument*, No. 41, NSW, Australia, April/May 2001, pp. 76–81.

_____, (Foreword Robert Powell), *Bedmar and Shi: Romancing the Tropics*, New York: Oro Editions, 2007.

London, Geoffrey (ed.), *Houses for the 21st Century*, Singapore: Periplus Editions, 2004.

McGillick, Paul, *25 Houses in Singapore and Malaysia*, Singapore: Periplus Editions, 2006.

Norberg-Shultz, Christian, *Roots of Modern Architecture*, Tokyo: ADA Edita, 1998.

Pieris, Anoma, 'Kevin Low', in Philip Goad and Anoma Pieris, *New Directions in Tropical Architecture*, Singapore: Periplus Editions, 2005, p. 183.

Powell, Robert, 'Architecture and Nature: Wilby Road House', *SPACE*, No. 6, Singapore: Panpac Media, December 2000, pp. 50–6.

_____, 'Architecture as a Palimpsest', *d+a*, No. 10, Singapore: SNP Media Asia, 2002, pp. 40–3.

_____, *The Asian House: Contemporary Houses of Southeast Asia*, Singapore: Select Books, 1993.

_____, *Modern Tropical Architecture: Tay Kheng Soon and Akitek Tenggara*, Singapore: Page One, 1990.

_____, *The New Asian House*, Singapore: Select Publishing, 2001.

_____, *The New Malaysian House,* Singapore: Periplus Editions, 2008.

_____, *The New Singapore House,* Singapore: Select Publishing, 2001.

_____, *The New Thai House,* Singapore: Select Publishing, 2003.

_____, 'Nuanced Materiality', *The Architectural Review*, No. 1265, London, July 2002, pp. 82–5.

_____, *SCDA Architects: Selected and Current Works*, The Master Architect, Series VI, Vic., Australia: Images Publishing, 2004.

_____, *Singapore: Architecture of a Global City*, Singapore: Archipelago Press, 2000.

_____, 'Singapore: The Next Generation', *Monument*, No. 32, NSW, Australia, October/November 1999, pp. 72–89.

_____, 'Singapore: The Next Generation: Part II', *Monument*, No. 43, NSW, Australia, August/September 2001, pp. 62–69.

_____, 'Space, Light and Materiality', *SPACE*, No. 1, Singapore: Panpac Media, March 2001, pp. 76–81.

_____, *The Tropical Asian House*, Singapore: Select Books, 1996.

_____, 'Umbilical Connections', *SPACE*, No. 1, Singapore: Panpac Media, January 2002, pp. 79–82.

_____, 'Up on the Roof: The Sian Tuan Avenue House', *SPACE*, No. 2, Singapore: Panpac Media, April 2001, pp. 70–6.

_____, *The Urban Asian House: Contemporary Houses of Southeast Asia*, Singapore: Select Books, 1998.

Powell, Robert (ed.), *Architecture and Identity: Exploring Architecture in Islamic Cultures*, Vol. 1, The Aga Khan Award for Architecture and Universiti Teknologi Malaysia, Singapore: Concept Media, 1983.

_____, *Modern Tropical Architecture: Line Edge and Shade*, Singapore: Page One, 1997.

_____, *Regionalism in Architecture: Exploring Architecture in Islamic Cultures*, Vol. 2, The Aga Khan Award for Architecture and Bangladesh University of Engineering and Technology Dhaka, Singapore: Concept Media, 1985.

Riley, Terence, *The Un-Private House*, New York: Museum of Modern Art, 1999.

Robson, David, *Beyond Bawa: Architecture of Monsoon Asia*, London: Thames and Hudson, 2008.

Schaik, Leon van, 'SCDA Architects: A Review', *SIA-GETZ Architecture Prize for Emerging Architecture*, exhibition catalogue, Singapore, 2006.

Serageldin, Ismail, 'The Architecture of the Individual House: Understanding the Models', in Robert Powell (ed.), *The Architecture of Housing: Exploring Architecture in Islamic Cultures*, Geneva: The Aga Khan Trust for Culture, 1990.

Tan Hock Beng, 'Appropriating Modernity', *a+u*, Vol. 97, No. 317, Tokyo, February 1997, pp. 116–17.

Tan Kok Meng (ed.), *Asian Architects*, Vol. 2, Singapore: Select Publishing, 2001.

Tang Guan Bee, 'Sense and Sensibilities in Architecture', interview with Tan Ju Meng, *Singapore Architect*, No. 214, Singapore Institute of Architects, June 2002, pp. 98–105.

Tay Kheng Soon, 'The Architectural Aesthetics of Tropicality', in Robert Powell (ed.), *Modern Tropical Architecture: Line Edge and Shade*, Singapore: Page One, 1997, pp. 40–5.

10x10, 2nd edn, London: Phaidon, 2005.

Tur, Elias Torres, 'Thoughts about Architecture', in Phillipa Baker (ed.), *Architecture and Polyphony: Building in the Islamic World Today*, London: Thames and Hudson, 2004, pp. 146–7.

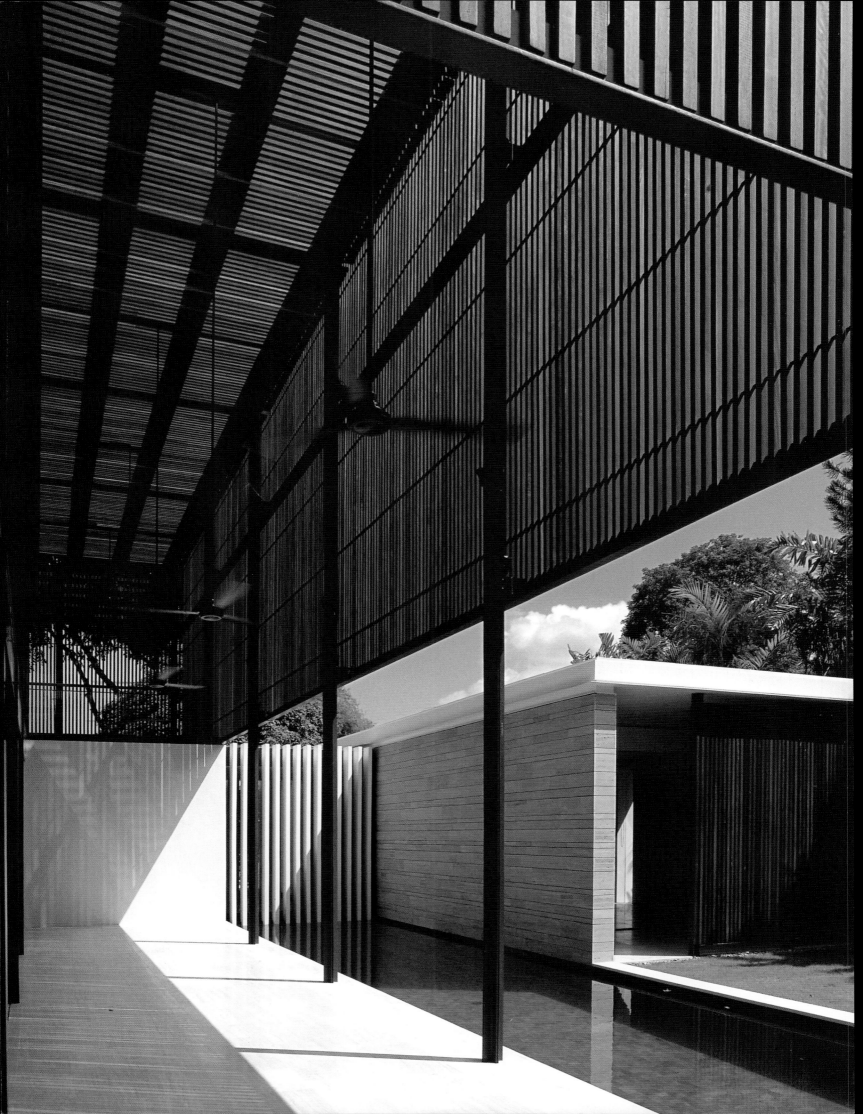

Directory of Architects

Brenda Ang
LAB Architects
12 Prince Edward Road
Podium B 03-08A
Singapore 079212
+65 6100 1889
www.aepdesign.com

Ernesto Bedmar
Bedmar & Shi Pte Ltd
12A Keong Saik Road
Singapore 089119
+65 6227 7117
www.bedmar-and-shi.com

Randy Chan
zarch collaboratives
139b Selegie Road
Singapore 188309
+65 6226 0211
www.zarch.com.sg

Sonny Chan Sau Yan
CSYA Studio Pte Ltd
5 Keong Saik Road
Singapore 089113
+65 6324 3128
www. csya.com

Chan Soo Khian
SCDA Architects Pte Ltd
8 Teck Lim Road
Singapore 088385
+65 6324 5458
www. scdaarchitects.com

Chang Yong Ter
CHANG Architects
16 Morse Road Unit 216
Singapore 099228
+65 6271 8016
www.changarch.com

formerkz architects
12 Prince Edward Road
01-01/02 Annex D
Bestway Building
Singapore 079212
+65 6440 0551
www.formerkz.com

Kerry Hill
Kerry Hill Architects
29 Cantonment Road
Singapore 089746
+65 6466 5081
www. kerryhillarchitects.com

Ko Shiou Hee
K2LD Architects
136 Bukit Timah Road
Singapore 229838
+65 6738 7277
www.K2LD.com

Lim Cheng Kooi
AR43 Architects
15a Purvis Street
Singapore 188594
+65 6333 4248
www. ar43.com

Ling Hao
Linghao Architects
14A Aliwal Street
Singapore 199907
+65 6443 8596
www.linghaoarchitects.com

Mok Wei Wei
W Architects
179 River Valley Road 05-06
Singapore 179033
+65 6235 3113
office@w-architects.com.sg

Siew Man Kok
MKPL Architects Pte Ltd
150 Cecil Street 12-00
Singapore 069543
+65 6223 4633
www.mkpl.com.sg

Kevin Tan
aKTa-architects
1 North Bridge Road 15-06
Singapore 179094
+65 3334 331
www.akta.com.sg

Tan Kok Hiang
Forum Architects
47 Ann Siang Road
Singapore 069720
+65 6323 4603
www.forum-architects.com

René Tan and Kwek Tse Kwang
RT+Q Architects
32A Mosque Street
Singapore 059510
+65 6221 1366
www.rtnq.com

Teh Joo Heng
Teh Joo Heng Architects
140 Robinson Road
05-09 Chow House
Singapore 068907
+65 6372 1110
www.tjhas.com.sg

Toh Yiu Kwong
Toh Yiu Kwong Architects
3791 Jalan Bukit Merah
#10-01 E-Centre@Redhill
Singapore 159471
+65 9387 8110
tohyk@pacific.net.sg

Wong Mun Summ
and
Richard Hassell
WOHA
29 Hongkong Street
Singapore 059668
+65 6423 4555
www.wohadesigns.com

Yip Yuen Hong
ip:li architects
11D Hongkong Street
Singapore 059654
+65 6536 9881
www. ipliarchitects.com

Author
Robert Powell
R5 Marine Gate Marine Drive
Brighton BN2 5TN UK
+44 (0) 1273 624 855
robertpowell42@yahoo.co.uk

Photographer
Albert Lim KS
12 Koon Seng Road
Singapore 426962
+65 6345 3218
albertlim55@yahoo.com.sg

TRACING THE ROOTS OF INNOVATION IN SINGAPORE'S RESIDENTIAL ARCHITECTURE 1960-2009

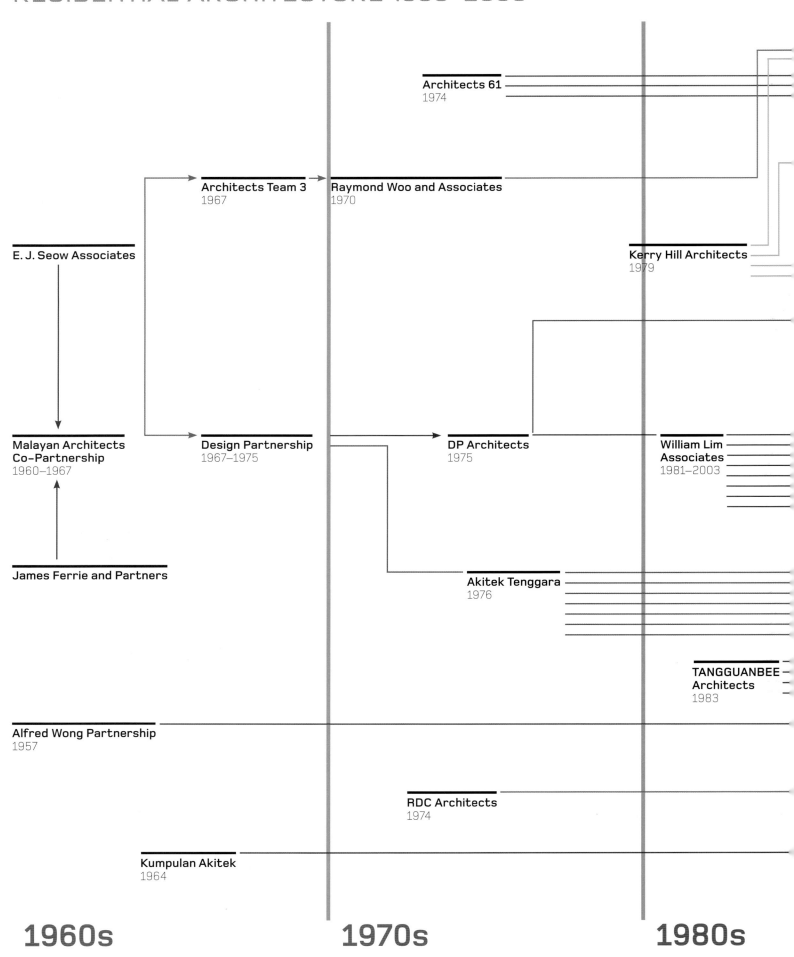

Architects 61
1974

Architects Team 3
1967

Raymond Woo and Associates
1970

Kerry Hill Architects
1979

E. J. Seow Associates

Malayan Architects
Co-Partnership
1960–1967

Design Partnership
1967–1975

DP Architects
1975

William Lim
Associates
1981–2003

James Ferrie and Partners

Akitek Tenggara
1976

TANGGUANBEE
Architects
1983

Alfred Wong Partnership
1957

RDC Architects
1974

Kumpulan Akitek
1964

1960s 1970s 1980s

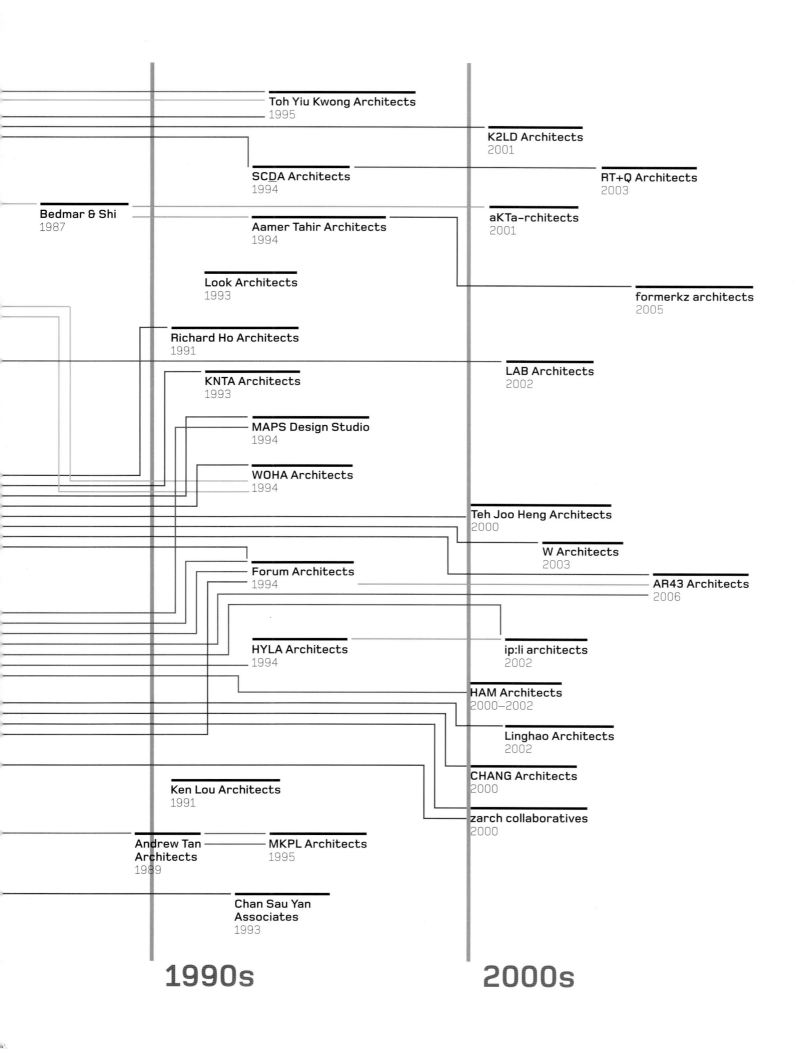

Toh Yiu Kwong Architects
1995

K2LD Architects
2001

SCDA Architects
1994

RT+Q Architects
2003

Bedmar & Shi
1987

Aamer Tahir Architects
1994

aKTa-rchitects
2001

Look Architects
1993

formerkz architects
2005

Richard Ho Architects
1991

LAB Architects
2002

KNTA Architects
1993

MAPS Design Studio
1994

WOHA Architects
1994

Teh Joo Heng Architects
2000

W Architects
2003

Forum Architects
1994

AR43 Architects
2006

HYLA Architects
1994

ip:li architects
2002

HAM Architects
2000–2002

Linghao Architects
2002

Ken Lou Architects
1991

CHANG Architects
2000

zarch collaboratives
2000

Andrew Tan Architects
1989

MKPL Architects
1995

Chan Sau Yan Associates
1993

1990s

2000s

Acknowledgements

Singapore was my home from February 1984 until March 2002, during which time I taught architecture and urban design at the National University of Singapore (NUS) where I held the post of Associate Professor. I became a Permanent Resident, edited the Singapore Institute of Architects Journal (1997–9), met and married my Malaysian-born Ceylonese wife and played cricket on the Padang at every opportunity.

Soon after my arrival in Singapore, in February 1984, I made the acquaintance of the distinguished architect and activist William Lim Siew Wai and his wife Lena Lim U Wen, the publisher and then proprietor of Select Books in Tanglin Shopping Centre. In 1987, Lena Lim commissioned me to write a book on contemporary Singapore architecture, entitled *Innovative Architecture of Singapore* (1989). It was the first attempt to examine the architecture of the Republic after two decades of Independence and it began a productive period of collaboration with Select Publishing that, over a period of fifteen years, produced nine books on Southeast Asian architecture. My constant touchstone during those years in Singapore was Tay Kheng Soon, principal of Akitek Tenggara and latterly Adjunct Professor in the Department of Architecture at NUS, who could always be relied upon to deflate any preconceived notions I entertained about Singapore and its architectural production. I also received advice and critical commentary from other academic colleagues, including Chua Beng Huat, Norman Edwards, James Harrison, Hee Limin, Heng Chye Kiang, Ho Pak Toe, Richard Hyde, Pinna Indorf, Lam Khee Poh, Joseph Lim Ee Man, Lim Soon Chye, Meng Ta-Cheng, P. G. Raman and Bobby Wong Chong Thai.

In this new book, I am indebted to a number of architects for permitting me to publish their designs. I wish to acknowledge, in particular, Brenda Ang, Ernesto Bedmar, Randy Chan, Sonny Chan Sau Yan, Chan Soo Khian, Chang Yong Ter, Richard Hassell, Kerry Hill, Berlin Lee, Lim Cheng Kooi, Ling Hao, Mok Wei Wei, Seetoh Kum Loon, Siew Man Kok, Gwen Tan, Kevin Tan, René Tan, Tan Kok Hiang, Alan Tay, Teh Joo Heng, Toh Yiu Kwong, Wong Mun Summ and Yip Yuen Hong.

I must also express my appreciation to the owners of the houses for allowing me to intrude into their private lives. Several desire to remain anonymous but among those who do not I wish to thank Simon and Michelle Cheong, Michael Ho, Dr Leong See Odd and Dr Loh Lih Ming, Donald and Valerie Low, William Ng, Yuan Oeij, Bernd Starke and Carol Lim Starke, Tan Eng Sim, Mr and Mrs T. P. Tay, Edmund Wee and Tang Wang Joo, and Richard Wong and Clara Hue.

I was also assisted by Chee Li Lian, Chu Lik Ren, Chua Z-Chian, Campbell Ian Cumming, Lillian Dirgantoro, Emilia Emilianay, Francis Goh, Ho Sweet Woon, Ida AK, Serena Khor, Koh Hui Hay, Kwee Liong Phing, Grace Lee, Look Boon Gee, Lye Yi Shan, Bernard Ng, Oh York Bing, Quek Tse Kwang, Satoko Saeki, Desmond Tan, Tan Hock Beng, Tan Kay Ngee, Tan Kok Meng, Tang Guan Bee, Charlotte Wong, Ye Minyu and Angeline Yoo.

I would have found it impossible to keep abreast of architectural developments in Singapore without the help of Lynda Lim Kwee Guek. We have worked together for 24 years and I receive from her copies of every article in the *Straits Times* relating to architecture. At the Periplus Publishing Group, Eric Oey, June Chong, Chan Sow Yun, Gail Tok and Margaret Kang were hugely supportive, as was freelance editor Noor Azlina Yunus.

Thanks are also due to Pravin Hari Ramalu and Allison Lai who provided accommodation in their spacious apartment at Tampines while I was researching the book, my daughter Zara Shakira who proofread the draft text, and my wife Shantheni Chornalingam who offered advice on the introductory essay. Finally, my sincere thanks are due to my collaborator, the vastly experienced architectural photographer Albert Lim Koon Seng, who sprinkles his own magic throughout the book.

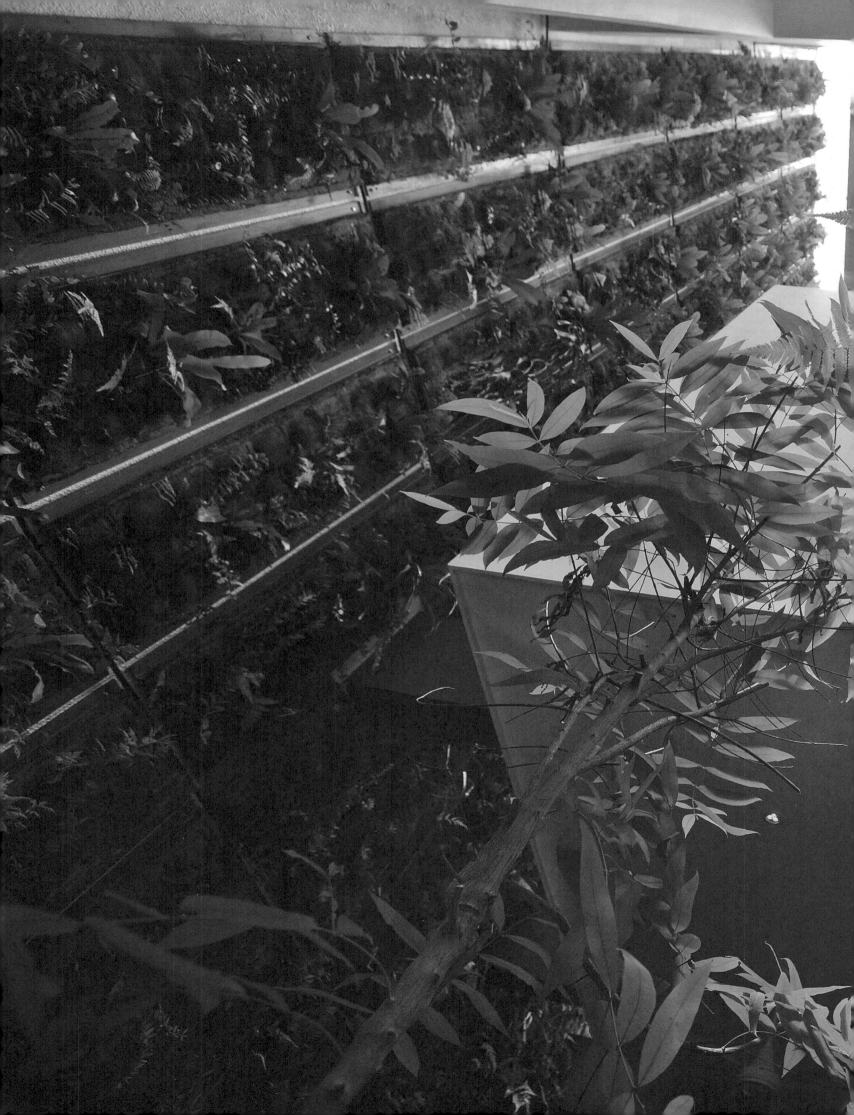